EX LIBRIS
Dana Q. Coffield

CLIMB EVERY MOUNTAIN

A Journey to the Earth's Most Spectacular High Altitude Locations

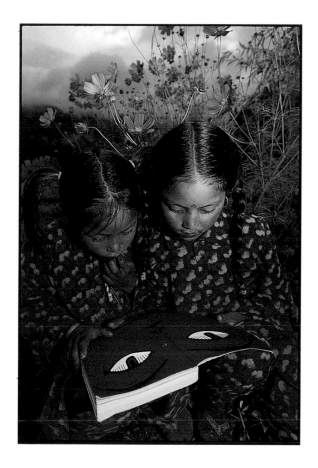

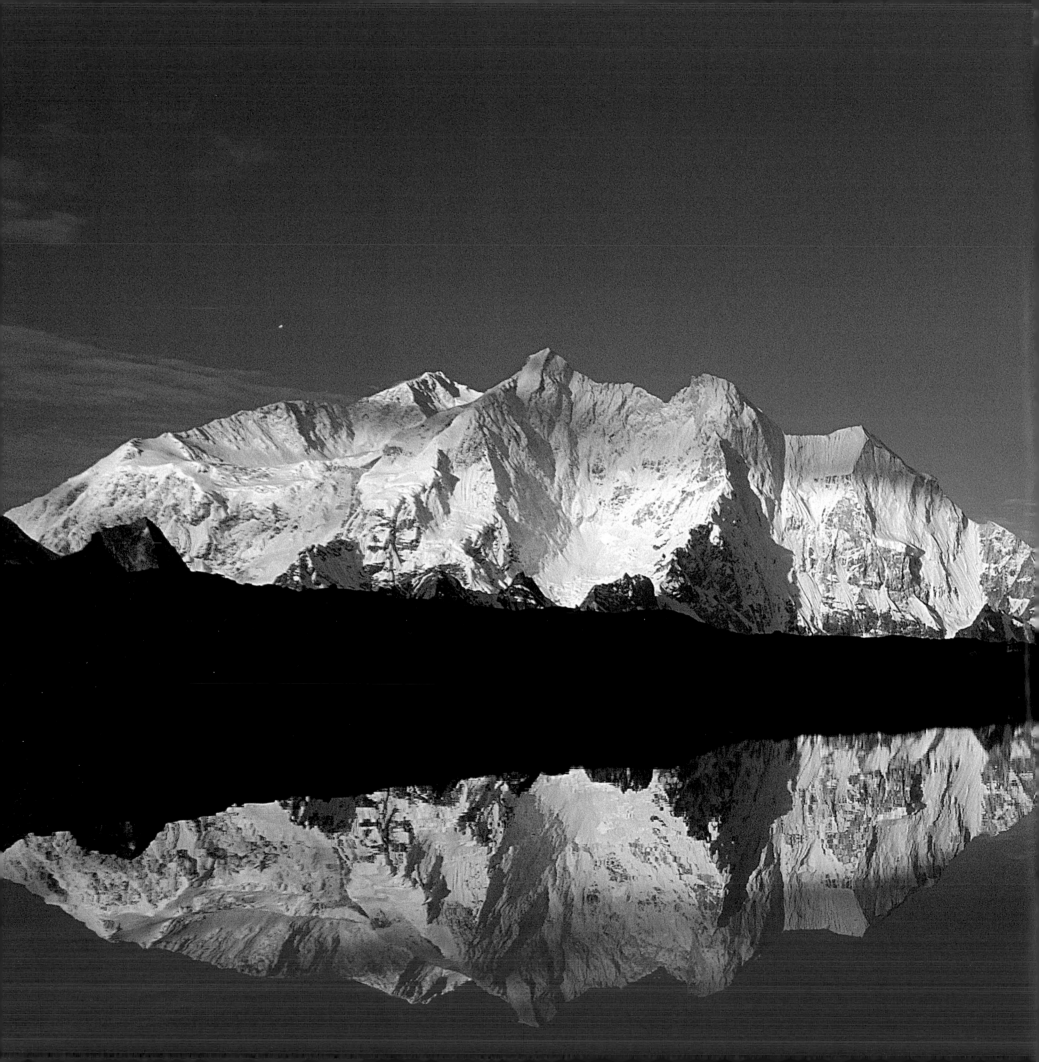

CLIMB EVERY MOUNTAIN

A Journey to the Earth's Most Spectacular High Altitude Locations

Colin Monteath

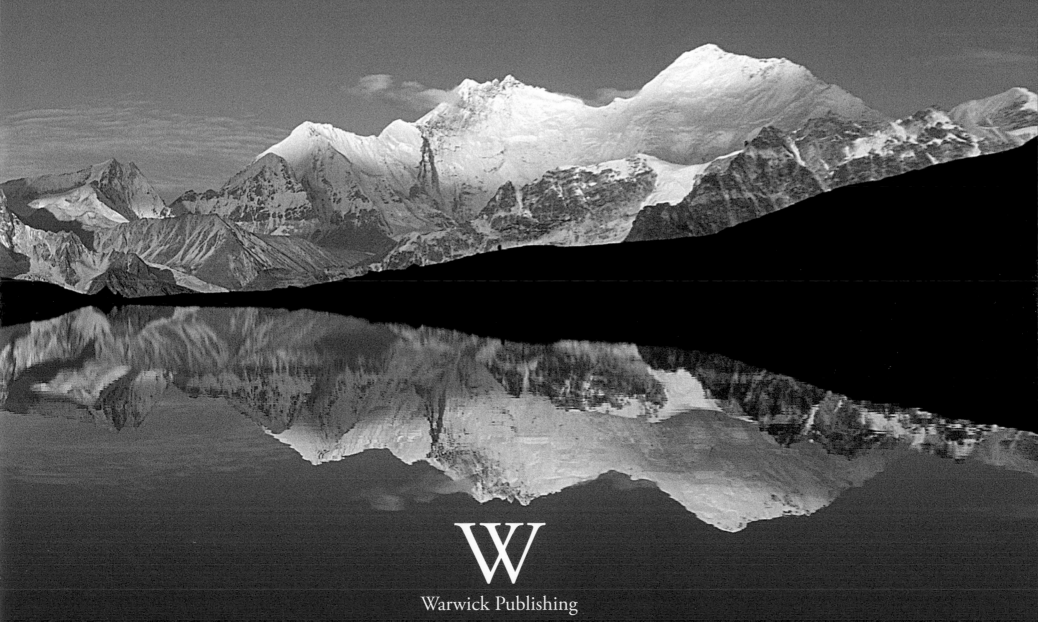

W

Warwick Publishing

We acknowledge the financial support of the Government of Canada through the Book Publishing Industry Development Program for our publishing activities.

ISBN: 1-894622-63-4

First published by Hedgehog House New Zealand as *Under a Sheltering Sky: Journeys to Mountain Heartlands*

This edition published by David Bateman Ltd, 30 Tarndale Grove, Albany, Auckland, New Zealand

Published in North America by Warwick Publishing Inc.
161 Frederick Street, Suite 200
Toronto, Ontario M5A 4P3 Canada
www.warwickgp.com

Distributed in North America by
Client Distribution Services
193 Edwards Drive
Jackson TN 38301
www.cdsbooks.com

Edited by Anna Rogers
Paintings by Yasoda – Ikon Art n' Mind
Colour separations by Andrew Budd, Tradescans
Publishing consultants – Bruce Bascand & Peter Watson
The Caxton Press, Victoria Street, Christchurch
Design by Sue Elliott, The Caxton Press

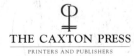

THE CAXTON PRESS
PRINTERS AND PUBLISHERS

Cover design by Clint Rogerson
Printed by Everbest Printing Company Limited, China

HALF TITLE: *Nepali sisters study a guide book, Simikot, West Nepal.*
TITLE PAGE: *Reflection from Tso-me-lung – Makalu (left) to Lhotse and Chomolungma, Karma Valley, Tibet.*
LEFT: *Sunset on Chomolungma and Makalu from Gokyo Ri, Khumbu, Nepal.*
CONTENTS PAGE: *Tore Stenseng skiing with huskies, Greenland icecap.*

Contents

Dedication

This book is for Denali and Carys,
with whom Betty and I have shared
the finest of journeys
and for the
1951 New Zealand Garhwal Expedition:
Ed Cotter, Ed Hillary, George Lowe
and Earle Riddiford, who set the pace
and style for Kiwi mountaineers
in the Himalaya.

Sir Wally Herbert

Colin Monteath is one of those rare individuals in our day and age – a romantic who is drawn to the wilder regions of the Earth, not by the call of instant fame to which so many of the modern 'explorers' all too eagerly respond, but by that far subtler insistence of spirit the more sensitive souls call wonder.

This view of the wilderness is by no means unique. It is, nevertheless, a view so seldom expressed these days that I see this book as Colin's gift not only to those who share his love of wandering off the beaten track, but to that whole generation of adventure seekers whose focus has become confused by their 'heroic' image of themselves.

Sponsors, of course, are partly to blame for feeding the worst of this hype to the press, and for creating this breed of modern 'explorer' who clearly think and act differently to those fur-clad and far more colourful characters of the so-called Heroic Age. The polar terrain is much the same, and the climate in general is similar enough to what it was a century ago. But the well-fed and well-equipped adventurers of today are constantly looking for new routes up the higher mountains, or new ways of dragging a sledge to the Poles – and with each passing year the stunts grow wilder and further from the experience of the original pioneers.

What was once the heroic obsession of men such as Peary, Shackleton, Amundsen and Scott, is now nothing more than a winter sport (played out in the Antarctic's austral summer, and in the two months of the Arctic spring) where the goal of each contestant is to succeed as quickly and as publicly as possible and to get out to reap the rewards of their hype – the money and the fame. Of the 400 or so who have 'conquered' the North or South Pole and are still alive to tell their

Wally Herbert at the North Pole, August 1991.

tale, only 12 have ever, by way of preparation, spent a full winter in the polar world in order to get in tune with nature – and this, to my way of thinking, says more about the state of mind and the motivation of these so-called explorers than they will ever admit. The plain fact is that most of these athletes (even those who are breaking records) hate the environment that they are fighting – so very unlike the high mountain people of the Himalaya and the Eskimo hunters who travel thousands of kilometres each year, sitting on their sledges, smoking their pipes, enjoying their world.

It is in the camps of such natives that Colin Monteath finds his kindred spirits, not in the cities where noise pollution includes the sound of the public's applause for the latest instant hero. Had he so chosen, he could so easily have been tempted off course and entered the polar record books ahead of those contemporaries who later made their names. Instead, Colin preferred the wilder places where only the native people travel, and it is for me a pure delight to join him on his wanderings, a long way from the crowded routes on Everest and the well-trodden roads to the Poles.

Here is a man so truly in tune with the wilderness regions that he moves through them like a gentle breeze, disturbing nothing, and yet refreshing everything and every soul he meets and touches as he skis, rides or plods traditionally along his way. Too many followers of Colin Monteath would, it is true, disturb the natural balance of the wilds, and those trackless areas he writes about with so much natural flair and love would very soon be overrun and spoilt. But this is a book for those who care, not for those who strive to conquer and I do believe his *real* admirers, sensing what he is about, will save a special place for spirit and come to share his wonder.

AT LEFT: *Flanked by Colin, Betty and Carys, Denali Monteath drives a Zodiac in Antarctica.* BACKGROUND: *The fins of an upturned iceberg catch the light.*

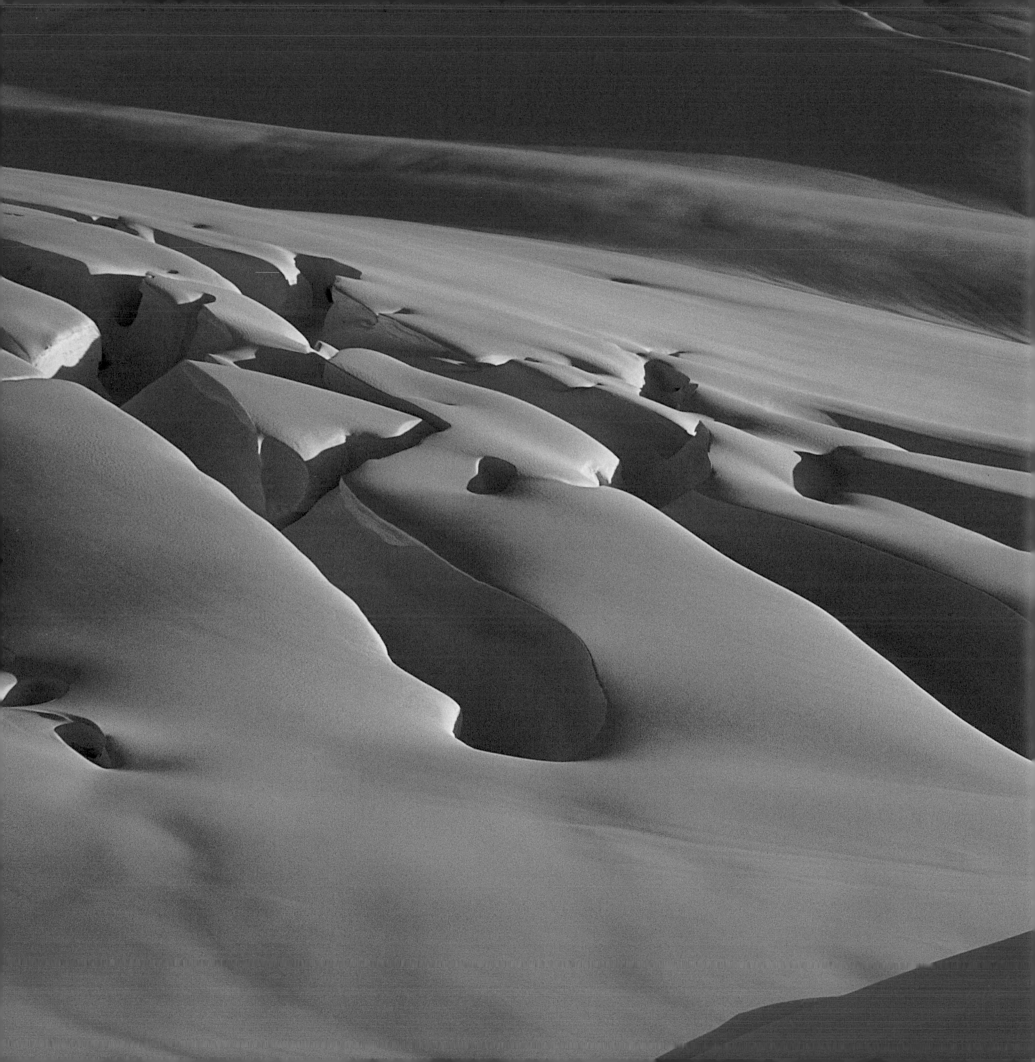

'The call of the little voices'

Chance encounters change lives. Close friends, passing acquaintances and even characters who emerge from old books often leave footprints across my heart. By opening mysterious doors, the influence of others has inadvertently altered the direction of my life. What began as a spontaneous journey to England to farewell a friend grew to become a pilgrimage to mountain heartlands around the globe. Though I did not realise it at the time, I was being inexorably drawn down the path that led to *Under a Sheltering Sky*.*

In April 1990 I flew from New Zealand to London to attend a memorial service for the renowned aviator Giles Kershaw who had died in an Antarctic aircraft accident. I had first met this charismatic Englishman in 1981 at New Zealand's Scott Base after the British Transglobe Expedition had crossed the continent. And then, in December 1988, when Giles flew me towards Antarctica, I came to think of him as 'The Little Prince' of polar aviation. He had just completed an exhausting private expedition that traversed 41,000 kilometres of Antarctica in a Twin Otter aircraft. After barely a night's rest in Punta Arenas, Chile, he turned around and co-piloted a battered DC4 back across Drake Passage so my two friends and I could climb among the high peaks of the Ellsworth Mountains. Passionate about Antarctica during 15 summers of faultless flying, the supremely confident pilot pushed himself hard on ventures that fired his imagination.

I sat on a wooden pew in the Royal Geographical Society lecture theatre and listened to eulogies for Giles, among them one by the American adventurer Beverley Johnson (herself now the victim of an air crash). Beverley concluded with two moving poems that Giles had written in the 1970s during

LEFT: *Nick Groves skiing at sunset, Fox Glacier, New Zealand.* TOP: *Polar aviator Giles Kershaw (left) and Greg Mortimer in a DC-4 aircraft en route to Ellsworth Mountains, Antarctica.*

*Republished as *Climb Every Mountain* 11

the decade he flew for the British Antarctic Survey. Expressing the peace and beauty he found during his fieldwork, Giles described how he yearned, one day, to be buried close to Alexander Island, the mountainous setting for many of his exploits. And now he had just been interred on a rocky ridge above a glacier in Jones Sound, not far from the crash site. Poignantly, Beverley spoke to a hushed audience of how, just as the poetry foretold, Giles's grave looked towards his beloved Alexander Island, its ice-clad peaks shimmering across Marguerite Bay above a drifting band of fog.

Feeling pensive and wishing to be alone, I wandered through the RGS library. Wide-eyed like Kim in his fabled 'Wonder House', I thumbed leather-bound books and marvelled at antique maps drawn painstakingly by the glimmer of oil lamps. I ran my fingers over Gino Watkins's sealskin kayak parked casually in a corridor. In the basement, I browsed dusty shelves of faded, hand-written diaries, scratched out lovingly in fountain pen during months of isolation in a damp tent. One bulged with pressed plants. Opened at random, an album from the 1920s revealed bleached monochrome prints of Englishmen, clad in baggy shorts and pith helmets, gazing resolutely into the distance on some obscure journey in Tibet.

Outside the RGS, in limp sunshine, I left Kensington Gore and, somewhere in the heart of London, entered a bookshop. On the point of leaving half an hour later, I found myself staring at the soft brown eyes of a portrait on the cover of Wilfred Thesiger's autobiography, *The Life of My Choice*. The striking oil painting that had caught my attention depicted the famed traveller in his 30s. Just then, I became aware of a tall elderly man in a dark pin-striped suit standing motionless beside me. He, too, was focused on those penetrating eyes as if nothing else mattered. I looked up into his leathered face, paused, then remarked, 'You're Thesiger, aren't you?'

As Thesiger inscribed his book for me we chatted about aspects of a remarkable life that has centred on lean, extended journeys in places such as Ethiopia, the Sudan and Arabia. His chiselled, wind-burnished features (80-year-old Thesiger lived much of the year with the Samburu in Kenya) took on a glazed, faraway expression when I commented on his collections of finely crafted images in *Desert, Marsh and Mountain* and *Visions of a Nomad*. My parting glimpse of Thesiger was of him striding purposefully down the pavement to disappear among the aimless jostle of shoppers.

Left alone, I was riveted by Thesiger's book jacket eyes. Somehow, I sensed that my future lay with fostering a passion for mountain travel rather than delving deeper into the arcane world of high-altitude mountaineering. I had a strong feeling that this brief encounter would somehow give me the courage to strike out in a fresh direction. Back in 1974, while climbing in the Peruvian Andes, I had consciously decided not to become a mountain guide. Yet, from

1973 to 1983, professional work in harsh Antarctic terrain dominated my life. Full-time employment with the New Zealand Antarctic Research Programme was immensely exciting but not without risks, often beyond my control. During this period I tried to pull back from hard climbing in the Southern Alps and purposely limited my participation in Himalayan expeditions. But by 1984, blessed with the new-found freedom of a polar and mountain photographer, I could no longer resist the pull of the world's great ranges.

At home again, Giles's memorial and those fleeting moments with Wilfred Thesiger haunted me. Delving into his 1959 classic *Arabian Sands* further convinced me to seek the rewards of unsophisticated travel. Each episode in *Under a Sheltering Sky* is far from the cutting edge of adventure and can hardly claim to be called exploration. I have merely sought the satisfaction of low-key expeditions undertaken, wherever possible, without the assistance of mechanised transport and in the company of local inhabitants and their baggage animals. To me, it is vital to break the dependence on engine-power in order to reap different, lasting rewards. To slow down and move at the pace of the land is the only meaningful way to see the detail of what is actually there. Crucially, each of the journeys in this book makes use of traditional forms of transport such as yaks, camels, horses and dogs.

Under a Sheltering Sky stems from my conviction that the sense of tranquillity and balance I have found in the mountains is worth sharing. But I often struggle to justify travel that can be seen as frivolous when others remain mired in conflict and disease. And with ecosystems under threat and species facing extinction, it is clear that the need to tread lightly on the planet cannot be ignored. Would the world be better off if I stayed at home? I take heart from friends who believe that I should never underestimate the long-term benefit to society or the environment of participating in low-impact adventures undertaken in a positive, loving manner. I hope that *Under a Sheltering Sky* expresses a spirit that will help to make a difference. Selfishly, I take solace from a toast by Sir Ernest Shackleton to Norwegian whalers on South Georgia: 'To those of us who are no damn use anywhere else'.

On New Year's Eve 2000, I found myself stuck off South Georgia on a ship with a seriously fouled anchor. After 12 hours of hard work, the Russian crew solved the problem by using winches to tension nylon hawsers that held the anchor chain in a precise position. Then they wrapped petrol-soaked rags around the ropes and set fire to them. One by one the ropes melted through and as the molten nylon lashed out across the deck, the anchor dropped free – a clever trick from an Indiana Jones movie! (Shackleton would have been the first to cheer.) The indomitable Shackleton, his sledging mate Frank Wild and others bewitched by this land of silence have had a profound impact on me. When Wild was asked why he kept returning to the Antarctic he suggested it must be

'The call of the little voices'. As our vessel left Stromness Bay at dawn, punching bravely into the stormy seas of a new century, little voices inside reminded me of journeys past and hinted at those to come.

In *Under a Sheltering Sky* I document my return to South Georgia in 2001 to retrace the route across the island pioneered by Shackleton in 1916 after his ship *Endurance* sank. Compared with Shackleton's epic, our crossing was a lighthearted affair, but, for me, it symbolised much that I value in the teamwork essential to polar travel. The chapter also features an earlier enterprise, based near Shackleton's 1908 Ross Island hut, which enabled me to climb the volcano Erebus and to scramble in the Transantarctic Mountains. After 26 seasons in Antarctica, I am increasingly convinced that private endeavour in the polar regions has inspirational value.

The object of crossing Greenland in 1993 was to traverse an icy wilderness with huskies. Completing the journey was satisfying in itself, though the enduring value stems from absorbing the serenity of a grand polar desert while trundling along with skis, wooden sledges and a bunch of unruly dogs. The bond that developed between the huskies and the drivers added an emotional factor that would not have been possible if we had zipped along on noisy snowmobiles. Handling huskies day after day also played a role in melding a close-knit team from a group of disparate individuals. I treasure that kinship.

Only two chapters involve the rigours of polar travel. Others describe less strenuous Himalayan undertakings such as a trek to the Nepalese side of Kangchenjunga, a pass-hopping traverse of northern Bhutan and a climb on Tibet's Gurla Mandhata close to the holy peak Kailas. Another Tibetan venture retraces George Mallory's 1921 exploration in the shadow of Mount Everest. These journeys involved treks that ambled along behind yak caravans or with porters. On the other hand, a 1994 expedition to the Chinese Karakoram used camels to reach a remote objective. The memory of clinging to the humps of those shaggy creatures while fording rivers remains more vivid than the struggle to a virgin summit.

Although an exotic environment offers its own richness and a distinct quality of light, memorable journeys can always be found close to home. Ski touring in the Southern Alps remains dear to my heart. Two such experiences, skiing the Routeburn Track and a circuit of the Franz Josef and Fox Glaciers, were not expeditions at all, merely brief visits to old haunts that rekindled an affection for long-loved mountains.

A love of ski travel has also lured me to big mountains overseas. With a daughter named Denali how could I not go to Alaska? A traverse of Denali (Mount McKinley), the highest peak in North America, was an intense sledging journey that demanded patience and stamina. In eastern Tibet, however, a dose of luck was sorely needed after a serious crevasse fall during a ski reconnaissance of the secluded Kangri Garpo Mountains.

What a privilege it has been to initiate adventures that began in my heart and ended up by setting out for a distant destination. Fascinated by the Russian Nikolai Prejevalsky's travels in Mongolia, I had a nip of whisky by the fire one night before gleaning information on the Altai Mountains from the fragile, foxed maps in his book. And then I entered the realm of Genghis Khan. Tierra del Fuego and Patagonia are distant in every way from Mongolia but no less wonderful. I end the book with impressions from my sojourns there.

I remain a hopeless romantic. Enchanted by the eloquent writing of early travellers and the monochrome plates in their books, I have embarked on a series of journeys to savour a wide variety of sacred landscapes, though my trips were seldom planned as exact recreations of original explorations. *Under a Sheltering Sky* is not a guide book, but I hope that others will be sufficiently inspired to initiate their own adventures. To help readers make sense of the sometimes complex geography and to draw them into the spirituality of the mountain landscape, each chapter concludes with a watercolour 'map' by Christchurch artist Yasoda. Delving into the books listed at the end of each chapter will provide a deeper understanding of the history and culture of each area.

My irreverent daughters describe me as a bit short of a full byte. They say I am not quite ready for the speedy world of cyberspace, but I am thankful that the soulless planet of pixels can be dismissed with the flick of a button. But what of ravenous huskies yowling on a crystal desert, steaming horses whinnying in a Bhutanese forest or yaks snorting in thin air on a Tibetan pass? And high camps, from Nepal to New Zealand, where you can lie beneath a canopy of stars and marvel at the uniqueness and antiquity of our world, its great beauty and fragility under a sheltering sky?

The more I travel the more convinced I am that this is far from a shrinking planet with nothing left to discover. Impressive though space travel has been, we have barely scratched the surface of the secrets held by our oceans. And, in Asian mountains alone, we are just starting to appreciate how few regions have been thoroughly examined. How I envy the next generation of mountain travellers who have so much new ground in front of them. For climbers with imagination and resolve, the scope for new routes knows no bounds. But, even on hills trodden a thousand times before, a fresh snowfall is all that is needed to rejuvenate the desire to explore.

Thankfully, on this crowded planet, it is still possible to be truly alone. To seek solitude and to tune the senses to the great blessing of silence is reward enough, whether you are in some distant land or just outside your back door. Indelibly imprinted on my psyche is the saying, 'Of magic doors there is this: you do not see them even as you pass through'. It is astonishing what can happen when you open your heart to the possibility of the next journey.

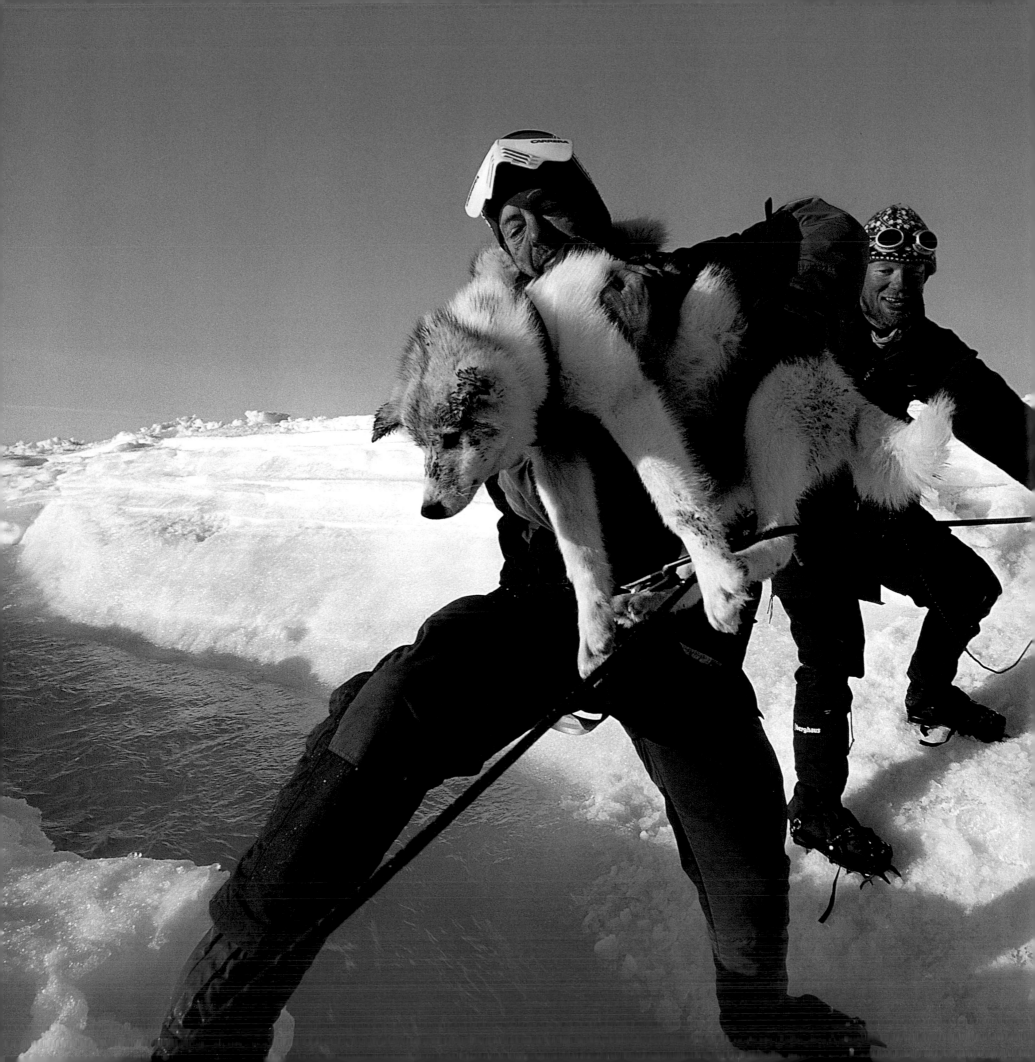

Above the Clang and the Clatter

A traverse of the Greenland icecap

One autumn evening [1883] I remember it still as if it were only yesterday…
Suddenly my attention was roused by a telegram which told us that
Nordenskjold had come back safe from his expedition to the interior of
Greenland, that he had found no oasis, but only endless snowfields, on
which his Lapps were said to have covered, on their ski, an extraordinary
long distance in an astonishingly short time. The idea flashed upon me
at once of an expedition crossing Greenland on ski from coast to coast…
So it struck me that the only sure road to success was to force a passage
through the floe-belt, land on the desolate and ice-bound east coast, and
thence cross over to the inhabited west coast. In this way one would burn
all one's ships behind one, there would be no need to urge one's men on, as
the east coast would attract no one back, while in front would lie the west
coast with all the allurements and amenities of civilisation.

Fridtjof Nansen, *The First Crossing of Greenland*

Ice-cold water surges down a U-shaped channel gouged in the glacier and plummets into an
inky blue hole. I jump across the glassy chute, mindful that a slip can easily prove fatal. Meltwater
racing off the western Greenland icecap has forced us into a series of protracted manoeuvres
on our descent from the dome-shaped ice plateau to the tundra on the coastal fringe. Our east-west
journey across Greenland is all but complete. And yet, just when the huskies are worn out and we

LEFT: *Mike McDowell throws a husky across a dangerous melt stream.* TOP: *Waking up after a snowfall.*

too are tired and drawn from a relentless sledging routine over rough ice, this maze of vicious streams barring the way is testing our resolve and our experience in the polar regions. Somehow, we have to get across…

Wearing crampons and secured by his harness to a hastily rigged rope, long-legged Mike McDowell is just able to straddle the stream at its narrowest point. He hitches the husky's harness to the safety line by a carabiner before grabbing the terrified dog and throwing it to me on the opposite bank. Wild-eyed and whimpering as if they have been thrashed, the huskies are caught one by one and clipped back into traces staked out on the ice. Our 22 dogs, owned by Greenlanders on the east coast, have learnt the hard way to respect frigid water: they are routinely used for hunting trips on treacherous sea ice.

Next, the survival gear is unloaded, piece by precious piece, and gingerly passed across the channel. It takes all five of us to manhandle the three wooden sledges over the gurgling chasm. The pile of boxes, tents and spare skis are then stowed back on the sledges in a well-tested sequence before the load is relashed tightly onto the decking. Securing the loads is always done with great care for to lose even a shovel could jeopardise our lives. Only when the lash lines are really tight can we shed crampons, step back into ski bindings and ready the dogs.

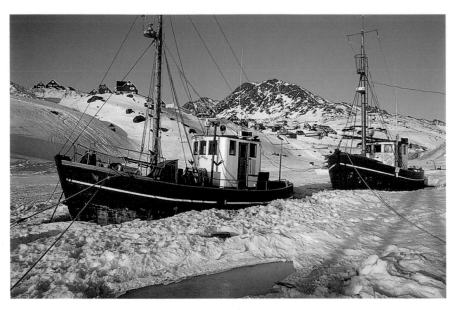

Fishing boats frozen in Ammassalik Harbour, East Greenland.

Barking mad, with tails held high, the huskies are charged with energy as they strain against the metal hooks driven into the snow behind the sledges. The anchors have to be pulled at precisely the right moment or we will have to wade in to sort out a snarling fight. Suddenly, we are off, the sledges hurtling away behind each other as they snake in wide arcs across mushy ice. Progress is frustratingly shortlived as the lead team lurches to a halt again when confronted by the next torrent only a few hundred metres away. As we are repeatedly stopped in our tracks, the painful process of unloading and reloading has to be endured again and again. That night, I am exhausted and bruised, but just when I think I can relax, the bitch Datuuma gives birth to two pups. I drag her onto my parka in the tent vestibule, make sure the inner door is firmly shut and doze off. Seeking warmth, Datuuma nuzzles open the zipper and I awake, bleary-eyed, to a contented mother curled up on my sleeping bag, licking blood from her mewling young. (Instead of being shot at the completion of our crossing, as is common, the dogs were cared for on the edge of the icecap by one of our two Norwegian members, Tore Stenseng. Later, our leader, Sjur Mordre, rejoined Tore for an west-east traverse, perhaps the first double crossing of Greenland since Knud Rasmussen in 1917. Happily, Datuuma's pups survived in a box strapped to a sledge.)

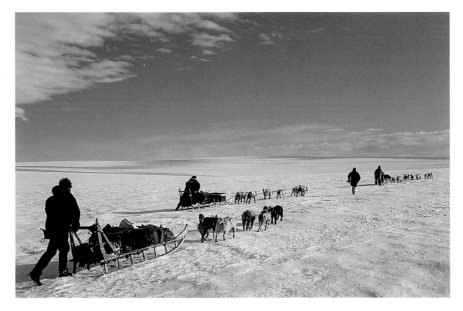

Three dog teams set off across the icecap from Ikerssuaq.

Next morning, four of us set off across the tundra under bulging rucksacks to trudge the final 60 kilometres to the settlement of Sondre Stromfjord (Kangerlussuaq). Our eyes, wind-weary and glazed from the constant glare of ice, are soothed by a patchwork of miniature flowers blooming bravely on the

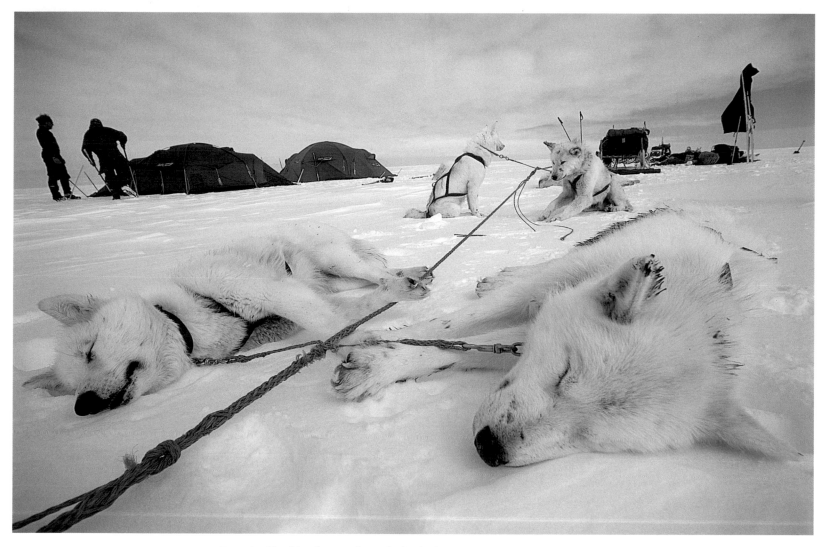

Dog-tired huskies drop at the end of a day's run. Tore and Sjur pitch camp.

tundra. After the bleak sterility of the icecap we breathe deeply, absorbing the heady aroma of peaty soil and aromatic plants. Below a glacier snout that leads to Davis Strait, caribou, some heavy with calf, browse ground-hugging herbs. Looking like cuddly toys, Arctic hares with white winter coats and gloss-black eyes nibble tiny plants. Musk oxen resembling moth-eaten doormats munch their way across open ground. The animals are oblivious to our passing, engrossed in the brief flush of spring on this massive island.

A hazy awareness of the Arctic emerged during my childhood in Scotland when I dreamed of Santa's reindeer pulling sledges at the North Pole, of wild, seafaring Vikings and of Eskimos snug in fur-lined igloos. Before long, my heroes were these remarkable people from the far north who used ingenuity and cunning to travel in a harsh land, eking out an existence by hunting with hand-made weapons. Later, I delved into exploration books, marvelling at the exploits of

such hard-bitten characters as Otto Sverdrup, Knud Rasmussen and Robert Peary, each of whom took heed of Eskimo sledging techniques. Through perseverance and improvisation, these early explorers gradually adapted themselves to the environment, and one, Viljalmur Stefansson, chose the title *The Friendly Arctic* for a book that attempted to dispel the inhospitable reputation of the high latitudes. Stefansson argued that it was possible to live off the land as the natives do and that the Arctic supported plenty of game if only you knew where to look and how to hunt. The next generation enthralled me too – *Boy's Own* stories of derring-do, written, in the main, by English university students such as Gino Watkins, Freddie Spencer Chapman and Martin Lindsay who spent long periods dog sledging in Greenland, learning by trial and error.

After my family emigrated to Australia, I remember standing in the student café of the University of Sydney on 19 July 1969, riveted by television pictures

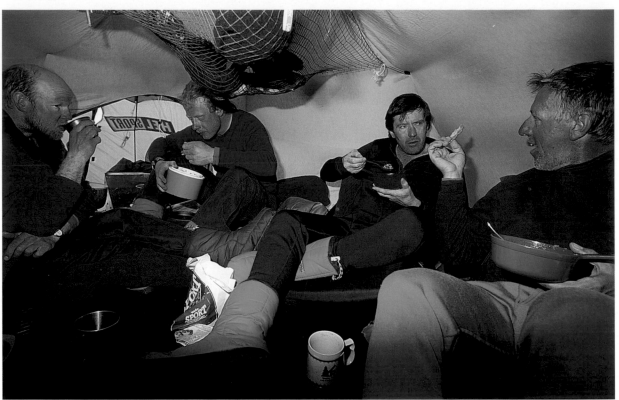

LEFT: *Mike melts ice for drinking water outside the tent.* RIGHT: *Tore, Sjur, Mike and Fred discuss the day's run during dinner.*

of Neil Armstrong's first tentative steps on the moon. A few weeks before, however, in early June, it had been an obscure news item in the *Sydney Morning Herald* that really caught my attention. Using dogs, Englishman Wally Herbert and three companions had reached Svalbard (Spitzbergen) from Point Barrow, Alaska, after a 476-day, 6000-kilometre crossing of the Arctic Ocean, at the time the longest continuous journey in the history of polar exploration.

Living beside a great surfing beach, I could barely comprehend such a cold, brutal journey. I was immediately struck by the contrast: the complex technology employed to reach the moon in a matter of days, versus the primitive, protracted concept of dogs dragging wooden sledges over chaotic pressure ridges of ice. Then to live through the sunless winter on a constantly moving ice floe, at times harassed by polar bears – for me, this was the ultimate in commitment. Somehow, in a way the courageous adventure of landing on the moon never did, a journey across the top of our planet made a lasting impression. With the stark image firmly in my mind, of a fur-clad Wally and his mates standing beside a battered sledge at the North Pole, I simply knew that, one day, I had to experience dog sledging for myself.

In August 1991, I had the privilege of travelling with Wally Herbert to the North Pole on what was his first return to 90° north since the historic traverse. Ironically, he was now a lecturer aboard *Sovetsky Soyuz*, a 75,000-hp nuclear-

powered Soviet icebreaker chartered by the tour company Quark Expeditions. Impressively, *Sovetsky Soyuz* had smashed its way to the pole, in places, through 5-metre-thick floes. (*Sovetsky Soyuz* was the fourth surface vessel to reach the pole; the previous three were also Soviet. On a voyage from Murmansk to Providenya in eastern Siberia, *Sovetsky Soyuz* completed the first surface vessel transit of the Arctic Ocean over the pole. Later, Wally and I stayed on board for a voyage that reversed Baron Nordenskjold's 1878 route through the North East Passage.)

On a foggy morning at the pole itself, I sat with Wally on a sculpted shard of ice surrounded by open watery leads while he smoked a pipe and chatted about his book, *The Noose of Laurels*. This brilliantly undoes myths of geographical 'firsts' by discussing Frederick Cook's and Robert Peary's flawed claims to have reached the pole in 1908 and 1909 respectively. Naturally, too, at this hallowed juncture of longitudes, Wally brought up the name Fridtjof Nansen again. Earlier, we had spoken of the famed Norwegian explorer during a visit to his bivouac site at Cape Norway in Franz Josef Land. It was here, during the 1893 Farthest North expedition, that Nansen and Hjalmar Johansen spent a grim winter after a dog sledging and kayaking epic during their unsuccessful attempt to reach the pole from the vessel *Fram*. The expedition had intentionally frozen *Fram* into the ice and let it drift across the Arctic Ocean for two winters

an audacious undertaking that caused a sensation among the world's geographers and navigators.

One of Nansen's recent biographers, Roland Huntford, summarises the Norwegian's position in the polar world.

> Nansen was one of the surprising figures who emerged from northern mists and helped to mould the age. He was the father of modern polar exploration – in its turn, the prelude to the leap into space… In the spirit of the age, Nansen had an urge to demolish reigning concepts. He was … a skiing pioneer, and revolutionised polar travel by the use of skis… He became the incarnation of the explorer as hero… He opened what is called the heroic age of polar exploration. His successors tried to build themselves in his image. The combatants in the race for the South Pole, Amundsen, Shackleton and Scott, were all his acolytes.

More than all the others, it was Nansen who finally lured me to Greenland. His 40-day ski crossing of Greenland in 1888 with five companions still ranks, more than 100 years later, as one of the truly great polar journeys. Everyone took note of Nansen's attention to detail – his conditioning to the cold and his innovative development of the Nansen cooker that effectively used the newly invented Swedish primus, the all-important kerosene stove that made polar travel possible. Nansen's carefully maintained footwear, his meticulously waxed skis and his lightweight, leather-lashed sledges, fragile but flexible, all proved to be major factors in his success.

Nansen sledges were also used in the Antarctic throughout the Heroic Era and were still in use with the New Zealand Antarctic Research Programme (NZARP) when I started work at Scott Base in 1973. As the field operations manager for NZARP from 1975 to 1983, I grew dissatisfied with the quality of the English-built Nansen sledges, partly because the wooden runners warped badly in the tropics on the sea voyage to New Zealand. Employing Christchurch's Bob Spence, a Scottish craftsman and former South Georgia whaler, we developed our own Nansen dog sledges, strengthening the bridges, handlebars and runners using modern laminating techniques.

I acquired the rudiments of dog sledging during those NZARP years. For nine summers at Scott Base I was in charge of the Kiwi dogs, taking pride each year in selecting and helping to train the winter-over dog handler. During crisp,

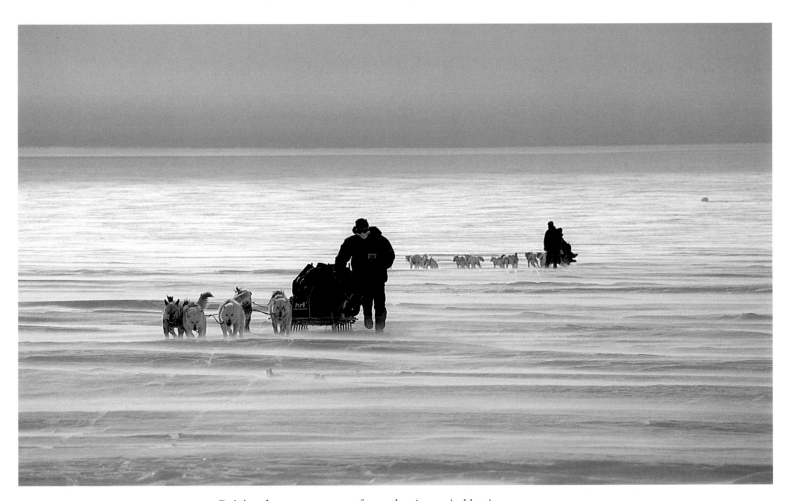

Driving dog teams across a featureless icecap in blowing snow.

spring days in October, I was able to take part in handover journeys involving both the outgoing handler and the newcomer. Sledging across the Ross Ice Shelf to Cape Crozier, clawing our way up Mount Erebus and hurtling across McMurdo Sound into the Transantarctic Mountains, we experimented with techniques no manual could ever teach. And we grew passionate about those massive huskies. Though retained only for recreation and short-term science support in those days, the Kiwi dogs helped to engender the romance of polar travel in many young New Zealanders. Dog travel imparted a range of skills and traditions that have now slipped away. Sadly, Scott Base huskies were ordered to be removed from the continent in 1987, followed a few years later by the Argentine, British and Australian dogs. The era of Antarctic bureaucracy had begun.

In March 1993, after a season on the Antarctic Peninsula working as a tour guide, I received a phone call from Mike McDowell, an old friend who had helped to get me started as a freelance polar photographer. Mike invited me to join him in Reykjavik, Iceland, ready to fly to Greenland and attempt a crossing of the icecap. After three months driving Zodiacs in the Southern Ocean, I had already agreed to a family holiday in Bali, but Mike's call promptly tore that idea to shreds, so I arrived in steamy Denpasar lugging polar clothing and a long ski bag. The customs officer was puzzled: 'Very thin surf board, sir?' Contemplating the long flight from Bali to Iceland after a week lounging in

a warm ocean with my wife Betty and daughters Denali and Carys, I mulled over the wisdom of alpinist Yvon Chouinard's quip, 'Only from the extreme of comfort and leisure do we return willingly to adversity.'

With a mosaic of sea ice stretching to the horizon, the flight from Reykjavik to Ammassalik was similar to the approach to Ross Island from New Zealand. A whisper south of the Arctic Circle, and the largest town on Greenland's east coast, Ammassalik beamed in bright sunshine, its cluster of wooden cottages resembling gaily painted dolls' houses. Lying askew and idle, like discarded toys, red-hulled fishing smacks were frozen into the bay, awaiting the spring thaw. Out on the sea ice a hunter whipped his dogs, the sledge, with its high-powered rifle strapped to the handlebars, skidding past a stranded iceberg. With a wan midnight sun overhead, it was impossible to go to bed amid such beauty.

Next morning, at Ikerssuaq, an isolated community 50 kilometres south of Ammassalik, we tossed our gear from a helicopter into a graveyard of paint-peeled crosses and bleached plastic flowers poking through snowdrifts. With the blades still turning, local hunters quickly stashed their winter seal kill on board, the cured skins no doubt destined for the fashion industry in Europe. Between them, 32 families in Ikerssuaq tether 28 dog teams in front of their homes. Gnarled women sat on porches chewing seal hide and sewing thigh-length sledging boots. We had selected Ikerssuaq as the start for our traverse because a glacier slopes gently down to the sea behind the village, providing an

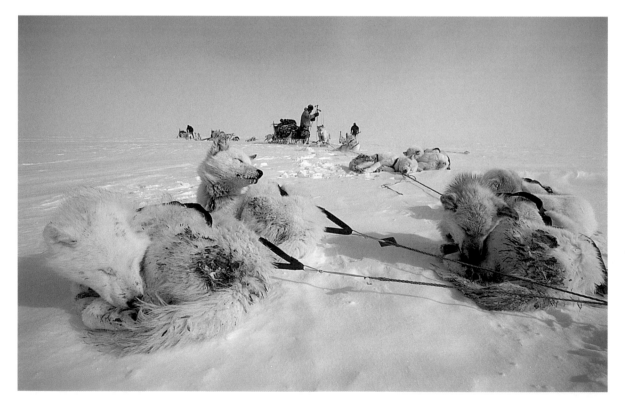
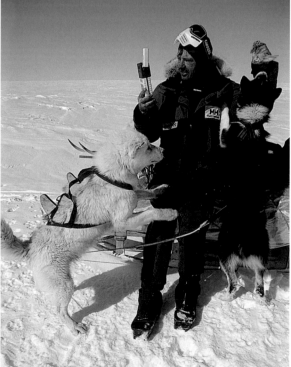

LEFT: *Huskies rest during a break while the loads are adjusted.* RIGHT: *Mike reads a GPS navigation aid while the huskies steal chocolate.*

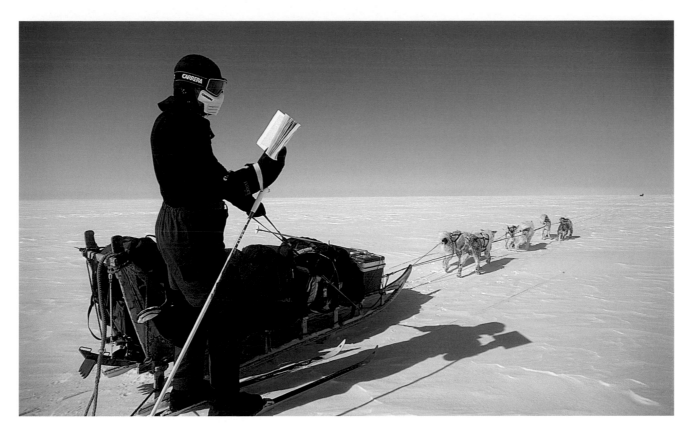

Mike multi-tasking – skiing behind dogs while reading Bruce Chatwin's Songlines.

easy passage through the coastal mountains and ready access to the icecap. Helping the four of us hump baggage from the graveyard was a wiry chap called Tore Stenseng. A passionate dog racer and a highly competent skier, Tore is also an environmental consultant at home in Norway. Before our arrival, he had rented the dogs for the crossing and had already laid a depot at the edge of the icecap.

Tore's school chum, and the instigator of the expedition, was freckle-faced Sjur Mordre, a tall, ginger-haired character, cast from the same Viking mould as his compatriots Nansen and Roald Amundsen. Disarmingly casual yet with considerable élan, 30-year-old Sjur had recently driven dogs to the North Pole and in 1992 manhauled 1000 kilometres across Greenland from Ammassalik to Jacobshavn. In 1990–91, with minimal fuss and publicity, Sjur used dogs to traverse from the Weddell Sea to the South Pole. The huskies were then flown out before Sjur and his brother Simen skied on to complete the fifth crossing of Antarctica in 105 days. After sledging down Amundsen's Axel Heiberg Glacier, the trio used parafoils to help pull their loads across the immense Ross Ice Shelf all the way to Ross Island. I first met Sjur in McMurdo Sound after this crossing just as Mike McDowell and I were about to embark on a climbing adventure in the Dry Valleys. By comparison with Sjur's more serious polar ventures, skiing across Greenland with us would likely be a pleasant jaunt, barely extending the Olympic-class athlete.

American Fred Morris, on the other hand, would undoubtedly be stretched to his limit. A close friend of Mike's, 52-year-old Fred was the oldest in our party, and although he was a skilled hunter and wildlife photographer, dog sledging proved to be a giant step into the unknown, challenging him beyond all previous experience. A former US Air Force pilot, Fred often entertained us in camp with embellished tales of sorties during the Vietnam era such as the time when he had to push antique furniture out of the back of a transport aircraft in order to limp back to Hawaii on one engine. One of Fred's sons happened to be the pilot of a Stealth bomber. When I learned that he was due to fly over us during our crossing, bound for an airshow in Amsterdam, I fantasised about the father and son thought processes: a proud Fred, grinding away on skis beside a sledge – 'That's my boy up there flying the most sophisticated aircraft in the world', while on the intercom to other pilots in the squadron – 'God darn it! See those dots down there. That's my old man, still skiing with hounds!'

As Apsley Cherry-Garrard wrote in his time-honoured Antarctic classic, *The Worst Journey in the World*, which describes a winter journey to Cape Crozier, 'those with whom you sledge will not be shopkeepers; that is worth a good deal'. Mike McDowell would need to be shackled to the counter to remain a shopkeeper for more than ten minutes. Bold as brass, the boisterous Aussie exudes an unquenchable thirst for offbeat adventures. An inveterate traveller

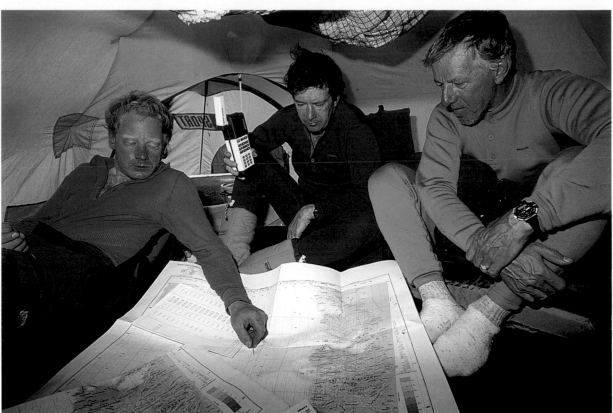

LEFT: *A husky is impressed as Mike takes a snow bath.* RIGHT: *Sjur plots our position on the icecap at the end of each day.*

since the 1960s when he wintered as a technician on Macquarie Island, Mike first sailed to the Antarctic in 1970 aboard *Lindblad Explorer*, the pioneer vessel of polar seaborne tourism. For 25 years, as an expedition leader and, later, as founder of the innovative company Quark Expeditions, Mike has probed the remotest parts of the polar regions, leaving competitors to gasp and follow in his wake. (A quark is a minuscule particle of high energy so, naturally, some wag dubbed Mike 'McDuck of Quack Expeditions'.)

In 1988, Mike and I climbed Vinson Massif, Antarctica's highest peak. Since then he has skied from the South Pole down the Scott Glacier, driven dogs with Sjur on the Arctic Ocean and dived on the *Titanic*. He has also initiated the concept of tourism in space. A past director of Adventure Network International and Polar Logistics, two companies that pioneered the use of private aircraft to the interior of Antarctica, Mike remains at the cutting edge of adventure tourism. With his own ski-equipped Basler aircraft, he provides occasional air support for national Antarctic programmes.

My fondest memory of Mike in Greenland is of watching him read Bruce Chatwin's *Songlines* while skiing along attached to his sledge by a sling. One day, Mike's huskies suddenly scampered up behind my team looking very pleased with themselves. Mike and his sledge were nowhere to be seen. Inexplicably, the

trace linking the huskies to his sledge had disconnected. A tiny dot on the horizon slowly materialised into a red-faced Mike who puffed into view, pulling the sledge. 'Did Nansen really manhaul sledges across Greenland?' was his only comment as he hugged the huskies. When I think of Mike in the tent, scribbling in a dog-eared diary to plan yet another trip, Robert Browning's line comes to mind: 'Ah, but a man's reach should exceed his grasp, or what's a heaven for?'

After leaving Ikerssuaq in mid-May, it took us the next two weeks to pull away from the mountainous east coast and steadily haul 800 kilograms of baggage to our high point (2600 metres) on the curved, featureless icecap. The final week of the journey was essentially downhill, yielding speedy, easy sledging until we confronted the melt streams. Largely because of a relatively smooth snow surface, we were at least a week quicker than anticipated. Unlike their iron-hard Antarctic counterparts, the wind-blown sastrugi we encountered in Greenland were mercifully soft, making them gentler on vulnerable sledge runners, fragile Nordic skis and tender husky footpads. Amazingly, we were never pinned down in our tents by a blizzard.

Camp routine became more efficient and less taxing as the traverse progressed. At first it took four hours from the time the sledges stopped till our heads hit the pillow. Sometimes I felt as if I had survived a workout with a polar

bear. (We carried a rifle in case a hungry bear had lost its bearings and found its way up onto the icecap.) At day's end, I often moved like an automaton while helping, with near-frozen fingers, to dig in the anchor plates to tether the dog lines. The harnesses were then stripped from the huskies and their paws were checked for cuts. Meanwhile, the others pitched the two tents, burying the valances under snow after pinning them down with boxes to ensure our dome-shaped havens would remain secure in a storm. Finally, we crawled inside to start the tedious process of melting snow to rehydrate food for our dinner and the dry dog food. As numb swollen fingers thawed over a primus we eagerly awaited a brew of tea. Cradling the scalding mug in both hands meant everything.

Even in the comfort of home I instinctively wrap my fingers around a hot cup, a reminder of the precious nature of simple things like warmth and shelter.

Evenings were treasured times when all five of us gathered in the largest tent to dally over soup and chat. Wildcat schemes of improbable journeys were bandied back and forth. Wet gloves, socks and balaclavas dried overhead, hanging above the stove in a net suspended from the ceiling. Food, of course, became the focus of the day. The ration box treated us well to a varied diet of high calorific value. In Norway, Sjur's wife had pre-mixed a tasty blend of dehydrated ingredients, weighing exact quantities of meat, vegetables and spicy sauces into numbered bags. This kept the cooking simple and enabled us to eke out the

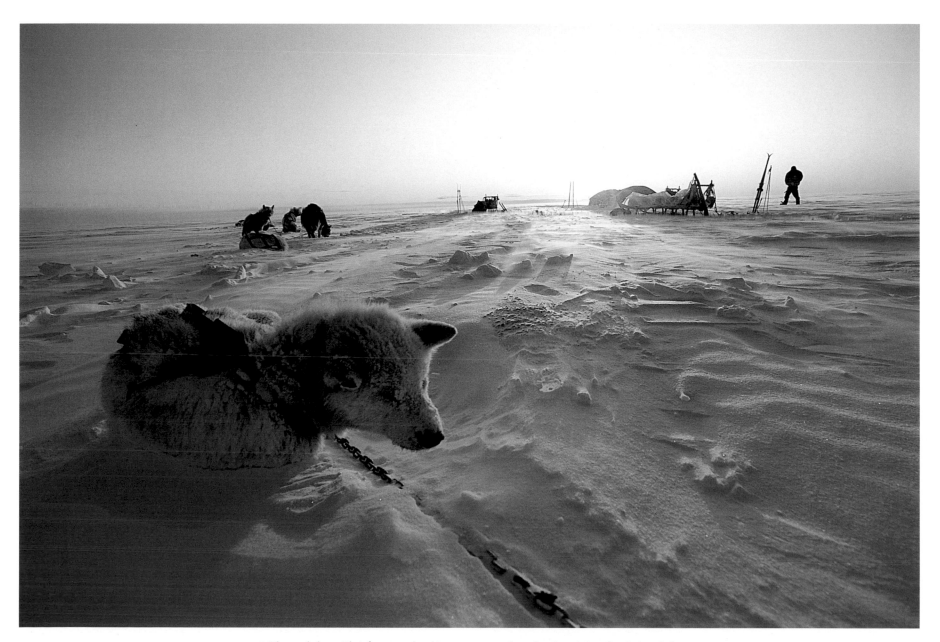

Mike and the midnight sun – huskies start to curl up for the night after being fed.

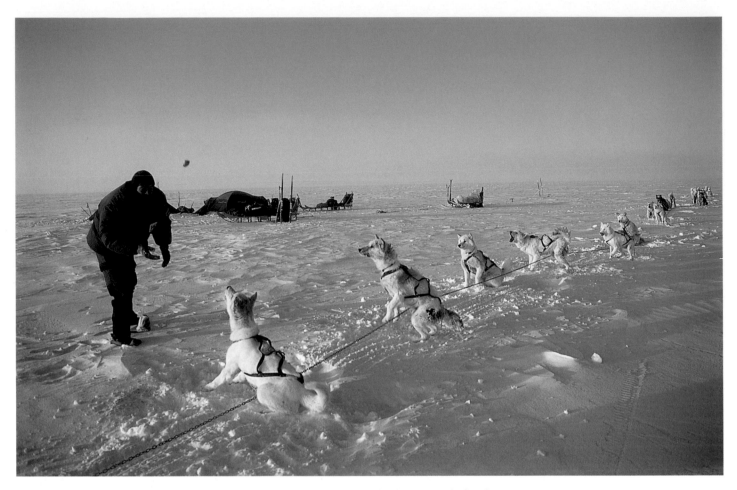

Before bed, Mike throws each husky a morsel of seal meat.

rations with some confidence. Thankfully, long gone are the dreary days when a gruel of pemmican hoosh was the meagre reward for a day's sledging. A bland extract of meat and oatmeal with a high fat content, pemmican was described by one early explorer as 'sufficient to keep the body twitching but not the soul'.

After we had wolfed the stew and packed away the licked-clean bowls, Mike took a GPS fix of the latitude and longitude. We all hovered over the map, eager to see our progress. Gradually, the pencil line crept across the white blank space in the centre of the island, away from green-shaded coastal fjords. Mike also calculated our bearing for the next day's run. More than a week sped by before we had whittled away enough of the journey to make the task ahead seem less daunting. It became psychologically easier to pace ourselves after we realised that nothing short of a crevasse accident could prevent us from completing the traverse.

Without the expected storms that would allow a blessed lie-in, I was never able to catch up on sleep. One night, when it was my turn to cook, I fell asleep while frying fatty salami in a pan, jolting back to consciousness only when the tent filled with acrid black smoke. Snuggled in a sleeping bag at last, it was a constant struggle to write even half a page in my diary before being overcome by drowsiness. A long-savoured novel remained unopened. With the five of us sharing two tents we rotated sleeping partners every night as each position had a designated chore assigned to it – cooking, feeding the dogs or filling the stainless-steel thermoses for breakfast (unbreakable thermoses are a huge boon to polar travel). One dreaded spot always caused me to flip-flop all night long: lying sandwiched between Mike and Fred. Despite earplugs, being the victim of synchronised snoring is terribly debilitating, especially when you know that the offenders, sound asleep, will emerge in the morning bright as buttercups. My companions were lucky the tallest tree in Greenland is a dwarf willow, barely 10 centimetres high. Surely snoring on an expedition is a hanging offence.

Our daily run averaged 35 kilometres and, depending on the bite of the cold and the strength of the wind, involved some six to eight hours of sledging. The route lay almost exactly along the Arctic Circle so, with high summer upon us in early June, the sun barely skimmed below the horizon at midnight. At lower elevations, at the start and finish of the trip, we travelled faster on a colder surface by moving at night, gradually switching to a day routine after gaining altitude on the plateau. Steering by compass, wind direction or the cast of

shadows, a skier would stay in front of the dogs for perhaps two hours at a stretch. It was a time to forget the foibles of the huskies and to enjoy the silent rhythmic nature of Nordic skiing, with the dogs content to follow the tiny red parka bobbing along in the distance.

When we stopped, to relash a load, untangle a trace or simply to reorient our direction, the sledge was tensioned between a rear anchor plate kicked firmly into the snow and an ice axe that pinned the lead dog's harness. Dog-tired, the huskies dropped where they stopped, flopping in the snow in a mirror-image pattern on each side of the trace. To reydrate, they simply scooped up powder snow with their lower jaws, often while on the run. Pulling off face masks, the five of us gathered to communicate, eager to exchange snippets of conversation which, often as not, were muffled by parka hoods or whipped away on the wind. Cowering behind a sledge that acted as a windbreak, we relaxed for a moment and guzzled hot juice from a thermos. Chunks of chocolate had first to be softened in the mouth, otherwise teeth, brittle in the cold, could snap. Speed was of the essence too, lest a husky should mysteriously unclip itself to give you a smooch and, often as not, steal a snack.

Appearing on the horizon like a mosque on a wind-blown desert, the bulbous white domes of DYE II grew ever larger as we spurred the dogs on. One of four radar stations in Greenland built in the early 1960s, DYE II was a major waypoint that we had navigated for from the outset. It was exciting to realise that this space-age installation plonked out here on an icecap actually existed. DYE II had been part of the Distant Early Warning (Dewline) network that spanned the Arctic from Greenland to Alaska. Initially designed to monitor Soviet bombers, the technology was later streamlined to give a 15-minute warning of nuclear missiles homing in on North American cities. As we approached the station a straggling skein of snow geese flew overhead, bound for breeding grounds on Ellesmere Island. At the height of the Cold War, such an event picked up on radar screens would have set hearts aflutter and had fingers hovering over red buttons.

It was incongruous to park panting dogs under such a massive edifice jutting skyward like a prop from *Star Wars*. Deserted with only four days' notice in 1988, DYE II, like its three ugly sisters elsewhere in Greenland, has been stripped only of its most specialised hardwear. Everything else required to support 125 personnel within the billion-dollar complex has been abandoned. The ultimate symbol of human indifference to wild places, DYE II now remains a hapless victim to the inexorable creep of ice. We climbed inside the main, acoustically perfect dome to croon bawdy ballads, then left, preferring the company of dogs. I fingered a small item I had picked up at random in a dark corridor and tucked in a parka pocket. Examining the find in the brightness outside, I discovered that my souvenir from this monument to paranoia turned out to be a heavily inked rubber stamp cut with block capitals – SECRET.

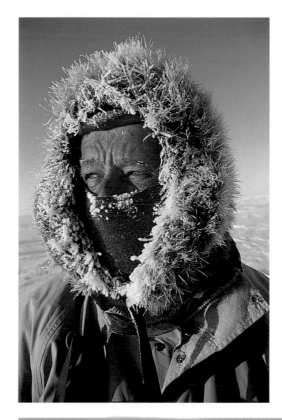

Behind his frosted facemask Fred Morris looks at the route ahead.

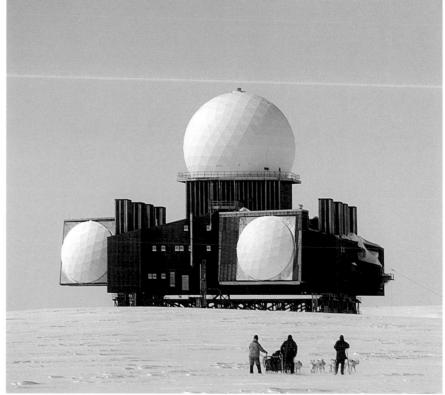

Approaching the abandoned DYE II radar station.

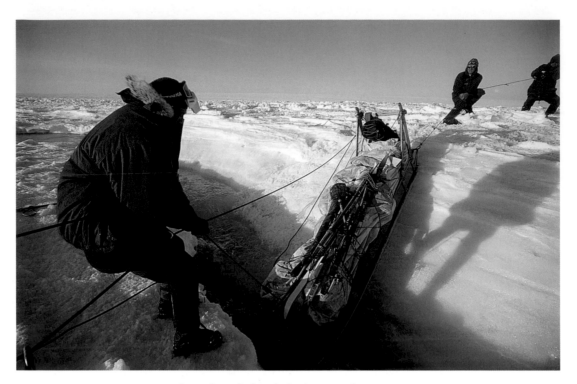

Lowering a laden sledge into a melt stream.

Nearby, much to our surprise, two Alaskans, Kevin Killilea and Earl Ramsay, lived in a shack so they could maintain a snow runway for the 109th New York Air National Guard. This skiway enabled rookie pilots destined for Antarctica in the austral summer to practise landing ski-equipped Hercules aircraft. Delighted to have three dog teams tethered outside their lonely outpost, Kevin and Earl were eager hosts. Their last visitors, a week before, had been Icelanders manhauling across on a line similar to ours. The seven of us, ensconced in a double-walled nylon cabin, dined royally, with conversation and cognac flowing long into the night. Gamel Dansk, a devilish Danish liqueur, nipped sun-ravaged lips.

Employed by the United States Polar Ice Coring Office, Kevin and Earl maintained radio contact with personnel stationed at two deep drilling projects sited at the highest point on the icecap at over 3000 metres, some 700 kilometres north of DYE II. Part of a multi-year science programme involving scientists from United States and Europe, drillers this season were in the final exciting stages of coring through 3 kilometres of ice to reach bedrock. Working on the theory that atmospheric dust deposited on the ancient ice was greater during ice ages when the world was windier and drier, scientists analysing the Greenland core can study a remarkable catalogue of past climate spanning 200,000 years, the oldest record available in the northern hemisphere. Startling information is being deduced from a wealth of clues yielded by embedded dust particles and gases trapped in the annual snow layers, highly compressed through millennia. Recent cores from Greenland and Antarctica have revolutionised

theories about ice ages and past climates. Evidence thus far seems to point towards abrupt climate change from past ice ages to the present climate – a 5° to 10°Celsius shift in as little as a decade – which completely reverses the previous theory of relatively slow change. For the polar regions and the rest of the world, the consequences of rapid global warming exacerbated by an increase in man-made carbon dioxide emissions are alarming.

As we pushed on next morning deeper into this hypnotic icescape, the descent from DYE II allowed time to marvel at the interplay of light on intricate snow textures. I particularly loved it when the dogs kicked up pink wisps of powder snow that slithered noiselessly across the surface away from the sledge. I smiled, remembering the silly things that had happened and reflecting with pleasure on the bond that had developed between the five of us and the dogs. Clearly, the huskies were unused to being treated kindly, as friends. Such moments became part of a treasure house of memories.

Feeding the huskies was always a memorable time. As I approached the dog lines, a deafening crescendo of high-pitched howls would erupt. Each animal would strain its utmost at the end of a chain, desperate to be first to snatch the energy-rich pellets from my hand. Every scoop of rehydrated mush had to be placed in exactly the right spot or a snarling, yelping neighbour would snaffle it. With little more than a growl, the slavering, rightful owner would be given the cold shoulder. Before creeping back to the tent, I often walked along the dog line, lobbing pre-cut chunks of seal meat to each animal. The ravenous

huskies would catch their dessert in mid-air, the raw fat-rich morsel disappearing in one gulp.

Serenity settled on the camp once more after the dogs were fed. With barely a whimper they curled up in the snow and tucked their noses under bushy rumps. Drifting snow soon covered them, providing extra insulation from the cutting cold. Before snuggling into my own bed, I lingered under an awesome sweep of sky and snow. I wandered out from camp, crouched in the snow and opened my senses to the movement of clouds and to Walt Whitman's 'splendid silent sun'. Nothing stirred, nothing rattled in the utter calm: the magnificent silence of Greenland way up here, far from the clang and the clatter, allowed private time to take stock.

A pernicious form of pollution, the incessant clutter of background noise in our daily lives is slowly but surely suffocating civilisation. It is even starting to pervade remote corners of the planet. An ominous lack of desire for solitude and the gradual devaluing of tranquillity is immeasurably damaging society. As I wandered back to the tent, silhouetted by a low-swinging sun, I drew strength from the knowledge that the polar regions still offer an antidote to the vagaries of modern life. Thus far, an untrammelled polar wilderness has been sheltered by geographical isolation and by wide-ranging though fragile treaties. Remoteness, however, is no longer a guarantee of protection against the human onslaught. There must be a change of attitude. As I elbowed Fred and Mike aside to make room in the tent, I pondered on a thought from the writer Terry Tempest Williams: 'If you know wilderness in the way that you know love, you would be unwilling to let it go. We are talking about the body of the beloved, not real estate.'

The final run to the coast was fast and furious, with the two Norskies in their element, skating for hour upon hour on thin racing skis. Setting a blistering pace, Tore was out in front while I clung to the load to photograph Sjur's exuberant gliding motion as he kicked his skis along beside the huskies. Grinning with the exhilaration of speed, Fred and Mike gripped the handlebars and yelled encouragement to the dogs. And then the smiles vanished – for just ahead we caught sight of the first river. Behind us, the sledge runner trail curved back over the horizon. Soon, the thin white lines would blow away, to leave no trace of our passing.

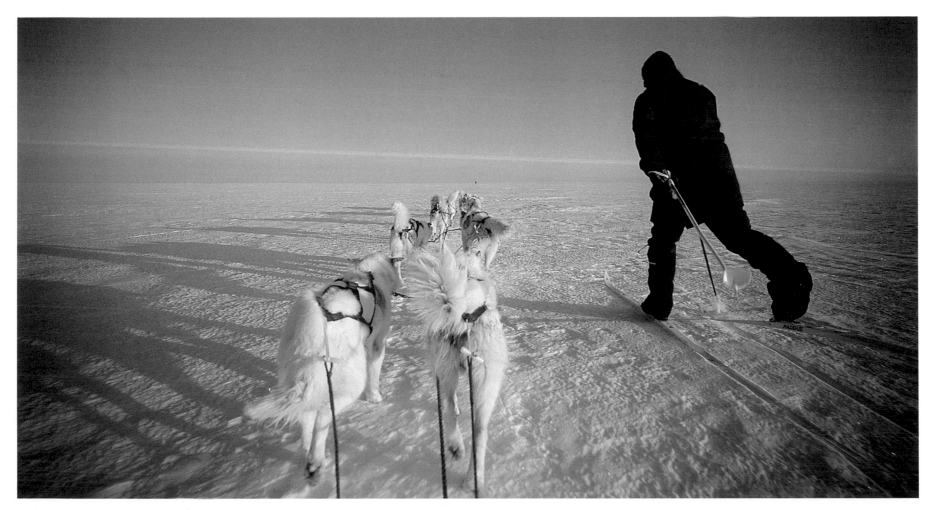

Sjur striding out on his Nordic skis to encourage the dogs as we sledge down to the western edge of the icecap.

NORTH POLE

ARCTIC OCEAN

GREENLAND

ALASKA

SIBERIA

CANADA

ARCTIC OCEAN

Kangerlussuaq
(Sondre Stromfjord)

Ammassalik

Ikerssuaq

DYE II

GREENLAND

SCANDINAVIA

Kalaallit Nunaat, Greenland

Alexander, Bryan and Cherry. *The Vanishing Arctic*, Blandford, London, 1996.

Ehrlich, Gretel. *This Cold Heaven – seven seasons in Greenland*, Pantheon Books, New York, 2001.

Herbert, Wally. *Across the Top of the World – The British Trans-Arctic Expedition*, Longmans, London, 1969.

Herbert, Wally. *Hunters of the Polar North*, Time-Life Books, Amsterdam, 1981.

Herbert, Wally. *The Noose of Laurels*, Hodder & Stoughton, London, 1989.

Huntford, Roland. *Nansen*, Duckworth, London, 1997.

Lindsay, Martin. *Sledge – The British Trans-Greenland Expedition 1934*, Cassell, London, 1935.

Malaurie, Jean. *The Last Kings of Thule – a year among the polar Eskimos of Greenland*, Allen & Unwin, London, 1956.

Mikkelsen, Ejnar. *Lost in the Arctic*, Heinemann, London, 1913.

Millman, Lawrence. *Last Places – Journeys in the North*, Houghton Mifflin, Boston, 1990.

Nansen, Fridtjof. *The First Crossing of Greenland*, 2 vols, Longmans, Green & Co., London, 1890.

Peary, Robert. *Northward over the Great Ice*, 2 vols, Methuen, London, 1898.

Rasmussen, Knud. *People of the Polar North*, Kegan Paul, Trench, Truber & Co., London, 1908.

Rasmussen, Knud. *Greenland by the Polar Sea – The Thule Expedition from Melville Bay to Cape Morris Jesup*, Frederick Stokes, New York, 1919.

Simpson, Myrtle. *White Horizons*, Gollancz, London, 1967.

Sorge, Ernst. *With Plane, Boat and Camera in Greenland*, Hurst & Blackett, London, 1935.

Spencer Chapman, Freddie. *Northern Lights*, Chatto & Windus, London, 1932.

Spencer Chapman, Freddie. *Watkin's Last Expedition*, Chatto & Windus, London, 1934.

Sage, Bryan. *The Arctic and its Wildlife*, Facts on File, New York, 1986.

Sorensen, Jon. *The Saga of Fridtjof Nansen*, Allen & Unwin, London, 1932.

Stefansson, Vilhjalmur, *The Friendly Arctic*, Macmillan, New York, 1921.

Sverdrup, Otto. *New Land – Four Years in the Arctic Regions*, 2 vols, Longmans, Green & Co., London, 1904.

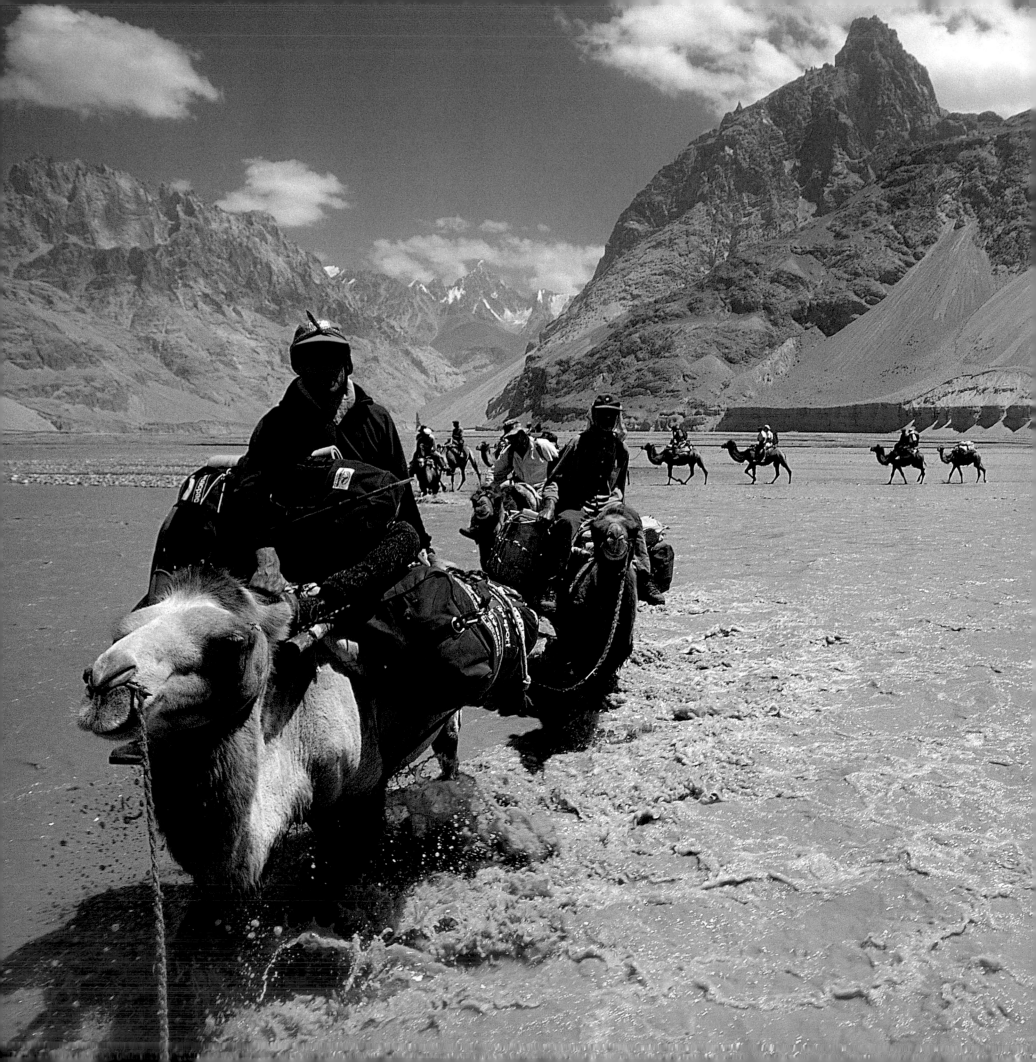

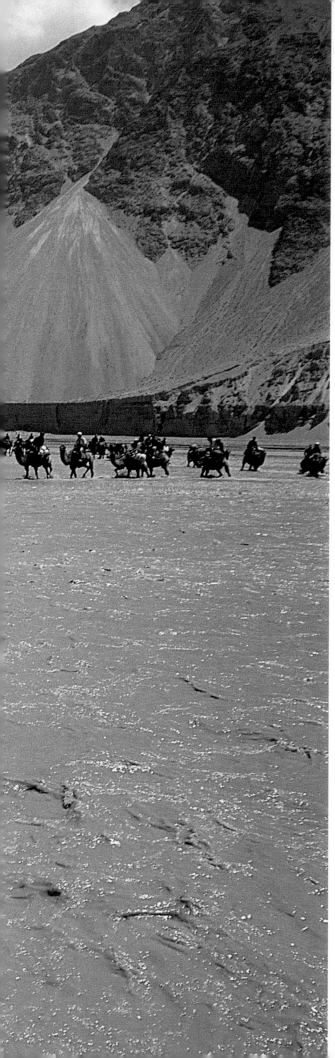

Still Serving the Savage Gods

Climbing Chongtar in China's Karakoram Mountains

The most obvious objective was the exploration of the unknown region, several thousand square miles, surrounding the basin of the Shaksgam River, immediately beyond the main continental divide. Represented on the map of the Karakoram by a challenging blank, it lay across the undemarcated frontier between Kashmir and Sinkiang...Bill [Tilman] and I used to boast that we could organise a Himalayan expedition in half an hour on the back of an envelope.

Eric Shipton, *That Untravelled World*

T he swirling brown water of the Shaksgam roars menacingly. Boulders thump unseen along the swollen braids of the riverbed, sending shivers of apprehension through the group. Even the imperturbable Uighur drivers are anxious as they edge the camels forward, committing them to yet another crossing.

A driver tugs the lead camel's nose peg, whistles, then kicks hard with his heels, urging his mount out into the flow. Linked by woollen ropes, other bleating beasts follow, each desperately trying to gain an illusion of security by tucking its snout into the rump of the one ahead. Bright green cud and saliva ooze from puckered lips. Bloodshot eyes bulge, nostrils flare and the younger camels whimper, their fear palpable.

Freezing rain numbs my hands despite efforts to warm them under the camel's floppy humps. Clenched fingers turn white as I grip the rope that secures the load. My thighs stiffen with cramp

LEFT: *Lucas Trihey leads a caravan of camels across the Shaksgam River.* TOP: *Id Kah mosque, Kashgar.*

from straddling two bulging kitbags. Suddenly, the camel lurches forward into a deeper channel. Water surges over the nape of its neck. Squealing, it begins to buckle at the knees and I am certain the force of the water is going to drag it down into the torrent.

Rather than risk somersaulting down the Shaksgam with a loaded camel, I consider launching myself off its back towards the bank some 5 metres away. On the verge of this foolish manoeuvre I hear a scream from behind. Martin Dumaresq, a trekking member of our expedition, is in the water, barely visible as both he and his camel are swept downstream. Buffeted by powerful waves, Martin is instantly at the mercy of the current, the meltwater chilling him to the bone. It is midsummer, so the river is at its peak, flowing directly from the snout of the Gasherbrum Glacier. Without hesitation, Jin Ying Jie, our liaison officer, thrashes his camel to shore, dismounts, then races downstream and dives in. Miraculously, Jin's timing is perfect and an exhausted Martin is caught and dragged to the bank.

As I stumble ashore, I can see that both Martin and Jin are trembling, desperately trying to rewarm themselves. Leaping off my camel, I sprint down the bank in an attempt to recover Martin's mount. Someone grips my wrist so I can lean out over the water and I just manage to grab the chain around the submerged animal's neck. All I can see poking above the water are a quivering nose and bulbous frightened eyes. Frantic that they may lose a precious camel,

the drivers rush up and together we haul the shaking young beast onto the bank. From now on, whenever we have to ford the river, there will be a scramble to mount the older, stronger camels. This nasty incident could so easily have turned out differently. Clearly, the Shaksgam commands respect.

Our band of five climbers and 11 trekkers from Australia and New Zealand had come together in the ancient Silk Road town of Kashgar. Some flew in via Urumchi, the capital of Sinkiang province, while others rattled up the Karakoram Highway from Islamabad, Pakistan, buying supplies of dried fruit and nuts in Hunza en route. We travelled to China's wild west with one objective – to make the first ascent of a virgin 7000-metre peak. Some two months later, however, we turned for home not only enriched by lingering memories of a fine climb but also relishing the impressions of a journey with camels into a rugged corner of the Karakoram Mountains.

The approach to the Chinese Karakoram is harder and more protracted than to the Pakistan side of the range. Unlike their Balti cousins in the south who routinely haul expedition loads on their backs up the Baltoro Glacier towards the mighty peaks of K2 and Gasherbrum, the Uighur and Kirghiz sheep herders from the northern Karakoram do not work as porters. Even if they did, there are no bridges or cableways across the powerful rivers protecting the route into the mountains. And, on foot, it is impossible to cross these dangerous

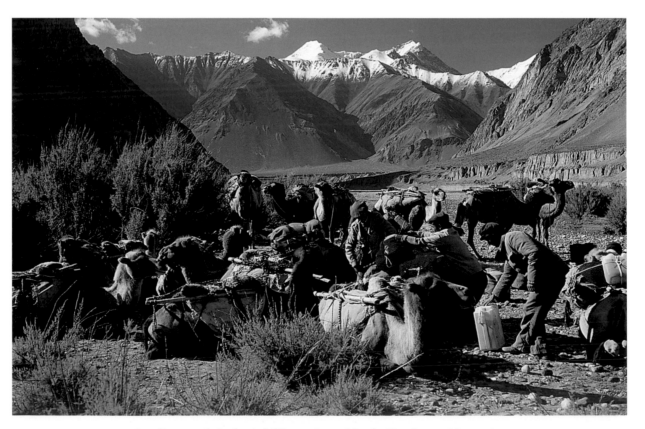

Loading camels in the Aghil Range bound for the Karakoram Mountains.

torrents so Bactrian camels are the only practical means of transporting supplies to base camp. Though they are not entirely comfortable with load-carrying over sharp stony ground, the camels' long legs and overall strength make them much better than horses as transport animals. And, crucially, at the repeated crossings of the multi-braided rivers, expedition members can leap onto the nape of a camel's neck, clamber up onto the load and hang on. As it turned out, clinging to the back of a camel in mid-stream proved scarier than anything we had to deal with on our peak, Chongtar.

At 7350 metres, Chongtar was then possibly the highest unclimbed summit in Central Asia. Directly opposite the north face of K2, Chongtar sits astride the short buckled K2 Glacier and the Sarpo Laggo, a 30-kilometre ribbon of ice that flows north from the China-Pakistan border. It was while high on K2 in 1990 that Greg Mortimer, our Sydney-based leader, recognised Chongtar as a gem amid a sea of unclimbed mountains. To our delight, no one had attempted the peak since 1985 when an American team led by Jim Bridwell turned back shy of the top.

Chongtar has three summits, each rising above a high snow plateau, itself over 7000 metres. From the outset we sensed that reaching the plateau would pose a daunting problem for our small team. Greg had seen that, from the east, Chongtar was protected by a series of hanging glaciers that regularly strafe the K2 Glacier with deadly ice blocks. Prolonged load carrying under ice cliffs to establish camps is sheer folly. So, gambling on being able to get the camels closer to the mountain by pushing them up to the Sarpo Laggo's glacial snout, and hoping that this approach would not be threatened by avalanches, we decided to channel all our efforts onto Chongtar's western slopes.

With only sketchy information on the Sarpo Laggo gleaned from journals and without any firm idea of Chongtar's geography from the west, we were attracted by the uncertain, exploratory nature of the trip. Virgin 7000-metre peaks, especially ones not expected to present extreme technical difficulties, are a dwindling resource and we felt sure Chongtar would not be ignored by other climbers for much longer. Excited by what lay ahead, we swung into action in August 1994.

I was drawn to Sinkiang primarily by the grandeur of the Karakoram landscape, though visiting the ancient city of Kashgar was also high on my agenda. An important trading centre on the Silk Route, Kashgar has for centuries been a melting pot of merchants, mystics and military spies, its crowded caravanserai frequented over the years by such illustrious travellers as Marco Polo, Sven Hedin and Aurel Stein. One of Genghis Khan's Mongol armies routed Kashgar (Kashi) in 1218. The fabled city is now a jumble of narrow, poplar-lined streets, mud-brick houses and dusty mosques set amid a patchwork of irrigated crops of cotton and multi-coloured melons. Lying on the western edge

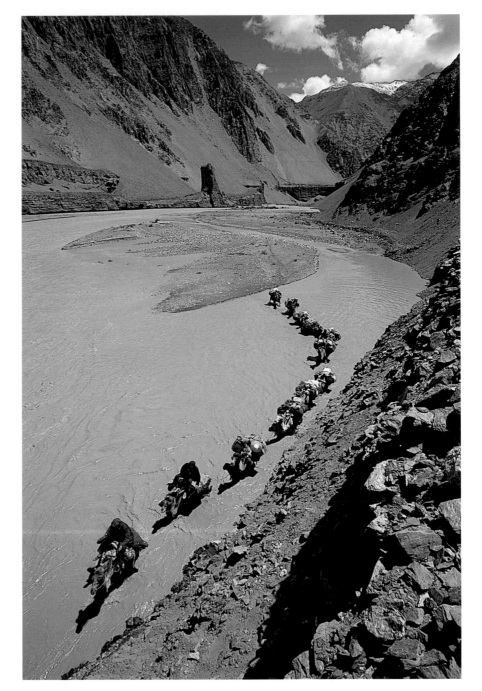

Our camel caravan in the Yarkand Gorge heading into the Aghil Mountains.

of the Taklamakan Desert, Kashgar weathers a scorching heat in summer while in winter it shivers, locked in a sub-zero basin of calm, frigid air. To avoid the brunt of summer, we timed our expedition to arrive in Kashgar in mid-August. By mid-October, when the rivers would be lower and autumn temperatures cooler, we planned to leave the mountains and return to Kashgar.

When the British Raj and Imperial Russia clashed in the late 1800s in a covert struggle for mastery, Kashgar was at the centre of intrigue as empires

Kashgar

Kashgar is famous for its melons.

A donkey labours under the weight of poplar logs.

Coppersmith at work, Kashgar market.

A worshipper leaves the Yarkand mosque.

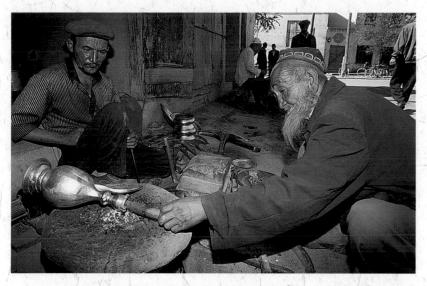

Heating a pot over a charcoal brazier.

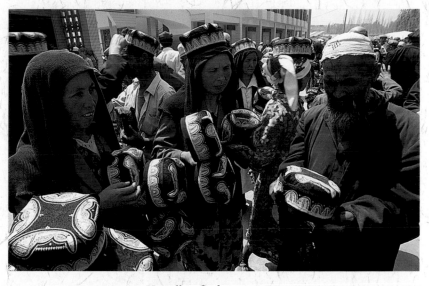

Hatsellers find a customer.

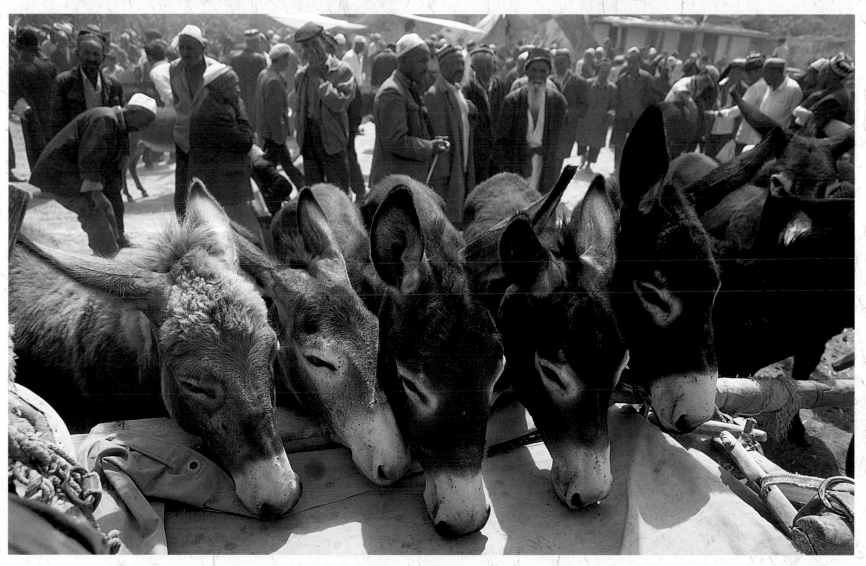

Mules for sale, Kashgar market.

jockeyed for position on the high roads of Asia. (Dubbed by one Tsarist adviser as a 'tournament of shadows', Chinese powerplay in this volatile region where three empires meet was also a major political force.) A focal point for soldiers, scientists and explorers embroiled in the Great Game, an unpretentious building known as the Chini Bagh (Chinese Garden) served as the British consulate. The Chini Bagh became a listening post for legendary names in foreign diplomacy such as Sir George Macartney (it was his home from 1890 to 1916) and, later, in the 1940s, the mountaineer Eric Shipton.

In 1937, before his two terms as consul in Kashgar, Shipton, and his puckish chum from Nanda Devi and Everest, Bill Tilman, completed an inspired trans-alpine journey into the Sarpo Laggo and Shaksgam Valleys after crossing a pass above the Baltoro Glacier from what was then British India. Until its original name emerged, Chongtar had been provisionally named Mount Spender, after Shipton's surveyor, Michael Spender. Reading *Blank on the Map*, Shipton's book about the Shaksgam trip, had had a significant influence on my desire to become a mountaineer: as a youngster, I vowed, one day, to climb in the Karakoram. (Shipton and Tilman, considered the ultimate exponents of effective, low-key mountain travel, have had a profound impact on the New Zealand style of mountaineering.)

In 1986, I looked down on the sweltering Tarim Basin surrounding Kashgar from the summit of Pik Kommunizma (7495 metres), the highest peak in the Pamirs that lord it over the southern flank of what was the Soviet Union and is now independent Tajikistan. I resolved then to visit Kashgar and find what was left of Shipton's Chini Bagh. So now, eight years on, while our Chongtar team assembles, I slip away for a few hours to explore the city. And, in luck, I stumble upon the old consulate almost straight away. What a delight to see that the building still retains its distinctive crenellated rooftop and burnt-orange mud-smeared walls. It does not matter to me that Chini Bagh has been all but forgotten, crammed behind a soulless hotel and transformed by the Chinese into the Flavour restaurant. Daydreaming as I lie in the rose garden, I visualise Shipton arriving at Chini Bagh in his favourite horse-drawn buggy. And, as Pakistani merchants sew their wares into cotton sacks, loading them on trucks bound for Islamabad, I picture the crafty Englishman smiling to himself as he transforms the consulate into a private climbing base from which to explore the ranges of Central Asia.

Kashgar's Sunday market has a distinctive charm all its own. At sunrise, after the muezzin's plaintive call to prayer has been answered, a throng of Kazakh, Uighur and Kirghiz traders streams into town. Weaving down dusty trails, drivers whip knock-kneed donkeys that pull bicycle-wheeled carts bulging with melons and wool. Slender women squat on the loads, secluded behind kingfisher-blue burkas – the only hint of femininity, a ringlet of dark hair gleaming with henna.

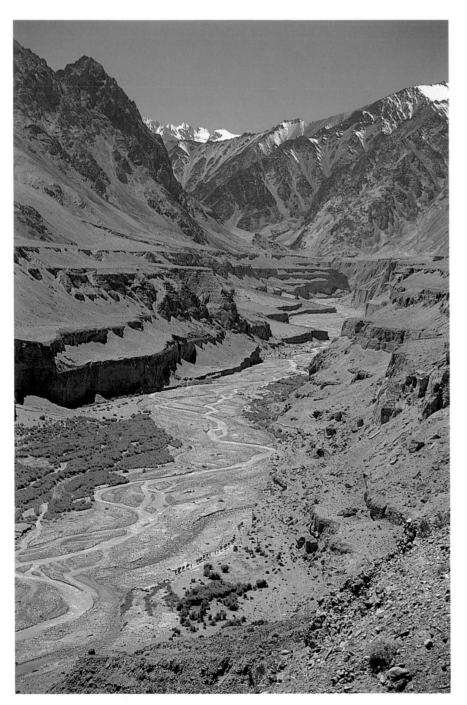

The caravan is dwarfed by the enormity of the Surukwat Gorge, Aghil Range.

Nearby, the bridge has been tossed aside by floodwater so horse-drawn carts ferry people and produce across the swollen stream below the market. The passengers are united by mud and merriment. They cling to each other on the gyrating trays as the ponies lurch through the current then skitter up the opposite bank. Sorting out who pays the ferryman is worth watching. Amid splashes and squeals of laughter, a snake swims frantically out of the way.

The open-air market is divided into sections, catering for items ranging from embroidered cloth studded with tiny mirrors and Afghan jewellery sold by refugees who fled the Soviet invasion of their homeland, to Pakistani truck parts and hand-crafted furniture. The air grows thick with the bedlam of banter. Wafting from food stalls, the aroma of sputtering mutton kebabs and freshly baked bread attracts custom. Goats and small boys flock to the luscious piles of watermelons, eager to pinch discarded rind. An apothecary springs up on the footpath, the rolled-back tops of his cloth bags revealing powders and potions to cure any ill. Shrivelled starfish and sun-dried yak foetus are on special. Crouched on a red worn kilim, a wizened gent with splayed bony fingers sucks on his samovar then flicks a feather duster over a little pyramid of furry apricots. Nearby, a gaggle of women badger an unsuspecting passer-by to buy a velvet skull cap. Squatting in an alley, two bearded cronies gossip. As one departs, he leaves behind the smell of sandalwood. The other returns to his work – tap, tap, tapping gently with a tiny hammer on an anvil, annealing a copper pot over a glow of charcoal.

Down a lane, blade shearers snip fleeces from fat-tailed sheep. Resigned to its fate, a sad-eyed horse hangs limply from a tree, trussed up in the air by a spiderweb of rope as two men pound away at its shoes. Under a spiral of dust and the hubbub of a crowd lies the camel and horse trading corner. Buzkashi riders – this horse game played with a headless goat (in Persian the name means 'catch-goat') makes polo look like a match for sissies – flash up and down a dirt strip to test a prospective purchase. As I rub the ears of donkeys in the sun, I watch a pock-cheeked man with a gleam in his eyes as he prises open the mouth of a mule. He fastidiously inspects the quality of its teeth, then anxiously shuffles the beads on an abacus.

Stall after stall glitters with an array of Kazakh knives. Wicked-looking blades are displayed in rows alongside finely tooled leather sheaths. Sparks fly as hand-wound grinding wheels sharpen dull edges. Most Kashgari men have a broad-bladed knife tucked into a woven waistband. And they know how to use them. Han Chinese are widely disliked and only the brave or the well armed wander in the Kashgar market. Overlords of Sinkiang, the Han Chinese have won few friends among the Kazakh, Kirghiz and Uighur peoples, owing to persistent persecution over many years and, since 1964, the testing of nuclear weapons at Lop Nor, deep in the heart of the Taklamakan. While China's brutal repression in Tibet has sparked worldwide outrage, its cruel actions in Sinkiang have received almost no publicity, even in the Muslim world. There is no Hollywood

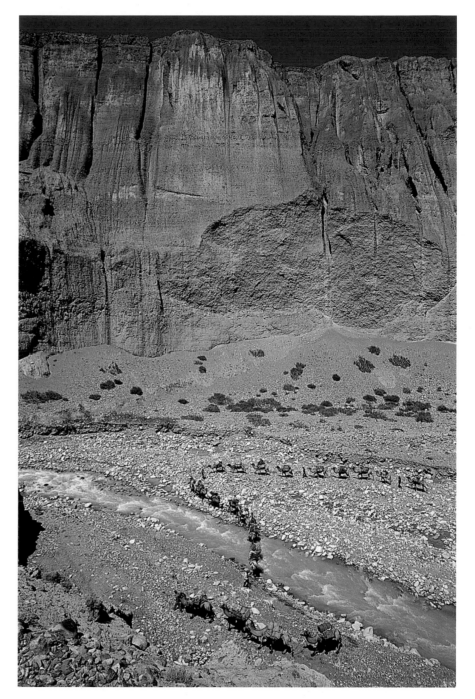

Under towering river terrace walls we climb into the Aghil Range.

Only a Leopard Should Wear These Spots

At the end of my market day in Kashgar dismay turns to anger when I am offered a variety of snow leopard pelts, openly displayed for sale for as little as $US200. Both market stalls and shops near Id Kah mosque have up to 15 snow leopard, clouded leopard and lynx pelts hanging from hooks. Other skins have been made into hats or jackets to catch the eye of the wealthier foreigners in town.

Hunted for in the depths of the Tian Shan and Karakoram Mountains during winter when the snow leopard's soft spotted fur is at its thickest, the luxuriant pelts have long been sought by the lucrative fashion industry in Europe and North America. Undeterred by the threat of sanction, Pakistani merchants are probably the main buyers: the skins disappear down the Karakoram Highway, destined for apartments in Islamabad or resale on the international market.

The snow leopard, *Uncia (panthera) uncia*, is found in Asian mountains from the Bhutanese Himalaya in the east, the Mongolian Altai to the north, throughout Tibet and Nepal, and as far as the western edge of the Karakoram and Tian Shan. Like its cousin the clouded leopard, which prefers to inhabit forests, the snow leopard of the high mountains is increasingly rare, with population estimates as low as 5000.

The World Wide Fund for Nature and widely published researchers, such as Americans George Schaller, Priscilla Allen and Tom Macartney, do all they can to influence the fashion industry and to discourage tourists from purchasing the skins. Importantly, they also try to educate local semi-nomadic herders not to take retribution on leopards that kill livestock for food. Conservation bodies and agreements such as CITES (Convention on International Trade in Endangered Species) are fighting a tough battle, for, with the supply of tiger bones for the lucrative oriental medicine market almost gone, poachers are increasingly targeting leopard bone as a substitute.

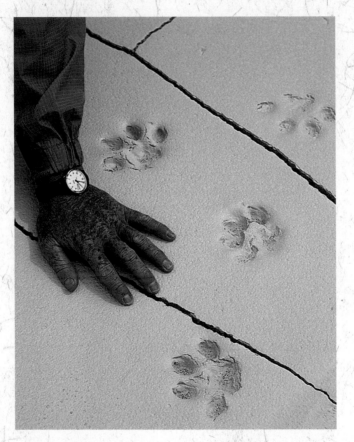

Snow leopard pug marks in mud under K2.

Other Asian wildlife such as deer, gazelle, ibex, Marco Polo sheep and Tibetan antelope are also under extreme pressure from human predation. The Tibetan antelope or chiru, *Pantholops hodgsoni*, are poached in vast numbers for their soft underbelly wool. The Shahtoosh wool is often sold in India as luxury shawls so fine they can be pulled through a wedding ring. To make each shawl, five female chiru are killed, *not* shorn as traders would have us believe.

If wearing a snow leopard coat is seen by some as the ultimate in femininity, then the masculine equivalent must be tracking and shooting one of these elusive cats, and taking home pelts or parts of the anatomy as trophies. For others, driven by the need to feed a family, hunting big cats is simply a means of survival. As many as seven skins are needed to make a single coat. With hard cash in urgent demand, especially since the collapse of the Soviet Union, commercial hunting safaris for the wealthy are now possible throughout Central Asia and Mongolia. Tragically, at present, the destruction of high Asian wildlife is relentless. Who can imagine a world without snow leopards?

European mountaineers abandon rubbish at Suget Jangal base camp under K2.

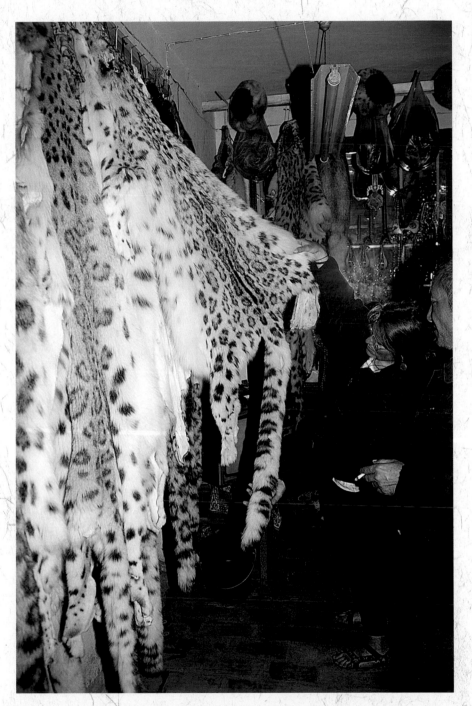

Sue Werner is horrified that snow leopard pelts are for sale in Kashgar.

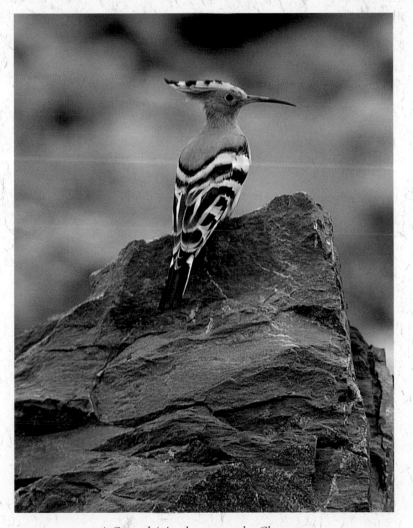

A Central Asian hoopoe under Chongtar.

to publicise and romanticise the plight of Turkestani Muslims and no Muslim version of the Dalai Lama to champion and personify their cause. As I leave the market I chance upon a massive statue of Mao Zedong, the last standing in China. With a benevolent hand extended over the street, Mao reminds Kashgar residents who is in charge.

On a rare haze-free morning, my eye is drawn past the mustard-tiled minarets of Id Kah mosque to a dazzling wall of snow-clad peaks stretching from the Pamirs to the Tian Shan. In the opposite direction, the Karakoram lies unseen, furtively hidden behind the veil of the southern Taklamakan. A crucible of volatility, Kashgar also remains a powerful magnet for mountaineers. I can hardly contain my excitement.

Jin Ying Jie, our tall, energetic Han Chinese liaison officer from the Chinese Mountaineering Association in Urumchi, bundles us into vehicles and we speed off from Kashgar across the southern fringe of the Taklamakan. We stop in Yarkand – I cannot pass this way without a visit to its ancient mosque so I can sit with old men in long gowns and astrakhan hats as they read from the Koran. Striking out eastward again, we grind on across a forbidding desert of sand and stone that lies in great heaving waves, a heartless flinty place. We spend the night in Kargalik, a small town at the base of a parched range of mountains called Kunlun Shan.

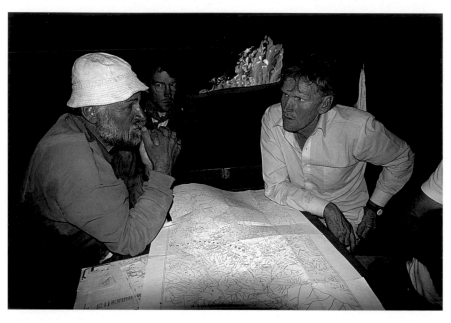

Kurt Diemberger (left) helps Greg and Lucas (behind) with Karakoram geography.

From Kargalik our convoy growls over a tortuous dirt road that traverses the Kunlun Shan, bound for the road-end and a rendezvous with the camels at a forlorn place known as Mazar Dara. By chance, Luke Trihey recognises three sun-burnished cyclists as we pass them on Chiragsaldi Pass. Though a newcomer to Asia, Luke is an expert climbing guide from Sydney's Blue Mountains, and the youngest, fittest member of our team. He invites his intrepid Aussie mates to spend the night with us as a break on their five-month ride from Islamabad to Lhasa. Spicy curry dishes embellished with chutney, cheese and chapatis flow from Sue Werner's kitchen as we yarn the night away. Outside, 22 camels chew cud beside the raging Yarkand River.

Twenty-nine-year-old Sue broke her leg last year while rock climbing in the Blue Mountains. She has joined us to strengthen the leg on the tough walk to Chongtar and, never having lived on a glacier, is delighted to cook for us on the lower mountain. Sue's mother, Margaret, is also a skilled expedition cook who has accompanied Greg on previous Karakoram journeys. Impish, freckle-faced Greg Mortimer is a geologist, Antarctic veteran and talented alpinist. By romping up the White Limbo route on Everest's North Face in 1984, then K2's North Ridge six years later, Greg joined the ranks of Reinhold Messner and Jerzy Kukuczka, the only other climbers at the time to have ascended the world's two highest peaks without using bottled oxygen. This is all the more remarkable as Greg faced serious pulmonary problems as a youth. To help finance our trip,

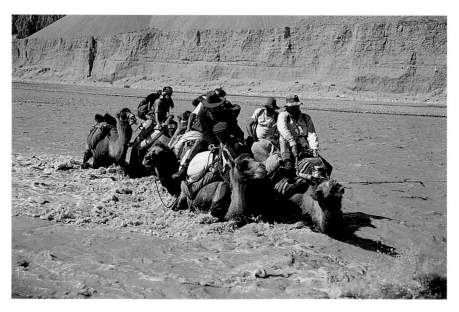

Camels carrying the trekking party struggle to cross the Shaksgam River.

Greg has come up with the idea of assembling a group of trekkers keen to get a taste of expedition life by accompanying us to base camp.

I have not bivouacked with the fifth member of the team for some 23 years. So, to find myself sharing a double bed with John Ewbank, as the result of a quirk in the hotel system, proves a novel way to start the trip. Now a singer-songwriter in New York, John was, in the 1960s, master of the then unheard-of world of Australian rock climbing, a close-knit community of spirited individuals. Back then, during my university years in Sydney, I lived for nothing else. John is like family and I relish the opportunity to climb with him again. Sadly, it is not to be. A snapped tooth forces John to leave the team in Kashgar and rattle for cover down the Karakoram Highway.

The eight-day traverse from Mazar Dara to Chongtar leads our caravan up the Yarkand Gorge and into the rust-coloured ravine of the Surukwat. A mighty rent in the land, the Surukwat cuts a perilous path into the heart of the Aghil Mountains as it winds under 1500-metre-high scree slopes and past towering conglomerate cliffs. It is hard to grasp the scale of the grand serried crags, the red, yellow and black rock splashed with harsh light. (Karakoram means black rock.)

It takes fully two hours to load the camels each morning, lashing plastic barrels of food and climbing gear onto wooden saddle frames padded with straw. Ambling beside the ponderous creatures we are gradually drawn into a time-warp and engulfed in the silence and peacefulness of big mountains as all connection with the modern world is severed. The shadows of the long-legged camels are like great tarantulas loping across the landscape. Though we traipse along behind the caravan, pleased to be walking at last, there is no hurry to reach our destination. Slowing to the pace of the land is one of the real delights of Asian travel.

Knowing that the seriousness of the Shaksgam watershed lies ahead, we enjoy hot, easy-rambling days while we can, splashing like children in gurgling streams and washing at day's end under waterfalls. With tents pitched snugly in a jangal (oasis) beside a spring, unhobbled camels munch tamarisk bushes contentedly through the night. The long, slow climb to the 4800-metre Aghil Pass will soon be followed by an ankle-twisting descent on loose rubble into the Shaksgam.

On the pass, an implacable wind nips muffled faces and a bright sun sears dust-sore eyes. Our team gradually merges with a small European one led by the 62-year-old Austrian Kurt Diemberger. A grand bear of a mountaineer, Kurt is setting off up the Shaksgam on his sixth expedition into the northern Karakoram for a reconnaissance into the rarely visited valleys under the 8000-metre giant Gasherbrum. Bringing the two groups together, our communal meal is prepared by a comical Chinese cook who resembles a rodent with his pointy ears and toothy grin. As Kurt is the most widely travelled climber to this remote part of China, at dinner that night I encourage him to consider writing a much-needed history of Karakoram exploration.

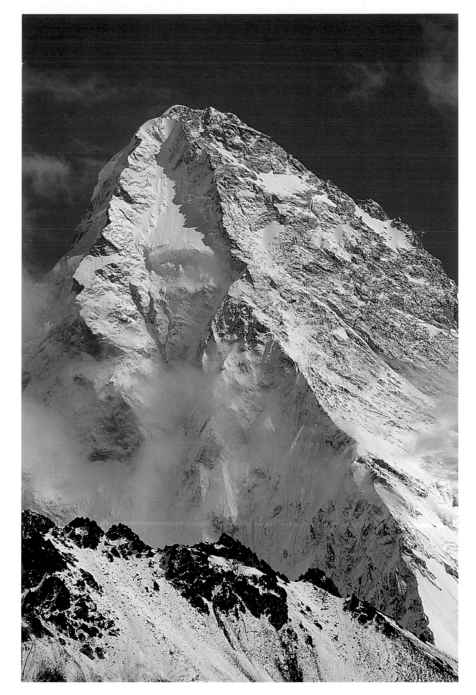

The North Face of K2 from above Suget Jangal.

Kurt's love for the tranquillity of the region shines through when he tells how he has tried to convince the Chinese to ignore a few climbers willing to pay high prices for helicopter access to K2's inner sanctum. Kurt feels strongly that those who wish to savour the grandeur of the Karakoram wilderness should earn it by approaching on foot. Thankfully, thus far, Kurt's plea has gained favour with enlightened Chinese administrators like Jin. Outside candlelit tents, a full moon is sewn like a sequin on the fabric face of the stars and snow is draped on

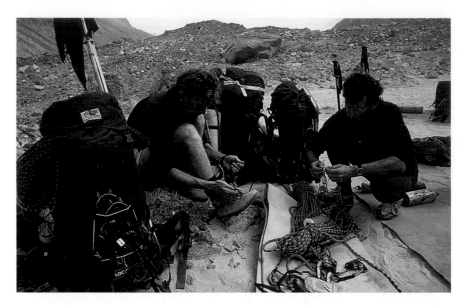

Greg and Luke prepare climbing gear, Chongtar base camp, Sarpo Laggo Glacier.

Sue makes pancakes in her kitchen under Chongtar.

nearby peaks like bolts of lace. As night draws on, rousing Italian songs fill the frost-covered tent. I drift towards sleep, deciding that the existence of the wilderness is essential to the human sense of balance, for only there can we truly appreciate who we are, how far we have come and how far we have yet to go. Long may the sanctuary of the Karakoram prevail.

Next morning, on the far side of the Aghil Pass, Kurt waves farewell and turns east while we head west, following the Shaksgam down-valley on its doomed passage towards the sands of the Taklamakan. We struggle down the Shaksgam for two more days, narrowly missing disaster when Martin and his camel are swept away. (We learn later that Kurt had a similar battle with the river, losing food and equipment.) Glowering clouds bring freezing rain as we near Suget Jangal, a lovely little oasis tucked beneath the confluence of the K2 and Sarpo Laggo Glaciers.

The arrival of our camel train at Suget Jangal proves to be charged with emotion. Greg and Jin are immediately incensed. They remember this place from two previous visits as a pristine sward of delicate alpine plants but now, as they stalk around furiously, they can see that it has become seriously degraded and mired in trash. For the past two months, Italian and Spanish climbers with Chinese, Nepalese and Pakistani staff have been in residence during a protracted attempt on K2 that has left one dead and another badly frostbitten.

Awaiting camels for the return leg to Mazar Dara, the Europeans sit listlessly, seemingly oblivious to the shards of glass, plastic, tins and rotting heaps of vegetables around them. And, as we look further, human waste and toilet paper are strewn everywhere among the boulders behind the camp. Incredibly, no one has considered digging a latrine in the sandy soil. Sherpas have even painted names on rocks in big yellow letters. Fuming, Jin scurries about, initiating a clean-up, though, finally, for now at least, garbage is left to smoulder in half-dug pits. We cannot camp in such squalor so unload our camels some distance up the valley, towards the Sarpo Laggo. Next morning, under our glowering stare, the Europeans depart, strapping their frostbitten colleague atop a camel. Flawed calculations meant that insufficient camels were ordered, leaving no room for all the packaging that has so eagerly been brought to the mountain. Even though I have to make an allowance for their lost friend, I cannot fathom why large, wealthy expeditions that can easily pay for extra baggage animals to retrieve waste still find it acceptable to desecrate fragile places like Suget Jangal. Karakoram pioneers Francis Younghusband, Ardito Desio (a member of the Duke of Spoleto's 1929 Italian expedition, who also led the first ascent of K2 in 1954) and Eric Shipton would be disgusted by these antics. What does it take to convince climbers that abandoning or even burying packaging in high mountain regions simply does not work?

Our arrival at the Sarpo Laggo terminal moraine, after another hot march, turns into an episode from *The Ascent of Rum Doodle*, the 1950s spoof in which

the porters reach the summit while the sahibs end up on the *wrong* mountain. Suddenly, our entire caravan of camels, complete with all the baggage, appears in the rain on one side of uncrossable rapids while a bedraggled bunch of climbers and trekkers stands forlornly on the other. The roar of the river eliminates communication so, after much palaver, comic messages are pulled backwards and forwards in a water bottle on a hastily rigged flying fox. The amused camel drivers simply curl up for the night among boulders while essential supplies for the expedition's survival (even the teapot!) jolt across the rope, just out of reach of snarling waves.

The climbing phase of the trip gets off to a flying start when the trekkers volunteer to spend a day humping loads up the Sarpo Laggo moraine. Finally, though, the four of us are left alone as Jin escorts the others down-valley with the camels. With no radios, no chance of helicopter rescue and with only Kurt's party some 80 kilometres away, we are left to our own devices, isolated until Jin returns in late September. This is the way we like it – a small, independent group, free to roam for a month among untouched peaks.

Days of grinding load-carrying follow, bashing over terraces and unstable boulders in an attempt to skirt the main thrust of the Sarpo Laggo's shifting moraine. Bharal mountain sheep peer down from crags, baffled by our feeble intrusion into their domain. How I love those nimble creatures – alert, graceful, adapted to perfection in a harsh land. And then, like phantoms, they vanish. Climbing steadily, we enter a tranquil valley where an advance base is set up at 5000 metres under the Chongtar Glacier.

Daybreak sees Sue bustling about constructing her kitchen. My morning is more leisurely, awaking slowly in the intimacy of a tent, reading for a spell and then stretching outside in the sun. To amble over and join the others who are already wolfing pancakes and perked coffee affirms why I crave such times with friends.

Able to travel independently, largely without the use of ropes, Greg, Luke, Sue and I became immersed in our own private world. We spend a pleasant week threading a path through an icefall, piecing together a safe route onto Chongtar's West Ridge. Acclimatised at last, we farewell Sue and, with crampons on, tack up the lower reaches of Chongtar to tuck a tent camp into a crevasse at 6000 metres. From our little crow's nest under a cluster of icicles soup bubbles away in the galley. We can almost touch Mustagh Tower with its iced-up shrouds and corniced sails billowing over the South Chongtar Glacier. Beyond, Masherbrum glows in the setting sun, a navigator in the night sky. On the southern horizon, the granite masts of Trango Towers appear as square-riggers punching into an ice-flecked Sarpo Laggo sea. Bearing away to the north, the cutter-like prow of The Crown slices across the crest of the Crevasse Glacier. Sleep comes quickly that night for dreamers who linger in such grand company.

Working our way up the west ridge, we had hoped to place another tent camp at 6750 metres, within striking distance of the summit plateau. As we gain altitude, however, the ferocity of the gusts worrying our windsuits rips that idea to shreds. It becomes harder and harder to communicate; fingers and toes turn wooden. Tent life in such a numbing blast would be miserable at best, likely forcing a retreat within a day or so. With winter nipping our heels, a setback like this could see our chance at the summit slip away. Instead, the dice rolls our way, for we all but stumble into a hidden crevasse. Hacking a passage into the roof of the slot with axes, we lower ourselves down a narrow shaft.

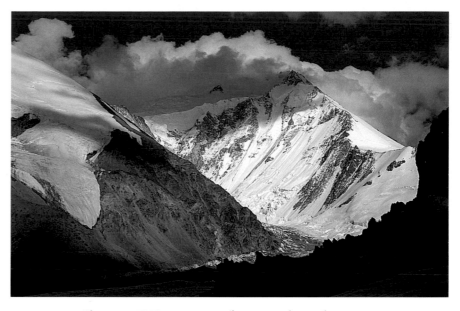

Chongtar, 7350 metres, seen from our advance base camp.

Greg brews soup at our 6000-metre tent camp in a crevasse.

Miraculously, 3 metres below the surface, we tumble into a large, perfectly formed chamber lined with icicles. Completely protected from wind, we sit on our packs and roar with laughter.

The autumn jet-stream winds that grip the upper mountain gradually wipe the smiles off our faces. Helpless, we are pinned inside this grotto for five frustrating days and five beastly nights. From the outset, as I squeeze a fourth cup of tea from the *same* tea bag, we debate the merits of descending to Sue's scrumptious cooking. We hang on up here but rest does not come easily for me. I toss and turn inside a lumpy sleeping bag stuffed with a fetid assortment of inner boots, mittens and cameras. I drift in and out of consciousness, picturing Shipton and his friends travelling way below us in 1937.

> We camped by a spring of clear water which rippled away in a tiny stream, edged with emerald banks of grass and chives, patterned with flowers. For wood we found an ample supply of the same aromatic plant that we had found in the Sarpo Laggo. After a supper of pemmican and boiled chives, we settled down on a comfortable bed of sand, and watched the approach of night transform the wild desert mountains into phantoms of soft unreality. How satisfying it was to be travelling with such simplicity. I lay awaiting the approach of sleep, watching the constellations swing across the sky. Did I sleep that night – or was I caught up for a moment into the ceaseless rhythm of space?

Tucked in a corner beside the stove, Greg does his best to keep us fed. To make water all he has to do is reach up and snap off another icicle that fizzes as it melts in the pot. One bleary-eyed morning, he singes his eyebrows and hands while changing a gas canister, ejecting the flaring monster in a raging arc over *my* sleeping bag. As time drags on, the insidious effects of altitude weaken us. Movements become sluggish. Mental games take their toll too, such as worrying about Sue's growing concern for our safety. The savage gods of Chongtar delight in testing our resolve.

The break for the top is marginal. The wind persists, draining the remaining energy we need to push upwards into steep rocky gullies leading to the summit snowfields. Powder snow blasts skyward off ridges, lashing exposed skin and driving through zips in our protective clothing. Jelly-like limbs struggle to function and, despite the moderate terrain, I fall behind. My mouth gums up with sticky white paste, my words slur. Dehydration has me in its grip. Tears well up, to smudge and freeze on my goggles as emotions well to the surface for a friend killed climbing. Somehow, with self-pity added to the baggage in my pack, a passage from Eric Shipton's *That Untravelled World* keeps me going. 'I became less and less concerned with the mastery of technical difficulty, or even the ascent of individual peaks, but more and more absorbed in the problems and delights of movement over wide areas of mountain country.'

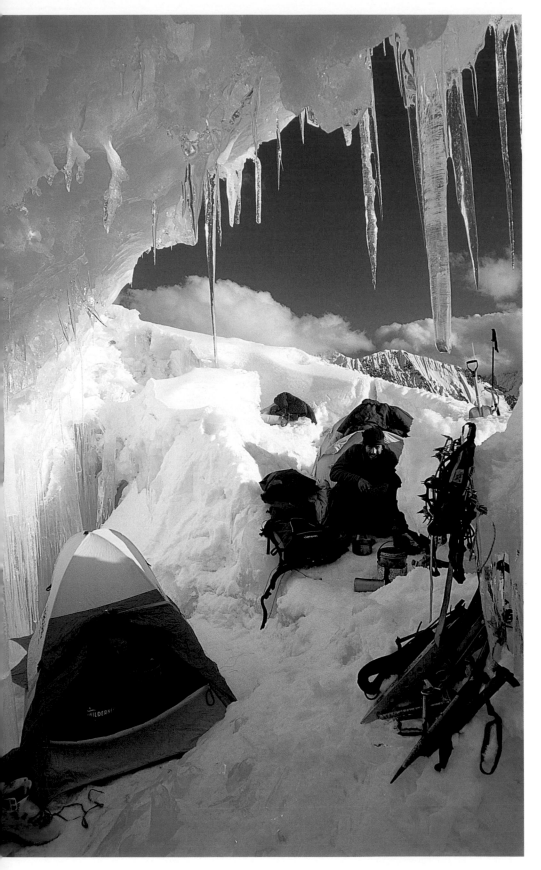

Greg and Luke enjoy the security of camping in a crevasse.

In the end I call for a rope, my confidence drained by my fragile state and the drop below – 1500 metres of wicked-looking bluffs, terminating abruptly on the buckled South Chongtar Glacier. Fear is honed by the powerful feeling of isolation. We cannot afford mistakes. Greg is obliged to slow his pace and guide me across gullies, carefully tending the 7-millimetre rope that connects us. Luke forges ahead, strong as ever, despite deepening snow. There can be no turning back now.

The summit is there. We can sense it. But it is elusive, lurking in swirls of powder snow. The cold is intense too – only minus 20°C but exacerbated by a wind that sucks away what little warmth is left in my body. I collapse at 7200 metres, flopping onto the lowest of Chongtar's summits. Greg and Luke sit nearby, sullen and chilled to the core, withdrawn into the cocoons of their windsuits. Too tired for photography, I merely flounder in the snow like a camel in the Shaksgam. Despite stunning views, this lofty perch is no place to linger.

Tantalisingly, the main summit appears only a whisker higher, perhaps 50 metres, lying at the far end of a near flat snow plateau. Only Greg has the strength to climb on and touch the top. Secretly, I am pleased Chongtar's third, more isolated summit remains unclimbed, its sense of mystery secure. Overhead, K2's summit pyramid looms, brooding in ominous black cloud. Luke sets off behind Greg but soon returns, in part to help shepherd me down to the crevasse camp. After years of looking after others in the mountains, it is a strange sensation to feel weak and uncoordinated, in the care of another. With all feeling in my toes

Greg and Luke look for the route ahead on Chongtar. The Sarpo Laggo Glacier is behind, with Changtok on the edge of the farthest moraine.

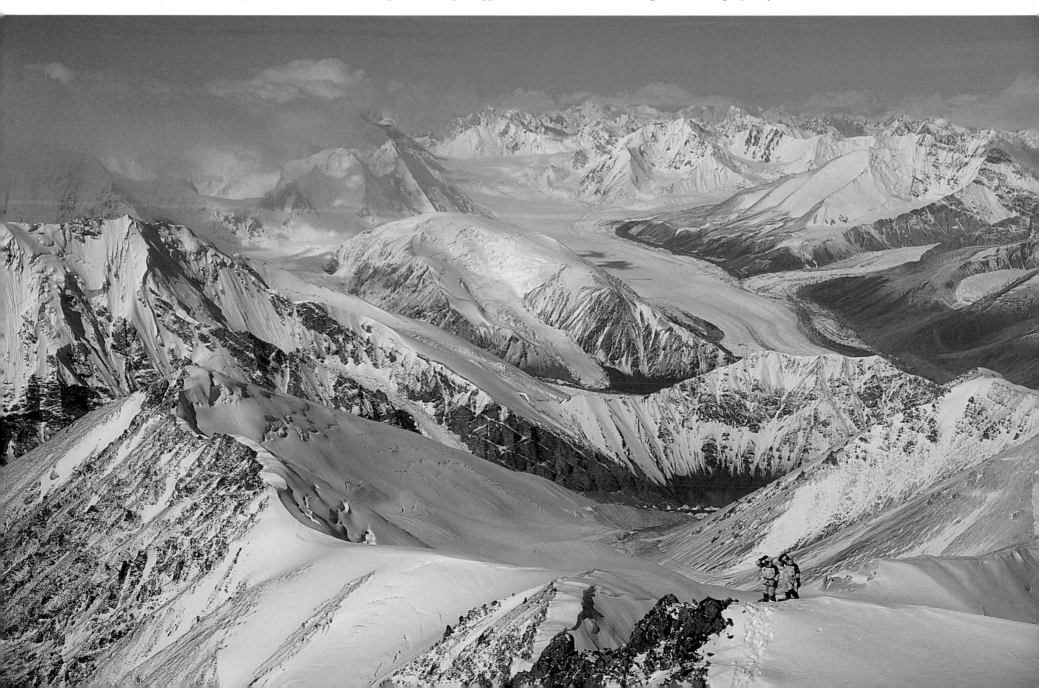

gone it is increasingly hard to judge where to place my crampons among the rocks. As Luke belays from above, he does well to snarl at me only a few times during our wobbly descent. My toes have been cold-damaged many times in Antarctica so, when climbing at altitude, I have to constantly guard against frostbite. This time they will remain without feeling for a month.

After another night shivering in the crevasse, the three of us drop gingerly down to the tent, only to find it buried under a metre of spindrift. With throats so dry we can barely speak, it takes forever to dig the damaged fabric out and repack the loads. Lethargy sets in. The final descent to the glacier is purgatory, relieved only by Sue's welcoming hug. A relaxed, two-day feast ensues, though with Jin and the camels due in a few days, pressure mounts to evacuate the mountain. Watched by bharal and hounded by rockfall, we lug ungainly loads down to a camp beside the Sarpo Laggo.

Keen to absorb more of our remarkable surroundings we separate, planning to reunite at the appointed rendezvous with the camels. Greg and Sue stay in camp to read and write while Luke sets off to fossick under K2. I embark on a three-day venture up the Sarpo Laggo. Time spent alone among big mountains is long remembered.

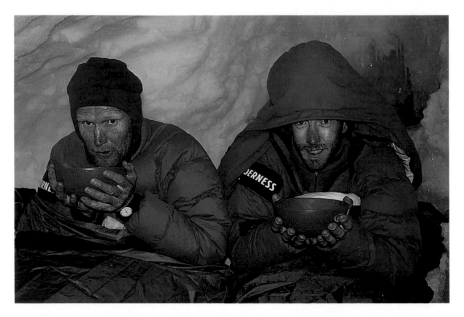

Greg and Luke drink soup while stuck in a crevasse at 6750 metres for five days.

Tiny flakes of autumn snow shimmy out of the night sky to usher us from the Karakoram. At Suget Jangal, crested hoopoes flirt and flash among clumps of tamarisk tinged with amber tips. Wild-ass kiang prance across the river flats as a skirling wind kicks dust up in little spirals from their hooves. A note found pinned to a tent door tells of Kurt's visit during our absence and of his gratitude at being able to raid our reserve food when he arrived hungry from a foray of pass-hopping. Unexpectedly, one morning, Jin pops up over the moraine, complete with pumping handshakes, broad grins, six camels and, heaven-sent, a load of watermelons.

By now, the Shaksgam is locked in winter retreat and the camels can easily ford the braided streams on our slog back over the Aghil Pass. The camel drivers are going home after a summer on the trail, so the banter is light-hearted. They joke and pass food among us in a manner reserved for footsore companions who have shared a journey. All the way to Mazar, Yarkand and on to Kashgar, I cannot shake the image of the banner of snow blowing from K2 and Chongtar. I see it still.

Sunset on Mustagh Tower from Chongtar.

My diary records parting impressions:

Snow leopard pug marks preserved in river silt near Suget Jangal are our final gift from Chongtar – a glimmer of hope for the survival of the elusive cat clings to the crags of the Karakoram – and then I remember the pelts in Kashgar market and wince…

Dawn catches the Tian Shan unaware. A filigree of moon-thrown shadows flits over the Tarim Basin as the rising sun transforms a patina of pastels on dappled snow. The apricot red orb bursts across the plain outside Kashgar to silhouette a cluster of clay burial mounds. Such a throb of colour reminds me that it took the Russian master Nicholas Roerich's brushstrokes slashed across the canvas of his journeys to capture the essence of high Asia …

There is a flutter of finches and the fat burble of doves, then a kingfisher darts over the river to sit patiently in a poplar. Kashgar, its perfume carrying to me on the wind, is alive with the bustle of autumn harvest – corn, cotton and a myriad of melons are hauled to market. There is a woman with hennaed hands, perhaps a favoured wife, who slips through a nail-studded door after casting a furtive glance through saffron-coloured silk. And there, a bearded Muslim wearing a scruffy black overcoat and a white turban shuffles down the steps of Id Kah mosque, his eyes closing as he holds the Koran aloft and reaches with open palms towards a cobalt sky. Others lean on cushions, clicking rosaries. Flying in the face of Han Chinese control, Kashgar continues to thrive on the Islamic energy of Uighur, Kirghiz and Kazakh cultures…

Racing to the Chini Bagh to board a rickety bus, I pull a sheath knife and cut a bloom from Shipton's rose garden. Immediately, two flashing blades challenge me. Glaring eyes, then laughter as the Kazakhs realise I am a threat only to their flowers. A stolen rose is seldom wasted. Expeditions usually end that way.

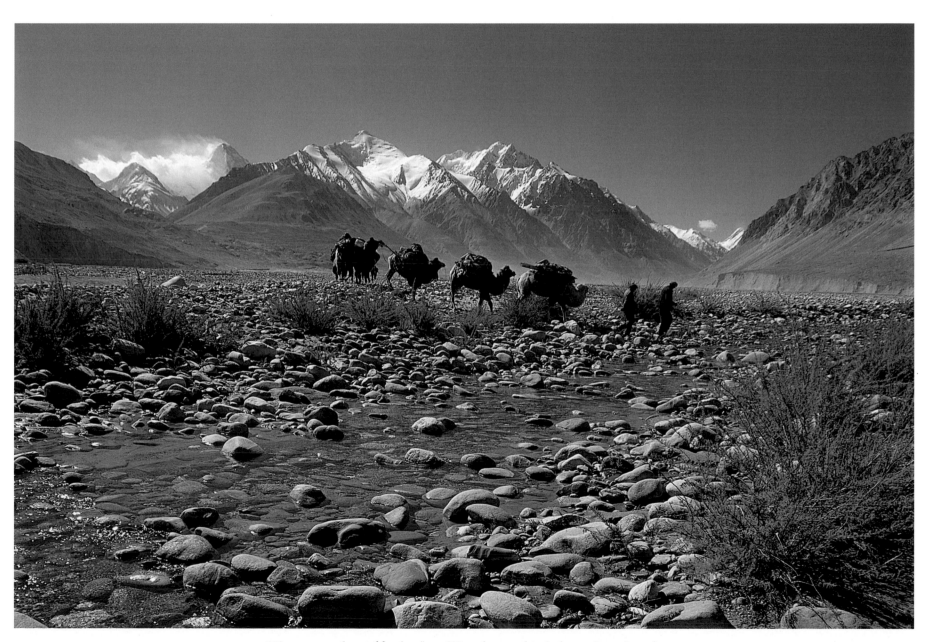

Winter snow plumes blowing from K2 as the camel train leaves Suget Jangal.

Playing the Great Game

A glacier table on the Sarpo Laggo Glacier en route to Changtok.

Changtok appears on our sketch map, a solid 20 kilometres up-valley from base camp, as an obscure dot on the lateral moraine of the upper Sarpo Laggo Glacier. I did not give the name much thought while we concentrated on climbing Chongtar. Only later, in the tent, when I delve into a battered copy of Francis Younghusband's *The Heart of a Continent* do I realise its significance. After an epic journey across Asia, Changtok was the last camp-site for Younghusband's party before it crossed a high pass into India. With my time in the Karakoram slipping away, I know I simply have to reach this place.

In 1887, Francis Younghusband, an impetuous British army captain seeking promotion, convinced his superiors that he should undertake a journey in Manchuria then, from Peking (Beijing), ride all the way to Kashmir in British India. The world's two most powerful empires had been flexing expansionist muscles for the past half-century, so British agents and their Russian counterparts stalked the high trails of Asia. With bluff and bluster on both sides, these intrepid young officers, often in disguise, acted out their fantasies of subterfuge, all but facing off against each other on unexplored passes. The Raj lacked accurate maps, so Younghusband's prime objective was to bring back geographical information that would shed light on potential routes through the mountains for a Cossack army attacking India's North-West Frontier, as was thought likely. The dashing Younghusband also saw the journey as an opportunity for pure adventure. Later, he was dedicated to military campaigns, to advising the early British Mount Everest expeditions and finally, as Sir Francis, to deeply spiritual writing. In 1904, Lord Curzon, arch-Russophobe and Viceroy of India, sent Younghusband to Lhasa as the political leader of the British military incursion.

The 1887 journey relied on camels and horses. It took Younghusband eight months to traverse westward across the southern flank of the Gobi Desert, then to ride south to Kashgar and on past Yarkand. (In 1868, Younghusband's uncle, Robert Shaw, had brought back the first secret report of his visit to Yarkand and Kashgar, inspiring his schoolboy nephew with tales of derring-do beyond remote frontiers.) Younghusband crossed the Kunlun Shan, then rode on into the heart of the Karakoram to become the first Westerner to reach the Aghil Pass. With bone-weary ponies, Younghusband and his men somehow negotiated the Shaksgam River and eventually clattered their way up the moraines and bare ice of the Sarpo Laggo Glacier. Low on food, with scant pony fodder and threadbare

clothing, Younghusband finally reached Changtok in October, at the onset of winter. On the opposite side of the glacier lay the perilous-looking 5800-metre Mustagh Pass, surely one of the trickier, least likely gateways to India.

Bound for Changtok, Younghusband camped at Suget Jangal and wrote:

I chanced to look up rather suddenly, and a sight met my eyes which fairly staggered me… a peak of appalling height, which could be none other than K2… it was one of those sights which impress man forever – a lasting sense of the greatness and grandeur of nature's work – which he can never lose or forget.

My trek takes two hard days up the Sarpo Laggo to reach Changtok, bivouacking under a boulder perched on a sun-sculpted pedestal of ice. At first, as I walk, I think that the noise I keep hearing is my camera tripod squeaking in my pack. Then, I realise that birds are flying beside me, gliding low and fast over the moraine. Like me, all are bound for Changtok. A grassy alp festooned with fading blooms, Changtok has been transformed into a staging point for many species of Central Asian birds. As I arrive, they are congregating beside tarns nestled among the moraines, apparently in preparation for a flight south over the Karakoram to winter on the Arabian coast.

It is a lichen-encrusted circular stone wall that really catches my attention. By orienting a sketch in Younghusband's book with the summit pyramids of K2 and Chongtar, it is immediately obvious that what I have found are the stones that once formed the base of the explorer's pyramid tent. It was from this camp that the Englishman set out in worn, smooth-soled riding boots to cross a slippery Mustagh Pass. Wisely, Younghusband left the pony men in residence at Changtok while he and a small party crossed the pass and made a perilous descent to the Baltoro Glacier on the far side. Days later, Younghusband sent porters with loads of hay all the way back over the Mustagh Pass so his beleaguered animals could travel on to India by a more circuitous route. Younghusband's party finally reached Srinagar after 18 months, surely one of the most remarkable journeys of 19th-century mountain travel.

The velvet of dusk draws around me as snowflakes, falling gently from a soft grey sky, pitter-patter on the last few pages of *The Heart of a Continent*. I close the book, curl up inside the stone haven and fall asleep to dream of driving camels across Tartary.

The Changtok campsite used by Francis Younghusband's team under Mustagh Pass (behind) before it crossed to the Baltoro Glacier and India.

K2

PAKISTAN

Baltoro Glacier

Chongtar

Changtok

Sinkiang,
CHINA

Sarpo Laggo
Glacier

K2 Glacier

S

Suget Jangal

Shaksgam River

Aghil Pass

Karakoram

Ambolt, Nils. *Karavan – Travels in Eastern Turkestan*, Blackie & Son, London, 1939.

Decter, Jacqueline, *Nicholas Roerich – The life and art of a Russian master*, Park Street Press, Rochester, 1989.

Desio, Ardito. *Ascent of K2*, Elek Books, London, 1955.

Diemberger, Kurt. *The Endless Knot – K2, Mountain of Dreams and Destiny*, Grafton Books, London, 1991.

Diemberger, Kurt. *Spirits of the Air* (Part 8: 'Under the Spell of the Shaksgam'), Hodder & Stoughton, London, 1994.

French, Patrick. *Younghusband – the Last Great Imperial Adventurer*, HarperCollins, London, 1994.

Hall, Lincoln. *First Ascent – the Life and Climbs of Greg Mortimer*, Simon & Schuster, Sydney, 1996.

Hopkirk, Peter. *Foreign Devils on the Silk Road*, John Murray, London, 1980.

Hopkirk, Peter. *The Great Game – On Secret Service in High Asia*, John Murray, London, 1990.

Macartney, Lady. *An English lady in Chinese Turkestan*, Ernest Benn Ltd, London, 1931.

Mason, Kenneth. *Abode of Snow – A History of Himalayan Exploration and Mountaineering*, Hart-Davis, London, 1955.

Meyer, Karl and Shareen Blair Brysac, *Tournament of Shadows – The Great Game and the Race for Empire in Central Asia*, Counterpoint, Washington DC, 1999.

Schomberg, Reginald. *Peaks and Plains of Central Asia*, Hopkinson, London, 1933.

Schomberg, Reginald. *Unknown Karakoram*, Hopkinson, London, 1936.

Shaw, Robert. *Visits to High Tartary, Yarkand and Kashgar*, John Murray, London, 1871.

Shipton, Diana. *The Antique Land*, Hodder & Stoughton, London, 1950.

Shipton, Eric. *Blank on the Map*, Hodder & Stoughton, London, 1938.

Shipton, Eric. *Mountains of Tartary*, Hodder & Stoughton, London, 1951.

Shipton, Eric. *That Untravelled World – an autobiography*, Hodder & Stoughton, London, 1969.

Skrine, C.P. *Chinese Central Asia*, Methuen & Co., London, 1926.

Steele, Peter. *Eric Shipton – Everest and Beyond*, Constable, London, 1998.

Tilman, H.W. *China to Chitral*, University Press, Cambridge, 1951.

Tullis, Julie. *Clouds from Both Sides*, Grafton Books, London, 1986.

Younghusband, Francis. *The Heart of a Continent*, John Murray, London, 1896.

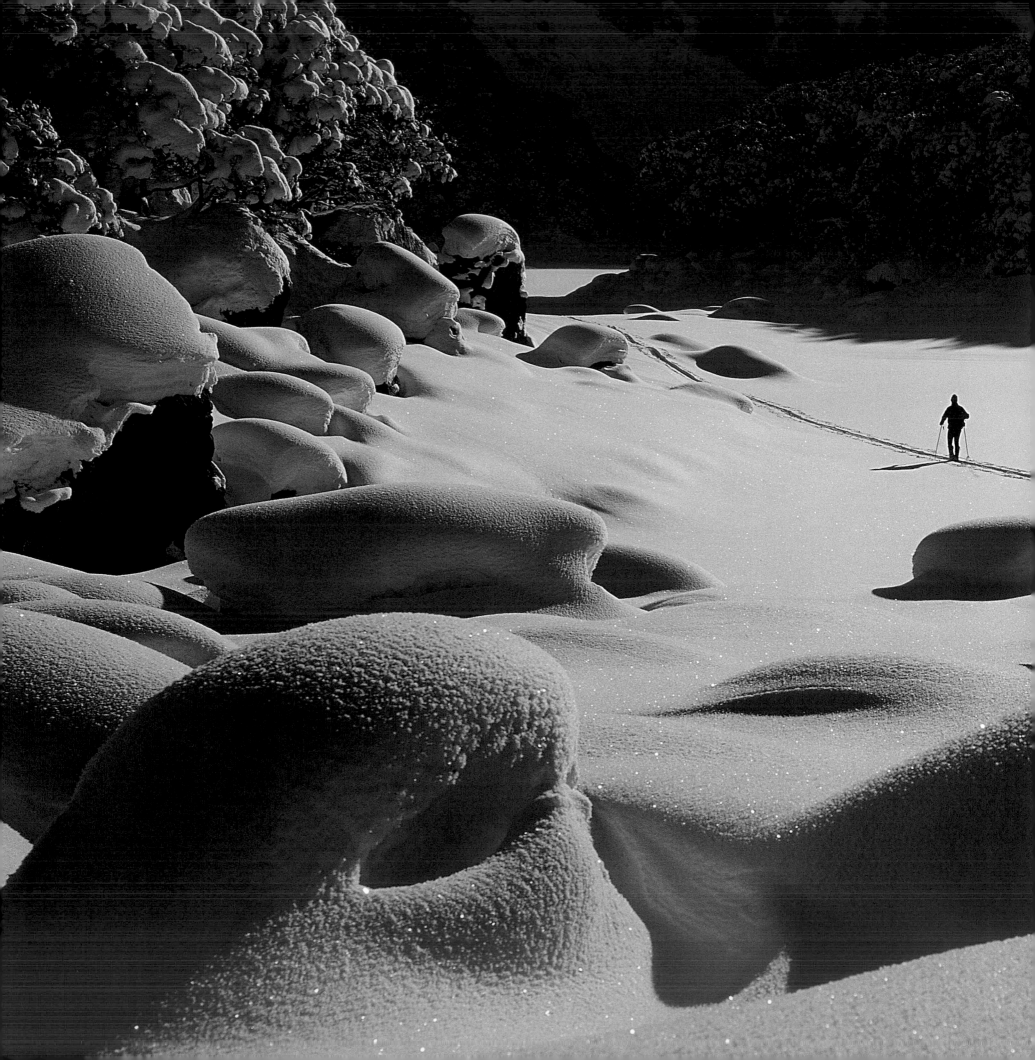

Avoiding the Paper Blizzard

Ski tours in the Southern Alps of New Zealand

Mountains inspire our highest selves. Wildness is a mirror that reflects how domesticated we have become. When we encounter mountains in wild places we experience the peak of our own humility. Whether we are standing at the summit or paying respects from below, we are flushed with awe. Perhaps this is the beginning of religion.

Terry Tempest Williams, *Extreme Landscape*

WINTER ON THE ROUTEBURN TRACK

M y ski tips floated through silken snow then glided to a halt on the wind-rippled blade of a cornice curled over Harris Saddle. In an instant I embraced the panorama beyond, from the shadowy depths of the Hollyford Valley with its beech tree canopies draped in snow, to the jagged arêtes and armour-plated buttresses of the Darran Mountains. Further down-valley past Lake McKerrow, Mount Tutoko glistened above Martins Bay, an age-old beacon for navigators in the Tasman Sea.

Standing beside me were two companions who gulped in great draughts of cold air as they caught their breath after the climb up from Lake Harris. Behind us, our ski tracks were scratched across the lake then cut around crags and in and out of the gullies tumbling down to the Routeburn Falls. A week before, in early July, I had made a brief foray into the lower Routeburn to confirm that the snow was low enough to attempt a complete crossing. Inspired by the conditions, I decided

LEFT: *Nick Groves skis across Lake Mackenzie on a carpet of crystals.* TOP: *Rob Brown, Routeburn Falls Hut.*

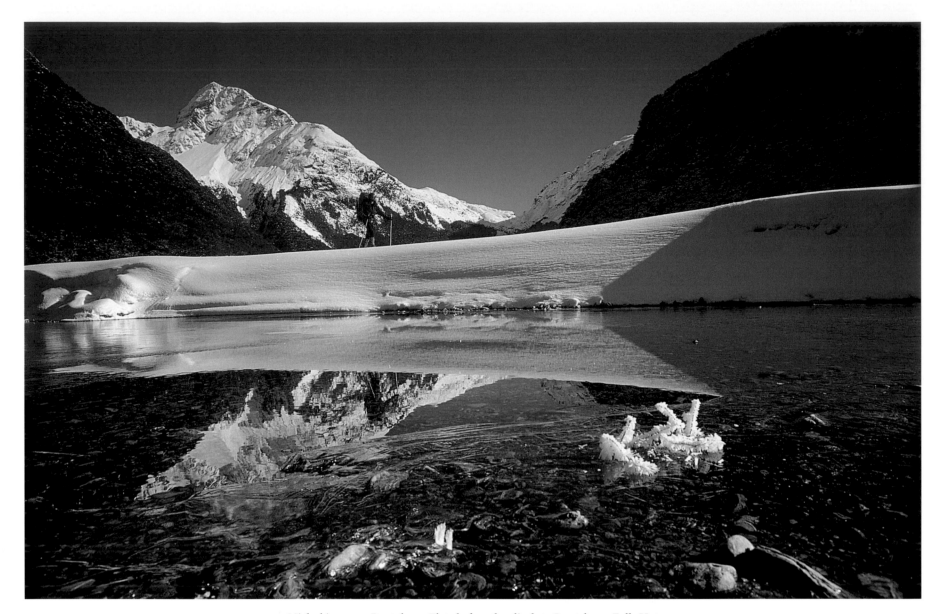

Nick skis across Routeburn Flats before the climb to Routeburn Falls Hut.

to return with Nick Groves and Rob Brown, two of New Zealand's most avid mountain photographers who, like me, are besotted by the Southern Alps in winter.

It had taken a day and a half to climb up to Harris Saddle, the highest viewpoint on the track. But, with winter light in short supply, we could not afford to dawdle before setting off across the Hollyford Face, bound for Lake Mackenzie. Swigging fluids and cramming in scroggin took priority before we stripped off the stick-on ski skins, clamped down the heel of the hinged bindings and rechecked that our avalanche beacons were transmitting properly. Pushing off, we angled the skis into the slope and edged across the open chutes that dissect the face. We held our height by hugging the contour until tensed thigh

muscles screamed in complaint. The remoteness of our situation hit home when deep snow slowed us down, making it important to ski one at a time across the steeper sections so we could monitor each other's movements. Avalanche conditions needed careful assessment, particularly on slopes where a slide could funnel a victim over a bluff into the forest below. Though the weather held for us, a southerly blow up here could easily thrash a slow, poorly equipped party. The Hollyford Face cannot be treated lightly.

At the far end of the face, a series of high-speed runs, interspersed with a few spectacular cartwheels, led to the descent to Lake Mackenzie. Side-stepping up onto the bluffs above the lake, we could make out the vague outline of the hut on the forest edge, 300 metres below. On high alert, we sensed a degree of

urgency creeping in as the mood of the day began to change. It felt as if the wilderness was hunkering down against the blast of subantarctic air. Heading up-valley, we sidled along the cliffline to outflank the trees on the usual descent route. It was hard to concentrate as we carved a path down a scree slope to the lakeshore, tiredness taking a toll on the elegance of our turns. If we skied hard, we might just make the hut by nightfall.

As the guillotine of cold-steel darkness plummeted, we shuddered at the thought of a bivouac. Even the sweat freezing in our clothing urged us on. Wearing headlamps, we slithered along shafts of light that bobbed across the frost crystals carpeting the lake. Each of us programmed the laboured shuffle of our skis to plough on until they banged into the front door of the hut.

It became evident, after we dumped our packs inside and settled in, that no one had been here for over a month. Year after year, as I ski in New Zealand's backcountry, it is rare to meet another party. The attraction of the Routeburn in winter is to plunge into a landscape cloaked in the subtlety of shadows and clusters of delicate crystals – a silent, untracked world of ice beyond the ken of most city folk, almost beyond the chime of birdsong. Idle chatter became irrelevant as each of us was entranced by the simple motion of skiing.

Twelve thousand people can't be wrong. Summer attracts a throng to the Routeburn, which has steadily increased in popularity over the past decade to rival its more celebrated cousin, the Milford Track. Only 30 kilometres long, the Routeburn crosses from the western boundary of Mount Aspiring National Park into the northern edge of Fiordland National Park. It forms a tiny though unique slice of world heritage New Zealand that stretches from Fiordland in a continuous coastal strip all the way to Aoraki (Mount Cook). The track's reputation, as one of New Zealand's premier, non-technical alpine crossings, suitable even for family groups, has placed it firmly on the international walking circuit. Unlike the 'one-way' Milford, the Routeburn can be started from either the Glenorchy end (beyond Queenstown) or from the Hollyford Road (near Milford). The booking system, designed to limit numbers and to manage the flow of summer walkers through the huts, has helped to preserve the quality of the experience.

I have completed the Routeburn only a few times in summer. In 1968, on my first tramp, the 1912 steamer, *Earnslaw*, was the only transport up to Kinloch and Glenorchy at the head of Lake Wakatipu. I hiked through a near pristine alpine paradise, meeting only a few others on the trail. Twenty years later, on another outing, I expected to find a few scars, but apart from the impact of a new, overly large hut at the Routeburn Falls, the track itself seemed in remarkably good health. Summer wardens have ensured that walkers carry out their rubbish from the easy-to-clean, gas-fuelled huts. Soap is forbidden in the lakes and

ABOVE: *Crossing a swing bridge in the lower Routeburn River.*

LEFT: *Rob is pleased to have squeezed through another devilish tree-trap.*

BELOW: *Rob and Nick set out from Routeburn Falls Hut bound for Harris Saddle.*

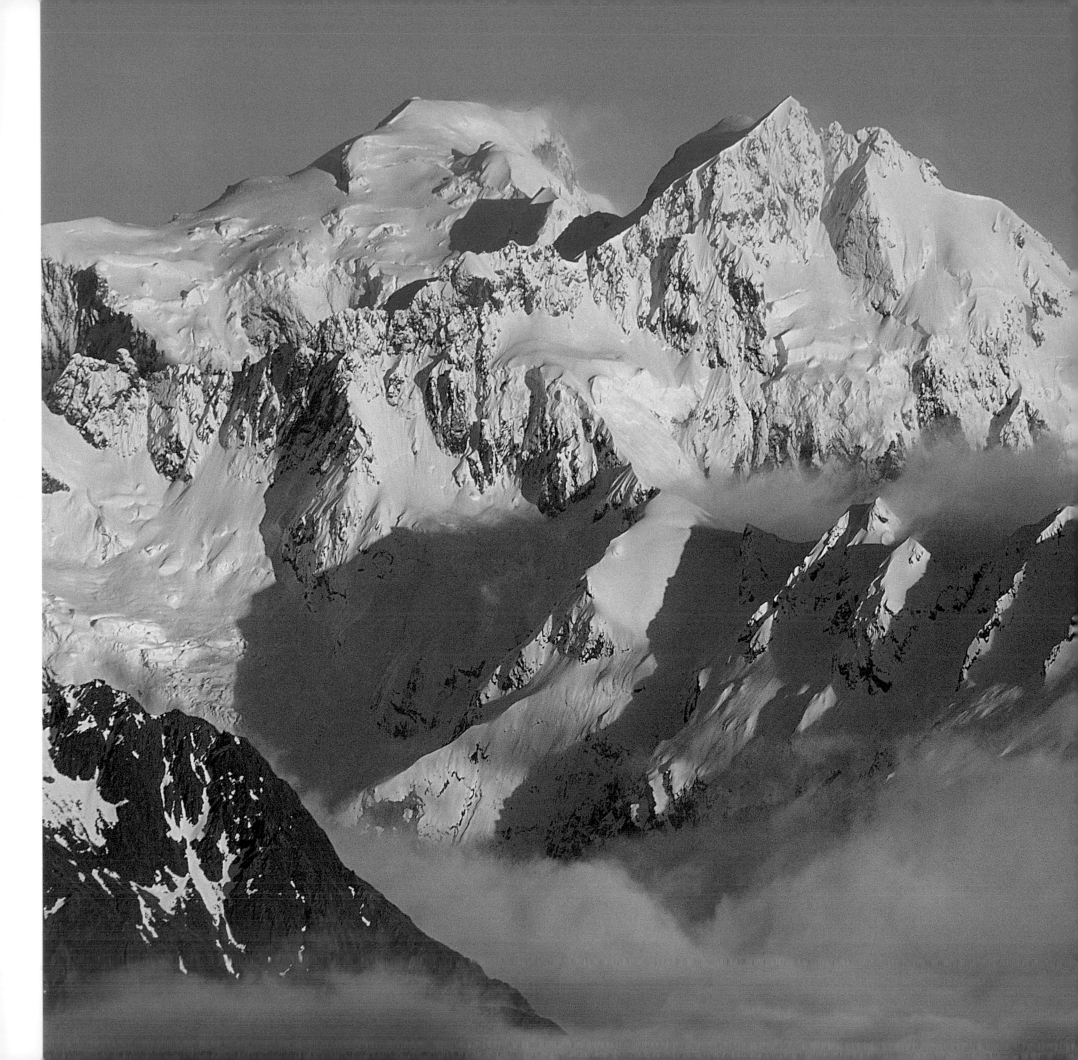

murky, snow-choked chasms. As the day wore on, a dash of humour helped to ease the bruising dealt to us by the tyranny of trees.

In a treehouse debating chamber above our heads, two quick-witted keas taunted each other like childish politicians, their red underwings a flash of brilliance compared with the opposition – a rather dull kaka that strutted about in another tree, scolding us with the squawk of a second-rate salesman. Robins flitted about my feet, ever-hopeful that insects would be disturbed by my passing. At times, the chubby, chattering little fellows all but landed on my outstretched hand. The final mad hurtle down to Lake Howden resembled Brer Rabbit bobsleighing through a briar patch.

Inside Howden Hut, our garments froze. In the dimness, Rob's fingers fumbled with matches as he lurched about with a pathetic stub of a candle, feebly trying to ignite damp wood in the stove. As the kindling hissed and smoke filled the kitchen, it seemed prudent for Nick and me to leave Rob to huff and puff into the firebox and explore upstairs. To our horror, we discovered that much of the bunkroom had been demolished. The trusses, smashed by the weight of snow on the roof, could easily have killed anyone sleeping in the top bunk. During dinner, the remaining rafters groaned like a wooden hulk beset by ice. A tad nervous of a total collapse, the three of us curled up like kittens and slept under the table.

Strapping on skis at first light, we flapped our arms and stamped up and down to get the blood flowing into digits that felt like frozen fish fingers. Impatient for the lazy sun to creep across the hillside and warm our rigid bodies, we rattled up and down the length of the lake. A sharp breeze lacerated our anoraks but we were soon exuberant at the brisk movement, unencumbered by packs. Our cheeks glowed. Then, hellbent on a hot bath, we rejoined the trail and skinned over Key Summit, a short climb before the descent to the Milford Road. Across the way on Mount Christina, a fearsome peak where even angels fear to tread, banners of snow streaked into a wintery heaven.

As I sped out of control down the last rutted slope behind Rob and Nick I felt quietly pleased with our homegrown journey. One by one, we clattered onto the skating rink of a road, much to the bewilderment of grim-faced motorists who fought to keep their spinning wheels on the tarmac. As our dishevelled little band thumbed a ride to Te Anau, I felt strongly that this mountainous heartland of New Zealand had to be the perfect antidote for the deskbound. Keen to avoid the paper blizzard? Simply throw on a pack and take one step beyond any carpark.

Nick is careful not to topple off one of the Routeburn's many bridges.

With the Hollyford Face stretched out behind them, Rob and Nick head for Lake Mackenzie. Down-valley lies Martins Bay and the Tasman Sea.

Tutoko (left) and Madeline, highest peaks in the Darrans from above Harris Saddle.

Summer in the Southern Alps

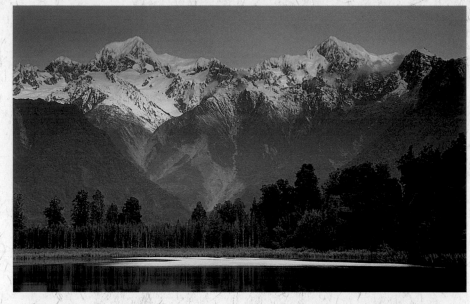

Mounts Tasman (left) and Aoraki (Cook) at sunset, Lake Matheson, Fox Glacier.

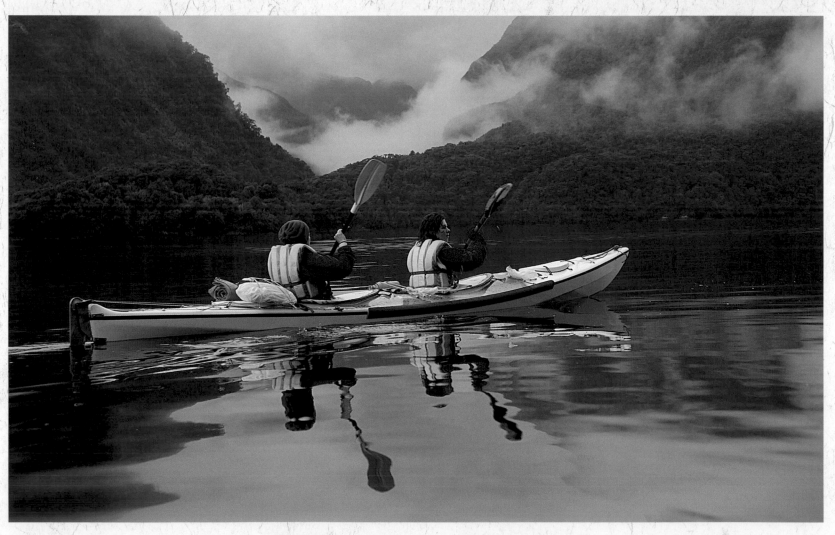

Sea kayaking, Doubtful Sound, Fiordland National Park.

*Crossing
Giant's Gate bridge,
Milford Track,
Fiordland.*

*Mount Aspiring
at dawn from
Cascade Saddle.*

*The privilege of
clean water,
Punchbowl Falls,
Arthur's Pass.*

*Frolicking in
Welcome Flats
thermal pools,
Copland Valley,
Westland.*

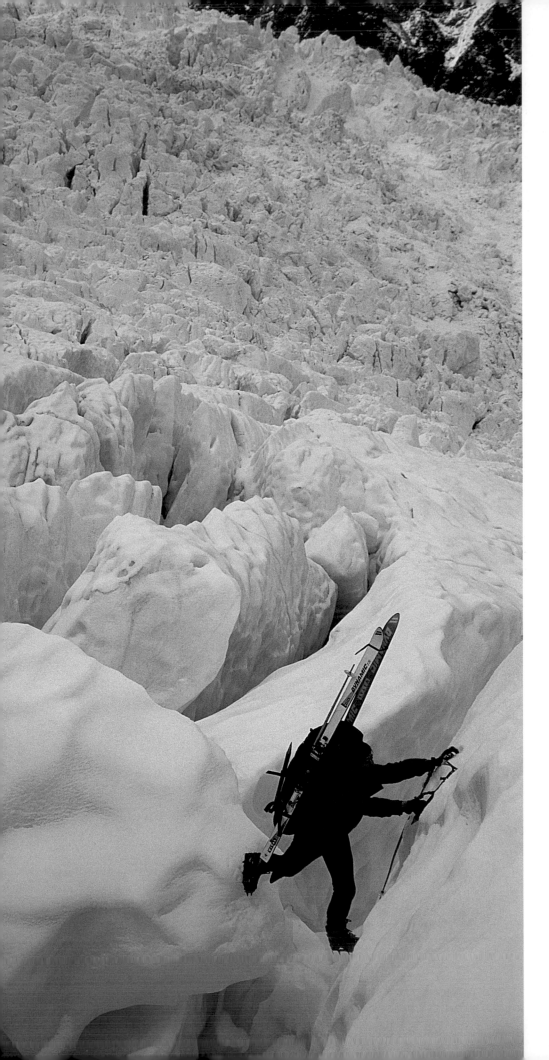

A FORAY ON THE FRANZ JOSEF AND FOX GLACIERS

Clumsy and stiff, Nick Groves and I stamped our feet and blew warm breath into cupped hands as paua-shell blue light filtered into the fern-clad valley. We had spent the night on the Franz Josef Glacier, huddled in a bivouac on a crude ice platform. With a keen sense of anticipation for the 10-day circuit of the Franz and Fox Glaciers that lay ahead, we clipped on crampons, shouldered bulky packs and nervously edged into the icefall. With skis extending from our loads as we crunched into a jumble of tottering seracs, Nick and I must have looked like stick insects making slow, gangly movements in a thorn bush.

Arms outstretched for balance, we tiptoed along wafer-thin arêtes of ice, uncertain if it was possible to find a way through. More often than not, we had to backtrack and seek another route, at times making long-legged leaps across chasms, slamming ice tools into the opposite walls and frantically clawing up the other side. Perseverance won the day, though we did mutter about retreat at one point as we nursed skinned knuckles while blundering about in a dead-end.

Finally, we hacked our way to the top of the icefall. From here, Almer Hut, our goal for the day, winked at us from the crest of snowy, 200-metre bluffs. Deep unconsolidated snow bogged us down as we fluffed about among awkward crevasses near the moraine wall where we could get scant benefit from using skis. It was dusk by the time we climbed the last slope to the hut, dug the door clear and entered the musty interior of the oldest refuge in Westland National Park. Soon, the primus was chugging away to melt ice chips for a brew, while, outside, we danced about in the cold to watch the sun slink into the Tasman Sea. Behind us, on the Main Divide, peaks from The Minarets to Mount Tasman blushed to the colour of claret.

I have romped around Westland and Mount Cook National Parks since 1967 and will never lose my fascination for the region and its colourful mountaineering history. It was in the late 1800s that the quest for Aoraki (Mount Cook) itself, properly got under way. I feel proud that three local boys, Jack Clarke, Tom Fyfe and George Graham, seized the prize on Christmas Day 1894, after a spirited climb of the North Ridge. The three brassy New Zealanders pipped the English dandy, Edward FitzGerald, and his Swiss guide, Mattia Zurbriggen, at the post. Standing there with long-shafted axes and wearing motley woollen garb, the trio would have been amazed had they known that, almost a century later, in December 1986, a lanky Kiwi lad called Rob Hall would fly off the summit clipped to a parapente canopy. And, remarkably, moments earlier, Queenstown guide Mark Whetu had skied solo down Zurbriggen's route.

Nick Groves tackles the Franz Josef icefall.

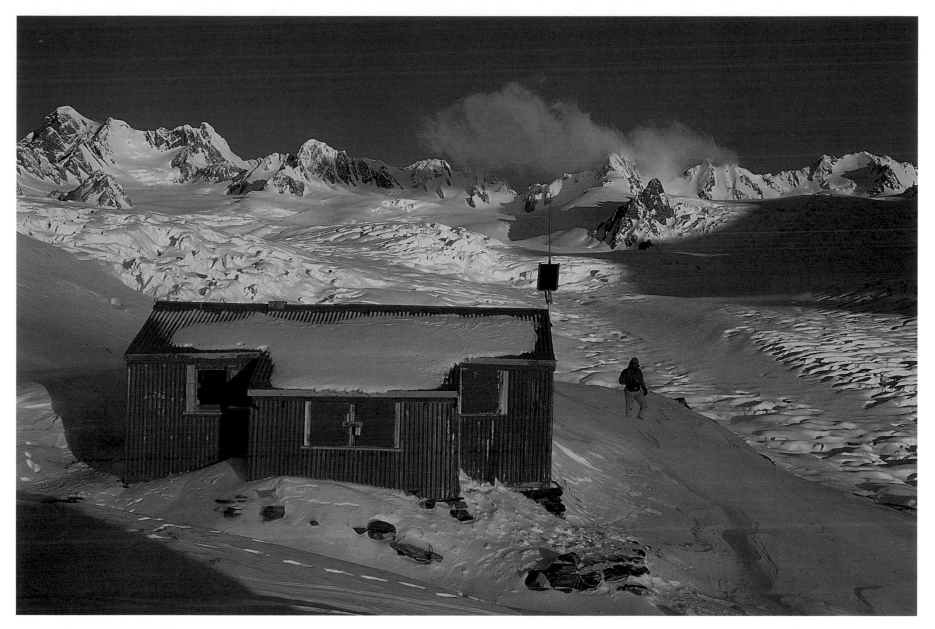

Nick outside Almer Hut. The Minarets (left) and other Main Divide peaks above the Franz Josef Glacier light up at sunset.

The panorama from Aoraki, the Cloud Piercer, is breathtaking. To the east, beyond the golden glint of the Tasman, Murchison and Godley Glaciers, tussock-coloured foothills link arms all the way to the Pacific Ocean. And, to the west, across the brooding Hooker Glacier, a huddle of our finest peaks elbow each other for room. In Aoraki's dawn shadow, the Franz Josef and Fox Glaciers spill westward, the rapidly moving rivers of ice cascading through rain-soaked gorges to emerge on the coastal fringe of forest and farmland.

To early West Coast Maori, Franz Josef was known as Ka-Roimata-o-Hine-Hukatere, the tears of the avalanche girl. She was grief-stricken when her reluctant mountain climbing companion, Tawe, slipped and fell to his death.

The silent ranges echoed to Hine's mournful cry, and her endless tears, flowing towards the sea, were frozen by the gods into a stream of ice. In 1642, the first non-Maori to 'discover' New Zealand, Dutchman Abel Janszoon Tasman, was more pragmatic, scribbling in his log, 'Towards noon saw a large land, uplifted high.'

Perched above a wind-flecked Tasman Sea, and these days commonly reached by aircraft, the névés of the Franz Josef and Fox remain one of New Zealand's most precious alpine playgrounds. Back in 1952, British ski racer Colin Wyatt produced a photographic book, *The Call of the Mountains*, which documented a number of ski mountaineering trips with the legendary

Nick near Drummond Peak, as the sun sets over the Tasman Sea.

Hermitage guide Mick Bowie. 'Deep bush now rose above the ice on either hand,' Wyatt wrote,

> and suddenly a screaming kea, flaunting his vermilion plumage overhead, welcomed us to the west coast…The Franz-Josef is one of the most amazing glaciers in the world, descending as it does through a deep gorge with mountains rising to 6000 feet on either side, from the region of perpetual ice at 8000 feet to dense sub-tropical rain-forest barely 700 feet above sea-level and but a few miles from the coast…The top basin of the Fox is an absolute skier's paradise – a huge area surrounded by lovely slopes and minor snow peaks, dominated by the 11,000-foot Mt Tasman whose rocky buttresses now towered against the dawn sky…the finest ice climb in New Zealand.

It was on Tasman, New Zealand's second highest peak, that Nick and I had firmly set our compass. We intended to ski from Almer up to Centennial Hut at the head of the Franz then cross West Hoe Pass to Pioneer, the uppermost hut on the Fox. From here, if the weather gods gave us the nod, we planned to tackle Tasman, stitching a route together up a seldom-used couloir that leads to Engineer Col and the lumpy northern rampart of the mountain.

Bleary-eyed, Nick and I peeped out of our sleeping bags at dawn when a squadron of keas clattered about on the roof, as rowdy as the Red Baron and Snoopy in a dogfight. Escaping the Battle of Almer, we bolted the stable door and pushed on up the Franz, taking turns to set the pace and break trail. Sensing they had us on the run, the keas dive-bombed us repeatedly out of the sun until they grew bored and the wing commander peeled off over Salisbury Snowfield to harass thar. The sharp kea cry fell away and we skinned on towards a rolling snowfield known as the Geike, a common ski-plane landing site. As the shadows lengthened, we swung northward and tucked our tent into a nook high under Drummond Peak. Once it was properly anchored to skis driven deep into the

snow, we plugged up to the ridge to watch the evening draw in around us. The air was bitter but the view sweet as the last gasp of the sun glanced across the Spencer Glacier and lit up the plunging, pearl-white neckline between Elie de Beaumont's two stylish summits.

It took the best part of the following day before we parked our skis outside Centennial, the trim New Zealand Alpine Club hut lashed to an outcrop called the Tusk. Just as we had found on the Routeburn, no one had been here for ages. A two-day sojourn at Centennial enabled us to dry out the tent and sleeping bags and repair minor damage to a ski binding. It also meant we could ski up to Graham Saddle under The Minarets, a popular crossing point for parties heading down the Tasman Glacier to the Hermitage. The run back to Centennial cleaned out some cobwebs when a cheeky wind kicked powder snow in our faces, nipping our noses. The squall reminded me of the winter when guide Gottlieb Braun-Elwert and I put a Singapore South Pole team through their paces as they prepared for a summer in Antarctica. Lashed by storm, the pole seekers failed to heed our advice and secure the three manhaul sledges. Losing a sledge and badly damaging a tent were valuable lessons for lads planning to take on the Polar Plateau.

For Nick and me, the ski through West Hoe to the Fox was strikingly beautiful. Glazed powder snow, fired to life by a furnace of light, blasted over my partner as he humped his load up the headwall. Silhouetted against the sun, Nick somehow looked like a camel, or perhaps a camel driver. Yes, I decided, the old rogue would make a splendid camel wallah, lounging on caravanserai cushions while sipping cardamom tea and picking his teeth with a curved dagger. I pictured him tugging on a hookah while a nautch-girl with a kiss like a cobra swayed her neck to and fro, twirling wristfuls of bangles in his face. Clearly, it had been a long week. But just then, appearing beyond West Hoe, through mist that smouldered like incense, rose the wraith of Tasman, a seductive mistress for any crusty mountaineer.

Pioneer Hut, the fourth tin-clad shelter in these parts since 1934, is the perfect bolthole on the névé from which to launch an attack on the noble summits of Douglas, Haidinger and Torres. It is the elegant Tasman, though, that commands the most attention, her alluring Heemskerck-Abel Janszoon Faces embraced by great icy limbs that, when seen from Okarito, appear like a white heron, kotuku, flexing its wings.

The plan that afternoon was to recce a route through an icefall under the Heemskerck to the base of the couloir that snakes up to Engineer Col. That done, we trundled home to our private lodge across untracked terrain. While we shared butterscotch sweets beneath Haast, I told Nick of skiing here some years back with Dave Bamford, John Nankervis and the English mountaineer Chris Bonington, our proposed climb of the South Face of Douglas in tatters as

Nick (bottom right) skis through crevasses on the Fox Glacier at sunset.

Aerial view at dawn of the eastern aspects of Aoraki (left) and Mount Tasman.

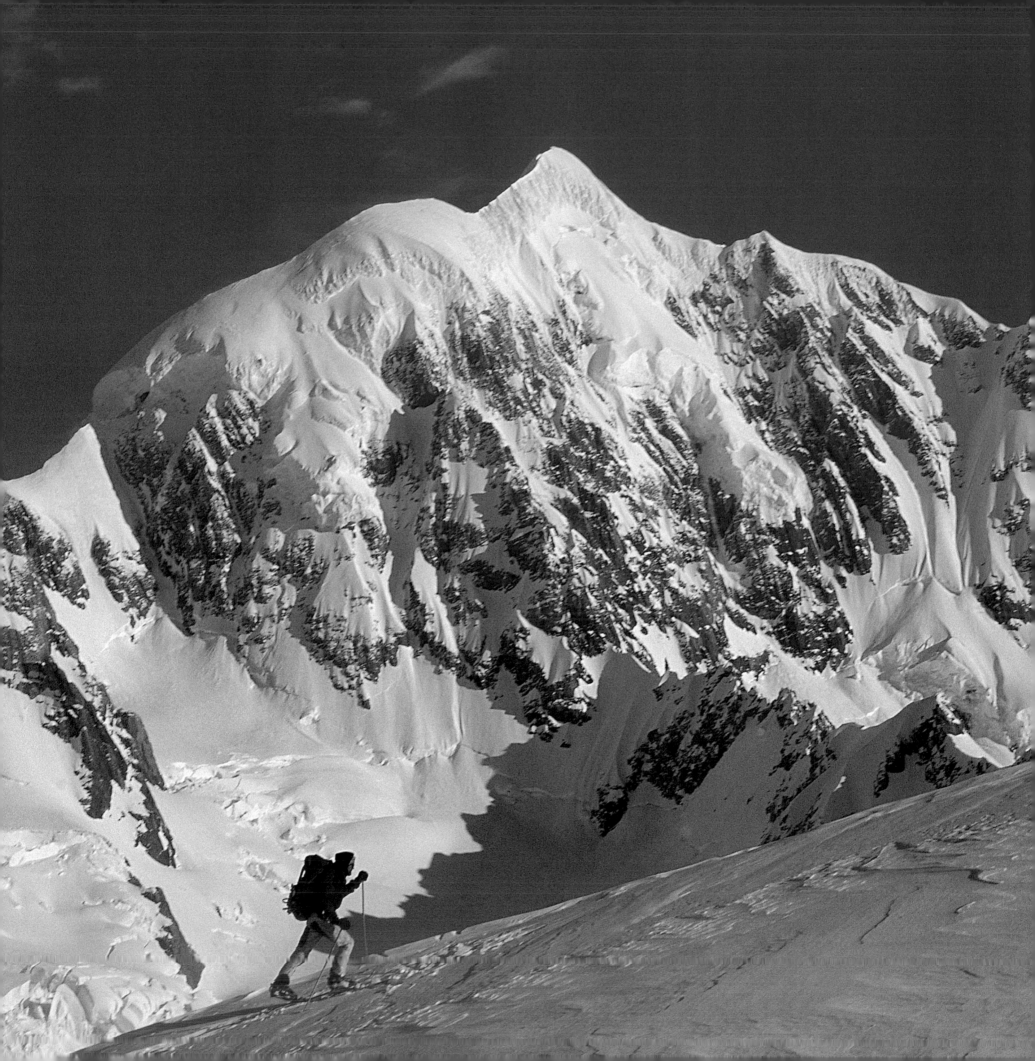

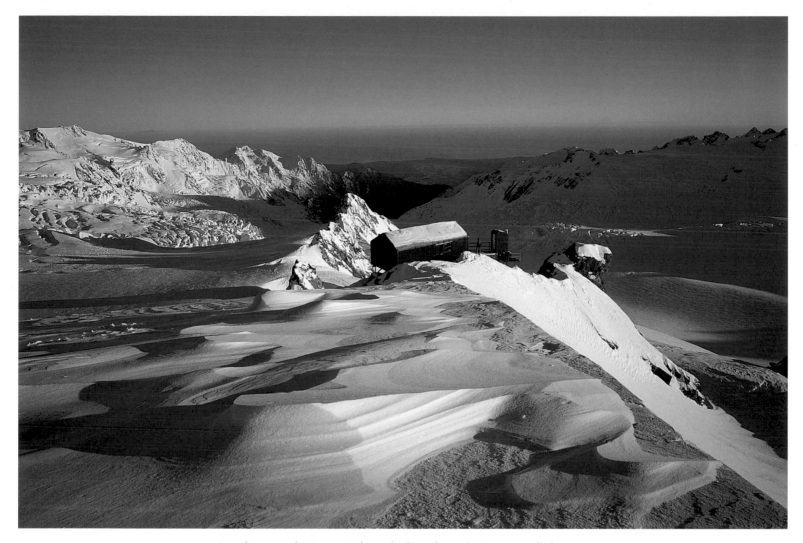

Standing outside Centennial Hut looking down the Franz Josef Glacier.

bad weather brewed. On Pioneer Pass that day, Chris had marvelled at being able to look between seracs rimmed by forest while he watched surf break on Gillespies Beach. We agreed there could be few such special places in the mountain world.

At dawn the wallah and I were tethering our skis to the bergschrund and scuttling up the ribbon of ice to Engineer Col. We climbed quickly before the sun loosened the bobbles of rime ice welded onto the rock by the battery of moist westerly air. I was glad to be in the confines of the couloir in winter, often the safest season in a shattered land of stonefall. As the wind rose, frustratingly snagging the rope on sastrugi, we gained some protection by swinging leads round onto the East Face. From there, it was straightforward to claw our way up a thin ridgeline to the summit.

Nick climbs Von Bulow, the Heemskerck-Abel Janszoon Faces of Tasman beyond.

At one point, I looked down Syme Ridge between my spreadeagled legs and spotted the orange dot of an old friend, Plateau Hut, still clutching the lip of Hochstetter Icefall. As I glanced to my left across the East Face, the dark ice patches on Silberhorn Ridge brought back memories of my first climb of Tasman in 1969. I was also reminded of the crafty FitzGerald, Zurbriggen and their 'porter' Jack Clarke in February 1895, when they hacked and stomped a route up Tasman with rudimentary crampons. FitzGerald was clearly still miffed at having missed out on Aoraki: in his description of Tasman's first ascent, he completely ignored Clarke's recent achievement.

I could hardly ignore Nick as we hugged on the top of Tasman. Despite the pummelling as the wind intensified, the bleat of my protest went unheeded. The wallah calmly unroped. Baring his teeth like a cat that spies a sparrow from behind a windowpane, Nick cramponed along the blade of ice connecting Tasman's twin-eared summits. It is rare in winter to be able to linger on a

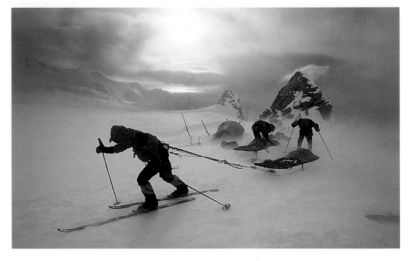

Singaporeans manhaul sledges in a windstorm on the Franz Josef Glacier.

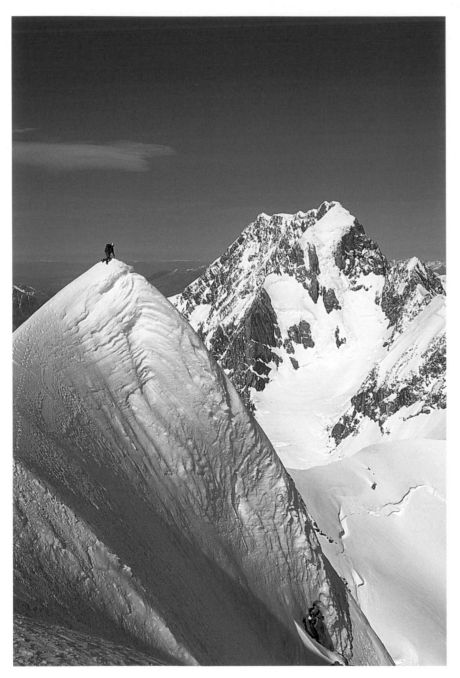

Nick on the summit of Tasman, the Linda route on Aoraki behind.

The chai wallah sups cardamom tea, Centennial Hut.

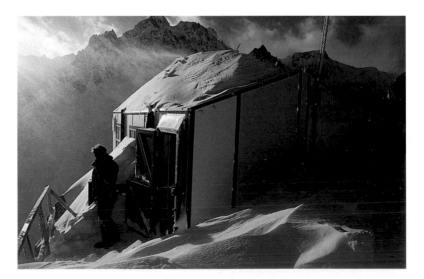

Chris Bonington clears the Pioneer Hut door, Fox Glacier.

mountain top. And, this time, I was only too pleased to clip the rope back into Nick's harness when he rejoined me and beat a retreat.

Torn off by the wind, shards of ice rattled down the Engineer Couloir towards our skis. The sound of strafing below did not appeal, convincing us to stay on the ridge and work our way over the crest of Lendenfeld to Marcel Col. Flattened by rampaging gusts and pushed perilously close to the cornice when the tirades became unmanageable, it was a slow way home, but a safe one, even if we had to ski gingerly back to Pioneer in the dark.

Caught catnapping at daybreak Nick and I were stalked by snarling cloud that was clearly creeping close enough to pounce. In a howling wind we escaped down the Fox towards Chancellor Hut. Staring hard through the shattered windscreen of iced-up goggles, we rattled on into the murk as fast as our skinny legs could ski. Flummoxed by a blind date with a snowfield known as Victoria, the blind led the blind back into a foxy glacier that had somehow reoriented itself in our absence. Steering by instinct more than good sense, we plunged into a white wedge of light that had been hammered between a black sea and a black, black sky.

Worn down by wind, we tripped over the ice-sheathed clumps of tussock above Chancellor, our faces peppered by sleet and our fingers clenched hard in sodden mitts. Inside at last, the rather wet wallah who stood dripping beside the purr of the primus was transformed into a sheikh in sheep's clothing when he conjured up the dregs of cardamom from his pack. The perfumed brew prepared a bedraggled pair for the duel with wild Spaniards on the bluffs below. And as we steeled ourselves for a damp skirmish with the lurking icefall, I drew solace from Tiziano Terzani's words in *A Fortune-Teller Told Me*:

This silence was a great discovery. Without the foreground of other people's words, I realised the glorious beauty of nature was in its silence. I looked at the stars and heard their silence; the moon made no sound; the sun rose and set without a whisper. In the end even the noise of the waterfall, the bird calls, the rustle of the wind in the trees, seemed part of a stupendous, living, cosmic silence which I loved and in which I found peace. It seemed that this silence was a natural right of every man, and that this right had been taken from us. I thought with horror of how, for so much of our lives, we are pounded by the cacophony we have invented, imagining that it pleases us, or keeps us company. Everyone, now and then, should reaffirm this right to silence and allow himself a pause, some days of silence in which to feel himself again, to reflect and regain a degree of health.

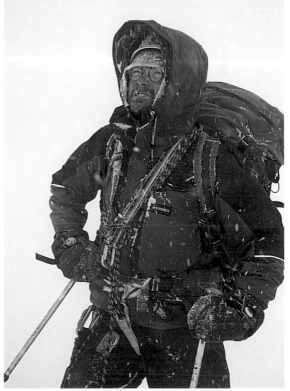

LEFT: *The last gasp to Chancellor.* RIGHT: *Lost in a whiteout, the chai wallah searches for Chancellor Hut.*

North
Island

South Island

AOTEAROA

Tasman Sea

Pacific Ocean

Centennial

Almer

Kotuku
(Mt Tasman)

Franz Josef Glacier

Pioneer

Aoraki
(Mt Cook)

Fox Glacier

Chancellor

Mount
Aspiring

Routeburn
Track

Tutoko

Madeline

Hollyford Valley

Milford Sound

Stewart Island

Fiordland National Park

New Zealand

Barnett, Shaun and Rob Brown. *Classic Tramping in New Zealand*, Craig Potton Publishing, Nelson, 1999.

Du Faur, Freda. *The Conquest of Mount Cook*, George Allen & Unwin, London, 1915.

FitzGerald, Edward. *Climbs in the New Zealand Alps*, T. Fisher Unwin, London, 1896.

Graham, Peter and H.B. Hewitt (ed.). *Peter Graham – Mountain Guide*, A.H. & A.W. Reed, Wellington, 1965.

Green, William. *The High Alps of New Zealand*, Macmillan & Co., London, 1883.

Harper, Arthur P. *Pioneer Work in the Alps of New Zealand*, T. Fisher Unwin, London, 1896.

Irwin, Sally. *Between Heaven and Earth – the life of a mountaineer, Freda Du Faur*, White Crane Press, Hawthorn, 2000.

Logan, Hugh. *Classic Peaks of New Zealand*, Craig Potton Publishing, Nelson, 2002.

Mannering, George. *With Axe and Rope in the New Zealand Alps*, Longmans, Green & Co., London, 1891.

Palman, Alex. *Aoraki – Mount Cook – a guide for mountaineers*, New Zealand Alpine Club, Christchurch, 2001.

Peat, Neville. *Land Aspiring – The story of Mount Aspiring National Park*, Craig Potton Publishing, Nelson, 1994.

Potton, Craig. *Classic Walks of New Zealand*, Craig Potton Publishing, Nelson, 1998.

Ross, Malcolm. *Aorangi – The heart of the Southern Alps of New Zealand*, Government Printer, Wellington, 1892.

Turner, Samuel. *The Conquest of the New Zealand Alps*, T. Fisher Unwin Ltd., London, 1922.

Vervoorn, Aat. *Mountain Solitudes: Solo journeys in the Southern Alps of New Zealand*, Craig Potton Publishing, Nelson, 2000.

Wilson, Jim. *Aorangi – The story of Mount Cook*, Whitcombe & Tombs Ltd, Christchurch, 1968.

Wilson, Jim and Alec Graham. *Uncle Alec and the Grahams of Franz Josef*, John McIndoe, Dunedin, 1983.

Wyatt, Colin. *The Call of the Mountains*, Thames & Hudson, London, 1952.

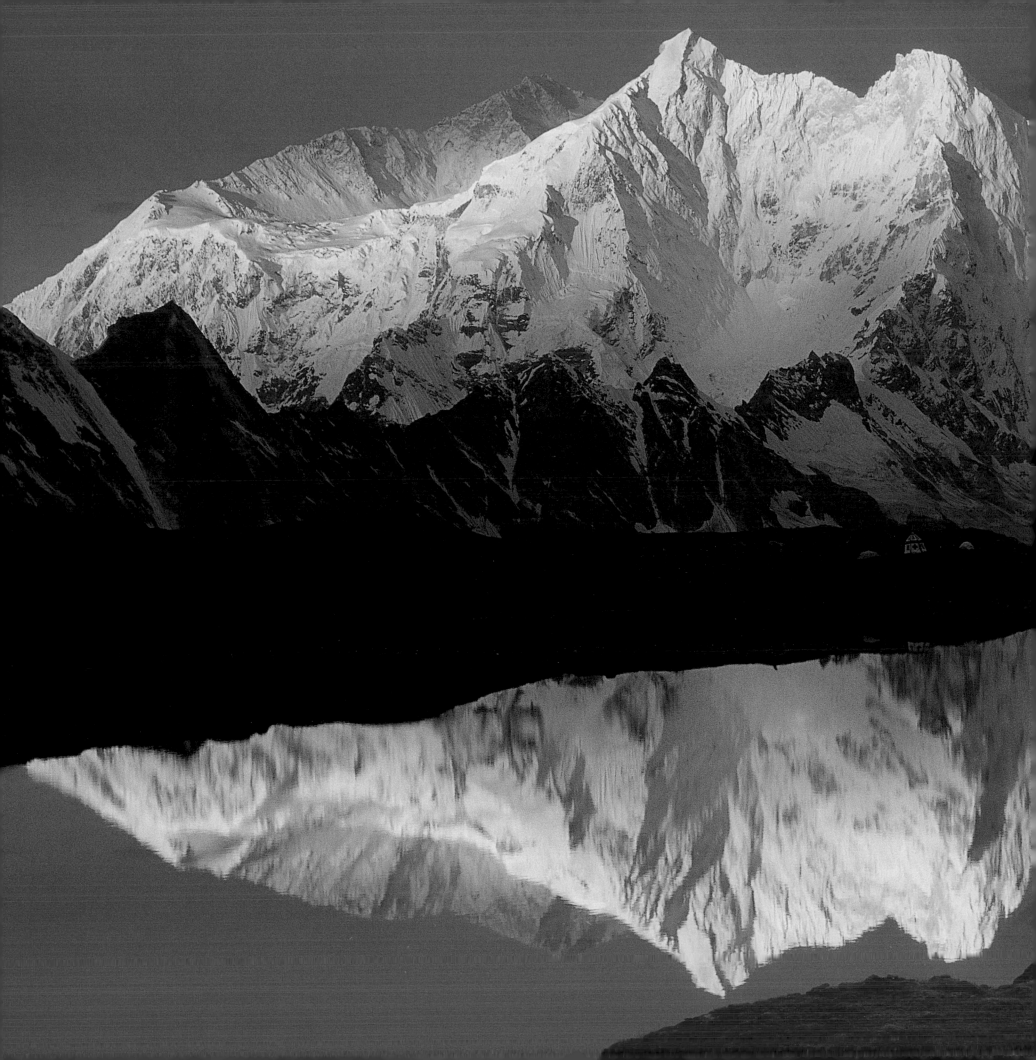

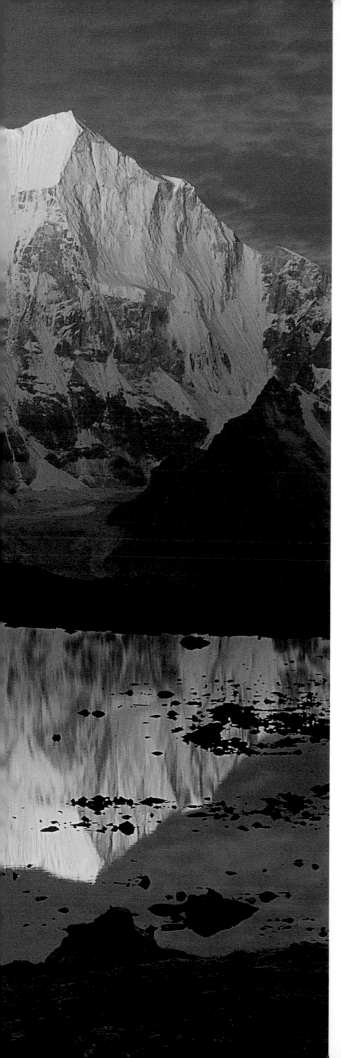

'We're just about to walk off the map...'

Retracing Mallory's exploration on the Tibetan flank of Everest

The white mountains were somehow touched to life by a faint blue light – a light that changed as the day grew, to a rich yellow on Everest and then a bright grey blue before it blazed all golden when the sun hit it, while Makalu, even more beautiful, gave us the redder shades, the flush of pink and purple shadows... But I'm altogether beaten for words. The whole range of peaks from Makalu to Everest far exceeds any mountain scenery that I ever saw before.

George Mallory, in *Mount Everest – The Reconnaissance, 1921*

I longed to return to Tibet and the flanks of Chomolungma. A highly sacred mountain, Chomolungma (Mount Everest) symbolises a formidable presence in everyday life for a great many Tibetans and, over the border in Nepal, for the Sherpa people. But, for me, dealing with the trauma of the deaths of my friends Rob Hall and Andy Harris on Everest, during a 1996 trip I withdrew from only at the last minute, it became clear that I could not go back to the mountain as part of an organised climbing expedition. Instead, by 1997, I fancied a low-key, trans-alpine journey in Tibet that would unravel some of Everest's best-kept secrets.

For 150 years Everest has held a powerful grip on the imagination of geographers, surveyors and mountaineers. For Sherpas, of course, actually climbing on Chomolungma over the past 80 years has meant a conflict between the need to earn a living and not offending their belief system when they enter the home of the gods. Although I respect modern mountaineers who need to

LEFT: *Makalu and Chomolonzo at dawn from Tso-me-lung, Karma Valley.* TOP: *Dew-covered edelweiss.*

73

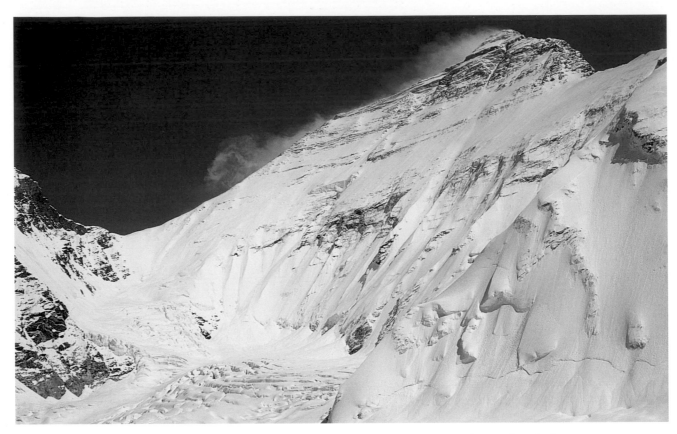

Chomolungma's North Face and North Col from the Lho La, Central Rongphu Glacier.

answer the call of such a compelling peak, I no longer feel drawn back to its slopes as a climber. To me, mountaineering has changed in the past 15 years, at least on the 8000-metre peaks like Everest where multiple expeditions on one route are now commonplace. And overcrowding in a spiritual place like Chomolungma holds little appeal. I do, however, retain an interest in the early attempts on Everest, especially those made in the 1920s and 1930s.

Back in 1984, on my first professional assignment as a mountain photographer, I had been lucky enough to play a small part in a highly successful Australian expedition to Everest. Thankfully, we had the entire Tibetan side of the mountain to ourselves for much of the post-monsoon season. Thirteen years on, in August 1997, I set my heart on returning to the Tibetan apron of Everest, this time to dig deeper into the mountaineering history of the world's highest peak.

On that 1984 trip I had spent a memorable interlude traversing Everest's 7200-metre Chang La or North Col. This two-day excursion over such hallowed ground was a break from my role of helping to film the climbers, who, without the use of bottled oxygen or load-carrying Sherpas, were poised to complete the White Limbo route on the North Face. The expedition doctor, Jim Duff, and I headed off one morning, taking care to avoid the easy-angled though avalanche-prone slopes under the Central Rongphu (Rongbuk) side of the col

Instead, we climbed pitch after icy pitch up steep runnels on the subsidiary peak, Changtse, before cutting across to the wind-scoured col beneath Everest's North Ridge. At dusk, we cramponed down into the East Rongphu Valley and were soon welcomed into camp by the newly arrived American climbers Jim Wickwire and John Roskelly. Next day, we regained our camp at 6000 metres on the Central Rongphu by way of a hidden pass north of Changtse.

Resting on the North Col that day, I had gazed upwards over tilted snowfields and overlapping rock slabs that reared sharply skyward towards the ultimate crest. My mind had drifted back to 1921 and to the other two British expeditions of 1922 and 1924 that made the first tentative probes up the mountain. Like the unconventional George Finch, who took part in the 1922 attempt, I had grown up on the east coast of Australia. I had always marvelled at Finch's innovative down jacket that made the 'colonial' the envy of his tweed-jacketed fellow climbers. Though some declared that 'Only rotters would use oxygen', Finch was pivotal in developing the 'English air' oxygen system with which he reached a record altitude – only 540 metres below the summit – in 1922. It must have been witnessing Finch's performance with this cumbersome apparatus that finally convinced the English mountaineer George Mallory to use bottled gas on his fateful climb two years later.

Rather than embarking on a large-scale mountaineering venture that would involve multiple camps and lots of equipment, a Kiwi mate, Peter Cleary, and I planned a lightweight journey to the remote eastern side of Everest. We wanted to retrace part of the route pioneered by Mallory in 1921 during his forays into the then unmapped Kangshung and Kharta – rugged glaciated valleys that are cradled in a massive cirque under Makalu, Lhotse and Everest. I packed my copy of *Mount Everest – The Reconnaissance, 1921* by Charles Howard-Bury, determined to identify some of the expedition's photo points by matching the plates in the book with what I could find on our trip. I also carried a copy of Captain John Noel's *Through Tibet to Everest*, an account of a clandestine trek towards Everest in 1913. Noel, a member of both the 1922 and 1924 expeditions, predicted that one day 'tourists' would be taken up Everest and that they would even be lowered onto the summit from a hovering aircraft.

Peter and I had travelled and climbed together many times before – dog sledging in Antarctica's Royal Society Range, attempting to scale Shivling, a needle-like peak in North-west India, and shivering side by side in a crevasse for three days while weathering a storm on Mount Sefton's East Ridge in New Zealand's Southern Alps. More than 2 metres tall, Peter cuts a striking figure not unlike a Khampa warrior from eastern Tibet. During an Antarctic training course near Lake Tekapo, at a time when Peter had flowing black hair and wore a black oilskin parka, a six-year-old skied up and asked, cheekily, 'Are you Bad Jelly the Witch?' Naturally, from then on, Peter was called 'Bad Jelly' after the character in Spike Milligan's children's tale. I could think of no finer person to share a trip among big mountains.

Thirty-five-year-old George Mallory was a charismatic, experienced climber whose name was destined to become irrevocably linked to Everest after he disappeared during his third attempt on the peak in 1924. Stricken with 'Everest fever' when he was beginning to earn a living from lecturing and writing as a professional climber, Mallory had felt compelled to return to the mountain and, with the 22-year-old novice Sandy Irvine, had made a desperate last-ditch bid for the top. (In 1999, an American expedition found Mallory's body at 8100 metres, some way below the crest of the North-east Ridge. It appears that he died as a result of a fall. Irvine's body has not been located, and it remains uncertain if disaster struck before or after they reached the summit.) Although the 1922 and 1924 expeditions provide a fascinating

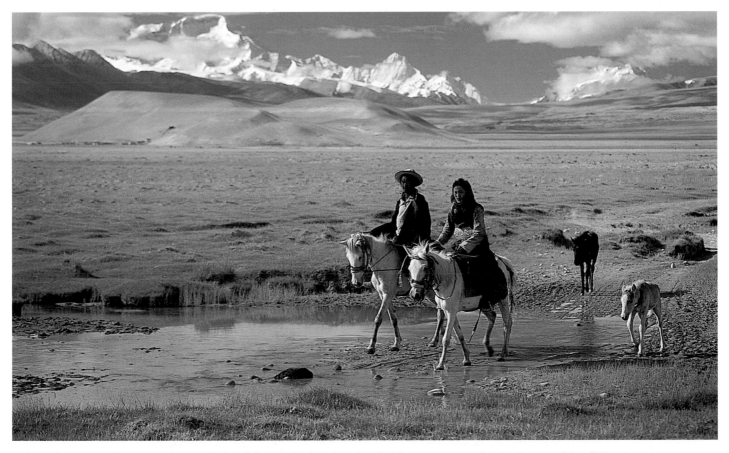

With Mount Cho Oyu behind them, a husband and wife ride ponies to market in the township of Tingri.

insight into climbers making the first forays above 8000 metres, it was the 1921 Reconnaissance Expedition and Mallory's dominant role in it that particularly fired my imagination.

Before Mallory set out for Everest in 1921, almost nothing was known about this mountain that appeared to be higher than all the rest. Labelled Peak XV in 1852 when it was first plotted on maps, Everest was seen as little more than a hazy bump on the horizon amid a sea of lofty summits straddling the border between Nepal and Tibet. The Tibetan name Chomolungma (Mother Goddess of the Earth) was unknown to the British at the time, so in 1865 the mountain was named (against his wishes) after Sir George Everest, the driving force behind the Great Trigonometrical Survey of India. From the Indian foothills, some 200 kilometres away, surveyors accurately calculated the height of the peak at 29,002 feet (now accepted as 29,035 feet or 8850 metres).

During the next 50 years, especially in distant London, the mystique of Everest grew. By 1920, Sir Francis Younghusband, President of the Royal Geographical Society, was instrumental in establishing the Mount Everest Committee in association with The Alpine Club. Although many of the best climbers had died during the First World War, the committee's express aim was to get British mountaineers to the summit, and from the outset, the names Mallory and Finch came to the fore. Nepal, and access to Everest from the south, was still politically out of bounds to the British so the Everest Committee had no choice but to route all three of its 1920s expeditions through Tibet, previously also an isolated country. Permission to approach Everest (the concept of actually climbing the holy peak was inconceivable to Tibetans) became possible only as a by-product of treaties forced on Tibet in 1904 by Younghusband after the Viceroy of India, Lord Curzon's, military incursion to Lhasa. In his book *Chomolungma Sings the Blues,* Ed Douglas speculates that 'Had all nationalities had the same kind of access as the British, then it's an uncomfortable truth that Everest may well have been climbed before the Second World War'. Mallory's North Ridge route was first climbed by the Chinese in 1960.

In May 1921, under the leadership of Lieutenant Colonel Howard-Bury, Mallory, with seven others, left Darjeeling with a caravan of mules and porters. Walking all the way through the Kingdom of Sikkim on a long circuitous route into Tibet, Mallory, his fellow climbers and the survey team embarked on a journey to Everest which, in its day, must have seemed akin to travelling to the moon. (In 1990, while searching for a decent cup of tea in Darjeeling, I signed in for lunch as an honorary member at the Planters' Club. Later, in the washroom, I was surprised to discover an original, though rather monsoon-ravaged painting of Mount Everest presented to the club by Charles Bruce, the leader of the 1922 and 1924 expeditions.)

The 26-metre-high Maitreya (Future Buddha) Jamkhang Chenmo in Shigatse towers over portraits of the late Panchen Lama and his Chinese-nominated reincarnate.

After a tedious six-week trek across the Tibetan Plateau, the British eventually camped among the Rongphu moraines under Everest. With the more experienced Harold Raeburn invalided out of the expedition and Alexander Kellas buried in eastern Tibet after a fatal illness, Mallory was suddenly propelled into the role of climbing leader. Undaunted, he set out to probe the defences of the mountain by making a series of forays onto the West and Central Rongphu Glaciers. Mallory had been awed by the mighty sweep of the North Face. In 1984, the face's sheer immensity had also left me humbled. On the Rongphu ice, utter silence and a feeling of isolation dominated. Only the fearless bharal blue sheep that came around the tents to nibble aromatic herbs helped to soften an otherwise forbidding landscape. (By 1997 base camp had been heavily affected. The Chinese now 'manage' the dozen or so high fee-paying expeditions in residence each season. From an unsightly concrete building, complete with squalid toilet and refuse pit, Chinese liaison officers supervise the 200 foreign climbers camped on the moraine.)

Mallory's team had experimented with snowshoes ('useful, but very awkward to leap in'), but in 1984 we skied across the upper névé to reach the Lho La, a 6000-metre-high gash at the base of Everest's West Ridge. Approached from the Rongphu, the Lho La is near flat but it plummets abruptly over the edge into Nepal. From this lofty perch I enjoyed yodelling to tiny dots of climbers below who were working their way through the chaos of the Khumbu Icefall. Mallory and Guy Bullock had been the first to see this fearful jumble of ice blocks from a pass between Pumori and Lingtren. They could look into the lower part of the Western Cwm that stretches up to Lhotse and the South Col. Mallory did not realise then, of course, that this southern approach to Everest would become the standard route after Edmund Hillary and Tenzing Norgay returned from the summit in 1953.

Crucially, despite the hindrance of swirling monsoon cloud, Mallory had his first glimpse of the North Col on an earlier foray from below the Lho La. Its significance as an access route to the upper mountain was immediately obvious. Given hindsight, it is surprising Mallory did not try to gain the North Col from the west for, even by the standards of the day, it is a straightforward climb. Instead, frustrated by lingering monsoon weather, he convinced the others to pack up and leave the harsh environs of the Rongphu watershed. (Until the route was found weeks later by the expedition surveyor, Edward Wheeler, the British had failed to recognise the outflow stream from the nearby East Rongphu Glacier for what it is – the entrance to a highway of smooth moraine and easy ice that leads directly to the eastern side of the North Col.) Determined to find a route to the all-important col, Mallory's party set out to join the leader, Howard-Bury, who was already established at Kharta, a district east of Rongphu near the lush forested gorges of the Arun River.

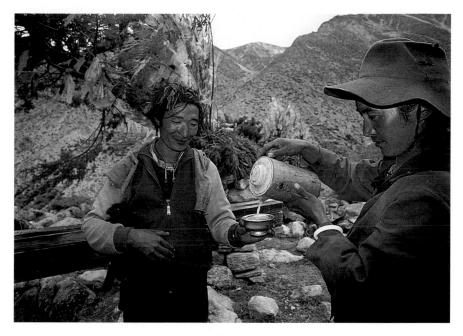

Sharing chung provides a welcome break from hauling timber cut in the Arun Valley.

After a fine stint of exploratory mountaineering, an advance base was established on the Kharta Glacier. From here, Mallory's party struggled across a high pass, the Lhakpa La, before finally reaching the North Col. On 22 September 1921, one of the most significant dates in Everest history, Mallory turned into a freezing wind to face the descent and beat a weary retreat to his camp above the East Rongphu. He wrote later, 'I doubt if any big mountain venture has ever been made with a smaller margin of strength. I carried the whole party on my shoulders to the end, and we were turned back by a wind in which no man could live for an hour… As it is we have established the way to the summit for anyone who cares to try the highest adventure.'

By pioneering the approach to the North Col Mallory opened the key passage for the seven subsequent British attempts on the summit from 1922 to 1947. As Mallory recrossed the Lhakpa La in 1921 he may have turned to catch a final glimpse of the banner of powder snow streaming from the summit. Though England and his young family beckoned, Mallory knew he would return to Everest.

Bad Jelly and I did not intend our 1997 sojourn in the high Himalaya to be a complete re-enactment of Mallory's explorations. For a start, our approaches to Everest could not have been more different. Whereas the British reached the Tibetan Plateau after a gruelling trek from British India, Peter and I were able to drive in three trouble-free days from Kathmandu to Lhasa, after lurching over the usual landslides in the Kodari Gorge. In Lhasa we exchanged our tourist visa for a mountain permit, hired a Tibetan liaison officer and a cook and then,

Return to Lhasa — The Lost City

A significant factor in my decision to return to Tibet was the opportunity to visit Lhasa again. In 1984, I had wandered the back streets of the city and bicycled out to Sera monastery to witness a 'sky burial' ceremony. Judging from historic photographs, I sensed that much of the traditional Tibetan architecture had not changed appreciably, despite 34 years of oppression following the Chinese invasion. Having read widely about the situation in Lhasa in recent years, however, I knew that in 1997 I was in for a few shocks.

As Peter and I approached Lhasa in our jeep, we drove fast along a tarsealed highway that I remembered as little more than a dirt track. It was evident that entire suburbs have been swept away, replaced by wide boulevards, clusters of new offices, hotels and shops of modern Chinese design. Sprawling industry and military barracks now lay on the outskirts of the city. A concrete factory spewed a blanket of thick white dust across the valley. Where the Tibetan medical school once stood on Chakpori Hill opposite the Potala palace was now a hideous tangle of barbed wire and radio towers. The transformation of the old Tibetan capital into just another Chinese city seemed almost complete.

But despite the impact of bland Chinese architecture and a proliferation of gaudy neon signs, Lhasa will remain unique as long as the all-seeing Potala palace lords it over the city. Thankfully, the Potala survived the ravages of the Cultural Revolution, though only because of last-minute orders from Chairman Mao. Although the Potala is now classified as a world heritage site, it is under threat from the encroachment of insensitive construction. And inappropriately located advertising signs now jostle for position near the Potala, further demeaning the spiritual significance of

The Potala, winter palace of the Dalai Lama, still dominates Lhasa. A large Mobil oil sign was recently removed from a foreground building as a result of international protest.

this magnificent building. Once tranquil lakes around the Potala have been radically altered: some are filled with concrete or now sprout rows of iron railings. It is hard to imagine any Tibetan choosing to have a family picnic in such an austere setting. In front of the palace, on a concrete plaza that was once a sacred lake, stands the hulk of a jet fighter. The aircraft, ostensibly for children to play on, is a reminder nonetheless of the omnipresent military power of China lurking in Tibet. Everywhere in Lhasa it is clear who wields the big stick.

In the Potala's inner sanctum surveillance cameras maintain an ever-watchful eye. Our guide often put a finger to his lips and pointed to hidden microphones. Until we left the building I had to guard my comments about the 'dead' museum-like feel to the palace, so as not to get the guide into trouble. In what were once the Dalai Lama's private chambers, even a portrait of His Holiness that was there in 1984 has been removed. (In a show of defiance against the illegality of possessing a portrait of the Dalai Lama, some impish Tibetans keep an empty picture frame in their homes or workplaces.) On rooftop courtyards that provide a grandstand view of the 'new' Lhasa stand dress-up boxes filled with traditional Tibetan costumes. These 'quaint' clothes are donned by Chinese soldiers and their girlfriends so they can have their photos taken for relatives back home.

Since 1996, 11,409 monks and nuns have been expelled from their places of study or worship. In 1999 alone, there were six known cases of deaths resulting from torture and abuse. The authorities expelled 1432 monks and nuns from monasteries for refusing to either oppose Tibetan freedom or denounce the Dalai Lama. At the dawn of the 21st century there were 615

documented political prisoners in Tibet. Remarkably, considering the brutal measures employed to discourage them, some Tibetans, commonly monks, still protest the occupation of their land each year. Often, the supremely holy Jokhang temple has been the focal point for these gatherings. Nowadays, on all four corners of the new plaza in front of the Jokhang, mounted video cameras spy on the crowds who mill around the souvenir stalls or prostrate themselves on a circuit of the nearby Bharkor.

Many Lhasa residents were forcibly evicted from condemned homes during the plaza's construction. Superficially, it is a more pleasant approach to the Jokhang than the squalid lanes I splashed through in 1984 but I sense that this piece of town planning went ahead only to facilitate rapid police deployment and speedily quell any disturbance. At least worshippers at the Jokhang today have the freedom to pray in the courtyard and enter the sacred shrine. I remembered my earlier visit when I ran my fingers over the stumps of metal bars that had only recently been sawn off. Not long before, the Chinese had kept pigs in the Jokhang, locking distraught Tibetans outside. I am sure, however, that today's apparent relaxation of control on religion is something of a façade to placate observers and lull them into thinking that all is well on the Roof of the World.

In every monastery we visited, including the remote Kharta gompa, the 'official' portrait of Gyantsen Norpo, the Chinese-nominated boy Panchen Lama, the second most senior religious leader in Tibet, was prominently displayed under the statues of Buddha – as it must be, by law. Nowhere did we see portraits of either the Dalai Lama or the Tibetan-nominated Panchen Lama. The Tashilumpo monastery in Shigatse, Tibet's second largest city, was the seat of the tenth Panchen Lama who died in 1989, reportedly in mysterious

As if from a house of horrors at the fairground, a distorted view of the Potala is reflected in the windows of a newly built hotel.

circumstances, after finally renouncing the Chinese regime. Gedhum Choekye Nyima, the child Panchen Lama finally approved by the Dalai Lama himself as the eleventh reincarnate, has been 'removed', together with his entire family, to a secret location in China. The kidnapping effectively makes the tiny monk the youngest political prisoner in the world.

On the positive side, despite the fact that large numbers of political prisoners remain in jail, widespread brutality and heinous acts such as the forced sterilisation of Tibetan women seem to be a thing of the past. The Tibetan language is again being taught in schools, at least in junior grades. But since seven out of every 10 Lhasa residents are now Han Chinese, Mandarin dominates both secondary and tertiary training. Unless they are fluent in the Chinese tongue most Tibetans cannot compete for the better jobs.

Cultural genocide has many faces. Although the powerful Chinese military presence in Lhasa is currently kept well hidden, it is perhaps the strident civilian economic invasion of the capital that will ultimately prove more deadly to Tibetan culture. Even so, I left Lhasa with a degree of optimism. In the face of overwhelming barriers, the spiritual strength of many individual Tibetans, such as the wild-looking Khampas I shared tea with near the Jokhang, remains remarkably resilient. Nonetheless, despite a slight relaxation of its grip on Tibet, in part to seduce Western tourism, it seems a belligerent China still has little idea of how to win friends either at home or abroad. At every turn, I felt Tibetans were still being marginalised in their own country. I could not shake the feeling that the struggle to possess Lhasa's soul is vastly one-sided. What was once a 'forbidden' city is now a 'lost' city.

with a jeep and a baggage truck, backtracked through the townships of Shigatse and Shegar towards the main spine of the Himalaya. I had specifically requested Tibetan staff; in my experience, the Chinese have scant affinity for extended mountain travel. And a Tibetan liaison officer would also be important to communicate properly with the yak drivers we would hire in Kharta.

Finally, our little entourage branched off the main road and began a spine-jarring ride into the Chomolungma Nature Preserve in the shadow of Everest. Instead of winding up to the end of the road at the Rongphu gompa (monastery), we turned east to grind over a narrow, water-worn track to Kharta. A cluster of stone and mud-brick houses surrounded by ripening barley crops, Kharta is nestled in a picturesque valley overlooking the narrow defile of the Phung Chu/Arun Gorge. Just south of Kharta, the powerful Phung Chu cuts a deep slash through the Himalaya on its tortuous descent as the Arun River into Nepal. We spent a night sorting food, fuel, clothing and tentage into waterproof kitbags suitable for lashing to yaks. In the morning, a late monsoon downpour set in as we waited for our caravan to arrive so Peter and I opened umbrellas and climbed up to visit the gompa.

Monks and a nun in the Kharta gompa compare their old print of long-deceased Kharta monks with the identical image in the 1921 Mount Everest book.

Surrounded by 12 grubby monks and a wrinkled nun inside the shabby little building, Peter and I could feel ourselves relax, content to be in jovial company and in the knowledge that we had finally left behind the present-day tensions of the so-called Tibet Autonomous Region. Helped by translations from our liaison officer, Dorje, we managed simple conversations with the monks, while they took delight in plying us with copious cups of salty Tibetan tea and handfuls of roasted barley.

I pulled out Howard-Bury's book to show them the original route maps and the fine monochrome plates of their homeland. Turning the pages brought spontaneous squeals of delight from the monks clustered around me as they spied images of Shegar's imposing White Crystal monastery and even the original Kharta gompa. Both buildings had been destroyed during the onslaught of the Cultural Revolution (1966–76), their demise pre-dating the birth of these young Buddhists now eagerly thumbing through the book. From 1950, when China first occupied Tibet, until at least 1976, several thousand monasteries were bombed, used for artillery practice, torn apart by hand or looted – in some cases by Tibetans themselves, cajoled into action by the fervour of Red Guards.

Laid out on the floor of the Kharta gompa is Mallory's map from the 1921 reconnaissance with the old print given to the gompa by the expedition.

One particular portrait, depicting Kharta's long-deceased clergy dressed in silk finery, brought stares of disbelief. A monk immediately scurried away to an outer chamber and returned, beaming, clutching a tattered print. Remarkably, the grimy, chipped photograph in my hand was identical to the one in the book. In order to double-check that precious glass plate negatives were exposed correctly, the British had set up a makeshift darkroom in Kharta. Howard-Bury must have presented this print to the Kharta monks who had helped the expedition.

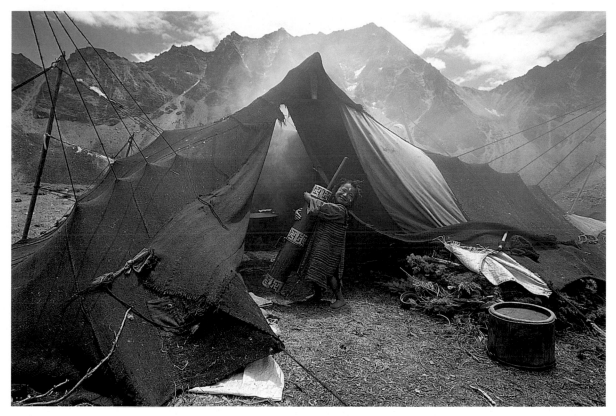

A young yak herder carries the plunger used for making tea into her yak hair tent, Thangsham, Karma Valley.
This could easily have been what a seven-year-old Tenzing Norgay would have done here in 1921.

Somehow, this crumpled photograph was one of the few treasured relics to be rescued from the original gompa before it was gutted by fanatics.

At last, Peter and I headed out of Kharta. Dawdling behind laden yaks and absorbing the delights of ever-changing colours and smells brought home just how much I love wandering along a Himalayan trail at my own pace. And, when you are weary from a day's march, it is always soothing to drift into sleep listening to the clonging of yak bells as the shaggy, grunting beasts graze outside the tent. Our caravan of four Tibetans, seven yaks and two lanky Kiwis spent several relaxing days strolling past a series of hamlets beside the gurgling rapids of the Kharta Tsangpo. Farmers in terraced fields whistled or waved at us as they prepared to reap the reward of a bountiful barley harvest after good summer rain.

Other groups of Tibetans, sometimes entire families, shuffled towards us on the trail, bent under gargantuan loads or accompanied by heavily laden yaks. Massive beams of pit-sawn timber, hewn by hand from the coniferous forests in the Arun Gorge, were lashed to both human and animal backs with rawhide or plaited woollen ropes. Because of the ruggedness of the landscape, we were witnessing a largely unmechanised version of what has happened on a massive scale, especially in eastern Tibet. Extensive building programmes throughout Tibet and in western China mean there is an insatiable demand for timber. The Chinese have constructed impressive mountain roads into various parts of eastern Tibet to plunder the forests. Contractors also cut timber in remote areas of Nepal and, using yaks, haul it out across border passes into Tibet during summer. The steady flow of timber coming towards us on the trail was being depoted at the Kharta roadhead ready to be sold by agents in Shigatse. Timber is now an important part of the local economy. Grinning at strangers in their land, the timber cutters were only too pleased to rest and share with us a flask of chung (barley beer). Slightly drowsy with alcohol, I nodded off in the midday heat until, with little warning, I was sent scurrying for an umbrella as a monsoon shower pelted down. Clambering on slippery trails over ever-steepening terrain, we won altitude haltingly as we headed for the Langma La.

A 5300-metre pass, the Langma La separates the Kharta Tsangpo watershed from the inner recesses of Karma-Kangshung, a near pristine glacial valley system tucked under three of the world's highest peaks. Our yaks snorted and snuffled some way below, jockeyed along by clipped shouts and piercing whistles from the yak drivers. Meanwhile, Peter and I lay spreadeagled and panting on the pass under a pincushion-like chorten – a cluster of bamboo canes festooned with bleached prayer flags and good-luck charms. The Langma La is a clear dividing

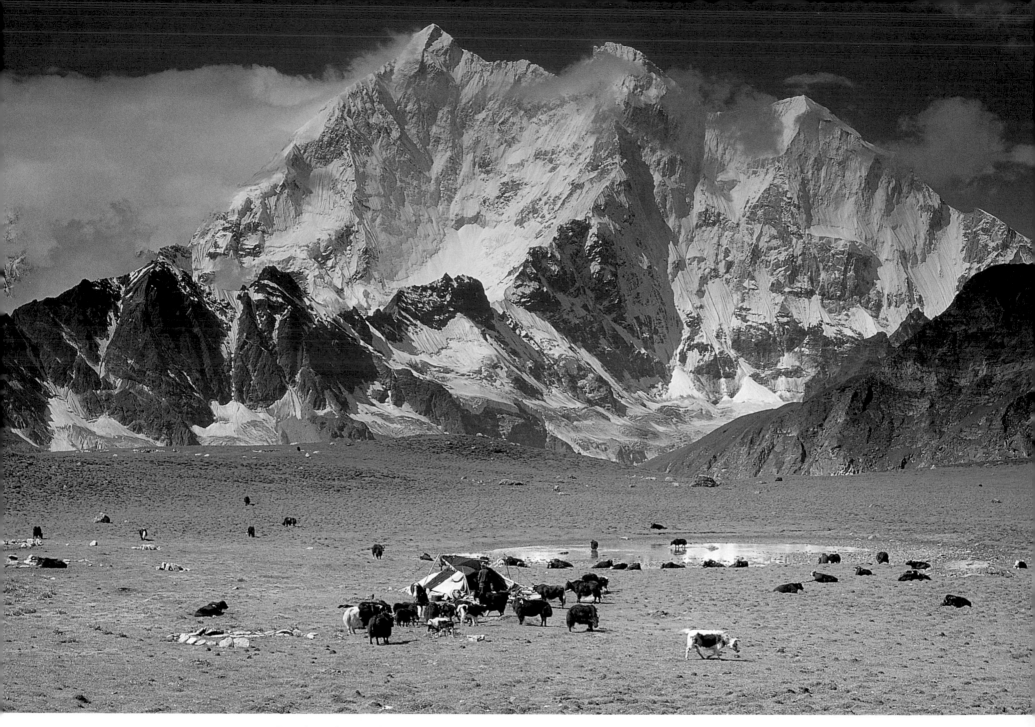

Camped at Thangsham under Chomolonzo in the Karma Valley, yak herders use this lush pasture for summer grazing.

line between the forested, agriculture-rich foothills behind and the distinctive alpine landscape ahead. Cresting the pass reveals one of the finest panoramas to be found anywhere in the Himalaya. The entire horizon spread before us was jammed with spectacular peaks piercing a cobalt sky, as if they, too, were towering monsoon clouds floating free. I stood riveted, unable to take my eyes off the lofty summits and plummeting ridges. Makalu, Chomolonzo, Chomolungma – even their names spoke of mystique and power.

On his first venture to the Himalaya, crossing the Langma La, Mallory and Bullock were also filled with wonder as they caught sight of the icy sawtooth blade of a ridge that makes a grand sweep from a peak they named Lhotse (South Peak) to the South Col, then rises sharply skyward again to the sculpted crest of Everest's Kangshung Face. From here, Mallory well knew where his elusive North Col should lie, but, tantalisingly, it remained hidden, tucked behind intervening ridges. Earlier, during the approach march, as they left behind the known part of Tibet, Mallory had written home to his mentor, Geoffrey Winthrop Young, 'we're just about to walk off the map'. Once again, Mallory was leaving the familiar as, dropping from the Langma La into the Karma Valley, he took the plunge and pushed on towards Everest.

Peter and I staggered on too, descending a steep rocky trail behind the yaks towards a sparkling, turquoise-coloured stretch of water called Shurim Tsho. This sacred lake has always been a popular place of pilgrimage for Tibetan families who travel considerable distances to camp and picnic there, solemnly circumambulating its boulder-strewn shore to be blessed for the year ahead. The festive atmosphere around Shurim Tsho winds down as the autumn snowfall ushers the families back over the Langma La to Kharta and beyond. Perched under stunning mountains, the holy lake radiates great peace and beauty, so Peter and I immediately instructed the yak drivers to pitch camp nearby.

Shurim Tsho is fringed by a lush alp known as Thangsham, a traditional pasture for yaks that have been driven across the high passes to graze there for several months during the monsoon. In 1914, on a pilgrimage from her home at Moyey, an isolated cluster of houses near Kharta, a heavily pregnant Tibetan serf called Kinzom climbed beyond Thangsham. She gave birth to a baby boy at the highly revered Ghang La gompa situated above the Rapchu, a tributary of the Karma. The Rapchu also has a sacred lake, Tse Chu, the water of long life, with a cave where Guru Rimpoche, Tibet's greatest saint, is thought to have meditated. The newborn infant, named Namgyal Wangdi by Ghang La monks, grew up almost within sight of Everest in the hamlet of Moyey. As a sickly youngster Namgyal's name was changed at Rongphu gompa to the more auspicious Tenzing Norgay, Lucky Follower of Religion. In 1921, the seven-year-old boy may well have had contact with Mallory's party near Thangsham as he tended yaks beneath the imposing flanks of Chomolonzo. It is fanciful though not impossible to think that a wide-eyed Tenzing may have plucked up the courage to point out to the strange British climbers seeking a route to Everest the path that leads down through the rhododendron forest towards the Kangshung Glacier.

In 1922, owing to harsh treatment from a feudal governor, Kinzom and Mingma, Tenzing's impoverished parents, left Moyey with eight-year-old Tenzing and trekked all the way to the Nangpa La, a high pass west of Everest near the 8000-metre peak Cho Oyu. After an exhausting journey with their meagre belongings the family settled in Thame, a small Sherpa village in Nepal's Khumbu region. Later, as a young Sherpa seeking work, Tenzing moved to Darjeeling, India. His later home in Darjeeling was named Ghang La, in honour of his Tibetan birthplace.

Selected by Eric Shipton in 1935, a strong and enthusiastic 21-year-old Tenzing Norgay set out from Darjeeling on the first of his four Everest expeditions via 'Mallory's route'. This wide-ranging expedition climbed 26 virgin summits, many of them above the Kharta Glacier, a stone's throw from Tenzing's original backyard. And then, in 1953, on his seventh trip to the mountain, this time from the Nepalese side, Tenzing partnered Ed Hillary on the first ascent of the mountain. All the way from the South Col to the summit Tenzing would have gained strength by looking down on his birthplace, Ghang La, and on Thangsham, the site of his carefree youthful days as a yak herder.

Beyond our Shurim Tsho camp, as I set out in the morning to enter the upper Karma and Kangshung Valleys, I came upon yak herders, still maintaining a semi-nomadic drukpa lifestyle at Thangsham, just as they did in Tenzing's day. As I approached one encampment of black yak-hair tents pitched in a flower-filled meadow, two snotty-nosed girls were busy trying to untangle frisky baby yaks that were vigorously head-butting each other. A man with coiled plaits of greasy hair sat cross-legged on the grass, rocking a huge skin ball backwards and forwards, slowly churning dri (female yak) milk into butter. Scattered around him, like a mob of tiny sheep, twists of bone-white cheese lay on the grass to dry.

Invited inside, I was offered the hearth so I could warm myself by the dung fire. Freshly blended tea and yogurt were pressed into my hands. Fiercely independent and proud of his heritage, an old man, reeking of juniper smoke, crouched in the back of the tent. He wore a rusty enamel badge of the Dalai Lama on a leather thong around his neck. Elsewhere in Tibet an amulet like this, if found by Chinese police, would likely result in imprisonment. Outside once more, and about to leave so I could catch up with the others, I brought out my felt dragon puppet. In a land that knows few toys, fear soon turned to delight as children found courage to chase the cavorting creature. Then, as the dragon dived for cover into the depths of my parka, the kids quickly formed a line so I could dab white lip cream on noses and cheeks. After giggles, handshakes and the Tibetan farewell, 'tashi delek', I wandered on with a pocket full of tangy cheese.

It took Peter and me another two days to follow the yaks into the entrance of the tranquil Kangshung Valley. With imposing ice-laden walls above and carpets of flowers at our feet, each night's campsite was more spectacular than the one before as we drew closer to the Lhotse-Everest Himal. The last gasps of monsoon rain blew into the valley each night but by dawn a clear blue sky arched overhead with sunshine flooding the peaks.

It was a thrill to camp on the Pethang Ringmo terrace, a major staging point for the 1921 climbers and still a lush grazing ground favoured by yak herders. By orienting the plate in my old book we were able to pitch our embroidered Tibetan tent in the same spot as Mallory – directly under the unclimbed walls of Chomolonzo. Little appeared to have changed, either with the extent of glaciation or, thankfully, with the vegetation cover. On the approach to Pethang Ringmo we clambered through largely untouched gnarled forests of dwarf rhododendron and juniper. Only a short raven flight across the border to Nepal, however, the Khumbu has been steadily desertified by the intense

difficult to judge where it was safe to camp or how far we still had to climb to the pass. But as we tottered over splintered granite scree slopes and made detours around milky glacial lakes, we were treated to a flush of flowers in full bloom. The relatively rare and solitary Himalayan blue poppy (*Meconopsis*) peeped out from under boulders and shining gentians and purple delphiniums added a vibrant splash of colour. Pink and yellow asters nodded beside thirst-quenching tarns. With woolly petals like tiny lamb's ears, creamy edelweiss were studded with morning dew that sparkled in the strong sunlight. Both the feathery, translucent saussureas and squat 'vegetable sheep' cushion plants appeared perfectly adapted to this high desert environment. Crested hoopoes, quick-witted birds that, to me, embody the essence of Asia, flitted low and fast over boulders as we approached. Shiny-black ravens gossiped with each other as they strutted defiantly in front of us, mocking our slow progress.

Stiff-legged after a bivouac below the pass and with our lungs heaving in the thin crisp air, Peter and I cramponed awkwardly up a steep snow slope, keeping the rope taut between us to guard against lurking crevasses. Again mist masked our judgement, occasionally enticing us off route onto treacherous snow with hard ice beneath the surface. Bulky rucksacks, dehydration and the altitude

took their toll, forcing us to give our utmost on the final stretch so we could regain easy ground and relieve the tension in complaining bodies. Then suddenly it was over: the Karpo La was ours.

Below this vantage point, as we squinted into the sun, lay two branches of the Kharta, looking like the silhouette of a hairy yeti with flailing arms. The rivers of ice that coalesced beneath us were buckled and contorted with a criss-cross pattern of half-open crevasses. And yet velvet seemed an appropriate word for the softness and texture of the newly fallen snow draped over the vast névé. There was not a hint of human presence. In sharp contrast, we knew that there would by now be over 100 climbers in nearby East Rongphu. In a frenzied game of tripping over each other's ropes, the dozen or so expeditions bound for Everest's North Ridge would soon be vying for space on narrow, litter-strewn campsites. With a similar number of climbers lured onto the northern side of the 8000-metre peaks of Cho Oyu and Shishapangma, it dawned on me that perhaps 400 climbers were jammed on only three routes, leaving hundreds of other Tibetan mountain valleys and thousands of peaks vacant. In this arcane world of high-altitude mountaineering, I realised how easy it was for the Chinese to control and benefit from what is, for them, a bizarre though predictable form of tourism.

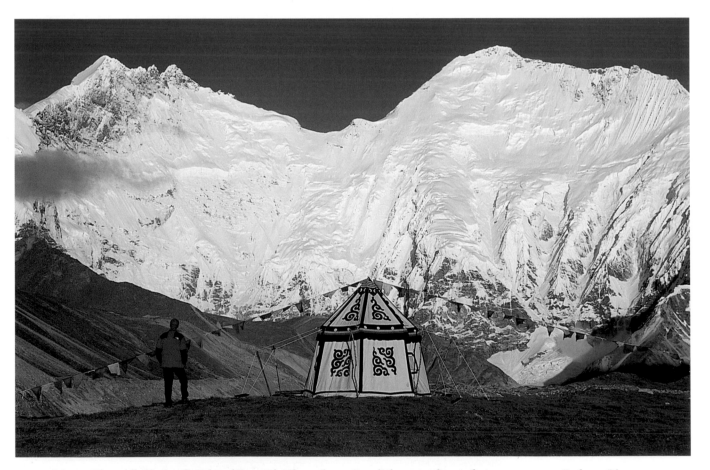

Mount Lhotse (left), South Col and Everest's Khangshung Face light up at dawn above our camp at Pethang Ringmo.

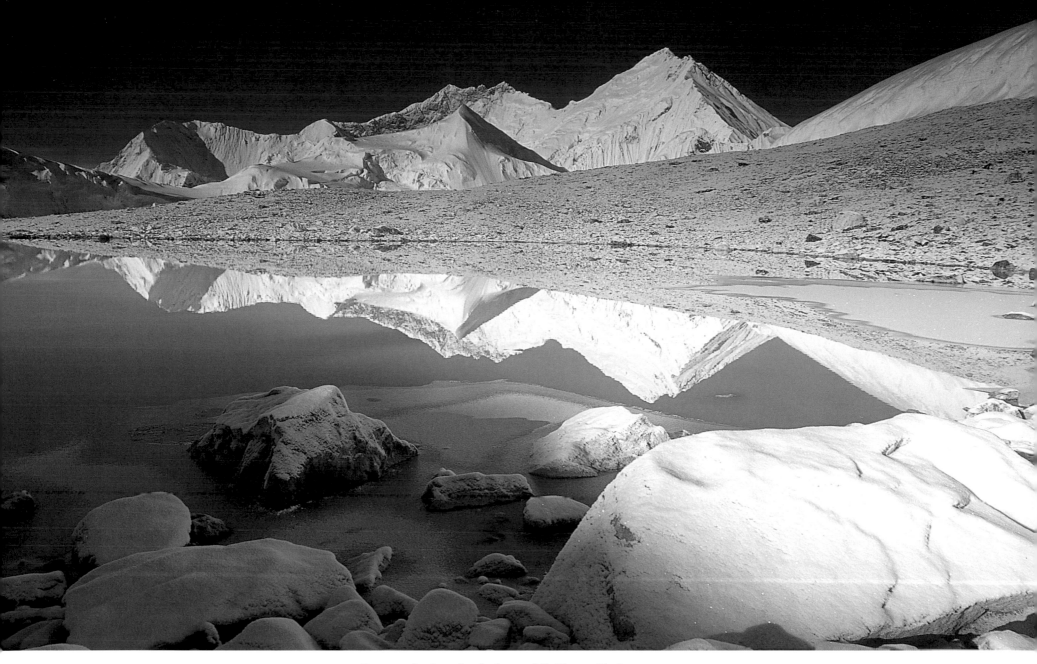

Everest reflection after fresh snowfall, Kharta Glacier.

Peter and I were the only two mountaineers in the entire eastern side of the Makalu-Lhotse-Everest Himal. Far from feeling smug, we relished the sense of space, the time to think and the absence of needless chatter. Somehow, it seemed irreverent to discuss the notion that this basin would make a perfect venue for a ski mountaineering expedition. It was almost a shame to defile the landscape with our bootprints as we threaded our way through an icefall that led down to a campsite under the Lhakpa La. Standing outside the tent that night as crimson light slashed across the upper ramparts of Everest, I pictured Mallory's valiant crossing of the Lhakpa La 76 years before.

A wind-raked pass connecting the Kharta with the East Rongphu, the 6700-metre high Lhakpa La proved to be the vital passage Mallory needed to get behind him before he could have a clear shot at surmounting the North Col. It took two determined pushes up the Kharta before Mallory, Guy Bullock and Edward Wheeler succeeded in crossing the pass. It is not technically difficult, but it is certainly high and, given the scale of the névé and their scant experience of load carrying at altitude, it was unquestionably a serious undertaking. In the prevailing soft monsoon conditions I could understand why the British strapped snowshoes on their nailed leather boots while the poorly clad, laden porters floundered along as best they could.

Mustering the energy to cross the Lhapka La at the conclusion of an arduous, drawn-out expedition was greatly to Mallory's credit and drive as a mountaineer. It was also an indication of the deep-seated passion for Everest stirring within

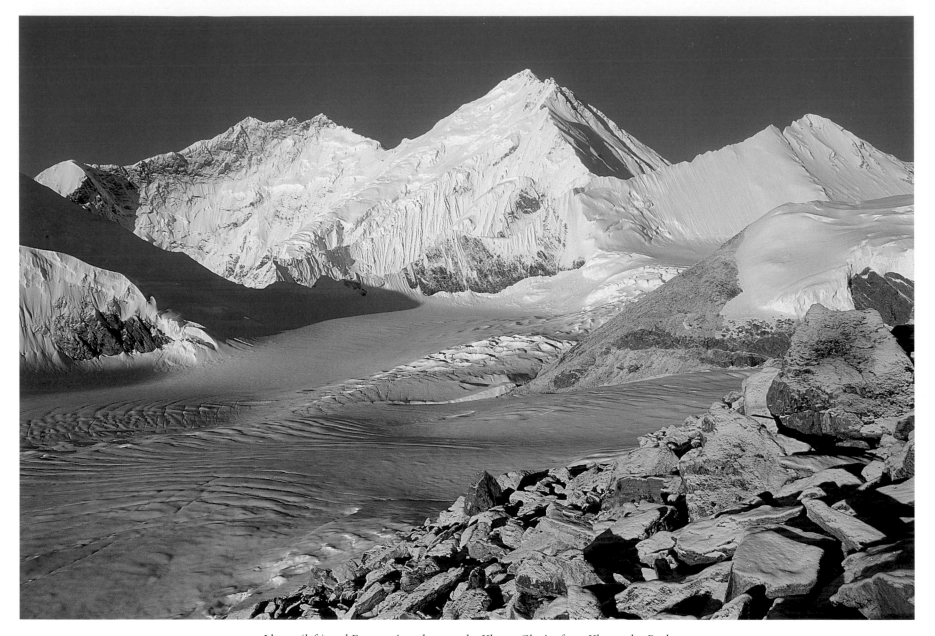

Lhotse (left) and Everest viewed across the Kharta Glacier from Khartaphu Peak.
The Karpo La is on the extreme left of the picture and the Lhakpa La on the extreme right.

him. And yet, while making his way up the Kharta towards the pass, Mallory had brushed aside information he received by way of a note and revised sketch map from Wheeler. When the expedition had relocated to Kharta, Wheeler stayed behind to continue his mapping survey of the Rongphu basin. By looking down into the East Rongphu Glacier from a vantage point, he finally saw what is now accepted as the obvious highway that led to the base of the North Col. With autumn nipping at their heels, it was expedient for Mallory and Bullock to push on and cross the Lhakpa La rather than circle all the way back to the East Rongphu. Wheeler, too, decided to join the final push for the North Col. The

discovery of the East Rongphu as an easy route to the heart of Everest effectively meant that the Kharta and Lhakpa La would be relegated to forgotten byways. That they remain so today I find greatly exciting.

Committed to rejoining our support crew on an appointed date, Peter and I turned away from the Lhakpa La. Instead, it seemed prudent to locate vantage points in the Kharta so I could rephotograph in colour some of the haunting images from the old book tucked in my pack. After a hard day of boulder-hopping over highly unstable moraine, Peter pitched our tiny tent by the snout of the glacier beside an ice-choked lake. Determined to catch

a final vista of the high peaks, I clambered back over the moraine to gain a wide terrace where I thought the 1921 team must have camped. As dusk lingered I climbed above the terrace onto the flanks of a 7200-metre peak called Khartaphu. Snug on a rocky platform as heavy cloud built up, I settled into a bivouac at 6200 metres. Despite a chill seeping into my bones, I drifted into fitful sleep as snowflakes flickered from a darkening sky. Snow flurries throughout the night woke me periodically and through the scrunched-up opening in my sleeping bag I could catch fleeting, bleary-eyed glimpses of the canopy of stars over Everest. As the snowstorm dragged on, it seemed as if my last chance for clear dawn light on Everest was slipping away. Come morning, though, I was in luck.

It began with a thin yellow line. The strip of lemon light gradually widened above the horizon, then slowly intensified into a burnt-ochre band. Still half asleep, it took me some minutes to fully appreciate that, above the drifting layers of mist wafting over the glacier, the sky was cut-glass clear. Dawn emerged as if projected in slow motion by a time-lapse camera. I witnessed the first rays of a newborn day glance across the soaring, unclimbed buttresses of Makalu and Chomolonzo. Through a mauve glimmer, I looked back across the way we had come – over the Karpo La to the Kangshung Glacier and down into the Karma – and then beyond, way beyond, to the mighty blade of Pethangtse poised on the border between Tibet and Nepal. In Nepal itself, I watched spellbound as life was breathed into the blocky pyramid of Chamlang, a striking peak deep in the Hinku Himal.

Then, seemingly in a flash, Lhotse, the South Col and the Kangshung Face caught the full blast of the sun. Iridescent mushrooms of ice on Everest's uppermost ridges glowed with such intensity that I had to squint even through the viewfinder of the camera. Then, before long, the Lhakpa La and the Kharta were transformed into a collage of subtle pastel hues, each crystal facet glinting in the frosty morning. As the sun crept up to my bivouac I shouldered my pack and crunched down newly fallen snow, bound for Peter's camp. A few days later, Bad Jelly and I rattled out of Kharta in a jeep, grinning all the way to Kathmandu.

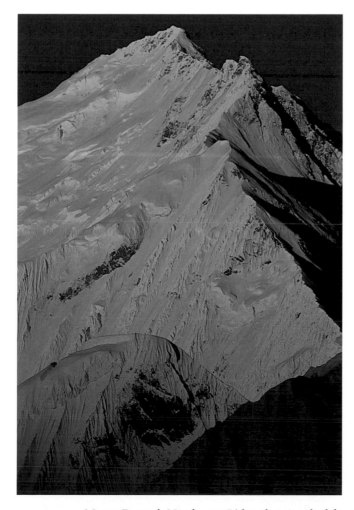

Mount Everest's North-east Ridge photographed from Khartaphu Peak at dawn in 1997 and in 1921 (right).

INDIA

Chomolungma
(Miyolangsangma)

NEPAL

Makalu

Lhotse

Chomolonzo

South Col

Pumori

Khumbu Icefall

Lho La

Chang La
(North Col)

Changtse

Pethang Ringmo

Lingtren

Karpo La

Lhakpa La

Khumbutse

Kangshung
Glacier

TIBET

West
Rongphu
Glacier

Karma Valley

Shurim Tsho

Central
Rongphu
Glacier

Sha-u La

Thangsham

East
Rongphu
Glacier

Langma La

Kharta Glacier

Kharta

Rongphu Gompa

Chomolungma, Tibet

Avedon, John. *In Exile from the Land of the Snows*, Michael Joseph, London, 1984.

Bishop, Brent. *The Myth of Shangri-La – Tibet, Travel Writing and the Western Creation of Sacred Landscape*, University of California Press, Berkeley, 1989.

Davis, Wade. *Shadows in the Sun – Travels to Landscapes of Spirit and Desire* (Chapter 4: 'The Clouded Leopard'), Shearwater Books, Washington, 1998.

Douglas, Ed. *Chomolungma Sings the Blues*, Constable, London, 1997.

Douglas, Ed. *Tenzing, Hero of Everest – a biography of Tenzing Norgay*, National Geographic, Washington, DC, 2003.

French, Patrick. *Tibet, Tibet – a personal history of a lost land*, HarperCollins, London, 2003.

Gillman, Peter and Leni. *The Wildest Dream: Mallory – His Life and Conflicting Passions*, Headline, London, 2000.

Hall, Lincoln. *White Limbo – The First Australian Climb of Mount Everest*, Weldon, Sydney, 1985.

Harrer, Heinrich. *Lost Lhasa*, Harry Abrams, New York, 1992.

Howard-Bury, Charles. *Mount Everest – The Reconnaissance, 1921*, Edward Arnold, London, 1922.

Keay, John. *The Great Arc – the dramatic tale of how India was mapped and Everest was named*, HarperCollins, London, 2000.

McCue, Gary. *Trekking in Tibet*, The Mountaineers, Seattle, 1991 (2nd edn, 1999).

Monteath, Colin. *Hall and Ball – Kiwi Mountaineers: From Mount Cook to Everest*, Hedgehog House, Christchurch, 1997.

Noel, Captain J.B.L. *Through Tibet to Everest*, Edward Arnold, London, 1927.

Pye, David. *George Leigh Mallory*, Oxford University Press, London, 1927.

Rowell, Galen. *Mountains of the Middle Kingdom – Exploring the High Peaks of China and Tibet*, Sierra Club Books, San Francisco, 1983.

Salkeld, Audrey and David Breashears. *Last Climb – The Legendary Everest Expeditions of George Mallory*, National Geographic Books, Washington, 1999.

Spencer Chapman, Freddie. *Lhasa: The Holy City*, Chatto & Windus, London, 1938.

Tenzing, Judy and Tashi. *Tenzing and the Sherpas of Everest*, HarperCollins, Sydney, 2001.

Unsworth, Walt. *Everest*, Allen Lane, London, 1981.

Venables, Stephen. *Everest: Kangshung Face*, Hodder & Stoughton, London, 1989.

Webster, Ed. *Snow in the Kingdom: My Storm Years on Everest*, Mountain Imagery, Colorado, 2000.

'Where snow leopards dance'

A pilgrimage to Kailas and Gurla Mandhata, Tibet

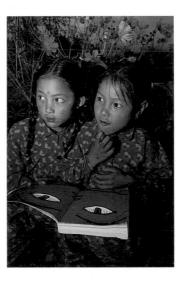

Manosarovar, the lake created from the mind of Brahma, is the holiest in the world… called by the Tibetans Tso Mapham – the 'unconquered' or 'precious lake' – is 14,950 feet above the sea and its waters are sweet, not salt as are so many lakes in Tibet. Very blue it was as we saw it in the continuous deluge of sunlight which so often illumines this country north of the cloud-gathering Himalaya – its extended coasts were bright gold, with the glaciers of Gurla, 25,350 feet, to the south and the snow capped cone of still more famous Kailas to the north… This peak, 22,028 feet, is arrestingly isolated, solitary: a great pyramid of black rock capped with snow. It is Ti-se of the Tibetans, sometimes written of as Kangchen Rimpoche, the Precious Ice Mountain, the centre of the universe.

Tom Longstaff, *This My Voyage*

For nigh on 20 years I had dreamt of setting out on a journey to Mount Kailas. There were periods, even after I found a copy of Lama Govinda's spirited account of his 1948 pilgrimage, *The Way of the White Clouds*, when I almost dismissed the idea that a mountain as striking and alluring as Kailas could possibly exist. And then, in August 1998, as our group crested the

LEFT: *A mani stone at sunset over Lake Manosarovar.* TOP: *Nepali sisters read a guide book, Simikot.*

93

A trekking camp in the Karnali Gorge above Simikot, West Nepal.

4600-metre Gurla La Pass in south-west Tibet after a trek up Nepal's Karnali River, the distinctive conical shape of Kailas was finally revealed to me. Shining white, thrusting skyward in a single flawless arc above the Chang Tang Plateau, Kailas glowed in the morning sun, a unique chorten-like dome of snow draped over horizontally bedded conglomerate. Just as I imagined it would be, the sacred mountain stood alone, dwarfing lesser peaks in the Transhimalaya, a dun-coloured range of retreating snowfields and remnant glaciers. Dazzled by the brightness of the scene, I squinted and stared at Kailas, seemingly afloat above the holy lakes of Rakas Tal and Manosarovar, vast life-giving oceans of turquoise water adrift on a parched highland desert.

I stood transfixed by a landscape I had wanted to breathe in for so long. The panorama I saw that day is, I am sure, etched on my mind with a clarity that will persist when most other memories of life have faded into each other like the folds of those amber hills. We had been on the move for 12 days since leaving Kathmandu, but Kailas was still some 70 kilometres away, compelling us to approach its flank on foot and complete the 50-kilometre circuit or kora of the mountain.

A keen wind whipped dust in my face, stirred up from a tangle of sharp-edged ridges and seared sandy ravines. Turning to leave Gurla La and make for a campsite beneath Chiu gompa on the shore of Lake Manosarovar, I spotted a herd of 15 kiang, the tawny Tibetan wild ass, *Equus hemionus kiang*. Only once before had I seen kiang, fleetingly, by the Shaksgam River in the Sinkiang Karakoram. It was a thrill to get a close-up view of these animals grazing peacefully above Rakas Tal. Elusive by necessity, the kiang became aware of our presence, cantered to high ground and disappeared. I pondered the fate of these graceful creatures, eking out an existence under stress.

Throughout the Himalaya the destruction of wildlife is widespread. Hunting kiang, wild yak, snow leopard, gazelle and chiru antelope has gone on spasmodically in the past among scattered nomad groups living on the Chang Tang. In general, though, the taking of life was once uncommon among the committed Buddhist population. As the ravages of the Cultural Revolution (1966–76) gripped Tibet, food shortages created severe privation. Inevitably, the wildlife suffered. Today, as the enticement of financial return overrides traditional values, organised poaching is taking place on an unprecedented scale.

In his book *Wildlife of the Tibetan Steppe*, renowned field researcher George Schaller notes that traders from Tibet use wildlife to barter for tiger bones from India, which are used as ingredients in traditional medicines – a two-way traffic in endangered species. Somehow, I have to cling to the hope that an overcrowded Asia will appreciate the significance of mankind's present impact on the Himalaya and halt the degradation of species and habitat before it is too late. Although the 1991 Tibet Wildlife Act is gradually having an effect, the process would slow further if the intrinsic qualities of wildlife and wilderness were directly linked to financial return. As overlords driven by the mighty dollar, the Chinese must understand that foreign 'pilgrims' will come to Kailas only if the region's sanctity is preserved.

Real pilgrims have come to Kailas for millennia, enduring much hardship on a long quest that often took months. The first Aryans of India who penetrated the Himalaya 3000 years ago knew of the existence of a sacred mountain. They believed that from its summit, the home of gods and cosmic centre of the universe, flowed a mighty river that fell into a lake, the source of four of the great rivers of Asia. As a metaphysical entity the peak was described in the *Mahabharata*, the epic of Hindu literature, as Meru, home of Lord Shiva, destroyer and transformer, and his consort, Devi. Tibetan Buddhists know it as Tisé, home of the four-faced demon Demchog and his scarlet consort, Dorje Phangmo. In its earthly manifestation the mountain came to be known throughout India as Kailas, the crystal. In Tibet, its name is Kang Rimpoche, jewel of snow.

Embodying deep-seated beliefs, Kailas retains a fundamental significance for four major religions – Hinduism, Buddhism, Jainism and Bön-po. A pre-Buddhist shamanistic religion prevalent in early Tibet, Bön po originated just west of Kailas in Gu-ge, the capital of the ancient kingdom of Shang Shung. It was on Kailas in the 12th century that the Bön po wizard Naro Bonchung, in defence of his supreme Bon teacher Shenrab, fought a battle of supernatural spells with Milarepa, the most celebrated sage of tantric Buddhism. A scar from this contest, marking Naro Bonchung's defeat after a race for the summit, is the huge snow gully that splits the South Face of the mountain. Known as a 'stairway to heaven', the gully and other features resulted in this aspect of Kailas being likened to a swastika, an all-powerful Asian talisman of spiritual strength.

The physical presence of Kailas, remote and almost unreachable though it is, continues to grip the imagination of a billion people throughout India, Nepal, Mongolia, Bhutan, Tibet and China. Kailas is to these people as Mecca is to Muslims and a pilgrimage to see the mountain, to complete a kora, to practise austerities and to meditate in its shadow is, like the Haj, a lifetime ambition. To achieve 108 kora is to attain Nirvana, the blissful state of enlightenment, free from suffering.

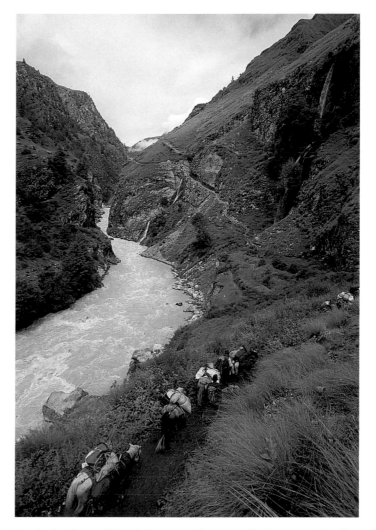

Ponies haul expedition baggage up the Karnali River towards Tibet.

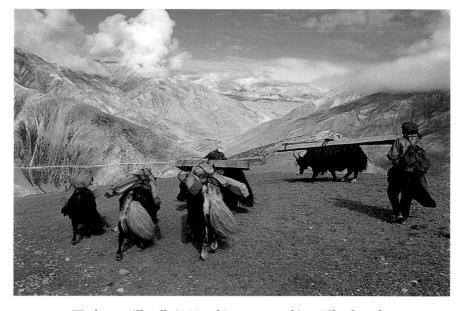

Timber cut illegally in Nepal is transported into Tibet by yaks.

Kathmandu

Nepali women buy powdered dyes during the Hindu Teej festival, Pashupatinath.

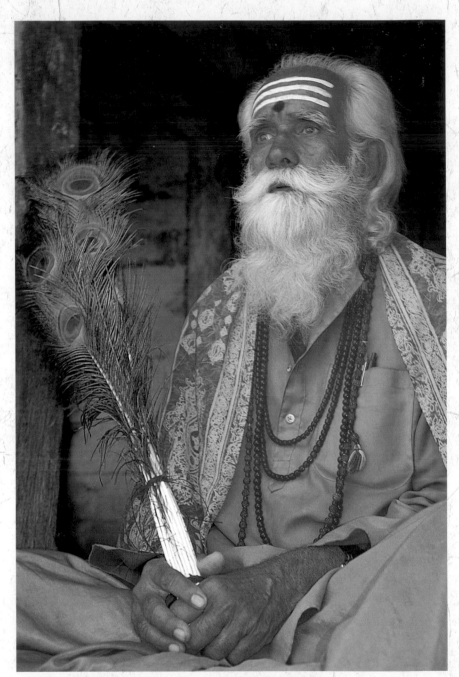

A Hindu saddhu, Pashupatinath.

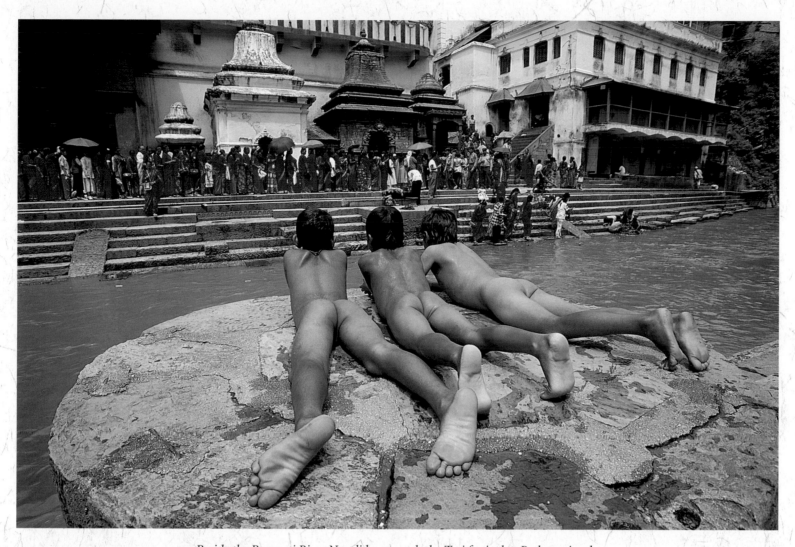

Beside the Bagmati River Nepali boys watch the Teej festival at Pashupatinath.

Bhodnath Buddhist stupa framed by marigolds.

*Himalayan historian
Liz Hawley and Mallory.*

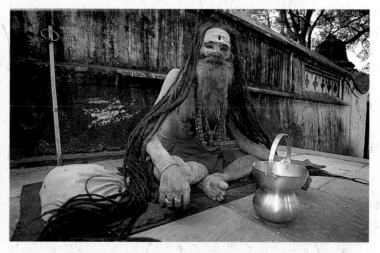

Hindu saddhus come from all over India to Pashupatinath.

In 2001, the Chinese further insulted the Tibetan sense of the sacred by granting permission to a Western team to climb Kailas. Fortunately, an international outcry forced the expedition to think again and cancel their plans. Only Shiva and Milarepa have *conquered* Kailas. To do so in modern times would be to conquer something in other people's souls. As Edwin Bernbaum, author of *Sacred Mountains of the World*, commented, 'I think the summits of some peaks, Kailas in particular, should be kept inviolate, if only to retain a sense of mystery – of the unknown that draws us to mountains – and to remind us of the higher values of mountaineering itself.'

Planning a single kora, our team of trekkers and climbers had hoped to avoid too much suffering by getting fit beforehand. For more than a week, we had splashed along muddy, monsoon-soaked tracks, walking from the town of Simikot, in the Humla district of western Nepal, up to the scruffy border post at Shera. We had then arranged for Chinese vehicles to drive us through the old Tibetan village of Purang (now Taklakot), over the Gurla La and on past Lake Manosarovar to the road-end at Darchen on the apron of Kailas.

Before the trek could begin, there had been frustrating delays in squalid lowland Nepalgunj, owing to a search for a crashed aircraft missing in the Kali Gandaki Gorge between Annapurna and Dhaulagiri. Finally, the hair-raising Twin Otter flight, through solid-looking clouds from Nepalgunj to Simikot's steeply tilted airstrip, was quickly forgotten in the bustle of setting up camp among clusters of bright yellow sunflowers. From here, we started to wind our way up through the fir-clad Karnali Gorge using ponies to carry the baggage. Gradually, the lushness of Nepal's forests dropped behind us as we gained altitude and entered treeless Tibet.

During the trek we encountered yak caravans carrying illicitly cut construction timber from Nepal into Tibet. The extensive resettlement of Tibet by Han Chinese has brought with it a rapid building programme of incongruous glass-fronted government offices and apartment blocks even in isolated towns like Taklakot. We spent a night in Taklakot after grudgingly being given clearance to enter Tibet by the Chinese military at Shera. A wretched period followed, locating a kitbag that contained irreplaceable equipment after it had bounced off

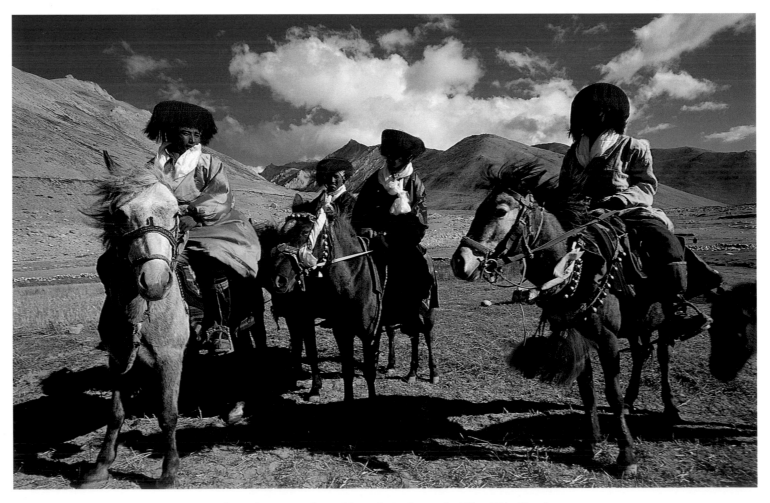

Tibetan horsemen dressed for a festival near the Tibet-Nepal border.

a truck. It was recovered only when one of the three Nepali pilgrims who had found it decided that it was wrong to keep property that did not belong to him.

Even though we used vehicles only from Shera to Darchen, I could not wait to leave them behind. I was so glad I had delayed coming to Kailas until I could walk from Nepal instead of driving all the way from Kathmandu. Such a drive, via Zangmu, at the end of the monsoon, is at least a week-long journey on nightmarish mud-choked roads. Unlike the many who rush to Kailas, we gradually acclimatised to the altitude by walking a few kilometres a day. When plans for the long-mooted Kailas airport surface periodically among Chinese tourism planners, I remind myself that planes and automobiles are a poor way of approaching sacred places. Only by slowing down can one appreciate the sheer scale and subtle beauty of the remarkable Chang Tang landscape. (It was ironic, considering how little traffic is usually met on the plateau, that our drive to Zangmu at the end of the expedition proved more dangerous than the trek or the climb on Gurla Mandhata. Four of us narrowly avoided serious injury in a high-speed side-swipe as two jeeps almost collided head-on while crossing open ground under Shishapangma.)

Despite radical changes to the social fabric of Tibet, I was thankful that the panorama radiating from Gurla La had not altered appreciably over the years and still fitted the descriptions by Victorian travellers. Notable past journeys to the Kailas-Manosarovar region include that of William Moorcroft, who, in 1812, was the first to describe it in detail since the brief references by Jesuit missionaries Desideri and Freye in 1715. Englishman Edmund Smyth discovered the nearby source of the Tsangpo in 1846 (a fact conveniently ignored by the Swede Sven Hedin when he claimed his discovery some 40 years later), and in 1905, in the aftermath of Younghusband's military incursion to Lhasa, the British officer Captain Cecil Rawling pushed westward past Kailas across what he called the Great Plateau on an expedition to Gartok.

During explorations that rivalled those of the well-known epics to emerge from Africa and the Antarctic, the geographical position of Kailas and its consort lakes was gradually documented. Remarkably, just as the ancient scriptures described, the source of each of Asia's four major rivers was pinned down to within 100 kilometres of the holy mountain. The mighty Indus does roar from a lion's mouth, to flow north from Kailas then west before charging south into the Arabian Sea. On the other hand, the Tsangpo thunders from a horse's mouth and trots sedately eastward for 1800 kilometres behind the main Himalayan range. The Tsangpo then leaps through the mountains in a jumble of spectacular gorges on its grand ride as the Brahmaputra into the Bay of Bengal. Together, these powerful rivers clasp modern-day Pakistan, India and Nepal like great embracing arms. To the west, the Sutlej spouts from an elephant's trunk, destined to become one of India's most revered

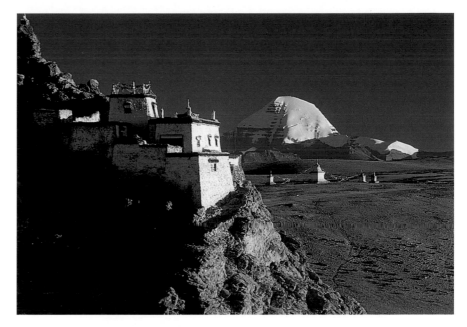

Chiu gompa and Mount Kailas from our camp between the holy lakes Manosarovar and Rakas Tal.

A Buddha carved in slate.

99

rivers. And, to the south, sweeping into Nepal through the defile we had just ascended, the Karnali River cascades from a peacock's mouth on a tortuous path before it merges with Ganga Mai, Mother Ganges.

After a rigorous trek and the bureaucratic delays as we passed through Taklakot, it was soothing to lie in a tent beneath the ancient Chiu gompa and listen to wildfowl calling from the shallows of Manosarovar. At dusk, I climbed a hill above camp to watch the sunset over the holy lakes. Chiselled mani stones and the ash of a funeral pyre lay on a summit that commanded a sweeping view. The burnished ramparts of Gurla Mandhata glowed to the south while, to the north, Kailas peeped out from under glowering red clouds. In fading light I scampered down to camp, jumping from ledge to ledge until, on one, my sudden appearance flushed a brace of crested hoopoe huddled for warmth. As they scrambled to get airborne, their flaring wings revealed flashes of black and white feathers. The birds darted skyward toward stars that flickered overhead like a cluster of butter lamps.

Within a week, after the kora, the climbers in our group planned to tackle Gurla Mandhata – Naimona Nyi in Tibetan, meaning mountain of black herbal medicine. At 7728 metres, this is the third highest peak to lie wholly within Tibet, after Shishapangma (8012 metres) and Namche Barwa (7756 metres). It did not look particularly steep or threatening in the warm evening light, but Gurla Mandhata's sheer immensity, lofty altitude and the low temperatures on the upper mountain would undoubtedly stretch us to the limit. Our leader, Shaun Norman, from Twizel near Aoraki (Mount Cook), is a mountain guide with extensive experience in New Zealand, Antarctica and the Himalaya. For

A pilgrim to Kailas beside mani stones and a chorten, Lake Manosarovar.

him, our climb on Gurla Mandhata was to be a low-key commercial operation, tending to the needs of his three climbing clients and three trekkers.

Next morning, after climbing the steep path to Chiu gompa, I joined pilgrims paying homage to tarnished Buddhas tucked into dark recesses under the monastery. Meanwhile, our Tibetan staff slipped away to a hamlet beside sulphurous hot springs and the trickle of a stream called Gang Chu that intermittently connects the two lakes. They had already filled large jars with holy lake water and now sought to purchase dried fish that hung from smoky rafters. Prized as medicine in Lhasa, 1000 kilometres to the east, these fish, with their grotesque translucent heads, can be taken only if they are found washed up on the beach as no fishing is permitted in Manosarovar.

Though Kailas is considered 'the navel of the world', the village of Darchen, three hours drive past Chiu and the usual starting point for a kora, has the reputation of 'an orifice a little lower on the body'. Adept at looking after his own interests, our Lhasa-born Chinese liaison officer, Mr Mo Mo, did his utmost to keep us overnight in one of Darchen's decrepit mud-brick hovels. Thankfully, after much arm waving and heated debate, we managed to make our departure that afternoon, relieved to bid farewell to the broken glass and garbage-choked streets. We even accepted Mr Mo Mo's spurious rationale when he insisted at the last minute on staying in Darchen, retaining our passports. Feeling like truant schoolchildren, we scampered after our laden yaks that looked like animated hearth rugs as they laboured uphill out of town.

The start of the kora was relaxed, easy walking on a good path that led to a campsite by the Lha Chu (God's River) under the 13th-century Chhuku gompa. Whistling marmots, mani stones and a myriad of prayer flags lined the route. Revelling in being able to slow down once more to yak pace, I had time to greet the characters we met on the trail, absorbing something of their vitality. Swept along by the spirit of the place, I enjoyed the handshakes and hospitality of herb gatherers, Hindu saddhus and Bön-po mendicants who, unlike all others, undertake their kora in an anti-clockwise direction.

The trek gradually got tougher, largely because of the increase in altitude. Near Dira Phuk gompa, we were engulfed in hail that soon turned to persistent snow. Separated from the group as we searched for a good campsite, I became chilled and sought shelter in a yak-hair tent pitched on a terrace by the river. Inside, a woman with a soot-smeared face suckled her infant. As I sat cross-legged beside a warming fire of juniper twigs and dung, she plied me with salty tea and thuk-pa, a noodle soup. Revived and about to leave, I gave her a portrait of the Dalai Lama which she touched reverently to her head then, for safe keeping, tucked into a jewel-studded amulet case between her breasts. Above us, Kailas remained hidden as the storm vented its fury. Sleet hissed against the tent and thunder rumbled around the mountain's ice-plastered walls. A

feeling of formidable power emanated from the brooding canyon-like walls draped in trailing waterfalls and the mysterious mist-riven ridges that disappeared into swirling cloud.

Setting out alone once more, I clambered above loose rocky slopes to a vantage point opposite Kailas. Puffing vigorously with each short burst of scrambling, I felt myself becoming charged with energy at being in such a potent place surrounded by sheer rock walls. I reached a ledge at 5600 metres, roughly the same height as Drolma La, the kora's high point that we would traverse the next day. Sheltering from the lash of hail, I squatted under an overhang beside a clump of nettles, Milarepa's main source of sustenance. And then I noticed a row of tiny crumbling clay Buddhas placed lovingly on ledges. As if on a balcony seat at the theatre, I was suddenly rewarded by the most memorable moment of the entire kora when a curtain of cloud parted to reveal Kailas's 2000-metre ice-raked North Face. Below, every eroded feature of the Lha Chu Valley was etched in bold relief by a thin skiff of snow. Down-valley, in the direction we had come from, the grasslands of the Bharka Plain, dotted with yaks under Gurla Mandhata, were infused with muted evening colours. For the briefest of moments, before fast-moving clouds engulfed Kailas once again, the very crest of the sacred summit was tinged with pink pastel light.

As a surprise for the next visitor to my eyrie I wedged a smiling portrait of the Dalai Lama into a protected crevice then set off, bounding down the scree for an exhilarating run to the valley floor. Near camp, I lurched through the ice-cold river in the dark, leaning heavily on a ski pole for balance in the rapids. Approaching the tents, I was confronted by the terrifying snarls of guard dogs from a Tibetan encampment. As the brutes launched into full attack mode, I thanked my lucky Buddhas for the ski pole. The dogs' owners seemed a trifle miffed by my un-Buddhist manners when, convinced the mongrels were not vegetarians and certain their bared fangs could not be held at bay much longer, I abandoned the pole and resorted to hurling rocks.

Away early next morning, despite the drawn-out performance of loading the yaks, Gerry Essenberg, a fellow climber from Christchurch, and I tramped together up a narrow path towards the Drolma La. Suddenly, as if conjured out of magical boulders, Tibetans of all ages surrounded us. Sharing the trail with pilgrims meant that Gerry and I could appreciate the significance of reaching the spot where time-honoured tradition dictates that an article of clothing or lock of hair is discarded before the final climb to the pass. (This symbolises death and rebirth into a more spiritual life.) Gerry and I were then invited to join a queue of giggling Tibetans so we could squirm flat-bellied, one at a time, through the tightest of tunnels under three enormous boulders. Thankful for being skinny (an undiscerning sod once described me as having the physique of a drinking straw), I emerged successfully on the other side, proving to the

ABOVE: *Pilgrims walk past Tarpoche prayer flag pole at the start of kora around Kailas.*

LEFT: *A Kailas pilgrim suckles her child inside her yak-hair tent during a hailstorm.*

BELOW: *Drying herbs for Tibetan medicine under Kailas.*

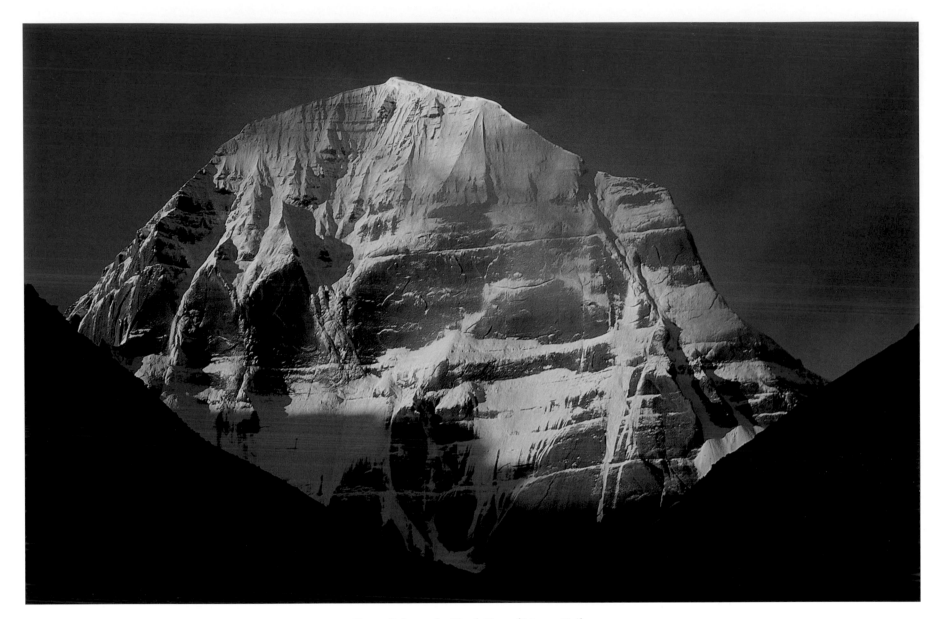

Dawn light on the North Face of Mount Kailas.

curious pilgrims that I was not a sinner. Much to his relief, the slightly chubbier Gerry just squeaked through the test.

The steady, zig-zag up to Drolma La was thirsty work, as evidenced by innumerable pull tabs from soft drink cans scattered on the trail. Offended by this unsightly garbage, especially under a holy mountain, I soon had my pockets bulging with the tiny aluminium rings. Amused by my antics, though perhaps thinking I was bent on accumulating religious merit, the Tibetans puffing uphill beside me started competing with each other to find the tabs and hand them over.

Reaching Drolma La is the culmination of determined effort and financial sacrifice for both Tibetans and other pilgrims (yatris), some of whom walk all

the way from India. Many of the yatris make the long hazardous journey north through the rugged, landslide-prone Garhwal Himalaya clad in little more than sandals and skimpy cotton garments. Drolma, goddess of mercy, is the most important female deity in Tibet and she is worshipped on the pass at a rock, Drolma Do, that is almost totally obscured by layers of sun-faded prayer flags. The ancient shrine received a particularly passionate level of veneration with multiple prostrations as each yatri struggled up to the pass. While the Tibetans tied on yet more prayer flags, I looped a silk kata (scarf) around a post then sat down to share my lunch with five teenage girls who wore face masks to ward off the chill air. As the girls warmly accepted me into their circle, they dipped sticky fingers into a wad of dark crystallised honey in a cloth bag, then passed

it to me. Chattering like chipmunks as we swapped food items from the depths of our packs, the curious girls were coy at first then flirtatious with this gangly stranger who had suddenly burst into their life. It was a happy time for all at this divine juncture of ice, rock and sky.

Camp that night was just before Zutrul Phuk gompa (Milarepa's cave) by the Lham Chu River. Perched on a rock, I sat watching bharal, blue sheep (*Pseudois nayaur*), as they romped and nibbled on a herb-studded scree above the river. Before long, the sun dropped behind a cliff and a damp cold gripped the camp, sending me scurrying for a down jacket and knee-length sheepskin boots. While my friends gathered in our mess tent, I retreated to the yak drivers' camp to warm my hands on their cast iron brazier. Only then, as we crouched around the yak dung fire, sharing tea laced with blobs of butter, did I realise that my hosts, Dorje and Lamseki, were brother and sister. Although our trek was valued employment for these nomads, they were obviously at home under Kailas and honoured to be completing their 11th kora. Lamseki's flashing brown eyes and beaming smile were enhanced by a chunky silver necklace that hung suspended from stretched earlobes. In the flicker of firelight her dark hair shone like a raven's wing. Draped in chains through the greasy, glistening braids, were her most treasured decorations – fingered-smooth Tibetan, Nepali and Indian coins, one dated 1908, featuring King Edward VII.

At the end of the kora next day, a deep feeling of satisfaction washed over me as I sat with friends, some new-found among our Tibetan staff. Baking in the sun, we waited for trucks to arrive and transport us back to Darchen. Glad to have us in his clutches again, Mr Mo Mo whisked us off to Chiu gompa just as a full moon floated over Gurla Mandhata. The following morning, half the group set off for the six-day drive to Lhasa, while the climbers – four Kiwis, Shaun Norman, Steve Tully, Gerry and I, and American John Kurnick – departed for a base camp at 5000 metres beneath Gurla Mandhata's western slopes.

The bliss of base camp allowed a welcome opportunity to paddle in an icy river and scrub dusty bodies and sweat-soaked clothes. It was also a time to refine our climbing gear, mountain food and clothing, eliminating all unnecessary items. It was important to ensure we had exactly the right number of kitbags. Eighteen yaks, due to arrive in the morning, would haul only a definite amount of baggage up to an advance base at 5500 metres. By afternoon, light snow persisted, so I retreated to the cosy confines of a sleeping bag to catch up on my diary. Meanwhile, as the others snoozed or read, Kwang and Sanduk, our Nepali cooks, whipped up a hearty pilaf with deep-fried battered vegetables. Earlier, while we had been on the trail beyond Simikot, the resourceful Kwang had spent 10 days escorting the bulk of the expedition baggage, driving all the way from Kathmandu to base camp. His transit into Tibet necessitated no less than

Tibetan girls share their lunch on Drolma La, the high point of the Kailas kora.

nine changes of truck contractors before all the landslides and road blockages in the Zangmu Gorge were behind him. Much to Kwang's credit, considering how many porters had handled the heavy bags on and off trucks, all our precious climbing gear was intact.

Pushed along by dour, hard-bitten nomads, yak caravans surged through camp that afternoon, laden with sacks of their staple tsampa flour from the newly harvested barley fields around Taklakot. Dusty and dishevelled, with red tassels in their long braids, the leathery traders had brought wool and yak hide products to trade with farmers on the terraced borderlands. For these swarthy ruffians, it is a bleak, hard life on the road. With Mr Mo Mo translating, the yak men told us that during the past winter heavy snowfalls had cut off villages, isolating the nomads in their flimsy yak-hair tents for an extended period. Many Tibetans froze to death and thousands of their precious yaks, goats and horses perished under a suffocating blanket of snow.

On 7 September, our rented yaks lumbered up to a rocky terrace under Gurla Mandhata, enabling us to establish a camp beneath the snout of the Ringgong Glacier. We were feeling fit; it would not be long before we could occupy the first camp on the mountain at 6000 metres. Snow flurries, though blissfully free from a nagging wind, became a regular feature of the ascent. From the outset we felt pressured to climb fast and gain height quickly as we had been forced into a tight schedule by the delays at the border. This is seldom a good recipe for success on a big mountain: slight hold-ups or the simplest of mistakes can easily cost the summit.

Pitching the tents in the obvious spot beside the glacier, we tripped over the detritus of our predecessors – Japanese food packaging, tent poles and gas

Sunset on Gurla Mandhata from above Lake Manosarovar. Base camp for the climb was on the extreme right of the picture.

canisters littered the moraine trough. Blinkered by self-importance, some climbers show a disregard for the environment that is, sadly, increasingly common in the Himalaya.

Following the 1985 Japanese-Chinese first ascent, a Swiss team had repeated the route, but we knew of no other successful climbs from this side. Though the Austrian Herbert Tichy attempted the peak in 1936 (he later made the first ascent of Cho Oyu), the only other attempts on Gurla Mandhata had been recent ones by two small American expeditions. A clandestine though successful raid was made on the North-east Ridge by the alpinists Annie Whitehouse and Eric Reynolds, who trekked over the border from Nepal. And, in 1997, the steep North Face was tackled by Charlie Fowler and two clients, only to end badly after a serious fall during their retreat from below the summit.

Back in 1905, that pioneer of lightweight expedition travel, Scotsman Dr Tom Longstaff, together with two Swiss guides, the Brocherel brothers, made

the first attempt to climb Gurla Mandhata after temporarily diverting from Charles Sherring's exploratory expedition to western Tibet. (Just as commercial guided ascents in the Himalaya are popular today, many of the well-known explorers and climbers in the early 1900s employed experienced European guides to oversee the safety of the party.) During our climb we established that Longstaff's party had entered the wrong valley system and had therefore never been in the best position for a realistic shot at the true summit. Despite being badly avalanched and swept down 1000 metres under the west peak (still unclimbed), they survived and went on to reach over 7000 metres, at the time the highest altitude attained by climbers. Two years later, in 1907, Longstaff and the Brocherels made the first ascent of 7120-metre Trisul in north-west India above the Rishi Gorge, for 23 years the highest summit achieved. In the Garhwal Himalaya, on the edge of the Nanda Devi Sanctuary, Trisul is clearly visible from Longstaff's high point on Gurla Mandhata. (In 1982, I ascended the Rishi Gorge as a member of a small New Zealand expedition. After belaying on dangerous sections of the 'trail', followed by a series of hair-raising river crossings, we changed plans and diverted into a side valley to help another team that was climbing Trisul. After this brush with Longstaff's Trisul, I have remained fascinated by the wily Scotsman's extensive mountain travels.)

With Steve, a long-legged apiarist from Canterbury who is not unlike a youthful Ed Hillary, I pushed on up the glacier to establish Camp II at 6600 metres in the lee of a serac. Despite the low angle of the route it had been a wise decision to opt for snowshoes instead of skis. Snowshoeing is to skiing what rowing is to yachting. Though hardly an elegant way to travel in the mountains, snowshoes do offer some advantages for a small remote party. Not only are they easier to transport than skis but a climber is less likely to twist a knee badly when load-carrying in crusty snow. Importantly, ponderous snowshoe travel keeps everyone together, so there is no excuse for not roping-up when travelling on glaciers.

After a week on the mountain, hauling gear, acclimatising and recovering from a streaming head cold, I felt ready to join Gerry, Steve and Shaun for the steep uphill slog to Camp III. By now, John had retreated from Camp II and waited for us at base camp. On a hacked-out snow platform, with two tiny tents

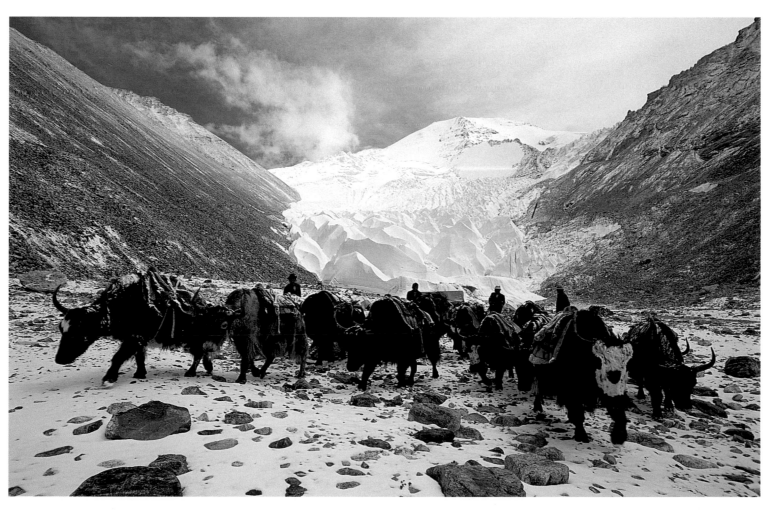

Yaks depart base camp after hauling expedition baggage to the base of Gurla Mandhata.

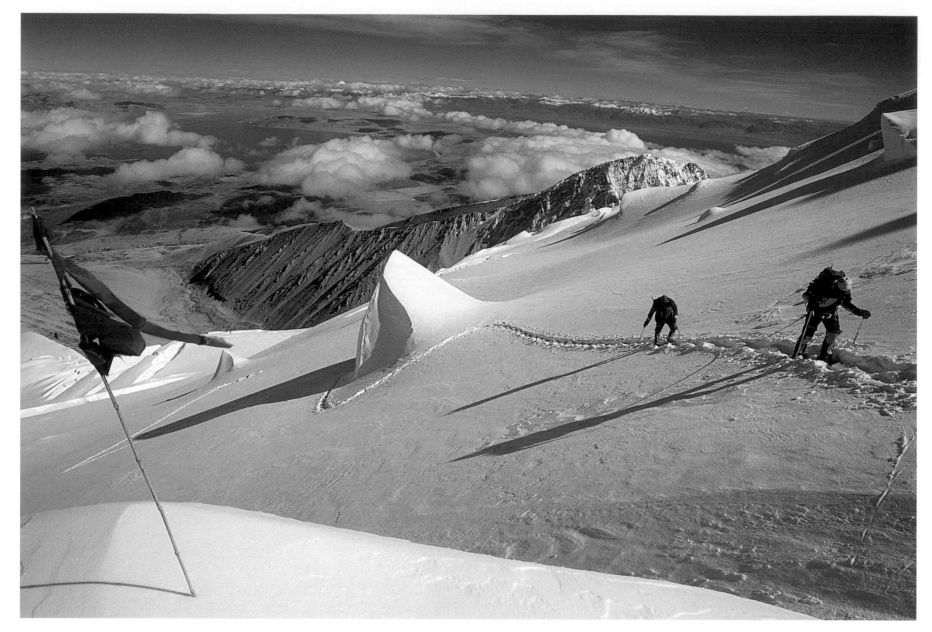

Gerry Essenberg and Shaun Norman on snowshoes above 7000-metre Camp III. Mount Kailas can be seen in the distance.

pitched end on, all the usual discomforts of 7000 metres kicked in: headaches, lethargy, the exhausting ritual of snow-melting and cooking, followed by a contortionist act in cramped quarters to get rid of brim-full pee bottles. In the mornings, giant frost flakes rained down from the single-skin tent walls onto sleepy, haggard faces.

After a day tent-bound in poor weather, Gerry and I broke out of the claustrophobic cocoons and climbed above the camp, determined to get a feel for what lay ahead. With rasping lungs we crossed the last crevasse bridge and gained access to a broad glaciated shelf under the massive summit headwall. We wore avalanche transceivers and carried shovels, though we were relieved

that snow conditions appeared stable. Satisfied that the gateway to the top was open, we rammed in some red flags and headed back for a brew.

At dawn the clouds parted to reveal wonderful views down to the holy lakes and beyond to the distinctive cone of Kailas – perhaps the finest vista of the climb. Handling a camera in the sub-zero temperatures outside the tent that morning resulted in a painful rewarming session for my fingers over a gas stove. On this day, our summit attempt, my toes remained 'solid and cold' – a dangerous condition but one I am used to above 7000 metres.

With hindsight, we realised we had placed Camp III too low and now, feeling pressured to descend and meet the pre-arranged arrival of the yaks, our summit

climb evolved into a chancy hit or miss affair. As the day wore on, altitude and heat gradually sapped our energy and drive, knocking out first Steve, then Shaun. In abominable conditions that even snowshoes had trouble dealing with, an estimated one-hour climb turned into four before we reached a crucial waypoint under the summit slopes. What first appeared as a simple climb rapidly reduced us to exhausted wrecks, desperately struggling to make progress.

As the others descended to the top camp, Gerry and I continued to plug upward. Despite plummeting temperatures and the lateness of the day we launched ourselves onto the headwall, convincing ourselves, naively, that the snow must surely improve if only we could reach the summit rocks, tantalisingly just above us. Foreshortening undoubtedly deceived us, but we could almost *smell* the summit. Thrashing upward in short bursts, we drew level with the 7500-metre west peak. With perhaps as little as 150 vertical metres to go before the summit we halted, no longer able to make headway in steep, unconsolidated snow that was waist deep in places. By now the sun had dipped behind the summit ridge and even the alpenglow started to fade. Bone-deep cold took command. 'Well, that's it then,' was all that was said. We placed a prayer flag at our high point and turned for home.

My diary outlines the urgency of the hour:

Push Gerry along – both tiring rapidly my toes seriously freezing, they will be numb for ages… back on snowshoes stumble repeatedly as darkness descends trip often on the rope. Find our depot of packs and headlamps just in time as we begin to lose the trail in the dark. Cold and exhaustion take over – hassle Gerry to hurry and repack his gear and move on. Impressive canopy of stars overhead…

Push, push, push on down until, thankfully, we spot a glimmer of light inside the tents way below… a shout to announce our arrival then crash inside. Thankfully, Shaun brews tea – then a bad night begins – chilled to the bone – too tired to eat – head lying downslope – frost has soaked parts of my sleeping bag – restless, no sleep. More than anything, disappointed for Gerry that we didn't make the top – so close to his first high summit.

As I swung an ungainly rucksack onto my back and set off on the descent to base camp, I caught sight of a beautiful band of orange light illuminating Kamet and India's highest peak, Nanda Devi, on the western horizon. With our departure from Gurla Mandhata imminent, I remembered a comment from Tom Longstaff's book, *This My Voyage*. Eighty-one years before the sunset I was now witnessing, Longstaff wrote of this same view from Gurla Mandhata. Perhaps the Scottish doctor best captured my own thoughts as I prepared for the long haul to Kathmandu. 'In the afternoon the clouds lifted in the west and there, 100 miles away, stood Kamet, a mighty cone visible from base to summit shone across the sunlit steppe. Even today, after so many years, that ineffable vision of space rises clearly before my eyes.'

Steve Tully prepares orange juice for Gerry and Shaun, tired after coming down to Camp I from a summit attempt.

In the distance, as I trudged downhill following the yaks away from Gurla Mandhata, the crystal-like pagoda of Kailas radiated a peaceful light, glinting among drifting bands of cloud. Milarepa's great mountain, 'where snow leopards dance', glowed for a time then quietly disappeared.

Kailas

Indus River

Nandi

Yarlung Tsangpo
(Brahmaputra River)

Sutlej River

Gurla Mandhata

Chiu Gompa

Rakas Tal

Manosarovar

TIBET

Taklakot
(Purang)

INDIA

NEPAL

Karnali River

Simikot

Kailas
and
Gurla Mandhata, Tibet

Allen, Charles. *A Mountain in Tibet – The search for Mount Kailas and the sources of the great rivers of India*, Andre Deutsch, London, 1982.

Allen, Charles, *The Search for Shangri-La: A journey into Tibetan history*, Little, Brown, London, 1999.

Bernbaum, Edwin. *Sacred Mountains of the World*, Sierra Club Books, San Francisco, 1990.

Batchelor, Stephen. *The Tibet Guide*, Wisdom, London, 1987.

Chan, Victor. *Tibet Handbook*, Moon Publications, Chico, 1994.

Chang, Garma (ed.). *The Hundred Thousand Songs of Milarepa*, Shambhala, Boston, 1999.

Gansser, August and Arnold Heim. *The Throne of the Gods*, Macmillan, London, 1939.

Goldstein, Melvyn and Cynthia Beall. *Nomads of Western Tibet – The Survival of a Way of Life*, Serindia, London, 1990.

Govinda, Lama Anagarika. *The Way of the White Clouds – a Buddhist pilgrim in Tibet*, Hutchinson, London, 1966.

Hedin, Sven. *Transhimalaya*, 3 vols, Macmillan, London, 1910.

Kawaguchi, Ekai. *Three Years in Tibet*, Theosophical Publishing Society, Benares and London, 1909.

Longstaff, Tom. *This My Voyage*, John Murray, London, 1950.

Moran, Kerry and Russell Johnson. *Kailas – On pilgrimage to the sacred mountain of Tibet*, Thames & Hudson, London, 1989.

Pranavananda, Swami. *Kailas-Manosarovar – the original guide plus ten maps*, SP League, Calcutta, 1949 (2nd edn, 1983).

Rawling, Captain C.G. *The Great Plateau*, Arnold, London, 1905.

Savage Landor, A. Henry. *In the Forbidden Land*, 2 vols, Heinemann, London, 1898.

Schaller, George. *Tibet's Hidden Wilderness – Wildlife and nomads of the Chang Tang Reserve*, Abrams, New York, 1997.

Schaller, George. *Wildlife of the Tibetan Steppe*, University of Chicago Press, Chicago, 1998.

Sherring, Charles, *Western Tibet and the British Borderland*, Arnold, London, 1906.

Snelling, John. *The Sacred Mountain – travellers and pilgrims at Mt Kailas*, East West Publications, London, 1983.

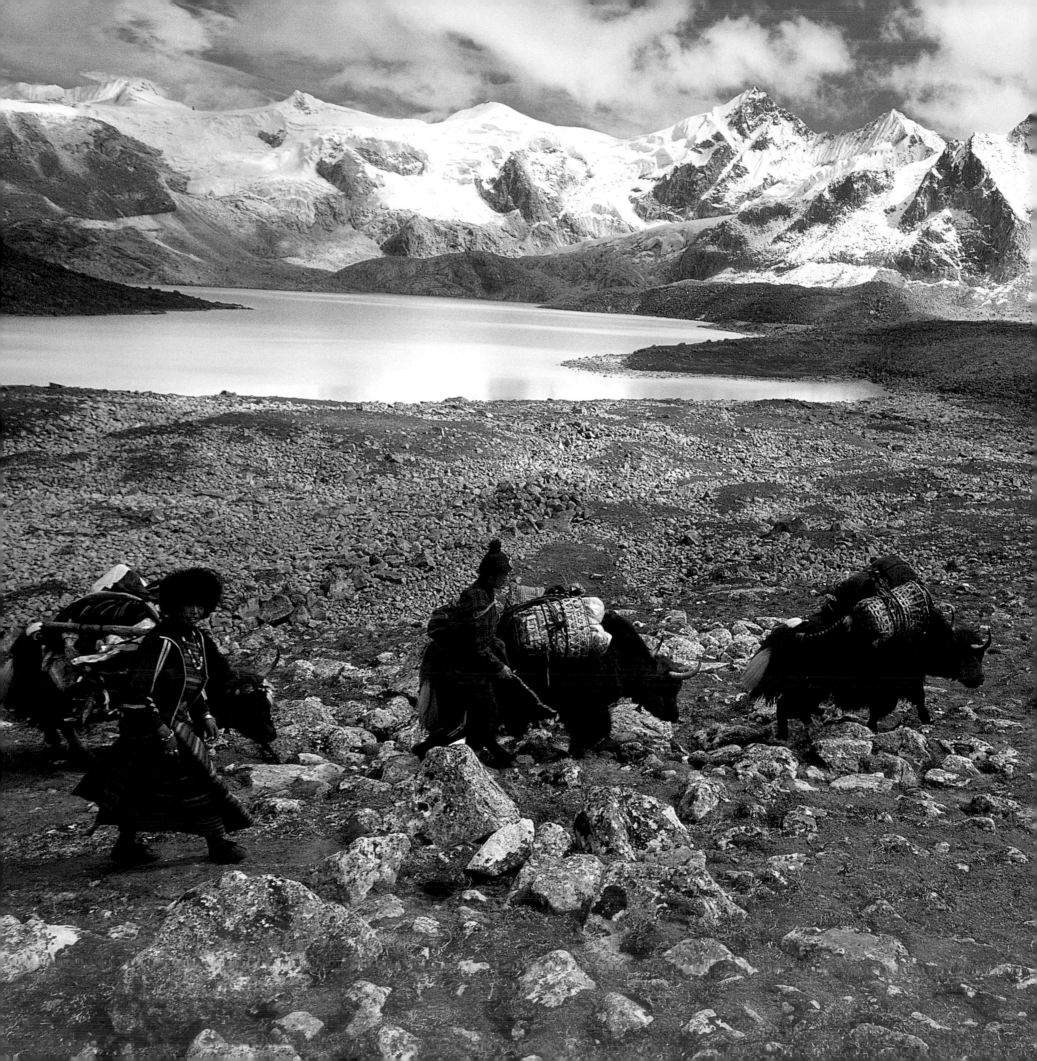

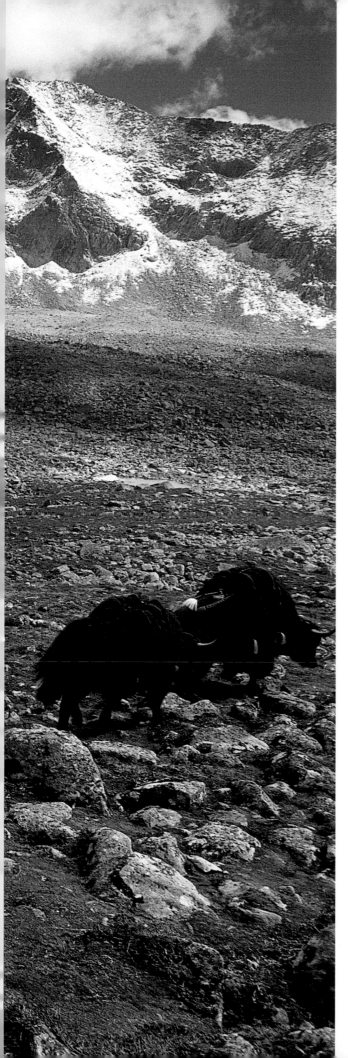

Beyond Here, Be Dragons

A trans-alpine trek across northern Bhutan

During those twenty-one years my duties took me to almost every corner of the beautiful mountain countries of Sikhim and Bhutan, with their heterogeneous population of Lepchas, Bhuteas, Tibetans, Bhutanese and Paharias… In climate every variation was to be found from arctic to subtropical, with scenery unparalleled anywhere in the world for magnificence and grandeur and the brightness and softness of its colouring, the bold, snow-clad and desolate expanses contrasting sharply with the rich and luxuriant vegetation of the deep-cut valleys close at hand.

John Claude White, *Sikhim and Bhutan –*
Twenty-one Years on the North-East Frontier 1887–1908

Cuffed by a chill wind I retreat further into my down jacket. Huddling closer to a fire draped in freshly cut branches I stretch stiff fingers toward a lick of flame. Thick wafts of smoke roil around my face, filling my nostrils and raking my sooty hair with the heady reek of juniper. In a time-honoured ritual, aromatic blessings drift skyward towards the dawn to help ensure the wellbeing of our party.

LEFT: *A yak caravan crosses alpine terrain on the way to Lunana.* TOP: *Laya women, northern Bhutan.*

Thimpu Thsechu

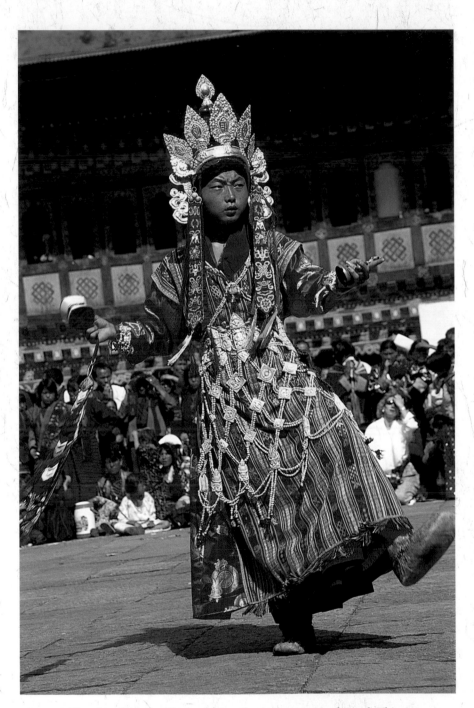

A Thsechu dancer performs during the post-monsoon festival, Thimpu.

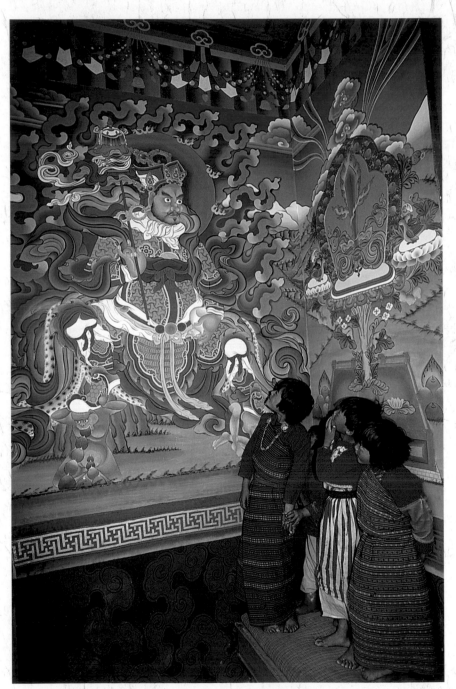

Children under a mural of the guardian at the Tashi Chho Dzong.

114

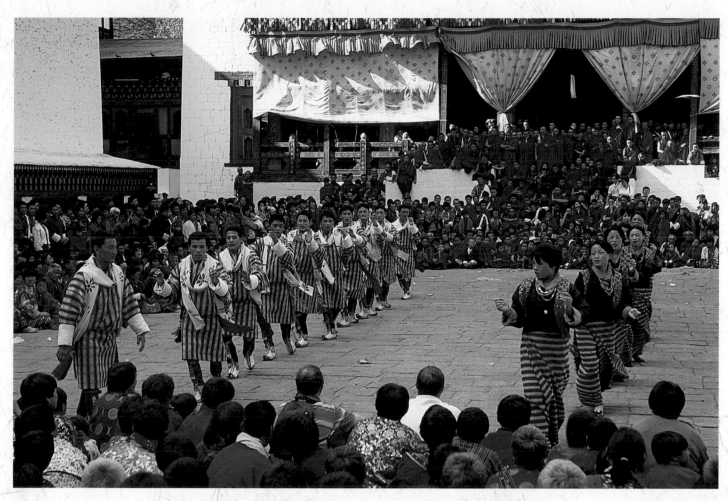

The royal dance troupe performs in the main courtyard, Tashi Chho Dzong.

LEFT: *Royal dancers wear exquisite national dress – for women, the kiru and for men, the gho.* CENTRE: *A Bhutanese woman engrossed in the festival dancing.*
RIGHT: *A shy Bhutanese woman waits to be blessed at the Thsechu.*

access, chimneyless houses are the norm and smoky rooms commonly result in eye disease. Light enters the living quarters through ornately painted narrow windows more often protected by wooden shutters than by glass. Chalet-style roof beams are covered with cedar shakes held down by large rocks. Fiery red peppers, essential in Bhutanese cooking, dehydrate on the rooftops which have space beneath for drying crops. Overhead, on pine poles, long white flags stencilled with windhorse motifs snap out prayers. Cobbled courtyards are often bordered by apple or orange trees while rice or buckwheat flourishes in neat irrigated terraces.

To allay farmers' fears that the gods were being offended, the King of Bhutan has banned mountaineering expeditions. Much as I once dreamed of climbing in Bhutan, I appreciate the sensitivity of this decree. There is an intangible though undoubted long-term spiritual value in retaining the virginal status of peaks like 7540-metre Gangkar Puensum, the highest unclimbed mountain in the world, tucked away in poorly mapped northern Bhutan. Wisely, this tiny nation has chosen to respect sacred landscape as a fundamental cornerstone of its heritage.

Enlightened policy-makers in Bhutan have made it a priority to retain their cultural values and preserve the environment rather than scrabble indiscriminately for tourist dollars. After the present king's coronation in 1974, when Bhutan's reclusive agricultural society was still steeped in ancient tradition, the gradual opening of the tourism door enabled Bhutan to be eased into the wily ways of 20th-century capitalism. There is much to be said for Bhutan's method of earning foreign currency: charging tourists determined to visit the country a high daily rate – approximately $US200 per person per day – which must be prepaid before a visa is granted. Despite this largely self-limiting approach, tourist numbers have crept up slowly from 2500 a year in 1990 to 7000 a decade later.

In 1995 I interviewed the Bhutanese tourism director, Tshering Yongden, who commented, 'Bhutan earns $US8 million a year by exporting apples and more by selling hydro-electricity to Calcutta so why attempt to double or triple the $US3million generated by tourism? We have looked closely at the impact of tourism on Nepal's cultural heritage and decided this is not the way for us. Rather than opening the floodgates to budget travellers, Bhutan would rather concentrate on providing a quality experience for the visitors who do make it to our country.' I came away from Yongden's Thimpu office heartened by Bhutan's determination to spurn artificiality, uniformity and disregard for traditional values, in favour of the retention of ethnically unique cuisine, dress, religion, language and literature. Unlike some of its neighbours, Bhutan has a real chance of significantly enhancing the life of its people while retaining some of the elusive qualities of a Shangri-la.

Primulas line the trail as ponies haul trekking gear towards Chomolhari.

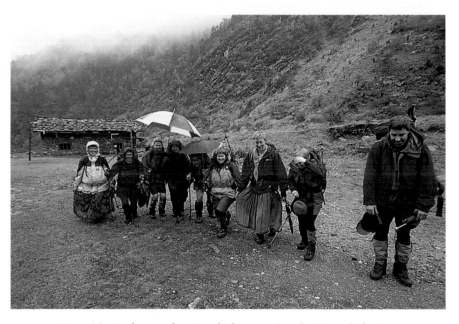

Practising to bow and curtsey before meeting the King of Bhutan.
Left to right, Betty Monteath, Helen Beaglehole, Pip Lane, Fi Miller,
Jim Harding, Gin Bush, Fi McPherson, Claudia Schneider and Dennis Pisk.

Having been stymied in 1995 by lingering snow, I planned the 1999 journey for the post-monsoon September to October period. Even though Bhutan is in the eastern Himalaya and monsoon rain can bucket down well into late September – the world's highest rainfall, 26 metres a year, occurs at Cherrapunji in nearby Assam – I gambled on being drenched in lowland forests against a fair chance of striking snow-free passes and clear blue skies in the mountainous north. It was vital to finish the trek by the end of October for, by then, the window of stable autumn weather would slam shut. Storm-bound and laden with snow, the passes would then be blocked as winter tightened its grip. For all that, umbrellas seemed a sensible last-minute purchase in Kathmandu before our group of ten, Betty and I plus eight others from New Zealand and Australia, boarded the one-hour flight to Paro – a step back in time to Druk Yul, to the storybook Land of the Thunder Dragon.

The Druk Air flight banked in front of Everest then skimmed past the five glittering summits of Kangchenjunga. Dipping over Darjeeling and verdant Sikkim, the plane glided on into the soft sepia light of the Paro Valley. After a tight turn over pine forest and a chequerboard of paddy fields the jet landed neatly amid a swaying carpet of gilded rice.

Airports are normally drab, unimaginative places but the new Paro airport, bankrolled by India to Bhutanese design and opened only months before our arrival, was a truly stunning introduction to a country immersed in artistic tradition. A rich blend of ochre, jade, gold and slate-grey, the crisply painted walls, columns and roof panels gleamed in the morning sun as we entered the terminal. Even the immigration hall is decorated with vibrant Buddhist iconography and detailed wheel of life mandalas grace its ceiling. Our guide, Thinley, dapper in his red and yellow gho, long socks and polished leather shoes, met our group outside and whisked us off to a stone lodge at Kitchu, in the upper Paro Valley. The ruling Drukpa class frowns severely on subjects who do not wear traditional dress in public – tartan dressing-gown-like ghos for men and vibrant, finely woven ankle-length kiras for women.

While our trekking staff packed food and equipment into cane baskets designed to fit on the flanks of horses, we set out on foot to explore the valley. What a treat it was to travel in a land where motor vehicles play such a minor role. The king ordered newly installed traffic lights to be removed from Thimpu's main street, leaving a single, highly decorated light outside Tashi Chho Dzong, the principal religious centre. As we walked, carefree schoolgirls in prim matching uniforms skipped along the road hand in hand, unperturbed by the occasional truck or taxi coming slowly towards them.

Kitchu monastery, built in AD 659 to pin down the left foot of a mythical ogress that plagued both Bhutan and Tibet, is only a short walk from the lodge. Its flagstones worn smooth by centuries of shuffling monks, Kitchu is nestled

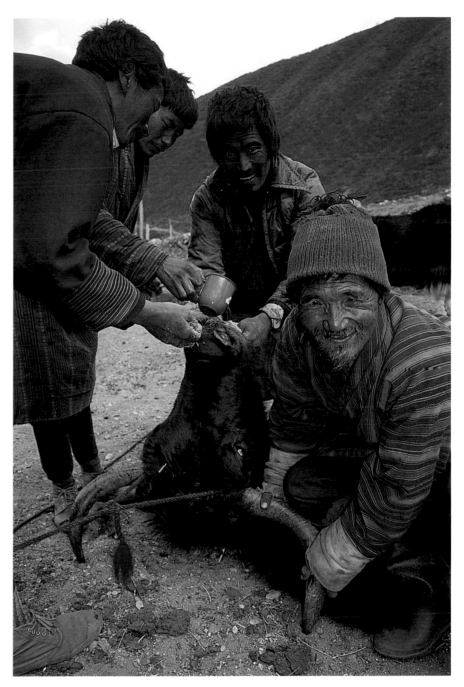

Force-feeding a yak with mouthfuls of barley soup to strengthen it for the high passes.

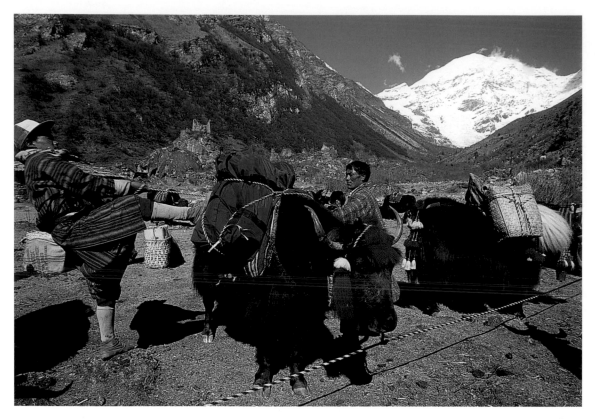

LEFT: *Tensioning the rope to secure the load, yak drivers ready the caravan to leave Chomolhari camp for the first of the Snowman's 5000-metre passes.*
RIGHT: *The Bhutanese take great pride in decorating their yaks with plant-dyed tassels and brass bells.*

under an ancient cypress tree. By chance, in the outer courtyard, we met the Queen Mother, Her Royal Highness Ashi Kesang. Graceful and utterly charming, she went out of her way to chat and welcome us to Bhutan. In 1968, she had helped to rebuild the monastery and now has private chambers there. She comes each year for a two-week puja (religious ceremony) performed by visiting monks from Bumthang, a district in the east.

Next day, after a three-hour drive to the capital, we attended the last day of the annual Thimpu Tshechu (festival) in the Tashi Chho Dzong, a massive monastery-cum-administrative complex, founded in 1641 and built completely without nails. From early morning until dusk carefully orchestrated dances in honour of the Guru Rimpoche were enacted by troupes colourfully clad in flowing silk gowns. The religious performances were interspersed with traditional routines by the royal dancers. Impish clowns provided bawdy, comic relief that added to the relaxed atmosphere in the stone courtyard. For the audience of many thousands, with men wearing a reverent white shawl over their gho and women in exquisite, intricately patterned kiras, it was a day of deep spirituality. For us, it was a moving, emotional introduction to Bhutanese culture. We sat for hours in silence, entranced by the slow rhythm of the music and the vibrancy of swirling masked dancers.

As I crept out of the hotel at dawn that morning, bound for the Thsechu, the nightwatchman had carefully adjusted my red and yellow checked gho, suppressing his amusement at my crude attempt to wrap the garment around me in the accepted manner. He lent me safety pins to keep the starched white cuffs in place. As I entered the Tashi Chho Dzong's stone courtyard, the chief of security grabbed me and whisked me into his office. Satisfied with my credentials but not my dress, the policeman sent an orderly to his home to fetch a spare white shawl for me to wear. Chatting over tea before the festival began, he told me how Bhutan still had a puzzling murder to be solved, rated as the only serious crime in the Year of the Tiger (1998). Founded by Guru Rimpoche as a meditation site in the eighth century, when he used a flying tiger to reach a precarious granite perch clinging to the rim of the Paro Valley, Taktshang or Tiger's Nest monastery was now in ruins, apparently torched by an arsonist. Priceless artifacts were damaged in the fire and the caretaker monk died.

Too polite to offer awkward answers or perhaps too naïve to think that Bhutan has enemies, the policeman suggested that an electrical fire may have sparked the devastation. From my previous visit I knew that no electricity reached the ancient shrine. Keen to sleep the night among cliff-hugging rhododendrons, I had clambered up towards Taktshang, which hangs like a

delicate orchid from a sheer rock face. I paused on the lichen-covered stone steps to absorb the tranquillity. Why would anyone want to spoil the perfection and solitude of Taktshang or denigrate a Buddhist shrine? Although there seemed to have been evidence of an intruder, it was possible that butter lamps burning beneath hanging tapestries started the fire accidentally. Such mishaps were a common cause of dzong infernos in the past. Outraged by the puzzling nature of the alleged crime, the energetic and astute 45-year-old King of Bhutan, Jigme Singye Wangchuck, had taken a leading role in the continuing investigation. Reported in *Kuensel*, Bhutan's only newspaper, a senior monk stated, 'The sanctity of Taktshang cannot be destroyed by the natural elements, be it fire or water. Now that an auspicious date for reconstruction has been agreed upon, Taktshang is once again rising from the ashes.' (The reconstruction has now been completed.)

The Snowman trek begins at Drukgyel, a fire-gutted dzong at the road-end, 15 kilometres from Paro. Using plaited yak-hair ropes, the pony-men lashed our loads to angled wooden frames on 22 horses, ready for the three-day trek up to Jangothang and Chomolhari. On my previous departure from here, this logistic performance had been enlivened when we were caught in the middle of an archery contest. Arrows zipped furiously over the nonplussed horses, then came zinging back again over our heads when the opposition fired their salvo at a thin wooden target at the far end of the clearing. Archery, Bhutan's national sport, is played passionately whenever there is a spare moment, with traditional bamboo bows or, for the affluent, imported fibreglass bows.

This time it was a little more staid, as we stood around yarning to Indian Army troops in full battle dress. Rather than arrows, orders flew in all directions. Geared up for an exercise, the radio operator, with a mud-smeared face and with branches poking out of his helmet, squawked into a walkie-talkie to monitor patrols seeking an 'enemy' hidden in the thick roadside scrub. Meanwhile, camouflaged soldiers shinned up and down a rope dangling from a vegetated cliff, as 50 skittish army mules, hobbled together, looked on.

An officer sporting a waxed handlebar moustache sat astride his trusty Lee Enfield motorbike. While I expounded cricket's finer points with great authority, his eyes glazed over and he barked at a starched orderly to bring me tea and pastries. (In 1982, on a clandestine expedition in north-west India's Gangotri region to climb a peak called Shivling, I became adept at lauding India's spin bowlers in order to squeak through military checkpoints.) Another officer, cool and controlled in his cricket whites, cravat and maroon blazer, strolled past, shouting clipped commands to a sweaty platoon that jogged down the road under the weight of automatic weapons. Because China occupies strategic positions along Bhutan's 300-kilometre border with Tibet, an agreement ensures that the Indian military plays a major role in bolstering near powerless Bhutan's

rudimentary army. During a border skirmish in 1962, when China made land-grabbing incursions into India on the Arunachal Pradesh and Ladakh (Aksai Chin) frontiers, the late King Jigme Dorji Wangchuk and his Bhutanese army reportedly held off Chinese troops for a week, armed with little more than bows and arrows. Of more immediate concern today, perhaps, are Assamese guerrillas who are fighting on the southern border for an independent homeland from within Bhutan's Royal Manas National Park.

When we were out on the trail at last, the rain started. Sticky mud spattered everywhere. Slogging behind sad-eyed ponies, we spent entire days jumping from log to submerged log or onto slimy rocks that barely kept their noses above the gloppy brown mire. Slowly, our party wound its way up through the forest towards Chomolhari, a mountain we could not yet see in the steady downpour. The air was warm under the dripping, lichen-draped trees, though some were tinged with the first hint of autumn. At least the leeches seemed to be hiding. So much for the predicted end of the monsoon, I muttered, as my world was reduced to the confines of a limp umbrella. At dusk, as we lurched into camp, Betty, Pip Lane, Jim Harding and Fiona McPherson were mucky enough but Gin Bush, a physiotherapist from Wanaka, was like a six-year-old who had been let loose with a potter's wheel. Her rather soggy state immediately won her the nickname 'Puddleduck', from Beatrix Potter's tale about Jemima. Like mud, the name stuck! Somewhat perversely, I mused that city slickers should walk on a muddy trail every so often just to be reminded that most of the world is not a highway of concrete or mown grass. And then the rain really set in…

But a few hours before Jangothang, just as our spirits were becoming waterlogged by the persistent deluge, we chanced upon the advance guard of a 100-strong royal entourage. Astride wet, steaming horses with hand-woven saddlecloths, escorts flanked the handsome King Wangchuk, his two youngest princes of ten offspring, three of his four queens (all of whom are sisters – only one mother-in-law!) and ministers of state. Typical of the popular Bhutanese monarchy, the royal party had persevered in the face of atrocious weather to inspect outlying villages. Not thinking for a moment that His Majesty would deign to meet the rather grubby foreigners in his care, Thinley was nervously galvanised into action when it became apparent that the king had dismounted and was heading our way. In a steady drizzle, we were hurriedly lined up, told to doff hats, collapse umbrellas and hide cameras. Under the watchful eye of discreetly armed Royal Guards, some of whom carried leopard-skin backpacks, our bedraggled line-up sheepishly practised curtseying and bowing, amid giggles of disbelief.

Like many Bhutanese children, Thinley had seen his king in the distance during routine school visits. But now, years later, to actually bow before him and answer questions about our journey in his own Dzonkha language was an

A Laya woman carries firewood home in a snowstorm.

Barley grain is stripped with curved knives in a Laya courtyard.

honour that would keep a smile on his face for days. There were nervous handshakes all round and an exchange of the universal greeting, 'Kuso zangpo la', before the king conversed casually with us in his refined English. He apologised for the damp weather and guaranteed that it would improve 'after the large depression in the Bay of Bengal moves away'. Commenting that he did not envy us the rigours of the journey ahead, the king enquired if we had enough medicine with us. As three of our group were doctors, we assured him that our extensive first aid kit was sufficient for most emergencies.

Although His Majesty had the advantage of a large rubber raft, which proceeded to lumber past strapped to a hapless pony, he highly recommended that we go fishing in a moraine lake above Jangothang. Though fish are considered sacred throughout the Buddhist world, fishing, once a serious offence in Bhutan, is now allowed for locals and tourists under a strict permit system. One of the group, Dennis Pisk, later tried his luck at the lake with the string from my kite tied to a stick, a bent pin and damp enthusiasm.

Thinley was deeply touched when the king gave him his walking stick. 'I'll never, ever part with this. It'll take pride of place in my home under a framed portrait of His Majesty.' For the rest of the journey the 'kingstick' played an important role in keeping us in line. After the king went on his way down-valley, we exchanged pleasantries with his attractive, elegantly dressed wives, sheltering under silver parasols as they rode by on decorated ponies. This charming encounter left us grinning all the way to Jangothang.

Chomolhari, 3000 metres above Jangothang, was as striking as I remembered it. During a rest day to facilitate our acclimatisation to the crisp thin air at 4000 metres, we caught glimpses of its upper ramparts through swirling cloud layers. On steep grassy slopes above camp, a herd of bharal kicked rocks down on me as I stalked them with a camera. Two lammergeiers circled overhead in slow motion. A grand night followed, swilling sweet tea, whisky and locally brewed singchang (barley beer) in the fug around the hearth. At sunrise, the pony-men vanished into the forest as we transferred our baggage onto the first of three yak caravans needed to push on towards Laya.

As the group embarked on the day's walk, I dawdled behind to watch yak drivers like Dorje and his doe-eyed wife Mindu work together to tie the loads onto their cantankerous, grunting beasts. In an attempt to stop yaks stampeding through the campsite dragging partially tied-on loads, each animal was tethered by a short rope to a stout peg driven hard into the ground. With caution born of experience, yak drivers treat the sharp end warily. Yaks have long curved horns and immensely powerful necks that can inflict nasty wounds as evidenced by one of the lads with us who had an ugly scar across his face.

Thick yak-hair rope criss-crossed each load. Tensioned expertly through small wooden rings steam-bent into a circle, the load was held in place by a

three-way pull on the rope. Proud of the six or eight yaks each owned, every morning the drivers attached dangling, plant-dyed, crimson tassels to the animals' ears. Green, white and red pom-poms were also plaited into bushy tails. Hand-forged bells, swinging from thick woven neck bands, clanged a warning for everyone to move aside or risk being nudged off the rutted track. To forget that a laden yak is unaware of its width and to then stand on the inside of the trail as it passes, is to chance being crushed. Remaining on the outside can result in a plunge over a precipice.

Yaks provide almost everything a Bhutanese highlander could ever need, from transport to meat. Rawhide, dried crunchy cheese and woven yak-hair cloth stitched into snug tents are important by-products. These waterproof shelters are used in summer when shepherds leave the village and adopt a semi-nomadic lifestyle to tend herds on high pastures. A family's wealth is still measured by the number of yaks it owns. Time and again members of our group who had travelled widely in the Himalaya remarked on the size, vigour and number of yaks we encountered in Bhutan. Only once on the six-day haul up to Laya did we have a problem with a stubborn yak that decided to ditch its precious load of eggs into a river. Before leaving home someone suggested that I should purchase a GPS navigational gadget. My response brought strange looks: 'All we have to do is follow the yaks. They know exactly where they're going!'

Without yaks no one goes anywhere in northern Bhutan. They are especially in demand in the autumn, to haul sacks of rice from the lowlands to remote villages before the arrival of winter. The necessity of this work meant that each of the three caravans of 25 beasts we contracted could cross only three passes before returning to its home territory. The swarthy yak-men, used to driving a hard bargain, became a law unto themselves. They were certainly characters, though definitely not ones to cross. Endeavouring to walk at the drivers' steady pace, we took delight in mimicking their whistles and hollers, hurling rocks to hustle the yaks as they plodded up steep winding trails.

There was much puffing and panting as we lurched over the first of many mist-riven 5000-metre passes. Despite the exertion, it was exciting to push onward, past the hawkbeak of Jitchu Drake, climbed by Englishman Doug Scott in 1988. And then, as the sun broke through, we marvelled at a rainbow arching over Linghshi Dzong. The old monastery, called Yugyel, commands a grandstand view from a grassy knoll above a tributary of the Mo Chu. Until recently it was used as a prison for smugglers of antiques. The blatant plunder of ancient paintings and religious stone sculptures is rife throughout Himalayan regions; items are often stolen to order for private collections.

Nursing weary legs, and, in my case a painful cricked neck, we traversed more high passes over a period of days, followed by a descent through pristine fir forest to a picturesque camp under the 7000-metre peak Gangchen Tag

A Laya school teacher goes through the Bhutanese alphabet with his pupils.

Swords captured in battle with Tibetans near Laya during the 19th century.

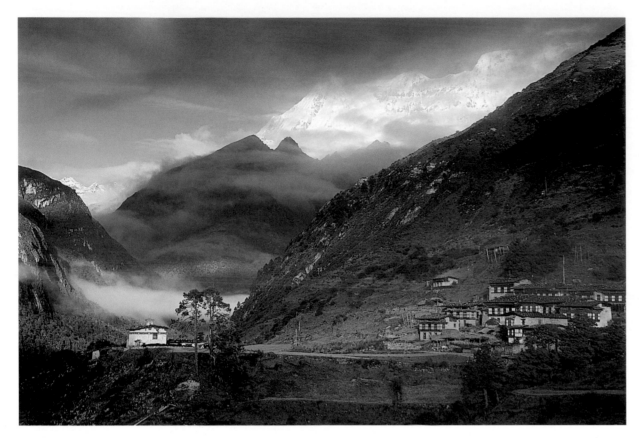

LEFT: *Morning mist rises from Laya, with 7200-metre Masa Kang on the Tibet border above.* RIGHT: *Taking yak saddles, a Laya father leaves home to trade in the lowlands.*

(Tiger's Ears). From tents pitched on a flower-studded alp at Limithang we were treated to a riveting mountain panorama as the mist parted to reveal a formidably steep prow of ice and rock. Refreshed, next morning, we looked forward to the fleshpots of Laya.

Reaching the trading town of Laya on 3 October in good health and on schedule boded well for the journey ahead. A well-earned rest day meant we could fossick in the narrow alleyways between medieval-looking houses and climb to the small lhakhang (temple) perched on the edge of a pine forest. Many of Laya's menfolk, known as Lyaps, were away on trading trips, driving pony caravans through the mist-shrouded Mo Chu Gorge. Others, in disguise and with forged papers, were making traditional, though now clandestine, journeys to Lhasa, five hard days of travel to the north, to buy bolts of Chinese silks and cottons for resale in Thimpu. In turn, Tibetans, in Chinese employ, commonly cross the border on furtive raids to hunt snow leopards and root up rare plants, prized ingredients of Chinese medicine.

Still in the village, the Laya women sported their conical bamboo hats pinned at a jaunty angle to shiny black tresses. They sang and gossiped as they worked together in high-walled courtyards. Cavorting and giggling like schoolgirls, they deftly wielded curved sickles to strip barley heads from sheaves of cut grain.

All were content to be outside in their rough black kiras absorbing the autumn sunshine. All too soon, a bitter winter would set in, confining them indoors. If the summer has been kind, harvest always proves to be a happy communal time in the mountains.

One woman, 55-year-old Puntso, had a worn face, twinkly eyes and a huge smile. She was accompanied by her fetching, deaf-mute daughter, Pema, with waist-length hair, wind-burnished high-boned cheeks and ebony eyes. Both wore turquoise and red coral jewellery embellished with exquisitely worked silver. To my surprise, they immediately recognised me from my previous visit. Ushering Betty and me inside their sooty kitchen, Puntso plied us with Tibetan tea laced with handfuls of puffed rice. Wide-eyed in amazement, the two women lavished me with gratitude when I produced portraits of them taken in 1995 after I had helped Pema with a nagging toothache. The photographs were immediately given pride of place in the family prayer room under the dusty, watchful eyes of Buddha. And then, squeals of joy erupted into loud chuckles as we presented Puntso with a pair of reading glasses. In return, we were shown two antique swords, much fondled family heirlooms belonging to a long-deceased relative. Masterpieces of hand-forged steel, beaten brass and beautifully tooled leather, the weapons had been captured in battle with Tibetan warriors.

Despite protestations that we could not accept such a treasure, Puntso pressed on us a tattered print of a Tibetan boy dressed in a yellow satin gown and a broad-brimmed hat. The lad was riding a white pony carefully led by senior monks. As the image touched our host's bowed forehead, it was clear that even this grubby image of the boy was held in great reverence. It transpired that he was the 17th reincarnate Karmapa lama, seen here approaching the seat of the late 16th Karmapa, in Sikkim's Rumtek monastery. Next to the Panchen and Dalai Lamas, this serene youth, as head of the Kagyu order, is the most important reincarnate in Tibet. In January 2000, three months after returning home, I was amazed to see the Karmapa again, now a 14-year-old, staring at me from the front page of the *Guardian Weekly* newspaper. In another blow to Chinese authority, a repressive regime which continues to state publicly that all is well in Tibet, the Karmapa had just fled over the Himalaya to seek sanctuary with the exiled Tibetan government in Dharamsala, India.

We changed yak operators in Laya and with fresh, strong animals pressed on towards Lunana, entering remote country beyond Rodufu's lush forest of cedar and juniper. From here it was new territory for me, so a spicy blend of anticipation and wonder grew with each bend of the trail. Mist and fast-moving clouds added drama to the fleeting glimpses of summits and an ever-changing landscape of plummeting ridges. Mountain ash, driven by its autumn chemistry, lit up the dwarf rhododendron blanketing the hillsides in an embroidered quilt of mottled amber and lustrous dark green.

On one steep section of trail, bordered by thick undergrowth, Thinley advised us to stay together so we could fend off inquisitive or hungry Himalayan black bears known to live in the area. To drive the point home, he told us that in Thimpu and Paro there are more injuries each year from bear attacks than from traffic accidents. Crossing pass after pass on the six-day section up to the Lunana district's outlying village, Chozo Dzong, we revelled in the late summer flowers, including clusters of glowing blue gentians. How magnificent it must be in mid-monsoon when the squat alpine rhododendrons are in full bloom. I remembered from my first visit the freshness of delicate spring flowers with different orchids at every glance. The carpet of primulas was so thick in places it had been hard not to crush blossoms as I walked. Myriads of butterflies with tangerine and turquoise wings had flitted around my feet, dancing on the flowers and drinking from puddles.

By now, as we dutifully wandered on behind the yaks, the chill of autumn was making its presence felt. On some passes drizzle turned to unfriendly sleet and in the mornings we often woke to scudding grey clouds. A skiff of snow sometimes covered both the tents and the dozing yaks tethered nearby. Thankfully, after a strenuous morning's walk, Mr Ongdi, our ever-smiling cook, whipped up hot tangy lunches for us, to be washed down by scalding draughts of lemon tea.

(One of Mr Ongdi's kitchen boys misinterpreted Betty's name so she became known as 'Bed Tea'.) At night in the mess tent, piping hot goat curry garnished with boiled potatoes and peppery poppadoms did wonders to ward off the cold. Amid chatter about the day's highlights, humour and mockery always simmered to the surface, helping considerably when our aches and pains got the better of us. Evenings were often topped off with a nip of Cointreau and home-made Christmas cake before we tumbled into bed to hug metal flasks of boiled water.

Pressure mounted to get to Lunana and to push on with the last of the yak caravans to clear the final three passes before the onset of winter. The prospect of being stranded by a major dump of snow in the harsh, desert-like country around Lunana made me shiver. With a perceptible change in the mood of the weather, we could sense winter brooding not far to the north in Tibet.

Bharal, blue sheep, at over 5000 metres near Bhutan-Tibet border.

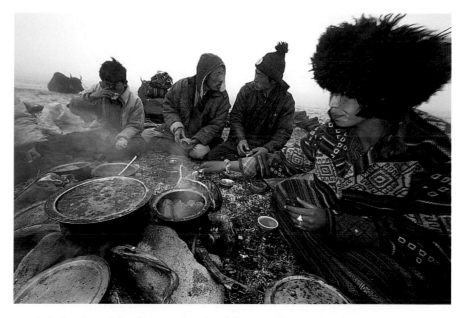

Mindu, the yak herder, prepares breakfast on a frosty morning near Lunana.

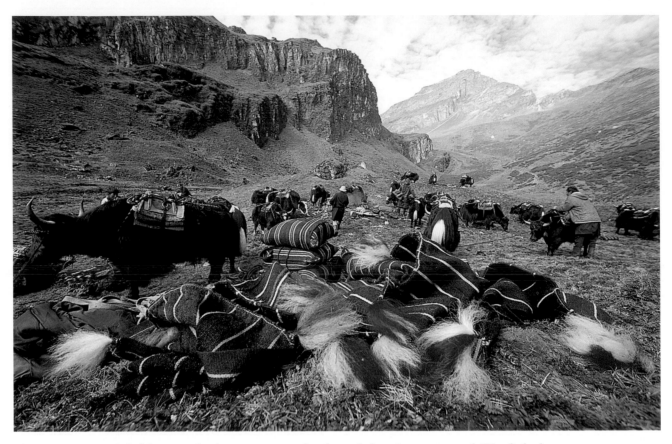

Yak drivers sort loads as our caravan heads south from Lunana towards Wandiphodang.

As we dropped down to the Po Chu (Father River) near the trek's most northerly point, we were confronted by a deep-cut gorge that had been severely gouged out by a flood. In 1994, a glacial lake's moraine wall had collapsed, sending a powerful surge of boulders and mud down-valley, sweeping everything in its path. Above, the flat-topped 7100-metre bulk of Zongophu Gang dominated the head of the valley. We had entered the Lunana district at last. On a bright morning, after a camp under a crisp, starry night-sky near Lhedi village, I watched a fresh-faced monk perform a puja for a newborn baby. With great solemnity, he fingered a dorje (a brass 'thunderbolt' that symbolises strength), clashed cymbals above his head and mumbled the mantras from the holy scripts in his loose-leafed prayerbook. An easy day's march to Chozo Dzong followed, clambering among polished river boulders and over drifts of dazzling white sand.

Arriving at Chozo Dzong was like stepping into a musty antique world. For centuries life here had not changed appreciably. Squat stone houses with narrow windows were battened down against a fierce wind that drove in from Tibet to hammer icy dust into every nook and cranny. Precious firewood piled around courtyards doubled as windbreaks. Dried pancakes of yak dung stacked on edge awaited stoking into open kitchen fires. Toothless grandmothers with claw-like fingers fussed around snotty-nosed infants with matted hair and grime-streaked faces. Interior walls were so burnished by smoke they had the sheen of old varnish. Beside the hearth, two large circular stones, turned by a handle, revolved around each other to grind barley grain into flour. (In other places, cleverly crafted stone mills were linked to paddlewheels in diverted streams.) Dismembered yak carcases hung to dry from rafters and coils of greasy blood sausage coated in dust were draped next to chains of smoked cheese blocks threaded on string. Chiru antelope horns and desiccated lammergeier heads were nailed to low door portals to ward off unwelcome spirits.

Life is far from easy in the sister villages of Chozo Dzong and Thanza. Hardship, however, has engendered resilience and strength of character in these people of Tibetan stock with their piercing eyes and shaggy sheepskin hats. Our Bhutanese staff repeatedly warned us that Lunana folk were not to be trusted yet we found them open, friendly and hospitable, welcoming us freely into their homes. Raggle-taggle kids, clustered in curiosity around camp, knew little of the stimulation of books, let alone school. Entranced by photographs of my own teenage girls, the gaggle of urchins crowded around me. Suddenly, they erupted in fear and fascination as I leapt in the air brandishing my fiery-tongued dragon puppet. Everyone desperately wanted a turn with the squeaking creature and,

given a chance, big brother rampaged in glee after little sister. Betty and I escaped and sought sanctuary by entering Chozo's crumbling dzong through massive solid wood doors. A solitary monk in patched, faded robes took us in tow. Clucking like a wizened bantam hen, he proceeded to bless our journey with a drawn-out series of chants uttered from the depths of his throat. For nearly an hour he droned out prayers from the hand-printed sheets encased in carved wooden boards.

We brought business to Lunana, of course, and before long Chozo Dzong was a hive of activity as each family readied its yaks for the haul down to the roadhead at Nikacchu, six days journey to the south. Forty yaks, twice our requirement, were outfitted with saddle cloths and baggage frames. The villagers were taking this opportunity to earn cash from us while making their annual pilgrimage to the lowlands, trading yak cheese for rice and peppers.

That final glorious week of yak travel, concluding 23 days on the Snowman, unravelled country that had been etched in my mind for years, ever since I studied the fine plates in *Sikhim and Bhutan*, John Claude White's classic 1909 account of leading British delegations on the frontier. The geography finally fell into place; the lie of the land made sense. Wanderlust was rekindled during days spent traversing the high alpine desert south of Lunana – a chaotic pile of lichen-crusted boulders, wind-seared glaciers and jade-tinted lakes. Above me, a blue sky that knew no jet trails allowed my mind to roam unhindered.

I woke next to a yak driver's family as they shivered behind a windbreak of stacked saddles. With frost on their hair, adults and children alike huddled together for warmth. Emerging from a snug down-filled cocoon, it was easy for me to hanker after their semi-nomadic lifestyle without the clutter of possessions.

On the surface, at least, it seemed a carefree life, though travelling with them day after day I was acutely aware just how hard they worked to produce the necessities of life. With stiff joints and numb fingers, a woman crawled out of snow-dusted threadbare blankets to coax a flicker of flame from sprigs of juniper. Before long, a breakfast of tsampa, tea and chopped chillies ground up with spring onions and rice was passed around the circle. The simple meal brought new meaning to the concept of sharing. The fire nipped my eyes as the smoke swung into my face but as the flames died, I added wood and watched my breath rise into the frigid air. We squatted together and chatted, waiting for the sun.

As Betty and the others scampered down the rocks to catch up with the yaks, I remained behind to sit alone on a windswept pass under bleached prayer flags. Betty and I had added our own string of flags, tensioned between two boulders, in memory of a young friend. At 5400 metres, this was the highest point on the Snowman, so it seemed a fitting place to release pent-up emotions. Up here, trivia was stripped to the bone and the excess baggage of selfishness crumbled in the face of such beauty. Somehow, after a long hard walk, it became easier to rerank priorities for the way ahead.

As we gathered on the final pass, Tample La, that led down to sparkling lakes, to the blessing of forest again and to a patchwork of carefully tilled farmland, Thinley, the true guide, threw his hat in the air and brandished his 'kingstick' aloft. 'My heart has been balanced on a needle – but now all is calm.'

I, too, turned to descend and join my friends. But on a whim I glanced behind me and caught a glimpse of distant peaks, unseen before. At that moment I knew I would return to Bhutan.

Enthusiastic school children greet a stranger by yelling 'Bhutan!' *A Gaza woman cuts green grain to feed stock under her traditionally painted house.*

SIKKIM

TIBET

Chomolhari

Masa Kang

Gangkar
Puensum

Zongophu Gang

Beyond here,
be dragons

Bumthang

Laya

Lunana

Jangothang

Gaza

Po Chu

Taktshang
(Tiger's Nest)

Mo Chu

BHUTAN
(Druk Yul)

Punakha

Thimpu

Paro

INDIA

Bhutan

Aris, Michael. *Views of Medieval Bhutan*, Serindia, London, 1982.

Aris, Michael. *The Raven Crown – the origins of Buddhist Monarchy in Bhutan*, Serindia, London, 1994.

Berry, Steve. *Thunder Dragon Kingdom – a mountaineering expedition to Bhutan*, Crowood Press, 1988.

Collister, Peter. *Bhutan and the British*, Serindia, London, 1987.

Doig, Desmond. 'Bhutan – Mountain kingdom between Tibet and India', *National Geographic*, Washington, September 1961.

Edmunds, Tom. *Bhutan – Land of the Thunder Dragon*, Elm Tree Books, London, 1988.

Gansser, Augusto. *Lunana – The peaks, glaciers and lakes of northern Bhutan, The Mountain World*, The Swiss Foundation for Alpine Research, Allen & Unwin, London, 1968–69.

Karan, Pradyumna. *Bhutan – a physical and cultural geography*, University of Kentucky Press, 1967.

Myers, Diana (ed.). *From the Land of the Thunder Dragon – textile arts of Bhutan*, Serindia, London, 1994.

Olschak, Blanche. *Bhutan, Paradise of the Himalaya – its tradition and development* and *An expedition to Bhutan – Richard Turner, The Mountain World*, The Swiss Foundation for Alpine Research, Allen & Unwin, London, 1966–67.

Olschak, Blanche. *Bhutan: Land of Hidden Treasures*, Allen & Unwin, London, 1971.

Markham, Clements. *Narrative of the Mission of George Bogle to Tibet (and Bootan) and the Journey of Thomas Manning to Lhasa, London 1876*, Pilgrim's Book House, Kathmandu, 1989.

Pommaret, Francoise. *Bhutan – a kingdom of the eastern Himalaya*, Editions Olizane, Geneva, 1984.

Pommaret, Francoise. *Bhutan – Mountain fortress of the gods*, Serindia, London, 1997.

Peissel, Michel. *Lords and Lamas – a solitary expedition across the secret Himalayan Kingdom of Bhutan*, Heinemann, London, 1970.

Ronaldshay, Earl of. *Lands of the Thunderbolt – Sikhim, Chumbi and Bhutan*, Constable, London, 1923.

Scofield, John. 'Bhutan crowns a new dragon king' and 'Life slowly changes in remote Bhutan', *National Geographic*, Washington, October 1974 and November 1976.

Steele, Dr Peter. *Two and Two Halves to Bhutan*, Hodder & Stoughton, London, 1970.

Spencer Chapman, *Freddie. Helvellyn to Himalaya – an account of the first ascent of Chomolhari*, Chatto & Windus, London, 1940.

White, John Claude. *Sikhim and Bhutan – Twenty-one Years on the North-East Frontier 1887–1908*, Edward Arnold, London, 1909.

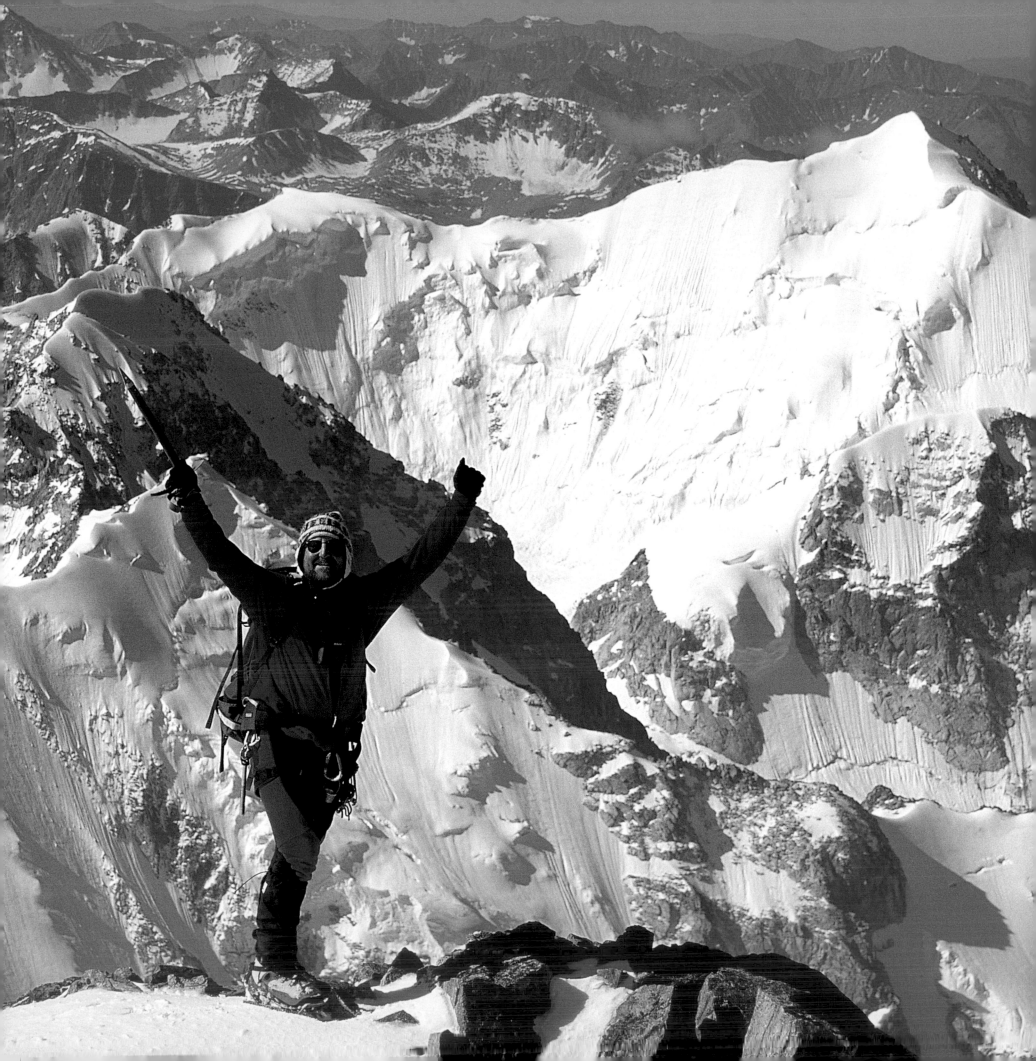

Under a Sheltering Sky

Mountaineering in Mongolia's Altai Mountains

Before us lay Mongolia, a land of painted deserts dancing in mirage; of limitless grassy plains and nameless snow-capped peaks; of untracked forests and roaring streams! Mongolia, land of mystery, of paradox and promise! The hills swept away in far-flung, graceful lines of panorama so endless that we seemed to have reached the very summit of the earth.

Roy Chapman Andrews, *Across Mongolian Plains*

It began as a rising dust cloud. Then the earth vibrated with hoofbeats as the Mongol horde charged over a grassy rise and bore down on me. Surely arrows would soon start flying. Clattering around the corner, a mêlée of horses careered into view in what was clearly going to be a close-run race. Dressed in silk tops with matching scarves in gaudy yellows, fluorescent greens and the sapphire of a kingfisher's wing, the young riders whipped their mounts mercilessly in a desperate dash for the line. Much to the delight of the roaring crowd, the leading pair was neck and neck to the last. The first to finish rode bareback while his rival, on a crude saddle without stirrups, cut a striking figure as he arched his torso, bare feet flailing in the air. In a rowdy free-for-all, spectators

LEFT: *Geoff Gabites performs an eagle dance on the summit of Khuiten.* TOP: *A Kazakh eagle hunter.*

Young riders set off to the start of a Naadam horse race.

surged around the winner, hailing him as a hero and smearing themselves in his horse's sweat, said to bring luck.

Every one of the 300 riders thundering towards me was between five and 10 years of age and it was hard to believe that such youngsters could stay mounted for the 30 kilometres of this gruelling race. Some did not. But even the riderless horses that crossed the line received a rousing welcome. Sucking her thumb again, as she had been when I first noticed her at the start of the race, one anxious little girl was close to tears from the emotional release of finishing. Last year, I was told, a six-year-old girl died in the crush as competitors jostled for starting positions. As more and more horses hurtled home to mill among the throng, the riders slumped in their saddles or dropped exhausted to the ground. With wind-seared eyes and faces caked in dust, the children beamed as proud parents rushed forward to congratulate them and lead them away to the family tent for a celebratory feast. Attending a Naadam horse race on only my second day in the country was a fine introduction to Mongol heritage. Experiencing the spirit of these youngsters set the tone for the mountaineering venture ahead.

The Naadam festival, with its vibrant mixture of horse racing, wrestling and archery, hinted at the Mongolia that lay out there beyond the capital, Ulan Baatar. I desperately wanted to travel and climb in this immense landlocked country of boundless deserts, forests, lakes and mountains. But the attraction was more than isolated glimpses of beauty. Mongolia's vast undulating grasslands, blissfully uncluttered by fences, would allow me to absorb the very essence of landscape. I also yearned for big skies where I could lie on my back and set my mind free. And, in a land where horses are still revered and the automobile does not dominate, I craved the opportunity to gallop over endless soft rolling hills. Mongolia, encompassed by Siberia and China, would be a place of extreme climates and raw terrain, yet I also sought to discover its gentler side – the play of pastel light on ancient mountains. Intrigued by an environment that has hosted the greatest land-based empire the world has ever known, I was drawn to passionate Mongols and feisty Kazakh herders. I felt sure I had much to learn from the traditional openness and hospitality of these semi-nomadic peoples.

A mountaineering expedition to the far west of Mongolia had entered my mind some years before after I saw an exhibition celebrating Genghis Khan's momentous empire. I set my heart on climbing in the remotest mountains in Central Asia and decided to use camels and horses to establish a camp on the edge of the glaciers. I started planning – making contacts in Mongolia to help with logistic support, studying rudimentary maps and reading accounts by the Russian explorer Nikolai Prejevalsky and the Englishman Douglas Carruthers. As always, it was fun to piece the puzzle together, especially as I had no real idea of what this journey would entail. Most people I talked to had only a hazy idea of where Mongolia was; many thought it was part of China. In 1921, Outer Mongolia became the world's second Communist country. For the next 70 years, the People's Republic of Mongolia was heavily influenced and supported by

the Soviet Union until Mongolia gained independence in 1990. The sudden withdrawal of Russian technical expertise and money has caused significant infrastructure problems over the last decade.

So, in July 2000, after two failed attempts in successive years to get under way, five other Kiwis and I finally set out for Ulan Baatar and a six-week expedition to the Altai Mountains. Accompanying Betty and me were long-time friends Shelley and Geoff Gabites. Avid trekkers, Shelley and Betty geared up for a series of forays from base camp on a grassy alp known as Tavan Bogd; I planned to tackle a few climbs of moderate difficulty with Geoff, a tireless expedition climber with many years experience in the mountains of Asia. A traverse of 4374-metre Mount Khuiten, the highest peak in Mongolia, was an obvious focus for the trip. Located where three empires once met, Khuiten sits astride Mongolia's ill-defined border with Sinkiang China and Siberia. For me, the appeal of the peaks around Khuiten lay in their location. It was of little concern whether the routes had been climbed before.

Khuiten's remoteness had to be factored into the expedition. After learning of a serious accident to a British team beyond Tavan Bogd in 1992 that nearly proved fatal owing to the difficulty of mounting a rescue, I was concerned about setting out with only two climbers. So when the opportunity arose for two experienced mountaineers, Dave Bamford and John Nankervis (Nank), to join us, our team was complete, compatible and, surprisingly, given the vagaries of our antique status as climbers, still reasonably competent.

On a separate venture, another pair of Kiwi mountaineers, Sandy and Jennifer Sandblom, planned an extended trans-alpine trek that would ultimately link up with us at Tavan Bogd. Both parties decided to engage the services of Graham Taylor, an easy-going Aussie who, after completing a five-month horse trek, settled in Ulan Baatar to create Karakorum Expeditions, now a thriving adventure travel company. (Dating from 1220, Karakorum, 370 kilometres south-west of Ulan Baatar, is the name Genghis Khan gave to the capital of his Mongol empire. It was occupied for only 40 years before his nephew Kublai Khan moved the capital to Peking. It is coincidental that the Karakoram Mountains, which straddle Pakistan and Sinkiang China, bear the same name.)

Just getting to Mongolia was an adventure in itself. It started innocently enough at breakfast in Beijing when I glanced at the *China Daily*. 'Today, 5 July, Viagra was officially released in China. Despite stiff opposition from the natural medicine fraternity it remains a widespread misconception in China that Viagra is an aphrodisiac.' If nothing else, I mused, the report should boost sales of Viagra and, with luck, prevent a few tigers from being ground up for love potions. Later that morning, we elbowed our way onto the Trans-Mongolian Express at Beijing's imposing railway station. Right on time, the train graunched into motion and our little expedition sank back and relaxed, only too pleased to be

The 25-metre-high Migjid Janraisig Sum Buddha in Ganden monastery, Ulan Baatar.

leaving the city's humid grey smog behind. The 30-hour train journey would traverse China's intensely farmed Inner Mongolia, then chug up towards the more arid Outer Mongolia, long known as the land of blue skies.

The dark green German-made train threaded its way northward through tunnels and mist-shrouded ridges draped in the embracing arms of the Great Wall. The Mongols must have been truly feared 'foreign devils' to warrant the

The Naadam Festival

The guard of honour for Genghis Khan's yak tail standards en route to the Naadam opening ceremony.

Our expedition was timed to reach Ulan Baatar before 11 July to coincide with Naadam, an intense two-day festival featuring Mongolia's national sports of wrestling, archery and horse racing. The three sports are known as Eriin Gurvan Naadam – the three manly games. The word naadam stems from naad, to rejoice or to play. An ancient celebration, Naadam takes place all over Mongolia, though in centres outside Ulan Baatar the dates may vary considerably. Naadam in smaller centres can provide more intimate contact with local people but the impressive opening and closing ceremonies in Ulan Baatar are definitely vibrant, colourful affairs – an ideal way for a first-time visitor to become immersed in Mongol culture.

The opening ceremony began with red-jacketed guards on exquisitely groomed white horses parading Genghis Khan's standards. After collecting the standards from the Soviet-style parliament buildings in Sukhbaatar Square, the horsemen trotted to the sports stadium on the edge of the city. Before Prime Minister Nambaryn Enkhbayar of the Mongolian People's Revolutionary Party (the former Communist Party) and a crowd of thousands, drummers, dancers and singers greeted the arrival of the horsemen. Then, much to the amazement of the gathering, 20 skydivers jumped from helicopters that circled overhead. To loud applause they landed precisely on target, trailing banners that heralded Mongolia's forthcoming participation in the 2000 Sydney Olympics. Next, competitors queued to pay homage to the white yak tails on long lances, their heads bowed in reverence. During the repressive years of Soviet occupation, practising religion or honouring Genghis Khan in any way had been expressly prohibited. Mongolians are rediscovering their proud history, allowing it to flourish once more in festivals such as Naadam, in Buddhist dance and in school education.

Midday temperatures during Naadam were high, though July is considered the rainy season. At times, sudden thunderstorms saw us scurry for cover, though the downpours settled the dust and cooled the air, making for pleasant evenings. We dined on trout, salad, fresh potatoes and Genghis beer before attending spellbinding concerts of dance, acrobatics and music. Rousing throat singers stole the show, backed by an 80-strong orchestra playing morin khuurs, carved string instruments shaped like miniature horses' heads.

During the day, contestants dressed in elegant silk robes (dels) of iridescent blue, golden-yellow and maroon engaged in spirited bouts of archery, said to keep ancient battle skills alive. The success of the Mongol cavalry during Genghis Khan's time has been attributed to the riders' ability to stand up at full gallop balanced on a high-sided wooden saddle, allowing them to fire short recurve bows in either direction. Each horseman had up to 20 fresh mounts in reserve, enabling the cavalry to cover astounding distances and outmanoeuvre the enemy. The tie that male Western office-goers persist in wearing as a mark of refinement has its origins in the Mongols garrotting their victims, dragging them tied by their necks to the saddle. As Lord Curzon, Viceroy of India from 1899 to 1905, wrote, 'Mongols are extraordinary people who once planted sovereigns on the throne of Peking. They overran and nearly conquered Europe, creating an amazing though ephemeral empire that stretched from Cathay to France and bequeathed to India the Mongol (Mughal) dynasty which left so deep a mark on its architecture and history.'

Chunky wrestlers wearing pointed four-cornered hats and clad in studded briefs and leather arm guards stalked warily around each other before locking horns to battle it out for supremacy. Winners of each tussle pranced around

A Mongol woman competes in an archery contest.

in a circle with arms outstretched, performing the traditional eagle dance. The crowd was stunned when the national hero Bat-Erdene withdrew from the wrestling at the semi-final stage, forgoing what would have probably been his 12th straight 'invincible Titan' title.

On the outskirts of Ulan Baatar – the capital has a population of 600,000 and the country's total population is 2.5 million – a tent town sprang up, with riders coming from near and far for the fiercely contested series of horse races. The 'parking lots' between tents decorated with Buddhist good luck symbols were filled with rows of horses tethered to overhead lines. Clusters of families and friends sat around, revelling in the carnival atmosphere and basking in the warmth of the brief Mongol summer. Kumiss (fermented mare's milk), known locally as airag, flowed freely.

Standing in stirrups and flourishing plaited rawhide whips, proud fathers rode around the camp to coach children on the finer points of galloping in a last-minute build-up to a race. Sharing a drink with a rowdy bunch of fiercely competitive horsemen, I made the mistake of calling Mongol mounts ponies. In a land that once created an empire which stretched from the Sea of Japan to Hungary, horses are still worshipped. I was told in no uncertain terms that they may be rather short horses but they are definitely *not* ponies.

After the mountaineering part of our expedition we planned a trekking trip to a high lake region of Tavan Bogd National Park close to the Chinese border. It was while watching the Naadam riders that the illogicality of walking in Mongolia suddenly struck me. The writer Freya Stark thought that riding swept the mind clean so, travelling on horseback, with camels to carry the baggage, had to be the best way to traverse this vast, inspirational landscape.

Throat singers bless traditional blue silk scarves at the opening ceremony.

Chinese building a 2400-kilometre long defence structure that stretched from Kansu province to the Yellow Sea. Though begun as early as 210 BC, the Great Wall as it remains today was designed during the Ming Dynasty so that five horses could travel abreast. It has the distinction of being the only man-made structure on Earth that is visible from the moon. Can you imagine the look on the stone quarry foreman's face when he received orders from the emperor – 'He wants to build what?' As we rumbled through one of the squalid soot-drenched cities north of Beijing I tore a 50-yuan note in half, slipping one piece to the Chinese attendant. He almost smiled, realising that if he gave us good service he'd get the other half in Ulan Baatar.

We knew we had entered the Gobi Desert only when a burly border guard turfed us out of bed at 2 a.m. and searched for stowaways in the baggage lockers under the bunks. Meanwhile, with the carriage jacked up, swarthy women clad in overalls and wearing platform-heeled shoes used sledgehammers to change the bogey wheels to the Mongol gauge. The logic may seem flimsy, but Mongolia maintains a different gauge railway to help protect itself from the avarice of a growing superpower on its southern border. Among the world's deserts, the Gobi is second in size only to the Sahara. Blanketing southern Mongolia, it stretches into the Chinese provinces of Sinkiang, Kansu and Inner Mongolia. The Gobi takes its name from the Mongol word for gravel-covered plain but it is also a forbidding mixture of salt flats, sand dunes, rocky escarpments and barren peaks. Precipitation in the Gobi ranges from 8 to 20 centimetres and snowfalls are common during the cold winter months of October to May. Dust storms plague the desert, whipping sand and gravel through the air with stinging velocity.

Of all the peoples of Central Asia destined to live between China and Russia – Kazakhs, Uighurs, Uzbeks, Kirghiz, Tadjiks, Tibetans and Samoydes – only

Horse and camel caravan hauls expedition baggage past bog cotton en route to Tavan Bogd base camp.

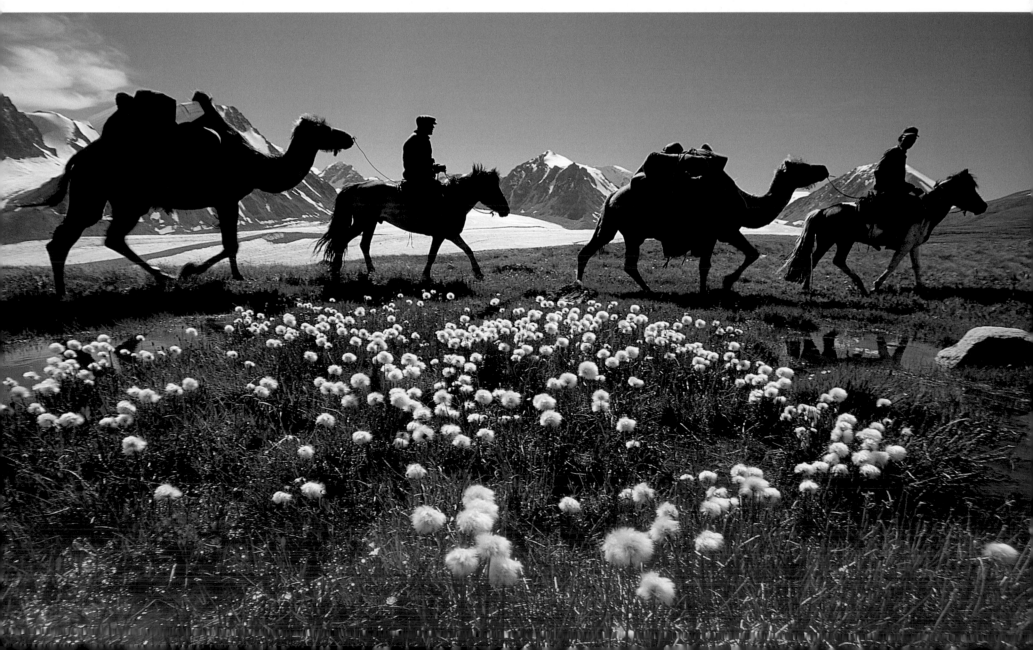

the Mongols survived relatively intact and emerged with a country to call their own. After 300 years of resenting Chinese domination and 70 years of suffering under tight Soviet control, Mongolia finally regained its independence in 1990. Our train would eventually trundle on to cross Mongolia from south to north and link up with the Trans-Siberian Railway for the five-day journey to Moscow. Grateful to uncurl our legs at last, we stumbled out of the carriage in Ulan Baatar, blinking in bright, thin sunlight.

Our dishevelled party of wide-eyed Kiwis was met at the station by a lanky, grinning Graham Taylor. Almost at once, in Graham's van, we were embroiled in a farcical traffic jam. As we crawled towards the city centre, I spotted a wild-looking horseman who stood in the stirrups and leaned forward as he cantered at a fair clip down the street. Fascinated, I watched the rider as he skilfully led five horses, weaving between belching automobiles with complete disregard. I knew then that I was going to like this place.

Graham dropped us off to explore the markets with our interpreter Chinzo. A dapper city boy with a spiky haircut, Chinzo turned out to be the most fastidious, obsessively clean-living liaison officer anywhere in Mongolia. He proved invaluable over the next two days as we set about purchasing food supplies to supplement the mountain rations we had brought from New Zealand. At one point, while we searched a shop for a pressure cooker to help stew the tough mutton we knew would dominate our menu, two scruffy men approached us to see if we wanted to buy a dinosaur head. The Gobi Desert is famous for its fossils, including 47 species of dinosaur. Ulan Baatar's Natural History Museum contains a superb dinosaur display.

The imminent Naadam national holiday would shortly close shops and government offices so we rushed to repack our food and climbing equipment and air freight it across Mongolia to the Kazakh township of Olgii, a four-hour flight to the west. Relieved to have this frantic part of the expedition behind us, Betty and I eased into the spirit of Naadam by visiting Ganden monastery in the heart of the city. Mongolians are primarily Buddhists, though in the Olgii district the Kazakh-speaking people are Muslims. As a symbol of freedom to the Western world during decades when Mongolia was a Soviet puppet state, Ganden was allowed to remain open, largely to convince outsiders that contentment reigned in Mongolia. In reality the terrible Choibalsan, Mongolia's own pathological clone of Stalin, butchered monks and destroyed monasteries on a scale akin to China's genocidal purges in Tibet. Young Mongolians today are starting to learn the truth of these brutal years. The dislocation was so severe that Mongolians are only now discovering they actually have family names.

On 13 July, with the vibrant two days of Naadam behind us, we turned our focus to the distant Altai Mountains, some 2000 kilometres away. After a two-hour MIAT flight over a gaunt, leopard-coloured land of scruffy pine forests

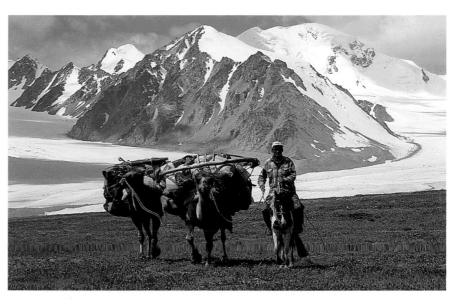

Camels hauling a dismantled ger below Mount Khuiten.

The Kiwi ger-iatric ward – climbers inside the base camp ger below Khuiten.

and raw craggy hills, we refuelled near a town called Moron. Crammed into the aircraft once more, I was face to face with a fat fish bought beside the runway and now stuffed in the seat pocket in front of me. We flew on for another two hours over a vast network of salt lakes. The plane descended towards what looked like a cruel desert wasteland saved only from oblivion by a lazy oxbow river, its vivid green verges dotted with white circular gers belonging to Kazakh herders. Collapsible, easily transported felt tents, gers are better known by their Russian name, yurts. From the air they looked like clusters of button mushrooms.

With Siberia a stone's throw away over a nearby hill to the north and Sinkiang China a mere scramble through a snowy pass to the west, we found ourselves in one of the most isolated spots in Mongolia, among some of the remotest mountains on Earth. To gain an appreciation for the scale of the Altai peaks spread out behind camp, on our first day at Tavan Bogd we clambered up a rocky 4000-metre bump called Malchin. Rain and snow flurries buffeted us all the way to the top. Unhindered by the need to acclimatise to the extremes of altitude normally encountered in the Himalaya, we had fun returning to base camp by a circuitous route, romping down a snowslope and bum-sliding into Siberia.

Next, we traversed a prominent peak called Nairandal. After crossing the Potanina Glacier, Dave, Nank, Geoff and I cramponed up steep frozen snow slopes to a summit plateau. We were rewarded with commanding views of Khuiten and Tavan Bogd, the name for Mongolia's five holy peaks that arc away to the north. Downclimbing a rocky buttress directly under Nairandal's summit, it did not take us long to drop onto easy-angled slopes and gain access to an unnamed glacier under Khuiten. Not roped to a companion, the lead climber suddenly broke through the masked roof of a small but nasty crevasse. It was a close call. Suitably chastened for our carelessness, we tied the rope into our harnesses and travelled down the glacier as two teams, keeping the safety rope tight between us all the way home.

In camp, we shared some happy moments with a gregarious American expedition that had suddenly turned up. Later, out on the glacier, we met their leader, the guide Tod Burleson (nicknamed 'Hot Toddy' by one irreverent Kiwi) as he descended from a whirlwind trip up Khuiten with a clutch of weary clients. During Hot Toddy's hurried departure next day, our naughty nomad took mischievous delight in picking a strand of straw and adding it to a camel's load, a dismantled ger. As the groaning camel lurched to its feet and staggered off down-valley, we wondered if Nank's last straw would break its back.

Alone once more, rested and with carefully packed rucksacks of lightweight food and minimal climbing gear, the four of us set off across the ice again, this time to occupy a high camp on the Potanina Glacier's upper névé. In two tiny tents pitched side by side directly under Khuiten's East Ridge, we snuggled into sleeping bags that night, eager to tackle Mongolia's loftiest summit next morning.

By now the weather was stable and calm, with clear nights producing hard frosts. The crampon conditions were perfect and the surface usually remained firm until early afternoon. By then, running water on the glaciers made even narrow crevasses a real threat. Soaked boots would be hindrance enough; becoming jammed up to the chest in a crevasse filled with icy water could well be deadly. As it turned out, the lower glaciers proved more dangerous than climbing Khuiten.

The east-west traverse of Khuiten was a pleasant affair. Treading a fine, frozen line between curly cornices overhanging the Potanina Glacier and the

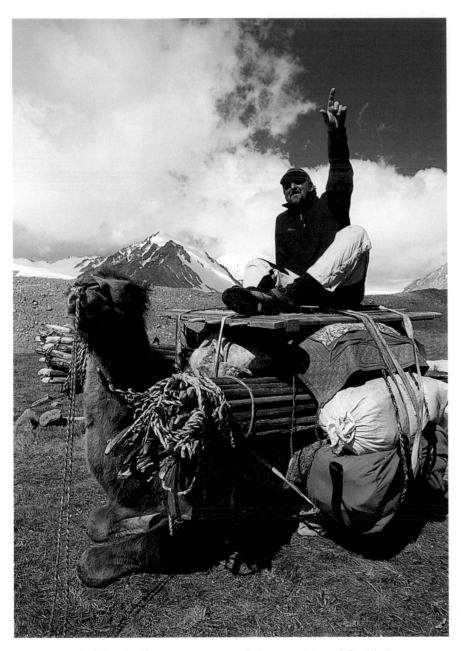

Geoff leaving base camp on a ger-laden camel bound for Olgii.

shattered shale-ice gullies that plummeted into China, each of us cramponed along at his own pace, lost in private thoughts. Such was our confidence there was no need to use a rope. As Geoff and I climbed onto the broad summit, a keen wind blasted us with powder snow. It tore away our yodels and yells to Dave and Nank, now appearing as dots on the ridge below.

To the north, the immensity of Siberia taunted us with sharpening glaciated tops on the horizon that appeared thin as paper above misty blue flanks. Nearby lay Tuva, an independent country until harvested by the Soviet sickle after the Second World War. (Tuvan cavalry fought the Germans on the Russian front.) In my preparation for Mongolia I had been thrilled to discover a 1938 diamond-shaped Tuvan stamp in my father's album depicting yaks under a mail service floatplane. An extensive basin of swamps and forests, Tuva has been described as the lost world of Central Asia. Rising in Tuva's mountains, the mighty Yenisey River is the Amazon of Asia, flowing northward for 6000 kilometres into the Kara Sea. Strangely enough, in 1991, I stood at the mouth of the Yenisey after a transit of the Arctic Ocean on the Soviet nuclear-powered icebreaker *Sovetsky Soyuz*. On a chilly beach, among ice blocks, we had found a cache of rusty walrus spears. Nearby, two mammoth tusks were dug from the silt. The estuary was littered with driftwood and smashed logs flushed all the way down the Yenisey from the taiga forests of Tuva.

Scanning the horizon to the south from my lofty perch on Khuiten I saw an attractive jumble of summits crowding the Chinese Altai. One elegant peak, sculpted like New Zealand's ice queen, Mount Tasman, turned my head, though it did not even rank a name on a rudimentary 1967 Polish sketch map tucked in my pocket. In only three days from Sinkiang's capital Urumchi, you could muster camels and horses to approach this peak and…ah well, another dream!

As we lay among flowers outside the ger after the climb of Khuiten, Sandugash served up beetroot-red borscht soup and potato salad with lashings of fresh yogurt. Betty and Shelley turned up soon after, home from a tramp that had been rewarded by secluded moments on high meadows spent sketching and writing. Occasionally, a strolling herd of camels would drift through the camp only to munch and move on, but not before, one day, tripping heavily over Sandy and Jennifer's guy ropes, badly ripping the tent. By now, in late July, our two friends had joined us after an 11-day trek that had crossed a glaciated pass above Lake Khoton. That night we all supped kumiss and swapped stories, then tiptoed off to snooze among scented herbs and listen to prayer flags chattering in the breeze. An hour-long eclipse of the moon cast eerie shadows across the tent.

Our next objective turned out to be a beauty – a climb of White Stupa, a shapely ice peak that had continually caught our attention in the soft evening light as we sat outside the ger. It was a five-hour trudge up the Aleksandrov

Glacier before we could occupy a high camp under the peak. It was the perfect place to read the powerful essays from Jack Turner's *The Abstract Wild*, an urgent plea to take a stand on retaining true wildness. As a huge moon glided across the heavens I drifted off to sleep, content to be with those sharing the bivouac, tucked away in this serene alpine playground.

Standing on Yeti Col next morning at the head of the Aleksandrov Glacier, we looked down into China and the Prejevalsky Glacier. Beyond, the South Ridge of Khuiten rose from the shadows. It was on this long rock and ice ridge, in 1992, that a boulder had crushed the leg of English alpinist Lindsay Griffen. A desperate week of extreme pain followed while Lindsay waited for his mates to secure enough fuel for a helicopter to reach Olgii then to make it over the border above Tavan Bogd and pull off a remarkable pick-up. Accounts of the ordeal are sobering and should be read by anyone contemplating an expedition in remote regions.

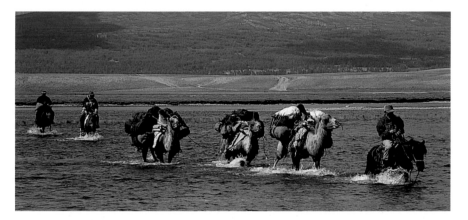

Our caravan crosses a river, bound for Lake Khurgan.

Bactrian camels and Sandugash beside Lake Khotan near the Chinese border.

Mongolia's Wildlife Under Threat

Takhis, Prejevalsky horses, grazing in Hustain Nuruu National Park.

During 20 years of expedition travel throughout Central Asia and the Himalaya I have been constantly dismayed by the plight of wildlife, under threat from poaching and the destruction of habitat owing to human population pressure. Sadly, Mongolia proved to be no different from other high Asian countries – snow leopard, ibex, argali sheep, antelope and wolf are all endangered species.

Mongolia's native horse, named after the Russian explorer Nikolai Prejevalsky in the 1870s, was last sighted in the wild in 1968. Only captive breeding in European zoos and private parks has kept this wonderful creature from extinction. Called takhis by Mongols, Prejevalsky horses have now been reintroduced into Mongolia at two sites, including Hustain Nuruu National Park, some 100 kilometres south-west of Ulan Baatar. Since the project's instigation by The Netherlands in 1992, and with dedicated support by the Mongolian government and volunteers, some 100 takhis have now been released into the forest steppe reserve. I spent a wonderful day at Hustain Nuruu and will never forget these beautiful horses coming down out of the hills in the cool of evening to graze in lush grass by the river.

The success story of the takhi offers hope that Mongolia is now more aware of the value of its wildlife and its unique environments – the arid, fossil-rich Gobi Desert, the vast open steppe grasslands, the stunted pine and larch taiga

forest in the north and the high alpine glaciated regions in the far western Altai Mountains. Sadly, though, other animals in Mongolia may soon face really tough times.

Descending a peak above Tavan Bogd one day, we stumbled upon a stash of argali sheep horn. Nearby, two derelict aircraft landing skis looked as if they had been used in winter as sledges to haul carcases. When Atai learned of our find he feared poachers from Siberia, though he said the kills may have dated from when Soviet troops occupied Olgii, only 200 kilometres away.

Atai and his network of rangers do what they can to educate herders on the need to protect endangered species. From her home in Olgii, Sandugash helps local Kazakh women sell their felt carpets, embroidery and cashmere wool, boosting their economy and in turn helping to fund the International Snow Leopard Trust, an initiative set up by American researchers Tom Macartney and Priscilla Allen. In exchange for marketing Kazakh craft the trust is trying to convince the semi-nomadic herders not to kill snow leopards in retribution when the big cats take their young camels, yaks, sheep and horses. (See www.irbis-enterprises.com and www.snowleopard.org)

Arghali horns dumped by poachers, Tavan Bogd.

Today, in the free enterprise system of an independent Mongolia, argali (*Ovis ammon*), ibex (*Capra sibirica*), snow leopard (irbis in Mongol), wolf and lynx are all actively pursued by hunters, some taken by wealthy Westerners who pay high fees to unscrupulous local entrepreneurs. The decline in ibex and argali numbers also threatens the snow leopard for the members of the Caprinae mountain sheep-goat family are the principal prey for this exquisite, elusive and solitary cat.

There are now only about 800 snow leopards in Mongolia, found mainly in the south Gobi and in the Altai Mountains. Despite complete protection in Mongolia, illegal hunting does occur, principally for trade in hides and bones.

Knowing my interest in documenting the plight of the snow leopard, Graham Taylor took me to a ger restaurant in Ulan Baatar which displayed no less than 20 pelts on its walls. Many souvenir shops in Ulan Baatar sold products such as fur hats made from the thick winter pelts of lynx, fox, wolf and snow leopard. It is vital that Mongolia's new leadership appreciates the implications of continuing to think that theirs is a limitless land of plenty.

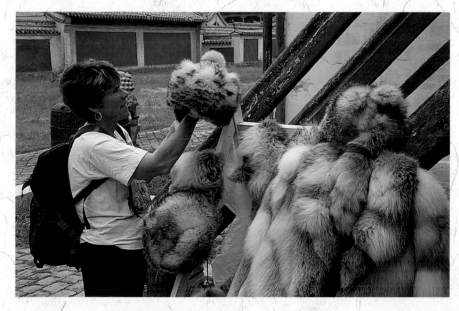

Betty examines fur hats, Ulan Baatar.

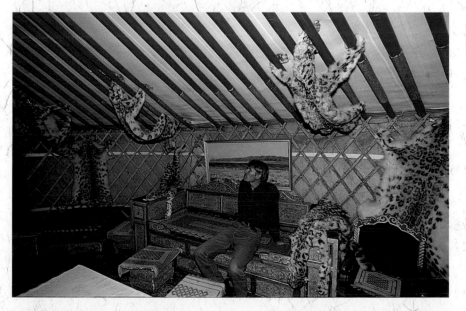

Graham Taylor in an Ulan Baatar ger restaurant with snow leopard skins on display.

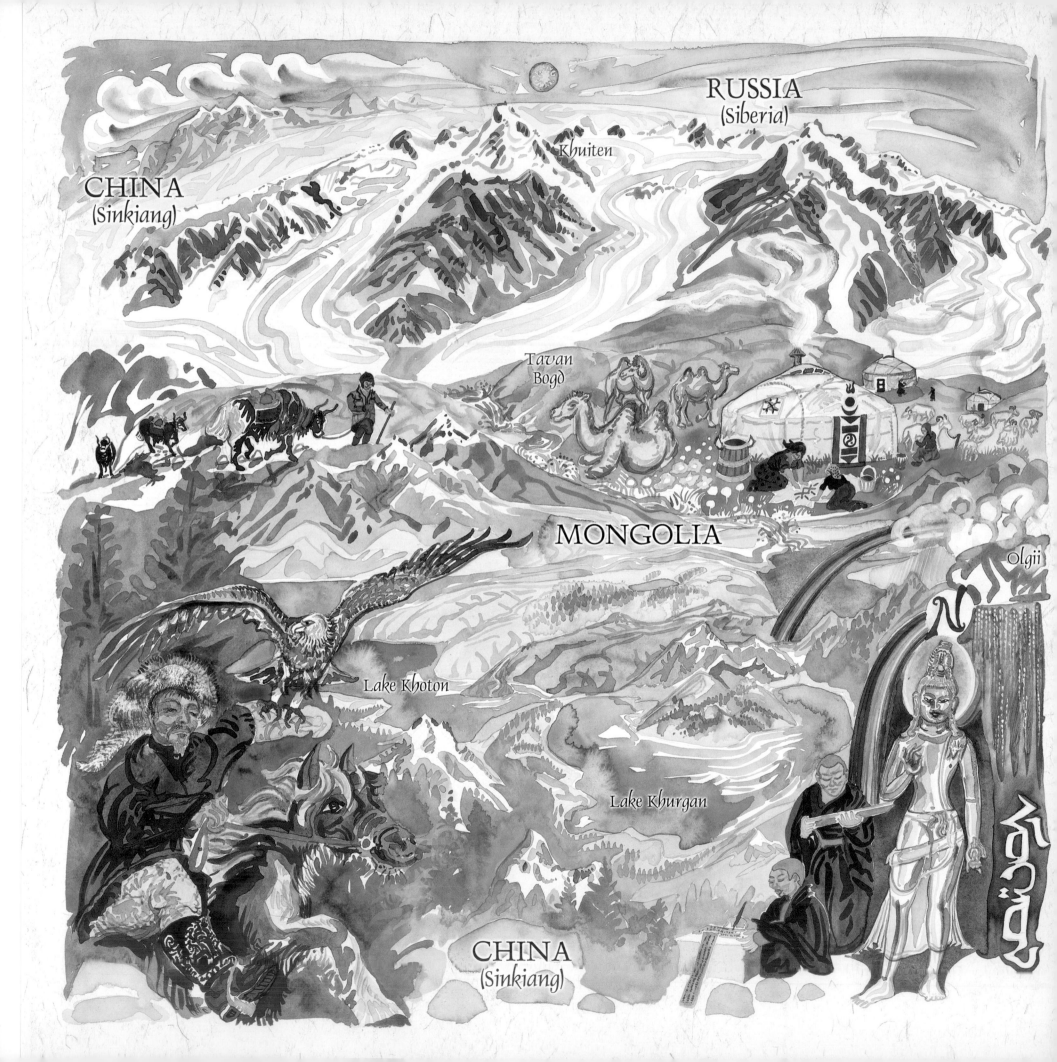

Mongolia

Andrews, Roy Chapman. *Across Mongolian Plains*, Blue Ribbon Books, New York, 1921.

Bawden, C.R. *The Modern History of Mongolia*, Weidenfeld & Nicolson, London, 1968.

Becker, Jasper. *The Lost Country: Mongolia Revealed*, Hodder & Stoughton, London, 1992.

Bisch, Jorgen. *Mongolia: Unknown Land*, Allen & Unwin, London, 1963.

Brent, Peter. *The Mongol Empire*, Weidenfeld & Nicolson, London, 1976.

Berger, Patricia and Terese Tse Bartholomew. *Mongolia – The Legacy of Chinggis Khan*, Thames & Hudson, London, 1995.

Carruthers, Douglas. *Unknown Mongolia – A record of travel and exploration in NW Mongolia and Dzungarai*, Hutchinson, London, 2 vols, 1913.

Gallenkamp, Charles. *Dragon Hunter – Roy Chapman Andrews and the Central Asiatic Expeditions*, Viking Penguin, New York, 2001.

Goldstein, Melvyn and Cynthia Beall. *The Changing World of Mongolia's Nomads*, The Guidebook Company, Hong Kong, 1994.

Haslund, Henning. *Tents in Mongolia (Yabonah) – Adventures and experiences among the nomads of Central Asia*, Kegan Paul, London, 1934.

Haslund, Henning. *Men and Gods in Mongolia (Zayagan)*, Kegan Paul, London, 1935.

Hedin, Sven. *Riddles of the Gobi Desert*, Routledge & Sons, London, 1933.

Lattimore, Owen. *Inner Asian Frontiers of China*, American Geographical Society, New York, 1940.

Lattimore, Owen. *Mongol Journeys*, Doubleday, New York, 1941.

Lias, Godfrey. *Kazak Exodus – a nation's flight to freedom*, Evans Brothers, London, 1956.

Man, Wong How. *From Manchuria to Tibet*, Allen & Unwin, Sydney, 1998.

Man, John. *Gobi-Tracking the Desert*, Weidenfeld & Nicolson, London, 1997.

Otter-Barry, R.B. and H.G.C. Perry-Ayscough. *With the Russians in Mongolia*, John Lane The Bodley Head, London, 1914.

Prejevalsky, Nikolai. *Mongolia – The Tangut Country and the solitudes of northern Tibet*, Sampson Low, London, 2 vols, 1876.

Sicouri, Paola and Vladimir Kopylov. *Forbidden Mountains – The most beautiful mountains in Russia and Central Asia*, Indutech, Milan, 1994.

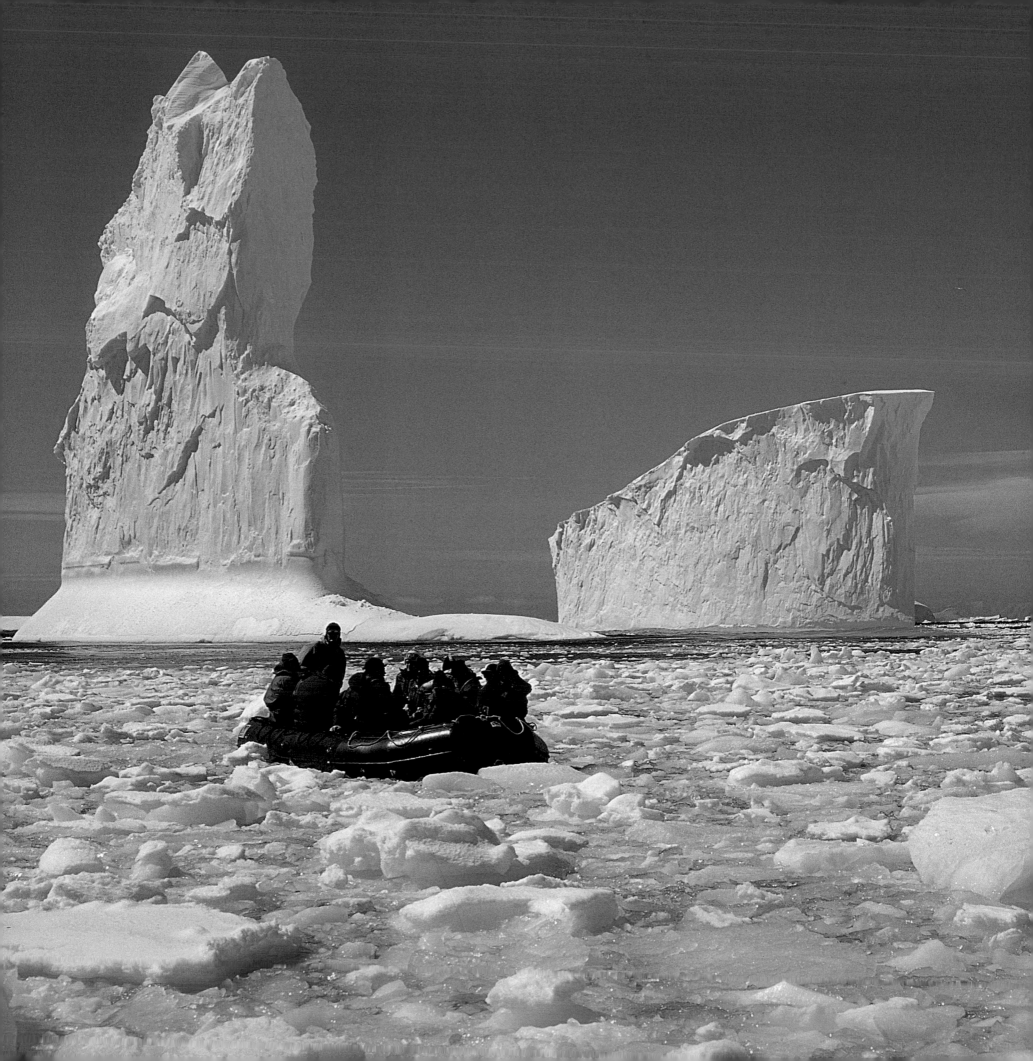

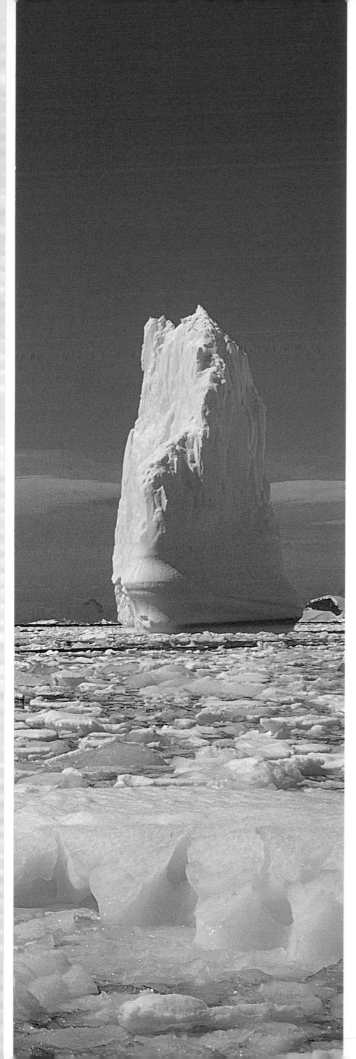

No Turning Back

Crossing South Georgia on Shackleton's route

For a joint scientific and geographical piece of organisation, give me Scott; for a Winter Journey, Wilson; for a dash to the Pole and nothing else, Amundsen: and if I am in a devil of a hole and want to get out of it, give me Shackleton every time.

Apsley Cherry-Garrard, *The Worst Journey in the World*

Wind-worn, wet and with one team member seriously chilled, our mud-spattered party stumbled out from the mountains as nightfall clamped around South Georgia. Bone-weary, the eight of us trudged across soggy snowfields and knee-deep bogs on the last leg of our three-day traverse from a southern fjord called King Haakon across to Stromness Bay on the north coast. Elephant seals belched from the ooze, king penguins gawked and moulting reindeer snuffed the wind, all indifferent to our passing.

Approaching the rusted hulk of Stromness whaling station, we squelched past a platoon of fur seal pups nimbly defending their territory. In dribs and drabs, each of us entered the manager's derelict house, a welcome refuge from freezing rain. As drenched garments were stripped and rows

LEFT: *Greg Mortimer drives through brash ice, Curtiss Bay.* TOP: James Caird *heads for South Georgia.*

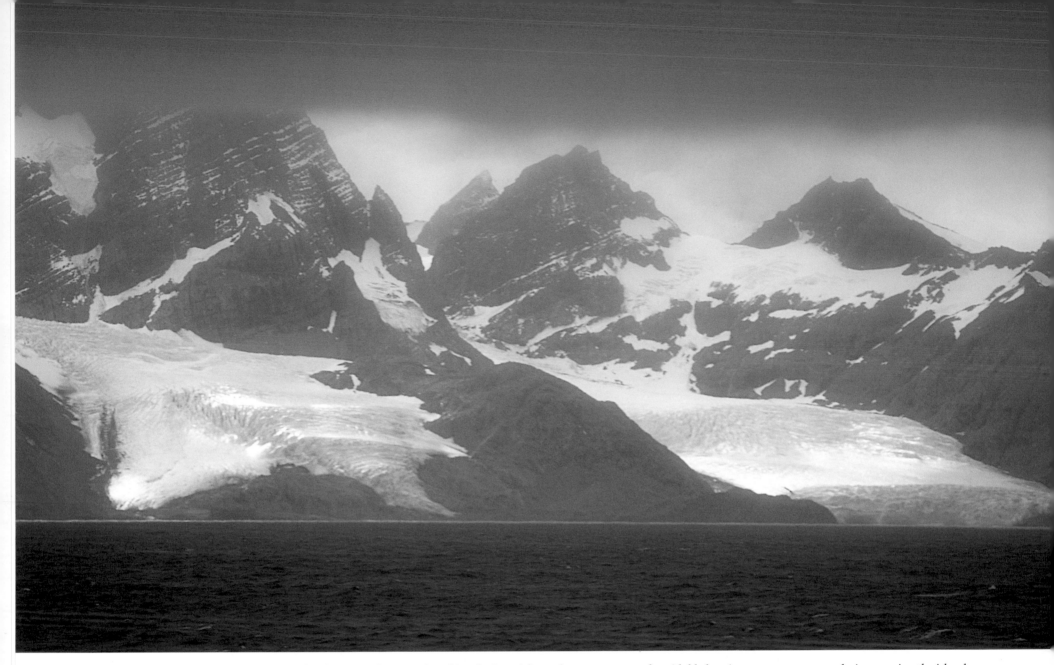

Glowering through storm cloud, the glaciers and mountains of South Georgia's south coast present a formidable barrier to anyone contemplating crossing the island.

nourishment, they took turns to grip the kerosene primus stove between their knees, painstakingly heating hoosh, a fat-rich, sloppy stew. The grim conditions deteriorated further when salt tainted the fresh water barrels. Unbelievably, two precious reindeer sleeping bags became so saturated they were thrown overboard.

Meanwhile, the New Zealand captain, Frank Worsley (Wuzzles to the crew), was topside, fighting to hang on while he aimed the sextant at a gyrating horizon. Absolutely critical, Worsley's navigation was made all the more tricky by soggy calculation tables, a questionable chronometer and only four brief sun sightings during the entire voyage. They knew that to miss South Georgia meant certain death in the Southern Ocean.

With the scales all but tipped against them until the last moment, Worsley managed to reach South Georgia's south-west coast in the best possible place,

though a storm prevented a landing for several days. By now, they were parched and salt-soaked and all were weak from lack of food. Finally, in an act of desperation, *James Caird* was beached in Cave Cove, a small embayment on the outer edge of King Haakon Bay. Worsley described the landing.

As *James Caird* grounded on the beach we leapt from her bows and hauled her up… we took it in turns to have a good drink. This water came from the swamps above, and it may have been peaty or muddy, but to us it was nectar. Meanwhile the boat was bumping heavily on the boulders, for even here there was a considerable surf. Her stern swung round against the rocky cliff and in the darkness her rudder was torn off… and was lost. We realised what this meant but we had no time to worry about it for it was imperative to haul the boat up out of the sea to prevent her from getting smashed.

And later, after seven days at Cave Cove, regaining their strength and jury-rigging the *James Caird*'s rudder so they could sail up the fjord, he wrote:

> I saw an object bobbing about in the surf and Crean waded out knee-deep to investigate… 'The rudder!'… After six days' wandering, with the vast Southern Ocean and all the shores of South Georgia to choose from, that rudder, as though it were faithfully performing what it knew to be its duty, had returned to our very feet. This incident strengthened in us the feeling that we were being protected in some inexplicable way…

By now, with the ever-present vision of their mates stranded on Elephant Island pressing on them, Shackleton knew an attempt to cross the island was imperative

On 10 March 2001, our ice-strengthened Russian vessel *Molchanov* pounded northward towards South Georgia from the Antarctic Peninsula on the final leg of a three-week voyage. I had long been intrigued by Shackleton's spirit in the face of incredible odds and this opportunity to visit the interior of South Georgia allowed me to experience for myself the explorer's most famous saga. In my 25 seasons in Antarctica I had been to many of the places Shackleton's men had first probed, particularly in the Ross Sea region, so crossing South Georgia was, for me, the final link in his story.

As we neared King Haakon Bay, briefing sessions were held, stoves tested and crevasse rescue gear stowed in packs. Our leader, Greg Mortimer, with whom I have climbed in the Karakoram and Tibet, now runs the Sydney-based Aurora Expeditions, an innovative polar cruise company that fosters camping, diving, kayaking, climbing and an appreciation of the wildlife. Greg was very conscious of the seriousness of guiding clients on a potentially extreme journey across South Georgia, so had turned down applicants with insufficient experience. Six were finally selected for the crossing: four Australians – Chris and Michelle Ward, Martin Dumaresq and Peter Marsh – an American, Tom Powell, and a hard-bitten 61-year-old Scot named Roger Booth. I knew Peter as a member of the New Zealand Alpine Club and both Greg and I had travelled with Martin in the Karakoram. During a shake-down climb on Rongé Island earlier in the voyage, Greg and I had observed the team's strengths and weaknesses. Given anything but extreme conditions, we considered the party would just squeak through.

Nervous anticipation of what lay ahead spread through the crossing party as *Molchanov* nudged closer to Cave Cove, *James Caird*'s first landfall on the outer edge of King Haakon Bay. Excited chatter from the other passengers was infectious, their enthusiasm an important ingredient in the success of our venture. Flurries of snow pranced around the stern, then cavorted and scurried across the crests of inky-black waves. Glowering peaks snarled at us from under a band of bruised cloud. Glinting in a feeble patch of sun, sealskin-grey glaciers folded like crumpled cardboard and flowed into the sea, the jagged lips of crevasses blowing skeins of powder snow skyward. In perfect unison, a pair of sleek sooty albatrosses wheeled overhead. Their forlorn and haunting *peee-aaah* cry is never forgotten by those who venture to these latitudes.

Conditions were favourable for *Molchanov*'s Zodiacs to land at Cave Cove. Our party, fresh-faced and fuelled by a cooked breakfast, assembled in front of

Looking down on Cave Cove, Shackleton's first landfall on South Georgia. King Haakon Bay lies behind.

There are no trees on South Georgia; this trunk has drifted from South America. The crossing party at Peggotty Camp ready to set off for Shackleton Gap.

Scrambles in the Heart of the Antarctic

Despite the blizzard raging off Ross Island we knew there would not be a second chance to leave *Frontier Spirit* and establish our camp at Cape Royds. With icy pellets peppering the windscreen, the helicopter tilted, then lurched violently from the deck, disappearing in seconds into a swirling wall of sleet. From Cape Bird we juddered 30 cautious kilometres around a coastline choked with heaving ice floes, gingerly feeling our way down to the surface near Shackleton's hut amid plumes of blowing powder snow. With summer already on the wane in mid-February and storms increasingly frequent, the five of us used our climbing ropes to secure the helicopter and our tents to the volcanic scoria at the campsite. Raucous calls from moulting penguins emphasised our proximity to the most southerly Adélie colony.

From the outset it had been a wild idea. Over the 30-year history of Antarctic seaborne cruising no ship had ever entered the Ross Sea twice in a single summer. So, in 1990, when Quark Expedition's *Frontier Spirit* decided to orient its maiden season around two voyages to the Scott and Shackleton huts on Ross Island, Australian adventurer Mike McDowell and I immediately decided to embark on a small private expedition. We planned to leave the ship on the first cruise into the Ross Sea, reboarding several weeks later when the vessel re-

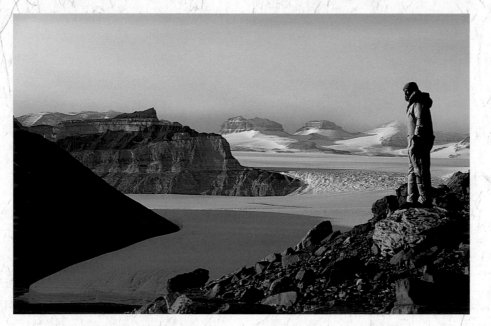

Mike McDowell admires peaks at the head of the Taylor Dry Valley.

turned from New Zealand with another load of passengers. Driven primarily by a desire to climb in the Dry Valleys of South Victoria Land, we also wanted make an ascent of Mount Erebus.

There was only one catch. To reach the Dry Valleys from Cape Royds, we needed a helicopter to cross the 80 kilometres of open water between Ross Island and the mainland. Mike and I grinned at each other. Masters of persuasion, it took us only one phone call to convince Japan's premier wildlife photographer Mitsuaki Iwago and his television director Kosaki to pay the hefty bill for the Jetranger and Australian pilot, Leigh Hornsby. All three were already on board, Mitsuaki more than eager to gain some quality time filming penguins. Only

hours before we were due to embark from Hobart, Mike and I rushed to buy a year's worth of supplies and advise the Australian Antarctic authorities of our intentions. Although the expedition was to last only three weeks, we had to cater for the possibility that the ship would not return, forcing us to spend the winter on Ross Island. I bought a fishing line in case the food ran out!

Cape Royds, the most inspiring historic site in Antarctica, was cast into the limelight following Ernest Shackleton's 1907–09 British Antarctic Expedition. The official account, *The Heart of the Antarctic*, documents the journey from Royds across the Ross Ice Shelf to discover the Beardmore Glacier, gateway to the Geographic South Pole. Shackleton turned back on the Polar Plateau 180 kilometres short of his objective. Frank Wild stood beside Shackleton at the furthest south point, cementing a relationship that led to Wild's participation in the *Endurance* expedition. (Though it may seem curious that Shackleton was the first to try and haul loads across a soft Ross Ice Shelf with ponies – animals that need to pull all their own food compared with huskies that, when other food is finished, can be fed to each other – it should be remembered that he was also the first to experiment with the precursor of modern tracked vehicles.) At the same time, after a 1600-kilometre sledging journey north from Royds, Shackleton's two geologists, Douglas Mawson and Tannatt Edgeworth David, along with Alistair Mackay, reached the wandering Magnetic South Pole. (At the Magnetic Poles the compass needle stands vertically as opposed to the Geographic Poles that mark the axis of the earth's rotation.) Completing the first ascent of the 3794-metre Erebus in March 1908, the two Australians, Mawson and Edgeworth David, were able to collect prized anorthoclase crystals from the rim of the remarkable volcano steaming away on their doorstep.

Back in the 1970s, I often camped at Shackleton's hut, sometimes when it was ice-sheathed by a blizzard. Inside, the musty smell of reindeer sleeping bags pervaded the drift of my mind while the clutter of artifacts was barely

visible in the heroic glimmer. I daydreamed, listening to the ghostly chatter of Frank Wild and Ernest Joyce in the 'Rogues' Retreat' as they cranked up the Albion printing press (with a candle underneath to keep the ink warm). Yarning the night away in a fug of pipe smoke, they turned out pages for *Aurora Australis*, the first book written, illustrated, printed and bound in Antarctica. Wind worried the hut all night – the bleached timbers creaked and groaned like Shackleton's ship *Nimrod* wracked by the Ross Sea. And then a husky howled.

Leaving Mitsuaki, Kosaki and Leigh in camp, Mike and I skittered over the wind-polished Barne Glacier to Cape Evans so we could meet and discuss plans with Keith Swenson and his four Greenpeace team mates snug for the winter at World Park Base (now removed from Antarctica). From here, the next morning, Leigh whisked us across McMurdo Sound to a campsite high in the Asgaard Range. Autumn snow blanketed much of the Wright and Taylor Dry Valleys. We spent a glorious week in windless conditions climbing easy though spectacular sandstone peaks. We also went for long cold walks from a campsite under Mount Dido in the Olympus Range to marvel at massive icefalls cascading from the Polar Plateau. With the United States and New Zealand government programmes shut down for the winter, it was a special feeling to scramble along a ridge of wind-eroded boulders and realise that we were the only people in the entire 3000-kilometre length of the Transantarctic Mountains. What an astounding juncture of ice and stone. This must be where the world begins – and ends.

Back at Cape Royds, in early March, Keith and Vojtek Moskal joined Mike and me to make a two-day ascent of Erebus. Swaddled in down jackets, the four of us cramponed across oceans of wind-sculpted sastrugi and clawed our way up searingly white snowfields that merged into rocky gullies near the top. The three-hour circuit of the crater rim in a temperature of -45°C was just bearable

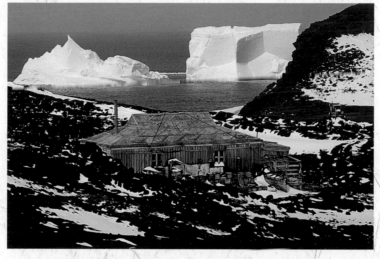

Shackleton's 1907–09 hut, Cape Royds.

Smoking fumaroles near the summit of Mount Erebus, with the sun setting over the 4000-metre Royal Society Range behind.

owing to a complete lack of wind. Beneath us, McMurdo Sound was engulfed by a blanket of backlit cloud as the sun plummeted behind the 4000-metre summits of the Royal Society Range. Two hundred metres below our perch, through billowing clouds of steam and sulphurous gas, we managed a brief, exciting glimpse of Erebus's molten lava lake. For me, this sparked a recollection of the three science expeditions I had taken part in during the 1970s. On one crazy escapade in 1978 that involved the renowned French volcanologist Haroun Tazieff, the geochemist Werner Giggenbach and I abseiled down the 100-metre wall of the Inner Crater to within a whisker of the bubbling lava lake.

Before beginning our descent to Cape Royds, we crossed to a cluster of 20-metre chimney-like fumaroles and hacked our way inside the towers with ice axes for a sauna in the hot soil. I was reminded of a line from the *Goon Show*, 'Come in laddie and warm yerself by this roarin' candle'. When we crawled outside again from the balmy atmosphere inside the fumarole, our moisture-laden clothing froze instantly into suits of armour. Anticipating an imminent rendezvous with the ship, we clanked rapidly downward, taking only six hours from the summit to the sea.

With the camp all but dismantled, and our garbage and human waste packaged for removal, we eagerly awaited *Frontier Spirit* to slice through a stained-glass sea and round the headland. Normally when climbing in remote places I am getting further away from my family. This time, as I boarded the helicopter for the last time, the reality hit home that my wife Betty and daughters Denali (13) and Carys (10) were actually getting closer by the minute. After years of being left behind while I roamed the continent, they were here, on board *Frontier Spirit*, experiencing the wonders of Antarctica for themselves. I will never forget the sparkle in their eyes as the helicopter engine wound down and I crossed the heli-deck to hug them.

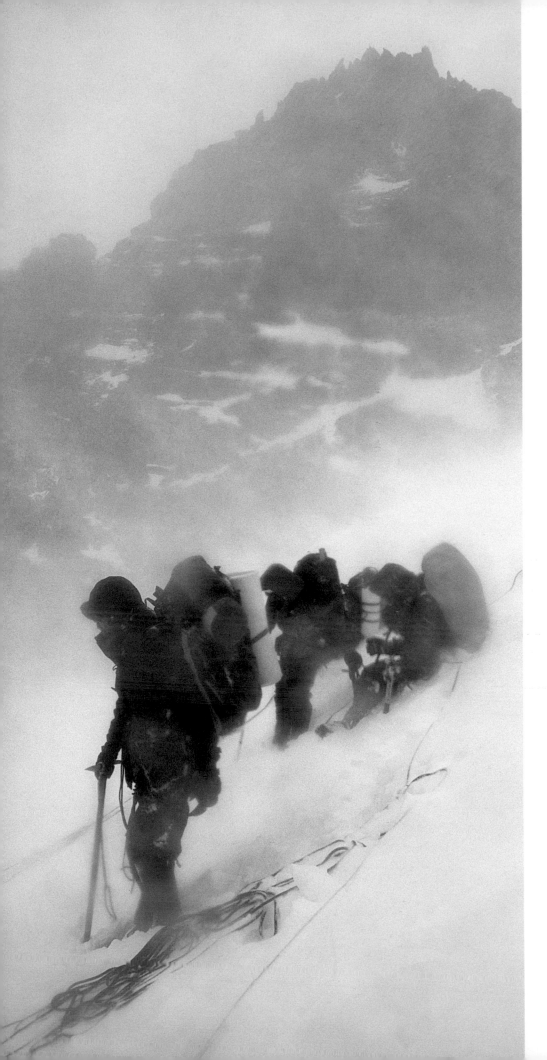

the overhanging rock where Shackleton's men had collapsed and huddled together for warmth after gorging themselves on freshly strangled albatross chicks. Balanced on slippery rocks, we read aloud from a dog-eared copy of Worsley's *Endurance*, his description of reaching the island sounding all the more poignant as freezing surf hissed and sucked at our boots.

After sailing up the fjord, Shackleton decided to land at a bleak beach they named Peggotty Camp, after the family in Dickens's *David Copperfield*. On the rocks, they found flotsam washed ashore from wrecked ships swept before the westerly gales all the way from Cape Horn. In Worsley's words

> …a sad tale of wasted human endeavour, of gallant seamen beaten by the remorseless sea. Piled in utter confusion lay beautifully carved figureheads, well-turned teak stanchions with brass caps, handrails clothed in canvas 'coach-whipping' finished off with 'Turks' heads' – the proud work of some natty, clever AB; cabin doors, broken skylights, teak scuttles, binnacle stands… There the mighty roaring Southern Ocean, tiring of its sport, had cast them up contemptuously to rot, in grievous memory of the proud, tall ships with lofty spars, of swift clippers, barques, barquentines, possibly even an old East Indiaman. Wreckage from schooners, sealers, whalers, poachers, pirates, and maybe even bits of a man-o'-war, lay around, for some of it may even have drifted there when Drake first battled round the Horn.

Having waited for a full moon to light their way, Shackleton finally set off across the island with his fellow Irishman, Tom Crean, and Worsley, leaving the three weakest companions, Harry McNish, John Vincent and Tim McCarthy, sheltered under *James Caird*. Though the wreckage from ships was long gone, I spotted a bleached tree trunk lying on the sand as we landed at Peggotty. (South Georgia is treeless.) Following Shackleton's route, our group shouldered hefty packs for a steady climb on bare ice, aiming for a low point on the horizon, now called Shackleton Gap. Judging by Shackleton's description, it was evident how much glacial recession had occurred in the intervening years.

From the gap, Shackleton thought he could see a lake; he later realised that it must be Possession Bay glowing in the moonlight. With a raw wind on the rise and snowflakes flickering in our faces, we too gained a brief glimpse of Possession Bay below us on the north coast. (The bay was first charted by Captain Cook in *Resolution* when he claimed South Georgia for Britain in 1775, the first national claim to Antarctic territory.) Reorienting himself toward the whaling stations in Stromness Bay, Shackleton turned inland to tackle the first major obstacle, Trident Ridge. Despite weak leg muscles, wasted by inactivity on the boat journey, the trio pushed on. With no tent and clad in worn-out clothing, Shackleton could not afford the luxury of sleep. Feeling far from heroic,

Wind batters the party on Trident Col as it descends to the Crean Glacier.

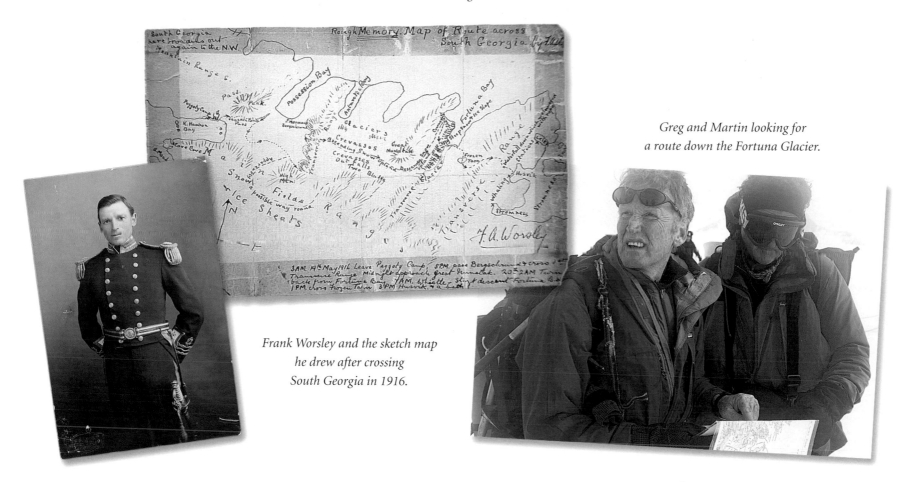

*Frank Worsley and the sketch map
he drew after crossing
South Georgia in 1916.*

*Greg and Martin looking for
a route down the Fortuna Glacier.*

we chose to camp. In fading light and harried by a nagging wind, we dug our tents in under Trident's evil-looking rock walls. A full-blown blizzard toyed with us all night.

By morning visibility was near zero. Tossed like rag dolls by powerful wind gusts, we fought hard to cross Trident Col, gaining a brief respite on the far side from the shrieking blasts of snow that plastered our clothing to our bodies. Communication was all but impossible. It was here that Shackleton's party had launched itself down a steep snow slope in the dark, sliding out of control on their backsides. All their bridges were down. As Shackleton wrote in *South*,

> I turned to the anxious faces of the two men behind me and said, 'Come on boys.' Within a minute they stood beside me on the ice ridge. The surface fell away at a sharp incline in front of us… We could not see the bottom clearly owing to mist and bad light, and the possibility of the slope ending in a sheer fall occurred to us; but the fog that was creeping up behind allowed no time for hesitation…. There could be no turning back now, so we unroped and slid in the fashion of youthful days… descending at least 900 feet in two or three minutes… But we had escaped.

With daylight to help us, Greg and I threaded a route through a jumble of crevasses, leading our party down to the relative flatness of the Crean Glacier.

For the rest of the day we trudged across the wind-scoured Crean in two teams of four, a tight rope between each member. Out of radio contact with the ship and with a jigsaw puzzle of half-hidden crevasses to negotiate, this was certainly no place for a mistake, or to linger. Though the comparison with Shackleton seems feeble, we too felt committed. There could be no retreat. And then the wind turned really nasty.

When sudden gusts hit we could do little but crouch, protect our faces and drive in the curved picks of our axes to stop being somersaulted across the ice. Then, without warning, another squall hit and the lightest member of our team, Michelle, took off like a wayward kite on a string. At times, it seemed as if her husband, Chris, was literally pulling her back down to the glacier. Then Chris would stagger forward and lurch up to his waist in a hole and Michelle would have to help dig him out. Worn down by the unseen danger of crevasses lurking below and an invisible enemy above relentlessly pounding our windproofs, this Keystone Cops affair seems comical when recalled before a warm fire. At the time, however, with dusk almost upon us and our wet clothing starting to freeze, we were far from laughing. We *had* to find shelter.

Shackleton drove Worsley and Crean to the limit, knowing that if they fell asleep they would die, as, in all probability, would the others on Elephant Island.

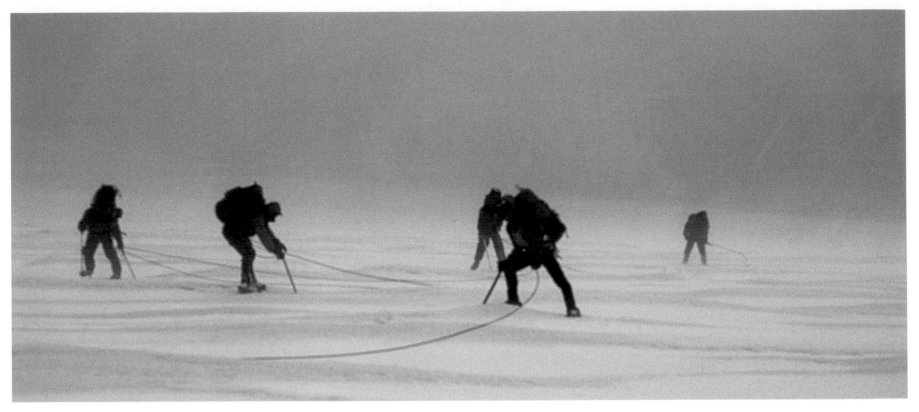

Staggering in a windstorm on the heavily crevassed Crean Glacier, the crossing party heads for a camp at the Great Nunatak.

At one point, after the briefest of naps, Shackleton roused his companions, telling them they had slept for half an hour. They stumbled on in deep snow, trying to locate the Fortuna Glacier, the crucial exit from the mountains. We decided the Fortuna could wait until morning and turned to face another numbing hour doing battle with unruly tents. There seemed a chance to avoid the worst of the wind by pitching our camp close to a peak Worsley labelled the Great Nunatak on the copy of his sketch map of the route tucked in my parka pocket. (I also had Duncan Carse's 1958 contour map. Worsley did have a rudimentary map of the South Georgia coastline with him though, of course, the interior was blank.) Struggling into the cramped tent beside Greg and Martin, I knew it would be a night to remember. As we wedged together like wallowing seals, I held onto vibrating tent poles and screamed at the others to ensure they were secure. Hunkered over the primus, each of us wrapped chilled fingers around steaming soup mugs until finally, curled foetus-like in damp bags, we drifted into a fitful sleep.

Our third day dawned clear and so cold that it took ages to stuff frozen tent nylon into packs and warm our stiff bodies with jerky movements. For a brief spell before the mist rose to meet us again, a wan sun lit unsullied peaks, tingeing their flanks in delicate pastel hues. Thankfully, probing our way down the Fortuna Glacier proved straightforward, enabling us to reach the coast five hours later. (Shackleton's crossing took a total of 36 hours in a single push during the wintery month of May; ours took 24 hours of actual walking time, spread over three short autumn days.) With the mountains and the crevasses behind us, nothing could seriously delay us, though a steady drizzle dampened our enthusiasm for fording an icy torrent cascading from the glacier snout. Startled king penguins looked on, corkscrewing their necks sideways in disbelief as we gingerly picked our way into the surging water in our underpants. Roger failed to link arms with team mates for support and fell in. Wringing out his clothing, he was heard to mutter, 'Another bloody day in the Highlands!' Climbing stiff-legged, it took us the final haul over steep rocky ground to warm up again. All the way from a sealers' cave at Fortuna Bay, our excitement grew at the thought of finally reaching Stromness.

As Shackleton's party descended to Fortuna Bay, they heard a shrill whistle, the first real indication that salvation was at hand. 'Seven o'clock came,' Worsley remembered,

and we listened intently. Then, clear across the mountains, in the still morning air, from eight miles away came the sound of the steam whistles of the whaling factories bidding the men turn-to. It was the first signal of civilisation that we had heard for nearly two years. For the second time on that march we shook hands; for each of us recognised that this was an occasion on which words were inadequate.

After the climb above Fortuna, on the wind-ravaged pass overlooking Stromness, Shackleton's men had a scary time lowering each other down a waterfall in the dark. But by then, nothing could stop the desperate trio from reaching the coast.

A vicious wind battered us too as we crossed Fortuna Saddle. We hid behind boulders and peered down on Stromness Bay, smothered in a rain-sodden gloom. After trudging down a wet snow slope I waded through bogs towards the once thriving Norwegian whaling station that now wore a sad face of neglect. Reindeer nibbled grass among forlorn graves. As I approached the manager's house, I tried to grasp something of what Shackleton must have felt as he realised that, by his own survival, he had just been granted a slim chance of rescuing the men still clinging to life on that far-flung rock.

At daybreak, with the last of our food simmering on the stove and snug in the knowledge that *Molchanov* would soon pick us up, we climbed the rickety staircase in Captain Sorlle's villa to find the old bath. The likelihood of crashing through rotten floorboards in the bathroom was probably as great as falling into one of countless crevasses on the glaciers. And huddling together in wind-lashed tents seemed somewhat akin to now cramming all of us into the wobbly bath – the same tub in which Shackleton, Worsley and Crean had left a black ring when they scrubbed off layers of grease and grime. 'Fortunately there were no ladies, still, we were a terrible-looking trio of scarecrows, but we had got so used to ourselves that we did not mind. Ragged, filthy and evil-smelling; hair and beards long and matted with soot and blubber….' Buzzing with excitement at our own small achievement, we felt our ritual in the bath was an odd but somehow apt way to honour Shackleton and his great escape.

On board *Molchanov* again, I dumped my pack and stepped into a hot shower. For me the trip was almost over but for Shackleton, leaving Stromness, another four months of worry lay ahead. There would be four protracted

King penguins gawk as the crossing party wades a glacier-fed stream in Fortuna Bay.

South Georgia Since Shackleton's Day

King penguins gleaming after a swim at Salisbury Plain, Bay of Isles.

South Georgia is the most beautiful island in the polar world, a frigid mountainous paradise where glaciers flow into the sea and where quixotic wildlife no longer fears the wrath of humans. Fur seals, hunted to the brink of extinction in the early 1800s, are back in great numbers, their inquisitive pups unable to resist snuffling and snorting in your face as you sit quietly on a beach. It is also a great privilege to watch thousands of gleaming king penguins waddle past, some stopping to chat or to peck snowy boots. But much has changed on the island Shackleton called 'The gateway to Antarctica', since the wooden-hulled *Endurance* tacked into Grytviken in November 1914.

An eerie pall of death still hangs over South Georgia. Although whales are increasing again on the Antarctic Peninsula, it is seldom that a cetacean bigger than an orca is seen close to the island. From 1904 to 1965 (when the shore-based stations closed), 41,515 blue and 133,735 other species of whales were processed in the six whaling stations. From 1925, whaling gradually became entirely pelagic (seaborne), with massive factory ships and fast killer boats removing the need for coastal installations.

Since the 1990s, bigger, more deadly leviathans, in the form of British nuclear-powered submarines (and a Soviet sub in 1966), have occasionally entered these waters to test their capabilities in the depths of the Southern Ocean.

Across the bay from where we stood around Shackleton's grave in 2001, lights from the whalers' museum peeped into an inky gloom. While museum caretakers Tim and Pauline Carr, isolated at Grytviken for the past ten winters aboard the wooden yacht *Curlew*, welcomed us for a drink, the clank of machinery echoed overhead among the crags as construction continued on a modern British Antarctic Survey (BAS) base at King Edward Point.

In 1982, science was completely disrupted when Argentine troops captured Grytviken. The resultant British-Argentine conflict that erupted in the South Atlantic Ocean, principally around the Falkland Islands, had a major impact on South Georgia and the nearby South Sandwich Islands. I have visited these islands as a guide most summers since 1983 so was used to being confronted by heavily armed British Gurkhas who beamed when greeted in their native Nepali. Two decades on, with the marine biology research facility now occupied by

BAS, the military has finally gone. (Lying within the Antarctic Convergence Zone, South Georgia is biologically part of Antarctica but, because it is north of 60°S, it is outside the political boundary of the Antarctic Treaty.)

Since 1993, as a resurgence of interest in Shackleton's journeys gained momentum, there have been three attempts with replica craft to recreate the voyage of *James Caird*. Two of them – by Britain's Trevor Potts and Germany's Arved Fuchs – reached South Georgia safely. A third, sailed by an Irish team, was scuttled halfway, the crew bailing out in dangerous conditions onto the support yacht *Pelagic*. In 2000, Fuchs, who had previously skied to the North and South Poles within a 12-month period in 1989, led the only team thus far to have completed the boat voyage followed by a crossing of the island.

In 1999, an American Museum of Natural History exhibition on Shackleton toured the United States and a similar display in England was oriented around the original *James Caird*. Classic accounts of the 1914–17 Imperial Trans-Antarctic Expedition, such as Shackleton's *South* and Frank Worsley's *Endurance*, are all back in print alongside a host of new titles, most illustrated with Frank Hurley's powerful images.

Several new television documentaries on Shackleton have recently been filmed. One of them, on location near Elephant Island, lost all three of

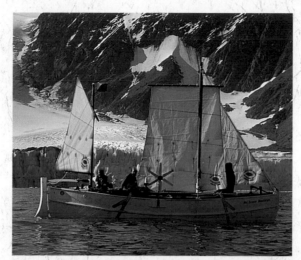

its replica craft while under tow in big seas. In March 2000, an IMAX film version of the Shackleton story featured three professional mountaineers: Reinhold Messner of Italy, Stephen Venables from England and American Conrad Anker.

Almost with impunity, the trio crossed South Georgia wearing sophisticated protective clothing and using ultra-light mountaineering gear, luxuries beyond the ken of Shackleton's party who staggered over to Stromness with scant equipment and dressed in ragged blubber-soaked woollens. They had driven screws from *James Caird* into their boot soles so they could grip the ice. In contrast, Messner broke a foot jumping a crevasse while wearing crampons on the Crean Glacier. (In 1989–90 Messner and Arved Fuchs skied 2800 kilometres across Antarctica.) In November 2000, a 17-member Geographic Expeditions team from San Francisco skied over the route, the first commercial group to do so. There have been approximately 20 crossings to date, many of them completed by the British military and BAS teams.

Shackleton mania has now reached new extremes: Dr Robert Ballard, for instance, who discovered *Titanic* in 1985, is proposing to dive to 3400 metres in the Weddell Sea in an attempt to locate *Endurance*. Even Shackleton's management style (on an expedition he considered a failure) is now being looked to by earnest business leaders as a model for success.

TOP: *The British re-enactment voyage of* James Caird *awaits wind off Elephant Island.* MIDDLE: *British Gurkha soldiers on patrol, Grytviken.*
BOTTOM: *What a privilege it is to sit quietly next to the magnificent wandering albatross.*

Honouring Shackleton in the bath at Stromness where he scrubbed himself clean after his crossing are, at back, Martin Dumaresq, Greg Mortimer and Tom Powell, in middle, Peter Marsh (left) and Roger Booth and, in front, Michelle and Chris Ward.

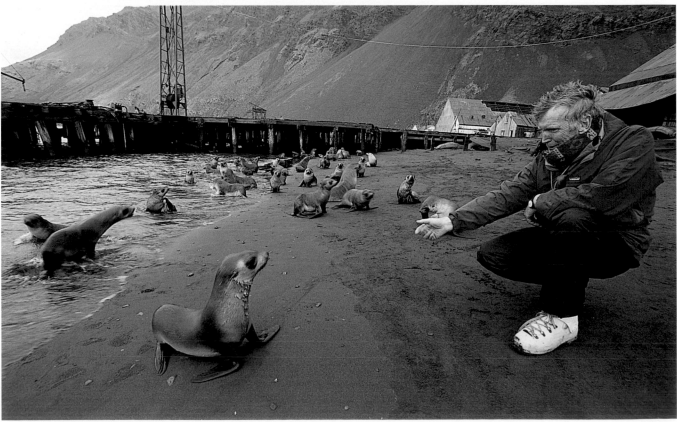

Greg Mortimer, playing with fur seal pups at Stromness, is one of some 3000 visitors each summer who are spellbound by South Georgia's inquisitive wildlife.

Paying our respects to Sir Ernest Shackleton at his graveside in Grytviken where the explorer died in 1922 on board Quest.

attempts with borrowed vessels before the marooned men were recovered from Elephant Island.

Molchanov moved further along the coast to Grytviken so our crossing party could pay its respects to Shackleton at his resting place in the whalers' cemetery. The 47-year-old explorer died there in 1922, after suffering a heart attack on board his new expedition vessel, *Quest*. In darkness we gathered around the headstone and I shone my headlamp on the back of the granite block to light up the Robert Browning quote: 'I hold that a man should strive to the uttermost for his life's set prize'.

As I walked down to the beach past a huddle of moulting king penguins I was flooded with images of this wild, wonderful island. Whenever South Georgia

and our crossing come to mind, I will recall, too, Frank Worsley's reflection on his salvation.

> I learnt afterwards that we had crossed the island during that winter's only interval of fine weather. There was no doubt that Providence had been with us. There was one curious thing about our crossing of South Georgia, a thing that has given me much food for thought, and which I have never been able to explain. Whenever I reviewed the incidents of the march I had the subconscious feeling that there were four of us, not three. Moreover, this impression was shared by both Shackleton and Crean.

Shackleton summed up his feelings more succinctly, 'We had reached the naked soul of man'.

ANTARCTICA

Weddell Sea

Elephant Island

Scotia Sea

ANTARCTICA

South Georgia

SOUTH AFRICA

SOUTH AMERICA

Cave Cove

King Haakon Fjord

Peggotty Camp

Grytviken

SOUTH GEORGIA

Crean Glacier

Trident Ridge

Possession Bay

Fortuna Glacier

Stromness

S

South Georgia

Alexander, Caroline. *The Endurance – Shackleton's Legendary Antarctic Expedition*, Knopf, New York, 1998.

Bickel, Leonard. *In Search of Frank Hurley*, Macmillan, Melbourne, 1980.

Carr, Tim and Pauline. *Antarctic Oasis – Under the Spell of South Georgia*, Norton, New York, 1998.

Dunnett, Harding McGregor. *Shackleton's Boat – The story of the James Caird*, Neville & Harding, Kent, 1996.

Fisher, Margery and James. *Shackleton*, Barrie Books, London, 1957.

Fuchs, Arved. *In Shackleton's Wake*, Sheridan House, New York, 2001 (first published as *Im Schatten des Pols*, Verlag Delius, Klasing, Germany, 2001).

Headland, Robert. *The Island of South Georgia*, Cambridge University Press, 1984.

Huntford, Roland. *Shackleton*, Hodder & Stoughton, London, 1985.

Hurley, Frank. *Argonauts of the South*, Putnam's & Sons, London, 1925.

Hurley, Frank. *Shackleton's Argonauts – A saga of the Antarctic ice-packs*, Angus & Robertson, Sydney, 1948.

Monteath, Colin (principal photographer). *Antarctica – The Extraordinary History of Man's Conquest of the Frozen Continent*, Reader's Digest & Capricorn Press, Sydney, 1985.

Monteath, Colin, Mark Jones, Ron Naveen and Tui De Roy. *Wild Ice: Antarctic Journeys*, Smithsonian Institution Press, Washington, 1990.

Monteath, Colin. *Antarctica: Beyond the Southern Ocean*, David Bateman, Auckland, 1996.

Monteath, Colin. Chapter 7 of *Antarctica – Private Expeditions* (ed. Jeff Rubin), Lonely Planet, Hawthorn, Victoria, 1996.

Mueller, Melinda. *What the ice gets: Shackleton's Antarctic Expedition 1914–16: a Poem*, Van West & Company, Seattle, 2000.

Piggot, Jan (ed.). *Shackleton, The Antarctic and Endurance*, Dulwich College, London, 2000.

Rex, Tamiko (ed.). *South with Endurance – The photographs of Frank Hurley*, Simon & Schuster, London, 2001.

Rowell, Galen. *Poles Apart: Parallel Visions of the Arctic and Antarctic*, University of California Press, Berkeley, 1995.

Shackleton, Ernest. *The Heart of the Antarctic – the Story of the British Antarctic Expedition 1907–1909*, William Heinemann, London, 1909.

Shackleton, Sir Ernest. *South – The Story of Shackleton's last Expedition 1914–1917*, William Heinemann, London, 1919.

Sutton, George. *Glacier Island*, Chatto & Windus, London, 1957.

Thomson, John. *Shackleton's Captain – A biography of Frank Worsley*, Hazard Press, Christchurch, 1998.

Venables, Stephen. *Island at the Edge of the World : a South Georgia odyssey*, Hodder & Stoughton, London, 1991.

Worsley, Frank. *Endurance – An Epic of Polar Adventure*, Philip Allan, London, 1921.

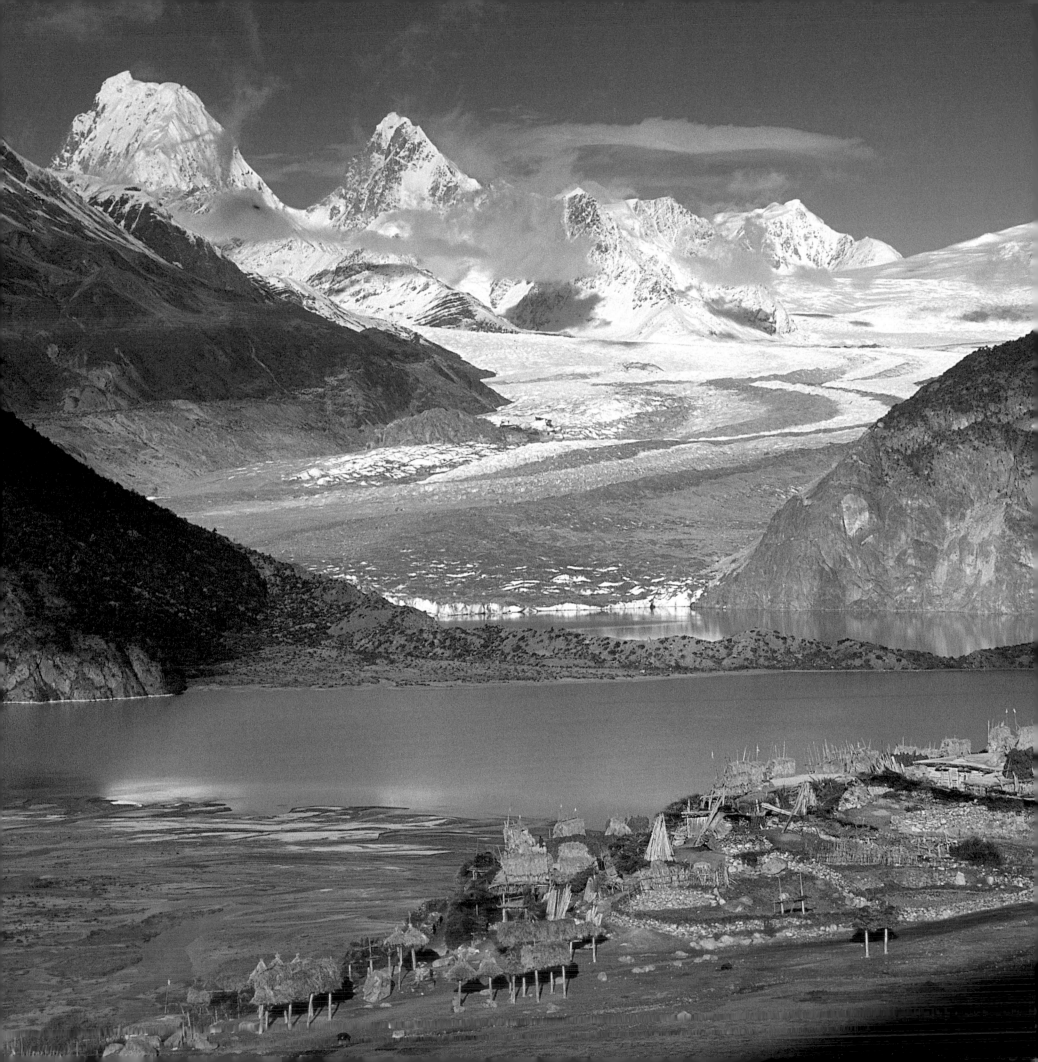

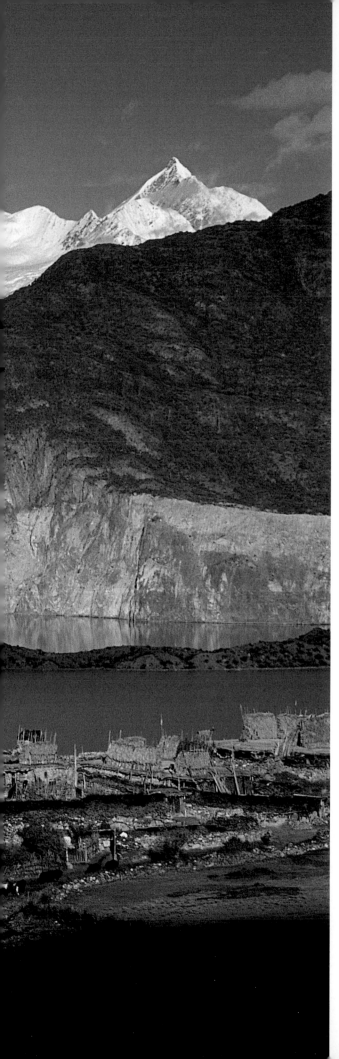

To the Land of the Blue Poppy

A reconnaissance of Tibet's Kangri Garpo Mountains

The Victorian naturalists were succeeded by a generation of hardy plant collectors. By the opening of the twentieth century, plant hunting had, like everything else, been commercialized. Thus came about the professional plant collector of today. When I joined the ranks, plant hunting was still an adventure: now it is a trade; presently it will be a trade union. Yet incredibly huge and difficult mountain regions remain untrodden by the foot of the collector. It is indeed certain not only that we have as yet only skirmished on the fringe of botanical Asia, but that by far the most difficult part yet remains to be taken in hand. We have been up to the barriers which fence off the garden; we have yet to climb over the garden wall.

Frank Kingdon-Ward, *The Romance of Plant Hunting*

I will never forget the awful sensation of the crevasse bridge collapsing under my skis. Even now, by a cosy fire, the thought of it makes me shudder. Engulfed by an explosion of powder snow as the wafer-thin crust crumbled, I plummeted 25 metres down a parallel-sided shaft, landing heavily on a plug of snow that hung precariously in the icy chasm. As I thumped onto my hip one

LEFT: *Lhagu village in the heart of Tibet's unexplored Kangri Garpo Mountains.* TOP: *Blue poppy.*

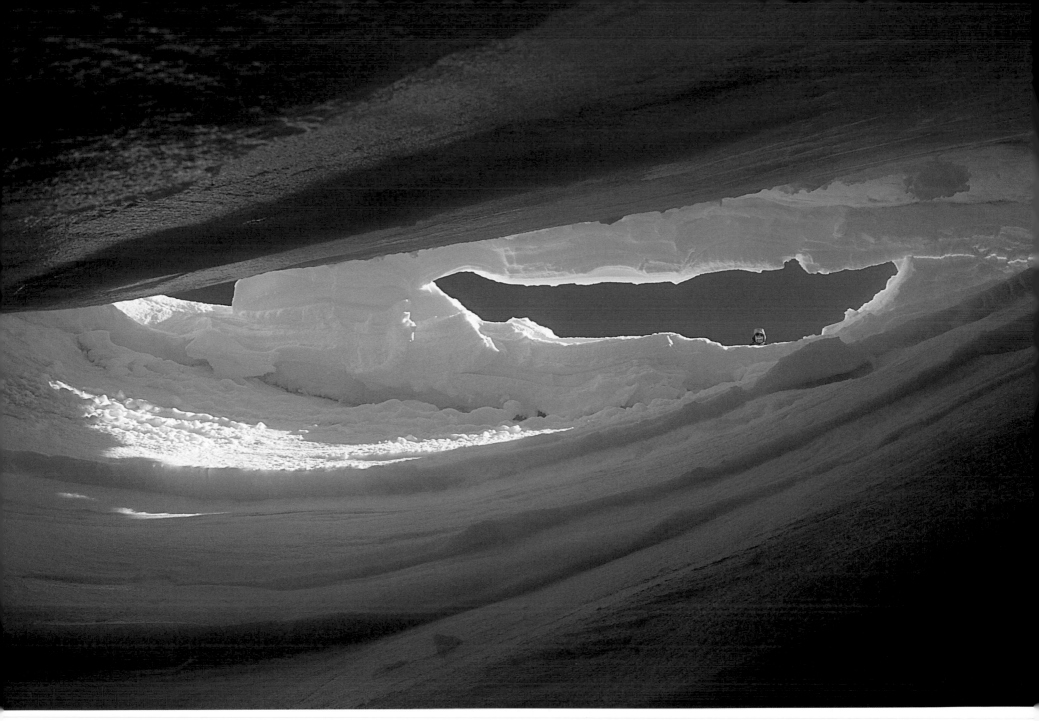

Wilf Dickerson looks down at the author after his fall into a crevasse at 5000 metres on the Lhagu Glacier.

ski ripped off, rattling into darkness below. Stunned from smacking my face, it took me a moment to register that my glasses were smashed and, more seriously, that sharp pain speared through my pelvis. My thumb was badly wrenched. Miraculously, everything else seemed intact. I yelled up to Wilf Dickerson then, instinctively, pulled out my camera and snapped his worried face looking down at me, framed by an elliptical slash of blue sky. That image highlights Wilf's disbelief that I was alive, though somewhat dementedly still taking pictures. Only then did the chilling reality of my predicament cascade over me like the snow that poured down my neck. As the fog of jumbled

thoughts cleared, I focused rapidly on one definite problem. The rope was in *my* pack!

Just moments before, Wilf and I had been happily skiing unroped through an icefall at 5000 metres. (Despite the hassle of lugging them across Tibet, the skis had been a wise decision, given the scale of the Kangri Garpo Mountains. Without skis, reaching the upper Lhagu Basin would have been utterly draining.) We had judged this part of the icefall safe but planned to rope-up on the edge of the massive snowfield above before continuing our reconnaissance. In this unexplored corner of Tibet, it had been exhilarating to be the first climbers to

catch sight of the tops of 6500-metre peaks emerging over the rim of the Lhagu névé. Alas, blinded by the beauty of virgin terrain, we had fallen into the trap of travelling blithely on an unknown glacier. Our only other rope was with Nick Shearer, John Nankervis and John Wild, who were well down the glacier that day, hauling supplies up to Camp II. I calculated that by the time they skied back to camp and realised that we were overdue, I could be stuck in this freezer for at least eight hours. By then it would be dark and numbingly cold. And I was already shivering, partly as a result of shock. With Wilf all but helpless on the surface, I had to get myself out of this hole.

Clipping on my crampons, I gingerly bridged down the scalloped ice below to a position where I could see the tip of the wayward ski. If I slipped at this point I would probably wedge badly. But I had to get that ski. After a dozen attempts, swinging a pole to and fro on the end of a sling, I managed to snag the ski skin with the hooked self-arrest grip. Clutching the ski, I thrutched back up to the ledge, tied into the middle of the rope and secured one end to the pack and skis, which I left lying on the ledge. Remarkably, the crevasse was just the right width for me to bridge. I propped my back against one wall, jammed my legs across the gap and pushed hard. Cautiously I inched upwards. With my crampon spikes scritch-scratching on the ice, I wiggled towards the sun. There would be no second chance.

Halfway up, breathing hard and braced between glass-smooth walls, I dismissed all thoughts of the drop below. As I craned upwards, I could see that Wilf had lowered a string of ski poles, safety straps and slings and was valiantly swinging the contraption backwards and forwards in the hope I could reach it. Finally, after a series of desperate lunges with my ice axe, I snared a pole. Gripping the basket in my teeth, I hauled up the free end of the rope and attached it to the pole. Hey presto! Snaking skyward like an Indian rope trick, the lifeline rose towards the light. With the security of a belay, and armed with a second ice tool that Wilf rattled down the rope, I took a deep breath and launched out of the splits position to start clawing my way up the wall curving overhead.

With a final heave, I flipped out of the cavern and lay gasping at Wilf's feet. I trembled with relief as we hugged. Together we hauled out my pack and skis which, miraculously, did not jam on the overhanging lip. On skis again, Wilf and I wobbled down to the cluster of tents. On the way I carved out a new direction for myself. But each time I tried to express these thoughts to Wilf about the journey ahead, the wind blew away my words.

On a crisp autumn morning in 2001, our gang of seven old friends flew from China's Sichuan province across eastern Tibet. The blush of dawn beyond Chengdu was a silken spray of rhododendron-red light. As the sun rose, shafts of soft pastel colours suffused the ramparts of Minya Konka and the hidden

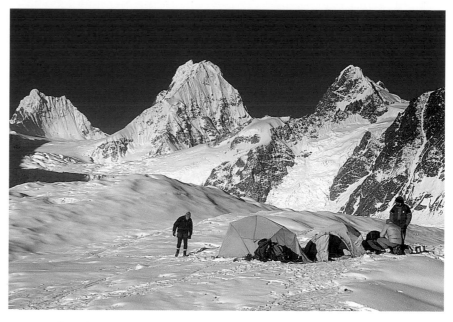

Camp I on the Lhagu Glacier under unclimbed 6400-metre Gongyada (centre).

mountains of Hengduan. And then, as we pushed on over Kham bound for Lhasa, rank upon secret rank of high peaks ripped through remnants of monsoon cloud.

Despite momentous change over the past half-century, the holy city of Lhasa continues to evoke a sense of mystery. Somehow, though it has been pushed to the limit by outside forces, Lhasa still embodies the fanciful notion of Shangri-la, at least in some Western minds. On my first morning back in the capital, I scurried along in the pre-dawn glimmer beneath the Potala Palace to merge with scores of Tibetans twirling prayer wheels as they shuffled around the Lingkhor, one of Lhasa's most sacred kora. To ensure good fortune, snuffly dish-mop apso dogs trotted beside the hooded figures, the tiny bells on their collars tinkling in the darkness. From a vantage point under the ruins of Chagpori medical college, I watched the sunrise light up a row of rusty poplars like candles flickering in a chill breeze. Gleaming white and maroon in the bright morning as it has done since 1645, the Potala reared towards a turquoise heaven, a lungta (prayer flag) of stone releasing peaceful spiritual energy.

In 1904, Lhasa was invaded by the British army, bent on protecting the northern border of the Indian empire. Embroiled in the Great Game, an ardent Raj toyed with the rumour of Russia negotiating furtively with Tibet. After violent clashes, an expeditionary force of red-coated soldiers under Francis Younghusband breached the strict seclusion so desperately defended by Tibet. Before this incursion, Lhasa had been dubbed the 'Forbidden City'. Then, in October 1950, four decades after the Tommies trooped back to Sikkim, much that was precious to the Tibetans was, once more, forbidden them, this time by China.

A Pilgrimage to Lhasa

A monk slaps his hands to make a point in a religious debate, Ganden.

Feeding a child near Jokhang temple.

A pilgrim outside Jokhang temple.

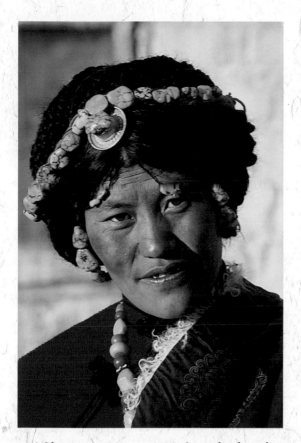

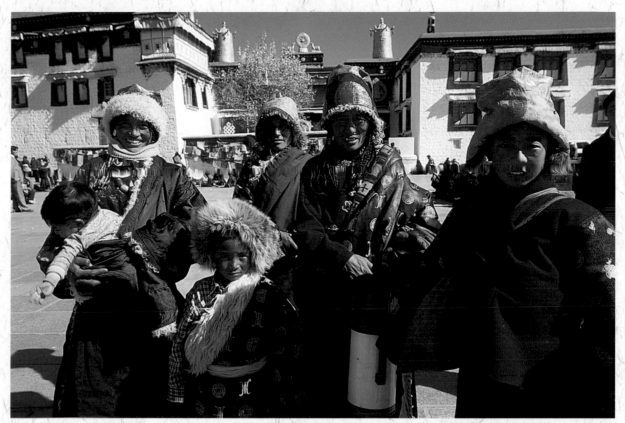

A Lhasa woman wears turquoise and red coral.

Pilgrims from Kham in eastern Tibet in front of Jokhang temple.

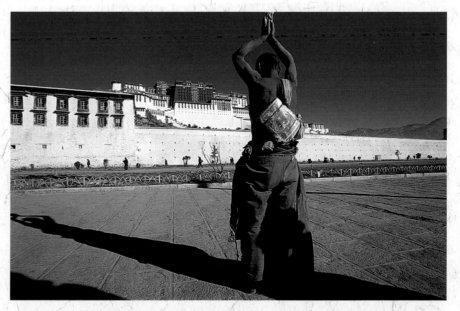

A Drepung monastery monk uses the sun to boil water.

A pilgrim on the Lingkhor circuit around the Potala.

For 50 years, the once powerful (some say degenerate) Tibetan theocracy has been severely tarnished and subdued by a brutal military occupation. In their homeland, Tibetans have endured genocide and now a degrading marginalisation by an alien culture. Yet Lhasa residents still possess an inner strength. Their infectious spirituality affects even those with whom they have the briefest contact. Imbued with a deep-seated belief that refuses to be stifled, leather-aproned pilgrims persist in prostrating themselves on kora around Jokhang temple, where butter lamps burn bright to honour the serenity of Jowo Shakyamuni, Tibet's most sacred Buddha. Mantras are intoned from the leaves of whispering books. En route to the Kangri Garpo Mountains, hundreds of kilometres from Lhasa, we encountered pilgrims bound for the Jokhang. As they prostrated themselves on the dusty road, patient donkeys ambled along just ahead, pulling small carts of meagre supplies.

I had been drawn to this new venture, my fourth expedition to Tibet, by an interest John Nankervis and I share in Frank Kingdon-Ward, the doyen of Himalayan explorer-plant collectors. In particular, we were fascinated by two of the Englishman's expedition accounts, *The Riddle of the Tsangpo Gorges* (1926) and *A Plant Hunter in Tibet* (1934). On the 1924 journey that became the subject of the first book, Kingdon-Ward botanised extensively around the 'great bend' of the Yarlung Tsangpo, Tibet's mightiest river. With its source 1800 kilometres to the west near Mount Kailas, it is now known that the Tsangpo transforms

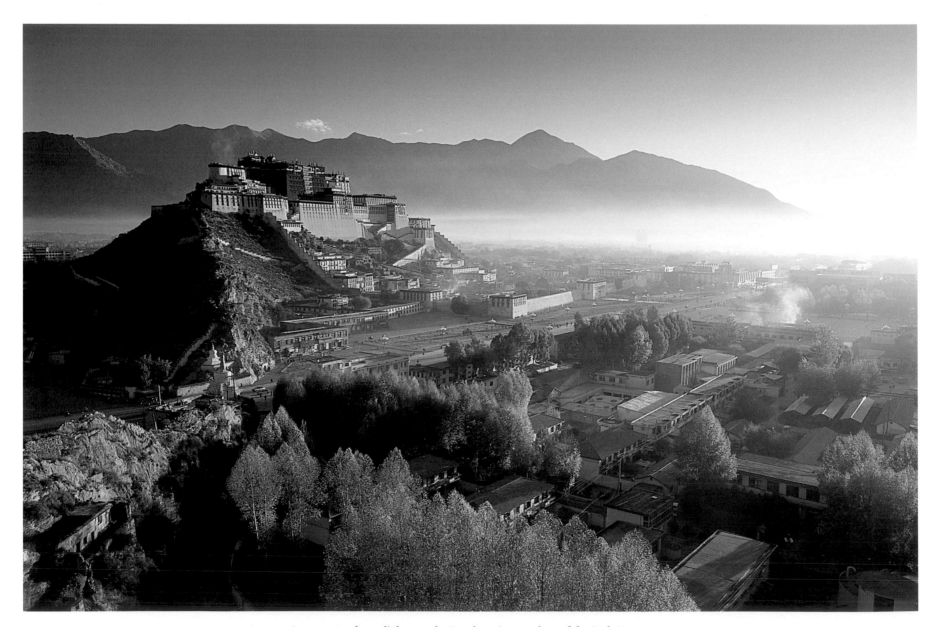

An autumn dawn lights up the Potala, winter palace of the Dalai Lama.

itself into the Brahmaputra and flows into the Bay of Bengal after surging between two striking peaks, the 7150-metre Gyala Peri and the 7782-metre giant, Namcha Barwa. But in the late 1800s, the Tsangpo Gorges were rumoured to conceal a waterfall that rivalled Victoria Falls. Cloaked in mystery and protected by fierce tribesmen and impenetrable terrain, the Tsangpo was the centre of considerable geographical debate. Determined probes to unravel its secrets were made by the pundit surveyor Kintup (1880) and British explorers Eric Bailey and Henry Morshead (1911–13).

As Kingdon-Ward explains in *The Riddle of the Tsangpo Gorges,*

> Connected with, and separated by the parallel mountain ranges [of South-east Tibet]
> are several big rivers which, rising in the cold heart of Tibet, set out complacently
> enough eastwards across Asia. Their sources are hundreds of miles apart and their
> mouths open on different seas. But all must first escape from the plateau, and all
> escape through one narrow gateway, which is a breach in the Himalayan axis – the
> Achilles' heel in that otherwise impenetrable mountain defence which rings Tibet
> like a wall. Here they are caught and squeezed between two of the mightiest uplifts in
> the world…The width of this gap, from the dislocated end of the Himalaya, where
> Namcha Barwa overlooks Assam to the eastern foot of the Yunnan Plateau is 200
> miles… In the extreme east flows the Yangtse…In the west…is the Brahmaputra, or
> Tsangpo… and between the two lie the Mekong, Salween and Irrawaddy.

In 1933, on Kingdon-Ward's second journey to the region, his party traversed from the Mishmi Hills in Assam to the Salween River in South-east Tibet. They crossed the 4600-metre pass, Ata Kang La, to breach a formidable mountain barrier that separates the sweltering jungles of Burma and Assam from the Tibetan highlands. Beyond Ata Kang La, Kingdon-Ward found himself surrounded by the magnificent landscape of the Kangri Garpo Mountains. During a three-month stay in Shugden gompa, the dedicated botanist described both the plants and the mountains. He noted that the range swept westward in a single 280-kilometre arc of uncharted peaks, untravelled glaciers and a maze of forested gorges until it crossed the fabled land of Pema-kö near Namcha Barwa. Again, his passion for the region shone through his writing:

> … a country of dim forest and fragrant meadow, of snow-capped mountains and
> alpine slopes sparkling with flowers, of crawling glaciers and mountain lakes and
> brawling rivers which crash and roar through the mountain gorges… of lonely
> monasteries plastered like swallow's nests against the cliffs, and of frowning forts
> perched upon rocky steeples… and no country in the world is so deeply rent by
> rivers… so bristling with high peaks.

Kangri Garpo has been sealed off by the Chinese military since 1962 when China invaded India across Tibet's frontiers with north-east India and Ladakh.

A hand-tinted portrait of the Dalai Lama hidden since his exile in 1959.

A yak driver drills a hole in a new saddle.

The 'great bend' peaks of Namcha Barwa and Gyala Peri seen from Serkhim La.

In 2000, however, the indomitable Japanese mountain traveller, Tamotsu Nakamura, alerted Nank and me that he had received permission to spearhead a reconnaissance into the hills around Lhagu, a cluster of hamlets lying between Ata Kang La and the now ruined Shudgen gompa. 'Mr Tom', as he calls himself, challenged readers of his detailed report to name the glacier that reaches the lowest altitude in Tibet (the Ata – 2440 metres) and the one with the largest surface area anywhere in the country (the Lhagu – 30 kilometres long by 5 kilometres wide).

Enamoured of Kingdon-Ward's historical accounts and intrigued by Mr Tom's geography lesson (enhanced by gifts of his fine exploration books), Nank launched a flurry of messages to the China-Tibet Mountaineering Association in Lhasa. We knew that an attempt on Kangri Garpo's highest peak, the 6882-metre virgin Ruoni, would likely attract a hefty peak fee, so we settled for an 'exploration permit' that gave us a wide-ranging licence to roam. Our dream was to climb lesser peaks as they caught our fancy. But one, Gongyada, a striking

6400-metre summit midway up the Lhagu Glacier, leapt out at me from Mr Tom's photographs. Those heavily corniced ridges would certainly be a tough proposition. Irrespective of whether we could attempt this peak, the terrain between Gongyada and the head of the glacier was, as yet, unseen, even by local villagers. What better lure for a low-key Kiwi expedition.

Leaving Lhasa in mid-October, we crossed the silver curve of the Kyi Chu (happy river) and headed south to the town of Bayi. That night, in what is now a Chinese stronghold, there was a 'twittering of sparrows' as ivory mah-jong counters spilled across tables in smoky cafés. Next morning, with two jeeps and a baggage truck, our convoy ground over the 5000-metre cloud-cloaked Serkhim La (with tantalising glimpses through cloud of Namcha Barwa and Gyala Peri), then on down into the Tsangpo watershed. We crawled along, following the raging tributaries, Parlung Tsangpo and Yigrong Tsangpo, that feed into the main gorge system. Like swarming ants, road crews toiled away on retaining walls built to keep the landslide-prone road from collapsing into the river.

Though we had delayed our journey until the ebb of the monsoon, the mud was still axle-deep in places. The drivers did well to get us through. With dizzying drops just a tyre width away, this was not an excursion for the faint-hearted.

The route from the old capital Pome up to the Zayul-Lhagu turnoff, stands out as one of the world's finest alpine highways. Around each hairpin bend soar unknown peaks, tumbling rapids and steep fir-clad hillsides laced with amber-stained trees. Although the road winds on to Kunming in Yunnan, the Chinese influence seems to diminish as you enter the higher eastern extremity of Tibet. Buddhist chortens grace the entrance to each village like giant pawns from a chessboard, emerging from the soil as inevitably as mountains. This is the southern fringe of Kham and, just as the People's Liberation Army found in 1950, it would still take a bold Chinese dragon to confront a fiery-eyed Khampa in these parts. The cavaliers of Kham have been described as masters of the bullet and the blade.

Harvest is a busy time for Tibetan women. The threshing and winnowing of barley on flat mud rooftops was in full swing as we pitched our tents in Lhagu village. Nearby, in wood-slab shacks perched over bubbling streams, waterwheels clicked away, turning heavy stones to grind barley into the staple flour, tsampa. While some used yaks to haul a crude wooden plough through the soil, others spread basketloads of dung in the fields. Nothing is wasted here.

Lhagu's only monk fussed about, fingering a rosary of beads as he supervised the lashing of the gompa's prayerbooks onto yaks. Moving from juniper-lined courtyard to courtyard with the yak train, the grubby, cloth-wrapped books were dutifully unloaded and carried ceremoniously into each stone house. With a glass of chang grasped firmly in fingers as strong as a vulture's claw, the monk chanted as he turned the loose-leaf pages. He offered thanks for a bountiful harvest. After considerable communal effort, the villagers were satisfied with the simple gift that summer had brought.

It was an honour to be invited inside homes to share tea. Once my eyes adjusted to the dimness, I found decrepit flintlock rifles in the rafters, dusty portraits of a youthful Chairman Mao and, sequestered away inside silver charm boxes to avoid discovery, hand-tinted images of a rosy-cheeked Dalai Lama in 1959 just before he fled to India. One elder told me that, without access to any documentation of what has befallen their country, they have scant information to pass on to the next generation. I did note, though, that the rudimentary texts shown to me by school children were, at long last, written in Tibetan script as well as Han Chinese. (In Lhasa, the Han Chinese language is now so dominant that some young Tibetans are losing the ability to communicate with their parents and grandparents.) Outside, the reality of a remote community hit home. Nick, who is a dentist in New Zealand, rolled up his sleeves, boiled instruments and, during two intense clinics, extracted some 40 teeth. As the Xylocaine wore off, huddles of glum patients sat

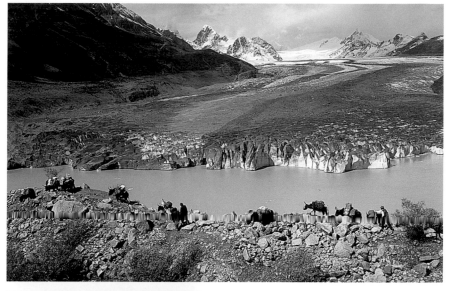

ABOVE: *Our yak caravan hauls expedition baggage towards the Lhagu Glacier base camp.*

LEFT: *Winnowing barley, Lhagu village rooftop.*

BELOW: *Nick Shearer runs a dental clinic in Lhagu.*

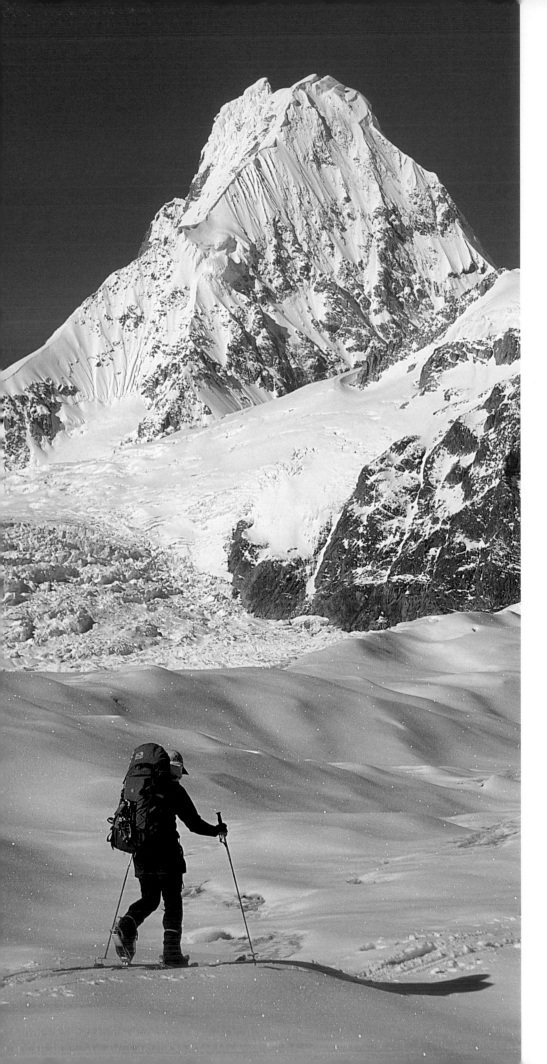

around holding their jaws. It was the only time that we did not see the Lhagu folk smile.

Meanwhile, distinctive Khampa men, with high burnished cheek bones and shiny black plaits laced with red silk tassels, assembled the yaks that could be spared from ploughing duty. The five of us set off to follow the lumbering baggage animals over a bluff, past an iceberg-choked lake and on up the glacial trough beside the Lhagu. With our departure, my wife Betty and Jos Lang, a Kiwi ski guide who lives in Canada, plotted their own adventure – to retrace Kingdon-Ward's crossing of the Ata Kang La and, later, to explore on horseback the forested valleys between Sumzong and Rawu.

We established base camp among stunted willows, though the edge was taken off what had been a grand day when Nank sprained an ankle badly, twisting it heavily among granite boulders. The injury was so serious that he considered leaving the expedition. Stoically, he persevered and was eventually able to ski on the Lhagu. After we had lugged loads up the lower Lhagu my diary recorded 'a good day of mountain travel even if we now have six loads in the wrong place'. Realising that base camp should be further up the valley, we recalled the reluctant yaks over a period of days and moved higher to a picturesque spot overlooking the ice. From a den in the imposing mist-shrouded bluffs above, a wolf howled. We awoke to the hush that a fresh snowfall brings. Winter was already waiting in the wings.

It took a solid week to ferry gear through a progression of dumps and camps on the Lhagu. It proved to be hard work and without extra boots and clothing we could not cajole the Lhagu lads into lending a hand. Clearly, they knew the lower glacier, for we found evidence of campfires where parties had crossed the ice in search of rare herbs for sale to China's medical industry. Tibet's most significant export is medicine. Thankfully, the skis came into their own after we established ourselves at 4500 metres in the centre of the glacier. On a smooth surface we could glide along even with heavy packs; the slick run home, after dumping loads, was a joy.

With Nank still favouring his ankle, 'Wilf the walrus' and Nick pushed ahead to probe the icefall under what became Camp II. Meanwhile, 'Just-as-wild-as-ever John' (Justice Wild presides in the Wellington High Court) and I cut across the glacier, bound for some superb skiing through a subsidiary icefall that gave access to the East Ridge of Gongyada. Above, a seductive little basin nestled under other alluring peaks. By now I had set my heart on Gongyada, though this idea was vetoed back at camp in favour of continuing on up the Lhagu. Even though I was disappointed at not being able to attempt a major climb, the decision to push on and explore the upper Lhagu was a fine consolation prize.

Beneath Gongyada, John Nankervis hauls a load up the Lhagu Glacier.

It was on 25 October, while skiing above Camp II, that I fell into the crevasse that could so easily have been my tomb. Curled up in a sleeping bag that night, on the verge of tears, I shook uncontrollably while nursing a badly bruised hip. In the dark next morning, the five of us roped up in two teams. Suitably chastened by my folly, we tiptoed through the icefall on ski-crampons, our headlamps bobbing across a crystal ocean.

Later that morning we crested the rim of the icefall and entered an enormous undulating névé. The scale of this snowfield became evident only after we reached 5300 metres under the soberingly steep western flank of Gongyada. Revelling in fast, exhilarating skiing, we plunged back into the basin, tumbling through a looking-glass of beauty at every turn. It was a rare privilege to stand beneath these 6500-metre peaks, sitting unnamed and untouched astride the crest of the Kangri Garpo. Through the saddles to the south lay India's Arunachal Pradesh and Burma.

Days later, after forays across the névé (one of which crested a snow dome at 5700 metres), I sensed that, as a group, we had become overawed by the remoteness and seriousness of the routes all around us. Keen to minimise access problems through the Tsangpo Gorge, we had chosen to arrive late in the post-monsoon season. Now, with winter nipping our heels, it would have been bitterly cold to venture above 6000 metres. It was clear, though, that our strength and motivation to climb had drained away. Even on skis, the distances had proved exhausting. We simply did not have the energy to place high camps under those uncut gems. They lie waiting.

I woke to the chirp of flycatchers nimbly foraging for crumbs outside the tent. One lay dead on the snow, its frosted wings outspread in a final, frantic act of flight. Cocking an eye towards the attractive peaks above base camp, we pointed our skis towards the morning sun and left. When we were in camp once more on the lower Lhagu, still days away from the scented herbs in the moraine, there was a whispering of rain that overnight turned to snow. The temperature plummeted. Cowering beneath sulking clouds, Lhagu had turned its face to winter.

After a reunion with Jos and Betty in the village, all seven of us took horses up to the wind-worn apron of the Ata Kang La. As Betty and I sheltered among dwarf rhododendron on a hilltop, I pictured Kingdon-Ward 70 years before, trudging over the icy pass in tweeds and hobnails, after sweating his way up from Assam's steamy jungles. From nearby snow-dusted hills, we tried to spy out the complicated access to Ruoni. Thus far, no one has even approached this massive peak. The scope for exploratory mountaineering in range after untravelled range in Tibet is staggering, perhaps rivalled only by Antarctica.

By mid-November it was time to leave Lhagu. As a final gesture of hospitality Betty and I were ushered into a riotous wedding party where the pressure of the throng inside one room literally caused the walls to bulge. I could not

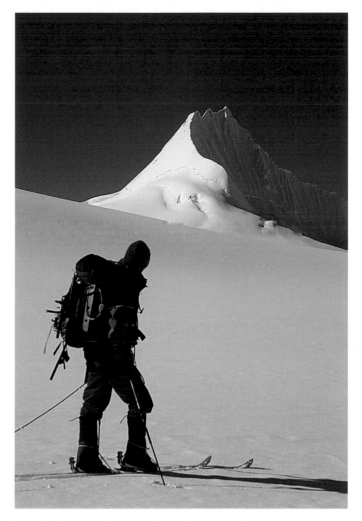

John Wild skiing under an unclimbed peak on the Lhagu Glacier névé.

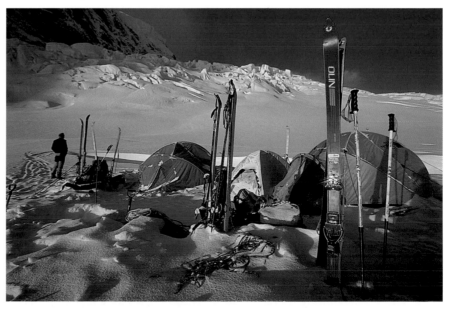

Wilf at dawn outside Camp II on the Lhagu Glacier.

Lhagu girls delight in showing off mani stones from their gompa.

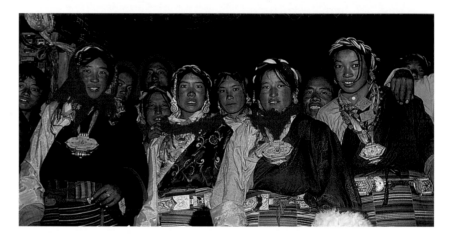

A traditional Khampa hairstyle with silk tassel and silver jewellery.

Lhagu women dressed for the wedding party.

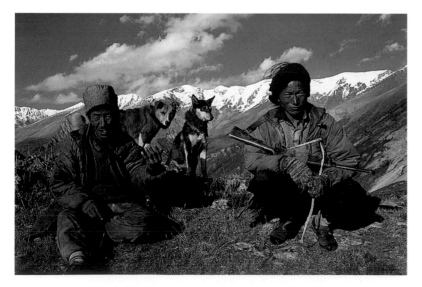

Lhagu villagers hunt bharal near the Ata Kang La.

A wedding guest indicates he has had enough chung to drink.

remember another wedding where the extremely shy groom, who was in our employ, preferred to be away up-valley tending horses. The coy 19-year-old bride did not seem at all perturbed by her mate's absence; they had known each other since infancy. Equally unfazed was a crush of attractive young women draped in silver and turquoise jewellery. With persuasive, wicked grins, they took great pleasure in filling me with chang. I am a tad hazy on the details, but I think I managed to avoid the plate of what looked like pig's penises.

We were strangers from a strange land beyond their ken, and the Khampas gazed at us, giggling at our peculiar habits and bewildered by our glittering array of possessions. As we did routine things around camp we were constantly the centre of attention, at least until dusk when a thumping generator kicked in. In a flash, everyone disappeared into a dark mud-brick room where the village's solitary television churned out raunchy Chinese soap operas. Outside, an untrammelled Milky Way bristled with ancient light.

Why were we rushing away from this isolated pocket of old Tibet where the rhythm of life swung only with the seasons? I had come to envy Lhagu the peacefulness and magnificence of its setting and, to a casual observer at least, the completeness of its society. I wondered if James Hilton had used Lhagu, or a village much like it, as the setting for his famed novel *Lost Horizon*, in which a British diplomat crash-lands somewhere in the Himalaya and discovers the lost valley of Shangri-la, a Utopia where the kind, gentle people never grow old.

Yet, with the construction of the road into the village, Lhagu faces the inevitability of change. Tibet, too, will increasingly confront pressure as the sweeping industrialisation of modern China gains momentum. Already, the four-year construction of a railway from Golmud to Lhasa is under way. Oblivious to the cruel power play being enacted on the western edge of Asia, we left Lhagu for the frightening world beyond the mountains. We had set out from New Zealand to a grim broadcast that the Americans had started bombing Afghanistan – 'We will bomb them back into the Stone Age'. Sadly, yet another war machine was rolling towards Kabul.

From a vantage point amid the ruins of Shugden gompa, the hub of Kingdon-Ward's plant paradise, I looked back across a mirror-smooth lake to Lhagu. I squatted among mani stones stacked around a crumbling chorten and ran my fingers over the revered figure of the saint Tsong Khapa, chiselled to perfection in lichen-covered slate. 'Small wonder…', Kingdon-Ward wrote in 1926 in *The Riddle of the Tsangpo Gorges*, 'that Tibet has captured the imagination of mankind. Its peculiar aloofness, its remote unruffled calm, and the mystery shrouding its great rivers and mountains make an irresistible appeal to the explorer. There are large areas of Tibet where no white man has ever trod.' So much has changed in Tibet and yet, as a mountaineer, I find it tremendously exciting that the Kangri Garpo Mountains remain largely unexplored and that the beyul (a powerful Tibetan sanctuary) surrounding the Tsangpo Gorge is secure.

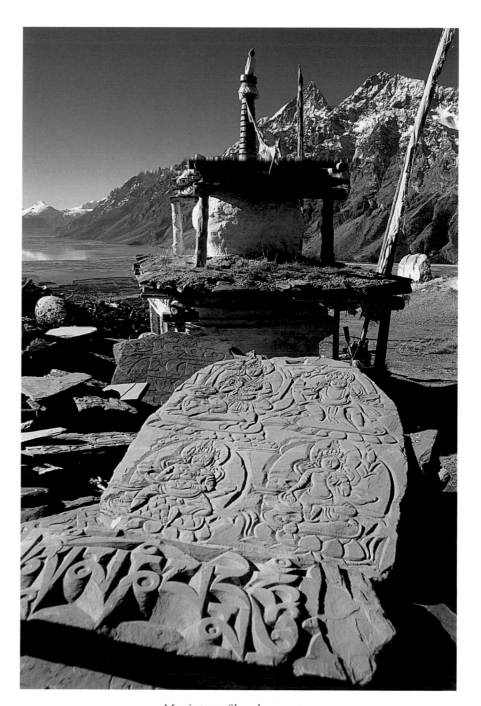

Mani stone, Shugden gompa.
Botanist Frank Kingdon-Ward based himself here in 1933.

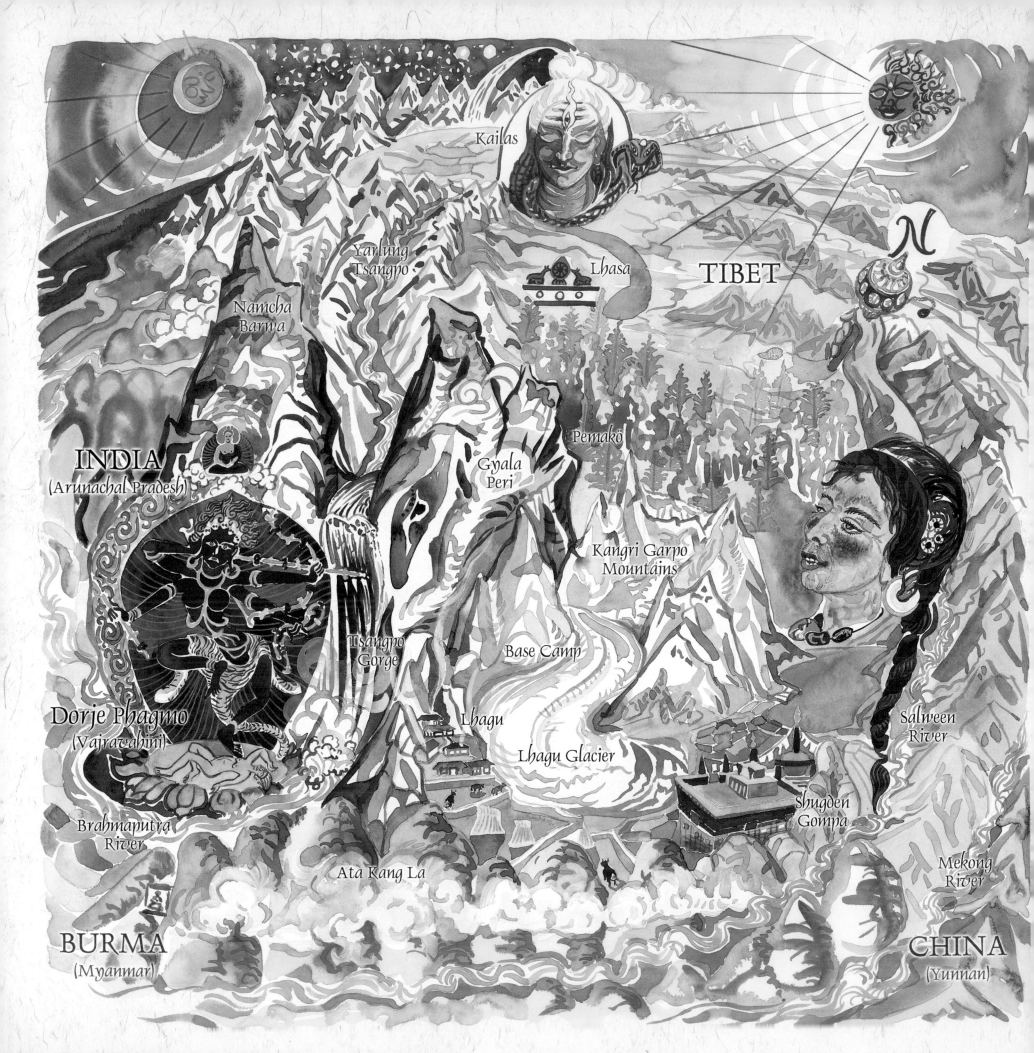

Kangri Garpo, Tibet

Bailey, F.M. *China-Tibet-Assam, A Journey, 1911*, Jonathan Cape, London, 1945.

Bailey, F.M. *No Passport to Tibet*, Rupert Hart-Davis, London, 1957.

Fletcher, Harold. *A Quest of Flowers: The Plant Explorations of Frank Ludlow and George Sherrif*, Edinburgh University Press, Scotland, 1975.

Hanbury-Tracy, John. *Black River of Tibet*, Frederick Muller, London, 1938.

Kaulback, Ronald. *Tibetan Trek*, Hodder & Stoughton, London, 1934.

Kaulback, Ronald. *Salween*, Hodder & Stoughton, London, 1938.

Kingdon-Ward, Frank. *The Land of the Blue Poppy – Travels of a naturalist in eastern Tibet*, University Press, Cambridge, 1913.

Kingdon-Ward, Frank. *The Mystery Rivers of Tibet*, Seeley Service & Co., London, 1923.

Kingdon-Ward, Frank. *The Romance of Plant Hunting*, Edward Arnold, London, 1924.

Kingdon-Ward, Frank. *The Riddle of the Tsangpo Gorges*, Edward Arnold, London, 1926 (and 2001 reprint by the Antique Collectors' Club, Suffolk, with additional material by editor Kenneth Cox *et al.*).

Kingdon-Ward, Frank. *A Plant Hunter in Tibet*, Jonathan Cape, London, 1934.

Knaus, John. *Orphans of the Cold War*, Public Affairs, New York, 1999.

Lyte, Charles. *Frank Kingdon-Ward: The Last of the Great Plant Hunters*, John Murray, London, 1989.

McRae, Michael. *The Siege of Shangri-La – the Quest for Tibet's Sacred Hidden Paradise*, Broadway Books, New York, 2002.

Nakamura, Tamotsu. 'Kangri Garpo Range in Southeast Tibet: Least known mountains in eastern Himalaya', *Japan Alpine News* (in English), The Japanese Alpine Club, Vol. 1, October 2001.

Peissel, Michel. *Cavaliers of Kham: The secret war in Tibet*, Heinemann, London, 1972.

Swinson, Arthur. *Beyond the Frontiers – The biography of Colonel F.M. Bailey, explorer and secret agent*, Hutchinson, London, 1971.

Teichman, Eric. *Travels of a Consular Officer in Eastern Tibet*, University Press, Cambridge, 1922.

Walker, Derek. *The Pundits – British exploration of Tibet and Central Asia* (Chapter 8: 'The Tsangpo-Brahmaputra controversy – Lala, Nem Singh and Kintup'), The University Press of Kentucky, Lexington, 1990.

Walker, Wickliffe. *Courting the Diamond Sow – A whitewater expedition on Tibet's forbidden river*, Adventure Press, National Geographic, Washington DC, 2000.

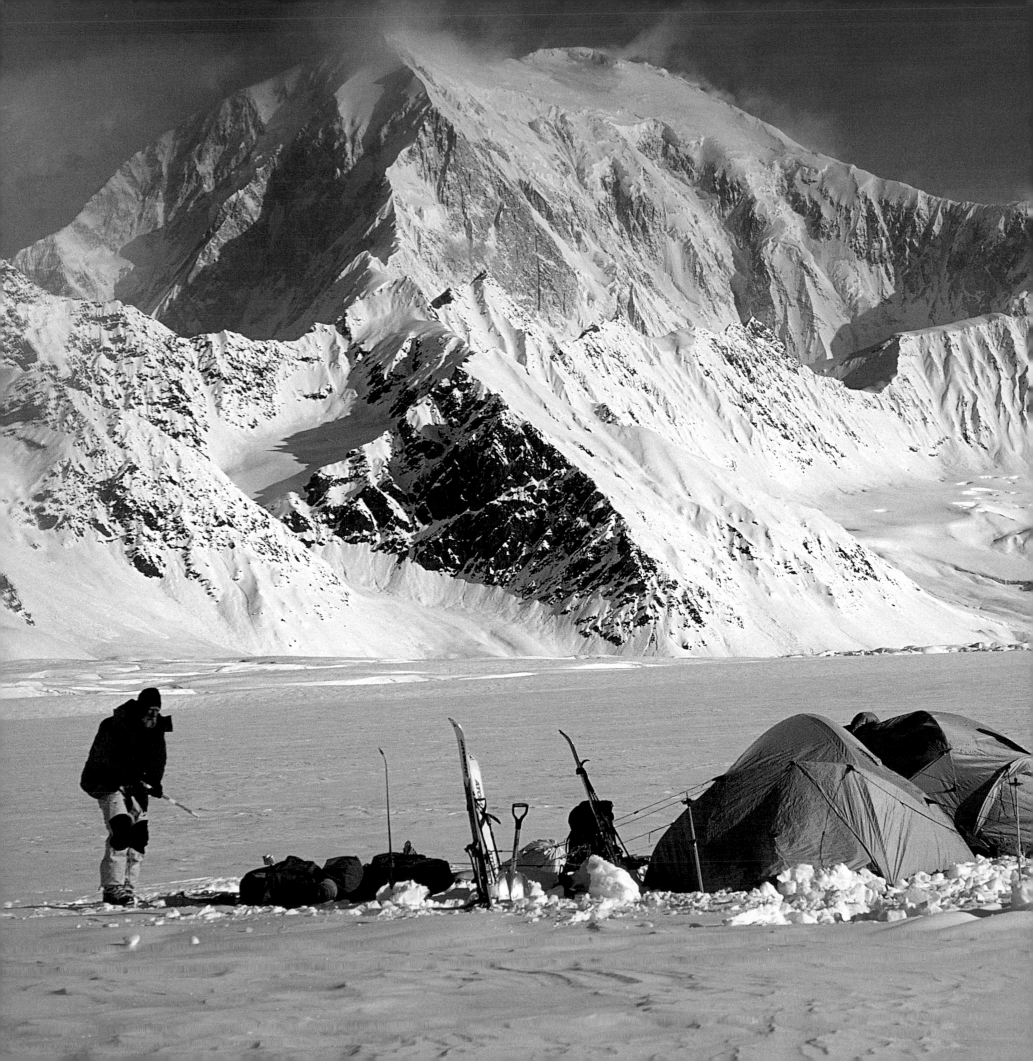

Yes, to Dance with Denali

A ski traverse of Alaska's Mount McKinley

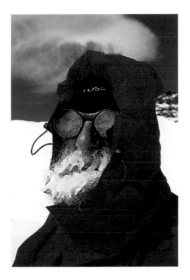

Denali remains unique among the mountains of the world. Situated at latitude 63°N, it is the highest point near the Arctic Circle. Piercing the central plain of Alaska, Denali is buffeted by storms from the Gulf of Alaska and from the Bering Sea. In few mountain locales of the world does the weather change so precipitously and dramatically. A balmy day of glacier travel can rapidly deteriorate into a day of survival snow-cave digging. The intense cold is, of course, another unique feature of Denali, comparable only to the Antarctic ranges. The Himalaya is tropical by comparison.

Dr Peter Hackett, preface to *Surviving Denali* by Jonathan Waterman

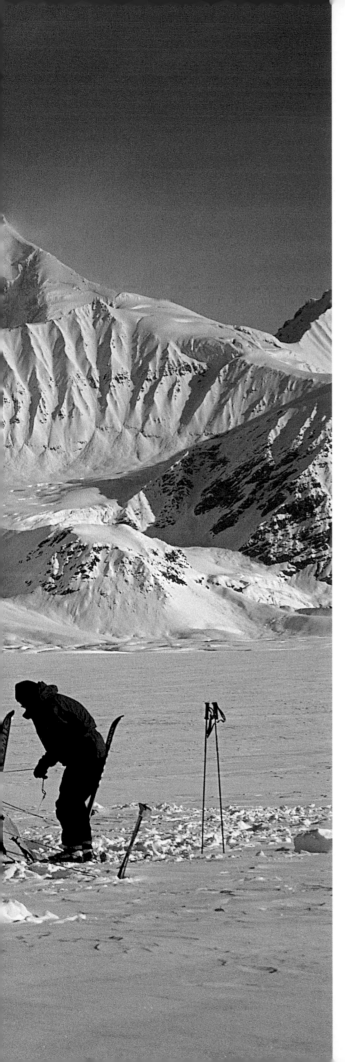

T urbulence bounced the Beaver sideways over the razor-sharp peaks of Little Switzerland. As the flimsy aircraft lurched into a scary tight turn above Pika névé, my fingernails dug into the upholstery. The plane pulled out of its dizzying spiral only to bank sharply and plummet earthward. Unconcerned, the pilot cranked down the skis and prepared to land. There was now little option but to touch down on the lower Kahiltna Glacier, blissfully flat compared

LEFT: *Campsite on the Kahiltna Glacier under Sultana (Mount Foraker)* TOP: *Eric Saggers, Denali Pass.*

ABOVE: *Gottlieb Braun-Elwert does his Alaskan homework before leaving New Zealand.*

RIGHT: *At Talkeetna, Gary Kuehn (right) and Eric wait for the weather to clear.*

BELOW: *Gottlieb and Eric sort and weigh expedition gear at Talkeetna airport.*

with Pika's crevassed slopes which seemed more a honeycomb of air than smooth ice.

With the Beaver airborne again, homeward bound for Talkeetna, we were alone in the Alaska Range, blinking in disbelief on a bright spring morning. There it was, just as I had pictured it would be – the mighty Denali, seemingly floating in front of me, still some 60 kilometres away and soaring 5000 metres skyward. Impressive. I always find it hard to contain my excitement among big mountains – with no fences, no computers and, save for great granite cathedrals where light glances through stained-glass mantles of ice, no churches where God is imprisoned.

I have a daughter named Denali, so an Alaskan venture had been in the wind for quite some time. But now, dumbstruck by the enormity of our surroundings, we faced the reality of the journey ahead. Eric Saggers, Gottlieb Braun-Elwert, Gary Kuehn and I floundered around in cold powder snow as we lashed gear onto plastic kiddies' sledges and smoothed sticky climbing skins onto skis. This routine would be well practised over the next 23 days before we could strike out for the highest summit in North America. Eric is an experienced New Zealand ski mountaineer, though we first met in Antarctica when working together during the aftermath of the 1979 Air New Zealand disaster on Ross Island. German by birth, Gottlieb runs a successful New Zealand guiding business, Alpine Recreation, and had climbed FitzRoy in winter. Gary is an American ski enthusiast who has now settled in Hobart so that he and his wife could work for the Australian Antarctic Division. At last, after a 12-month gestation, our south-north traverse of Denali was under way.

The original concept had been quite different: to start some 200 kilometres away, on the opposite side of the mountain. Tracing a finger over a map in my library, it had seemed a simple enough idea to fly into the remote community of Kantishna near Wonder Lake on the north side of Denali. From there we had planned to shuttle a 30-day load of food and fuel to McGonagall Pass, then ski up the Muldrow Glacier to Karstens Ridge. Keen to go for the top after climbing Karstens and the Harper Glacier above, we had set our hearts on retracing the first ascent route pioneered in 1913 by the Reverend Hudson Stuck, Archdeacon of the Yukon – 'I would rather climb that mountain than discover the richest gold-mine in Alaska'. Instead of downclimbing the same route as Stuck had done, we wanted to go over the top of Denali, descending the West Buttress to the Kahiltna Glacier. Rather than fly out from the snow runway under Mount Hunter, we hoped to rummage in our reserves and ski on down the Kahiltna for a pick-up on the tundra beyond the glacier snout.

Thankfully, the climbing rangers knew better. At our briefing in Denali park headquarters, Joe Reichardt and Roger Robinson (and later, Brian Okonek, who has guided the south-north traverse many times) strongly suggested that,

with patchy winter snow cover up to McGonagall Pass, we stood a better chance of success by reversing the route, starting on the lower Kahiltna with a guaranteed smooth sledging surface. In hindsight, it was sound advice: we would probably have ground to a halt hauling heavy loads up the Muldrow. Groups that attempt a north-south traverse usually arrange for a dog team to pre-position a depot on the Muldrow during the late winter. This task is not easy to organise from overseas since it is important to personally select preferred brands of food and strip off wasteful packaging.

After an efficient transit of Anchorage, which had involved the baking of 250 muesli bars in Gary's tolerant in-laws' kitchen, we had rolled into the snow-covered township of Talkeetna, still barely clawing its way into spring after the long haul of winter. With aircraft grounded by heavy rain, we lingered in snug cafés crammed with memorabilia and moose heads. A tatty collection of posters lined the walls: 'Alaska – where men are men and women win the Iditarod' – the 1600-kilometre Anchorage-Nome dog sledge race won three times by Susan Butcher in the 1980s – and 'McKinley never saw Denali', referring to the 1896 renaming of Denali as Mount McKinley after the 25th American president, who never went to Alaska.

Into a bakery one morning strode a lanky bushman in greasy jeans that were more patch than denim. He parked his rifle then, mingling with fresh-faced climbers in crisp down jackets, filled the coffee cup tied to his belt. As he scratched his matted beard, I caught sight of glazed eyes fixed in a faraway stare – the look of someone too long alone in a log cabin.

On 1 May 2002, I was rudely awoken by the rush of fresh air as I lurched out of the Beaver onto the glacier. As I clipped on my skis, I knew I would fall in love with Alaska (despite its loose allegiance to a flag that looks like a bar code), its funky people, its prolific wildlife and its remarkable landscape. The Russians made a bad mistake in 1867, selling Alaska to the Americans.

We broke into the sledging routine gently by deciding not to hump heavy rucksacks on our backs. Instead, we strapped the packs on top of the laden sledges, ensuring that heavy items were placed as low as possible in the load to

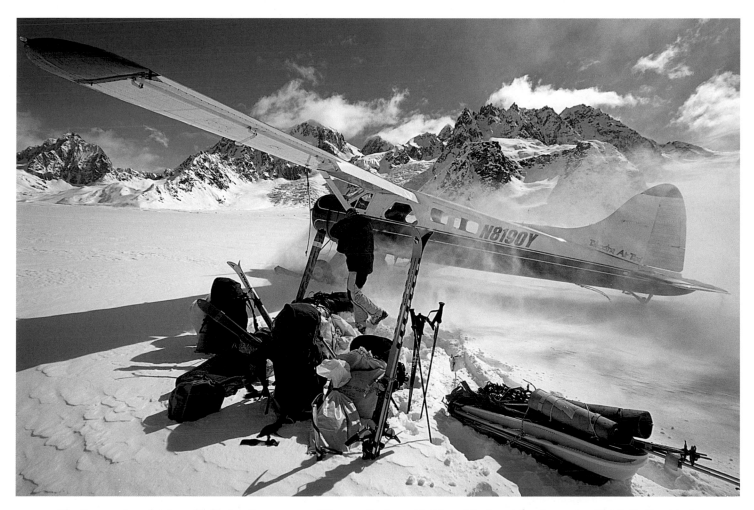

The Beaver aircraft takes off after landing our expedition on the lower Kahiltna Glacier under the peaks of Little Switzerland.

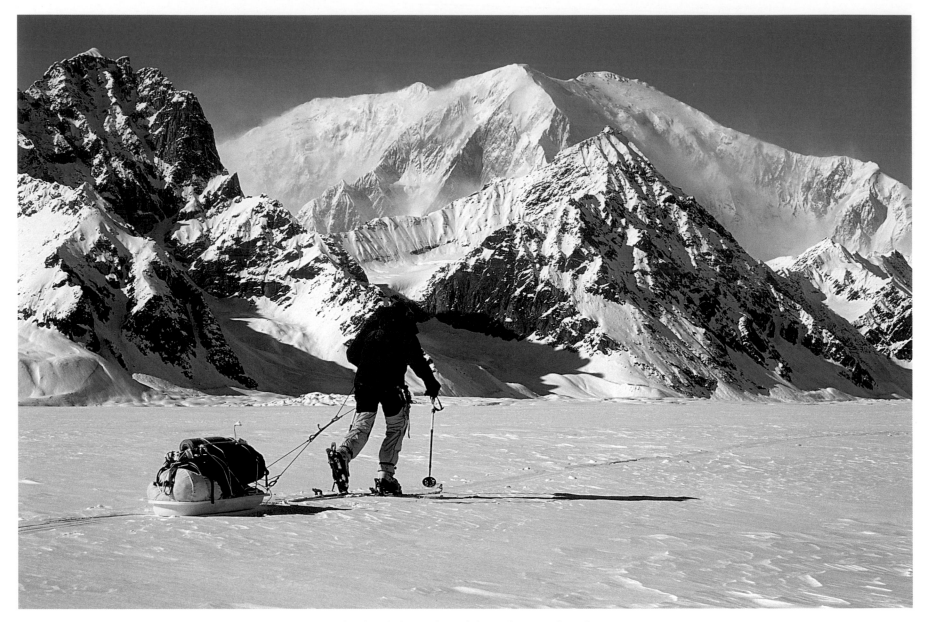

Eric hauls a sledge on the Kahiltna Glacier under Sultana.

minimise the frustration of capsizing. It took us three days on a velvet-smooth surface to glide past the massive bulk of 5150-metre Mount Foraker, also named after an American politician with no connection to Alaska. The Athabascan Indians have always known Foraker as Sultana, Denali's wife.

At this point we diverted up a fork of the Kahiltna to an airstrip-cum-camp under Mount Hunter. Here, ski-planes darted in and out, disgorging a growing number of climbers who had arrived for the annual pilgrimage to Denali's West Buttress. Included among them was a platoon of US Marines in virgin-white clothing who were later spotted searching the snow for their whiter than white packs. Even though we now had to share the route with others, it was grand to

sleep beneath Hunter's Moonflower Buttress, a stunning 2000-metre route of sheer granite and overhanging ice. It was first climbed in 1981 by the Kiwi Paul Aubrey and the great American alpinist Mugs Stump, who was later killed guiding on Denali's South Buttress.

Sunny, stable weather prevailed, eliminating the need to rush. A relaxed approach eased our adjustment to the camp routine, the cold and, gradually, the altitude. Visiting the Hunter camp enabled us to pick up our additional 21-day supply of food and fuel flown in by air taxi. Importantly, we bought additional fuel from the camp manager, taking all the worry out of prolonged bouts of cooking higher on the mountain. This luxury would not have been

possible had we done the traverse in the other direction. Food can cause unexpected problems. Returning to Talkeetna from the Hunter camp after a ranger patrol on Denali, Joe Reichardt once hitched a ride with a group that had flown in solely to eat pizzas. On takeoff, the plane made a spectacular cartwheel down the glacier and was completely wrecked. Miraculously, Joe and the others were uninjured. Expensive pizzas!

We spent the next two weeks double- and triple-carrying loads up through the usual string of West Buttress camps at 2600, 3500, 4200 and 5000 metres. At the top two camps, the rangers, doctors and volunteer climbers maintained an impressive rescue capability. They also furthered climber education by ensuring that everyone disposed of human waste properly (biodegradable bags thrown in crevasses) and removed rubbish from the mountain (on departure, plastic bags and fuel cans marked with the team's permit number must be accounted for to avoid a fine).

We made steady progress, losing only one day owing to snowfall. It seemed unlikely that the stationary high would persist for long – Denali has a savage reputation as a polar mountain lashed by strong winds and frozen by low temperatures – but persist it did. What a blessing: cloudless skies, relatively mild temperatures and near windless days, even at the notorious Windy Corner.

Above Windy Corner, at the 4200-metre camp, we redistributed our remaining 18 days of rations into three loads. Although our foursome had more supplies to position on the mountain than others going up and down the same route, our lighter loads meant we could travel faster and move upwards even during the occasional spell of marginal weather. Importantly, making several journeys to a higher camp meant we did not burn out as we adjusted to the altitude. And we reaped the benefit of sleeping longer at lower elevations, going up to occupy the next camp only when everything was in position for a final carry of personal gear.

Too many visitors seemed to downplay the effects of altitude and exhausted themselves trying to storm the mountain with big packs. Some foreigners (and Americans with short holidays) stressed themselves unduly, following a tight schedule, attempting the summit from low on the mountain, then wondered why they ran out of puff shy of the summit, stumbled on the descent (at times with serious consequences) or fell foul of frostbite. Ignoring the fundamentals of mountain travel, one European guide, in his haste to retreat to the 4200-metre camp after a botched summit attempt, inexplicably left clients high on the mountain. One client later suffered a fall, a nasty bivouac and, next morning, an awkward high-altitude helicopter evacuation. Surprisingly, internationally qualified guides cannot legally take clients to Denali unless they work for one of the American companies with an official national park concession. Denali may not be a really high mountain but it is *big* and cannot be rushed. It deals

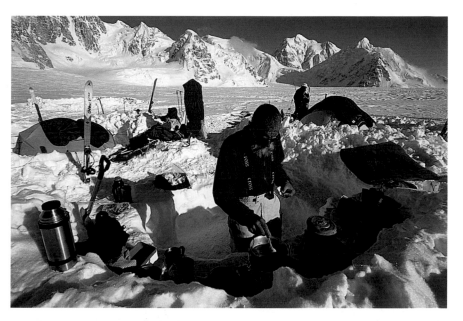

With Mount Hunter in the background, Eric cooks outside on the Kahiltna Glacier.

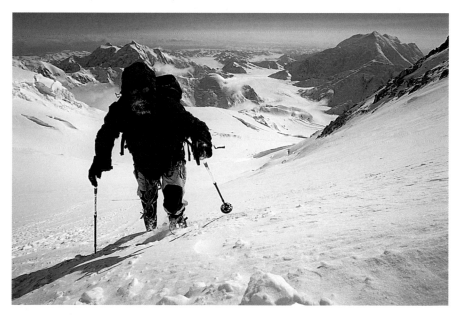

Eric hauls a load up the West Buttress route towards our 5000-metre camp. The Kahiltna Glacier and Sultana lie beyond.

Eric leaves the high camp for Denali Pass (at left).

Eric crampons over Denali Pass.

Eric uses a snow saw to cut blocks for a windbreak around the Harper Glacier camp below Denali Pass.

harshly with mountineers who are not in tune with others in their team or with the environment.

Some also underestimate the insidious nature of the cold, failing to add extra fats to their diet, drinking insufficient fluids or sleeping badly owing to inadequate insulation. As tent partners, Eric and I snuggled into separate down bags inside two outer bags that zipped together to form a cosy single unit. Sleeping with Eric and his bushy ice-clad beard was like curling up with a cross between Santa Claus and Roald Amundsen. Crucially, the down bags retained their loft while the synthetic outer bag, coated with frost crystals during the night, dried quickly in the morning sun. Gloves, socks and inner boots stayed soft and warm between the two layers.

For breakfast, Eric and I took turns to fry slices of salami with home-dried tomatoes in peppered butter so we could bolster the meagre long-term energy output of muesli and honey. Somehow, amid happy banter, the smell of sizzling salami cleared out the cobwebs of sleep and helped to focus my mind on the day ahead. During the snow-melting ritual, filling insulated waterbottles and thermoses, we hunched over the stove for long spells after dinner and at breakfast. We made a point of not leaving the tent in the morning before downing two, often three brews from big mugs. Concerned to keep my damaged toes from freezing, I wore neoprene overboots (that held clip-on crampons perfectly), closed-cell foam inner boots and skindiver's neoprene socks. Each evening I dusted my sweaty feet with talcum powder and changed into dry woollen socks.

After the third carry along a ridge laced with rock gendarmes and icy arêtes, we camped on a shelf at 5000 metres, cutting snow blocks and jigsawing them together into a protective wall. It was a hard place to live in at first, cold and exposed to the slightest breeze. Clearly, though, we had benefited from the lengthy acclimatisation process, gradually gaining strength for the climb to Denali Pass, 400 metres above. With the clear weather still holding, it took resolve to pace ourselves and not simply attempt to bag the summit from this south-side camp. We were focused on completing the traverse; the summit had to remain an optional extra. We felt certain of success if we could establish a camp tucked high on Harper Glacier, a narrow, wind-scoured ribbon of ice that flows northward between Denali's two summits. To achieve this, we needed to haul six days of supplies over Denali Pass for the descent of the Muldrow. It also seemed wise to position another six days' food and fuel on the Harper as back-up in case of storm.

On three successive days the four of us cramponed up the firm slopes to Denali Pass before finally digging in and occupying the Harper campsite. And the last day was a shocker, with powerful wind gusts repeatedly flattening us against the slope. Several parties turned back. Eric and I almost did so too, but could not stand the thought of a prolonged delay on the *wrong* side of the mountain, so pressed ahead. Reluctantly, Gary and Gottlieb followed. Waiting

for a lull, Eric and I sprinted uphill for a few seconds, then hurriedly hunkered over our axes again. Scary. My breath sucked away by the wind, I panted uncontrollably on the pass. Eric caught up and we hugged. Against all expectations it was sheltered in the Harper, enabling us to pitch the tents in some degree of comfort. Our priority was to consolidate the snow-block wall construction initiated on previous visits. Strong radiation and persistent wind abrade snow walls quickly, necessitating constant maintenance, so Eric cut hefty fins of sastrugi that we stacked against the inner wall like plates of armour. The Harper is a serious place to be pinned down in a windstorm, but we felt secure behind our circular fortress. It had been well worth the exhausting effort.

A questionable summit dash turned in our favour as the spirals of powder snow whipping off ridge crests abated. The nagging wind drew breath just as we passed Archdeacon's Tower, our agreed turn-around point had the blustery conditions persisted. On open slopes, free from crevasse danger, it was pure pleasure to push on at our own pace, cramponing unroped all the way to the top. Like most summits, it was further than anticipated, but finally, a neat, narrow ridge culminated in a cluster of Buddhist prayer flags snapping in a stiff breeze. Tattered old flags scattered a message of peace over America; others, imprinted with prancing windhorses, emerged from my jacket in remembrance of friends.

As newcomers to Alaska, Eric and I were chuffed to climb Denali on our first attempt. For Gottlieb and Gary, success was particularly sweet too, as both had previously missed out on the summit. Some years ago, Gary had been stuck in a storm high on Denali for 10 days; in 2001, Gottlieb had turned back on the South Buttress with a client. And now, what a thrill it was for all of us to look down the upper ramparts of the hallowed Cassin Ridge and across to the jagged

Eric fries salami for breakfast on the Harper Glacier.

Eric descends from Denali's summit,
Gary and Gottlieb close behind.

Gottlieb (left), Eric and Gary reunite below the summit of Denali.

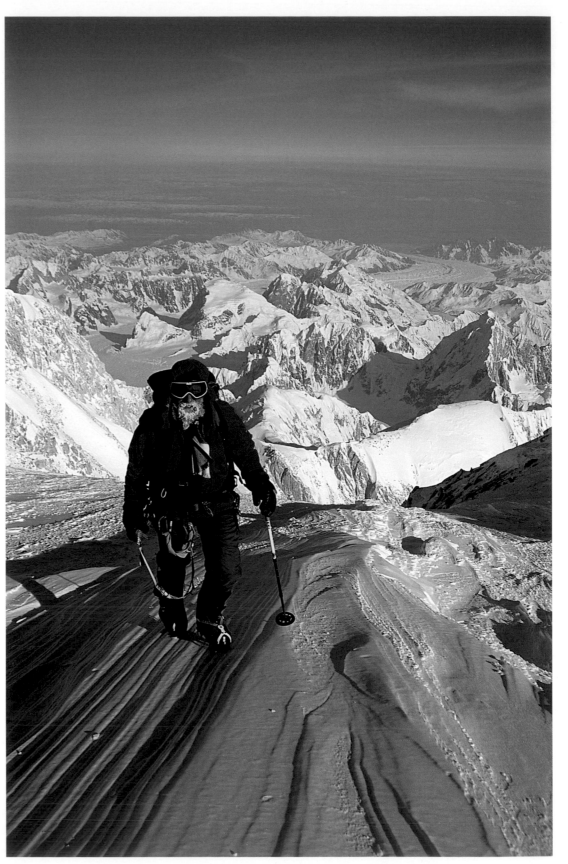

Eric near the summit of Denali, with Mount Huntington below (at right).

blade of Huntington, first climbed by famous French guide Lionel Terray in 1964 and surely one of the most impressive peaks in Alaska. Feeling frivolous, and knowing it was downhill all the way to Wonder Lake, I did a merry little dance with Denali, then descended.

Excitement grew next morning as we contemplated fresh horizons, crunching down the Harper to camp near Browne's Tower, a granite buttress perched on top of Karstens Ridge. From here, the Karstens snakes its way into the icy depths of the Muldrow Glacier. As we fought to control two beastly sledges on the steeper parts of the lower Harper, I stole a moment to marvel at the 45° gully that rose above me all the way to North Peak.

In 1910, a team of Alaskan Sourdoughs – prospectors and trappers – hauled a spruce log all the way up this gully to the summit ridge (logs were used on the Muldrow for crossing crevasses). To counter the blatantly false claim of the first ascent of Denali by Dr Frederick Cook in 1906 (a publicity stunt to raise money for his 1907–09 attempt to reach the North Pole – also a fudged claim), these tough Kantishna men mushed dogs up the Muldrow, determined 'to prove that Doc Cook was a goddam liar'. One of them, Charlie McGonagall, had previously found a pass (now named after him) that was quickly recognised as the key access to the glacier. He considered the Muldrow 'as smooth as Wall Street, the easiest of walking'. In a remarkable piece of climbing, the Sourdoughs reached the top of the North Peak, genuinely thinking it to be the loftier of the two summits. They hoped (in vain) that the 4-metre flagpole, erected on the final rocks, would be seen from Kantishna as proof of their climb. It took other bold attempts – notably by Belmore Browne in 1912, to 'within a 200-metre stroll' of the true summit – before Stuck's party finally made a definite ascent of the higher South Peak in 1913.

Even though these early climbers had the benefit of rudimentary 'creeper' (instep) crampons, when my turn came to descend the long curving Karstens Ridge, my respect for the pioneers increased markedly. The Karstens is not that steep, but it was our 25th day on the move. With a tired body, an unwieldy pack that was top-heavy with skis and an empty sledge tethered by a short rope flailing around my ears, I had no confidence or inclination to move quickly. With massive dropoffs into the Muldrow and the Traleika, it was certainly no place to stumble. Painful hours later, belaying pitch by icy pitch, Eric and I neared a spectacular campsite perched on the ridge. Thankfully, Gary came back up to rig a top-rope and make it easy for us to downclimb a tricky blade of ice. After a badly needed meal, Eric and I stood outside the tents at midnight. In silence, we watched a watery sun skid beneath brooding cloud, then skim along the horizon beyond Wonder Lake. Directly behind camp, a full moon rose over Ruth Gorge.

Yet more concentration was required on the Karstens in the morning before we could drop off into a snowy amphitheatre nestled between gigantic ice

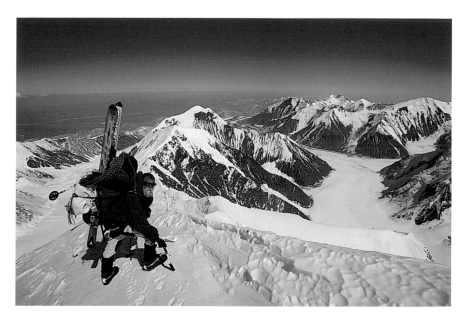

With a heavy, awkward load, Eric begins the descent of Karstens Ridge. The Muldrow Glacier is to the left, the Traleika Glacier below.

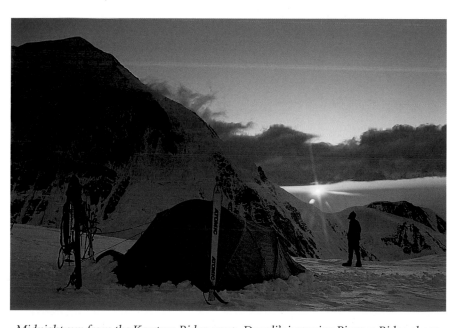

Midnight sun from the Karstens Ridge camp, Denali's imposing Pioneer Ridge above.

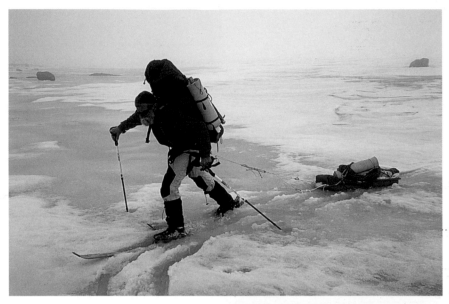

*ABOVE: Eric hauls a sledge
through a melt stream,
on the lower Muldrow Glacier.*

*RIGHT: A willow ptarmigan
at Clearwater Creek,
near Wonder Lake.*

*BELOW: Somewhat grubby after
29 days on Denali, Eric rubs
a little moose into his hair.*

cliffs and Denali's imposing Pioneer Ridge. It was a relief to exchange crampons for skis and to offload heavy items onto the two remaining sledges. Even though the crevasses in the Muldrow turned out to be narrower and easier to cross than expected, it felt safer to keep all four of us on one long rope, tensioning the sledges between the middle two skiers. It took two more days to descend the Muldrow, threading a path through buckled icefalls and, on the lower reaches, sloshing through melt streams. At one point, still wearing skis and towing a sledge, Eric was up to his knees in icy fast-flowing water. Finally, after fluffing about in a white-out, we camped under McGonagall Pass.

As we crossed McGonagall in the freshness of a calm clear morning, a cluster of purple flowers winked at us from among granite moraine. The tiny blooms heralded a welcome escape from the maw of ice. A final two-day walk to Wonder Lake lay across the joy of open tundra. Caribou with calves snuffed the wind at our passage, retreating nervously to higher ground. Displaying remnants of white winter plumage, willow ptarmigan chortled in the scrub beside the camp at Clearwater Creek. How wonderful it was to rip off clunky climbing boots and wiggle our toes in the grass. You can sense the end of a trip when the last of the scroggin is scoffed.

As we peeled off layer after layer of clothing, and increasing amounts of bare skin appeared, we were glad that we were here early in the season and not facing an onslaught of voracious mosquitoes. And, as rain set in beyond McKinley River – the main braids were easier to ford than we anticipated – we grew wide-eyed at the *big* bear prints in the mud. We convinced ourselves that grizzlies cannot smell the fragrance of unwashed climbers. In reality, the bears were probably kept at bay by the screech of off-key Bob Dylan songs as we lumbered along under bulging packs. Unquestionably, bears need to be treated with respect, especially when they are hungry after winter's long hibernation. We cooked our evening meal at Clearwater one hour before pitching camp to minimise the smell around the tents. What little food we had left was depoted further up the river away from camp. (From bitter experience, Alaskans also fear moose in the spring after they have dropped their young.)

Ground down by 29 days on the go, it was four weary, rain-sodden lads who finally dumped their packs on the verandah at Wonder Lake Ranger Station. The ridge-hugging flight out from the isolated village of Kantishna next day revealed the grandeur and the serenity of the Alaska Range. What a privilege it had been to linger in an untamed landscape.

Like many good trips, this one ended by meeting old friends. Cari and Dave Johnston and their son, Galen, treated us to fine Alaskan hospitality at their log cabin tucked away in a silent spruce forest near Trapper Creek. A lofty beanstalk of a man, Dave had just retired after more than 30 years as a ranger for Denali State Park. In 1967, he made the first winter ascent of Denali. In 2001, he

climbed the mountain again, this time with Cari and Galen who, at 11, became the youngest to reach the summit.

When we parted, Galen left with his parents to polish off his last few ascents of the highest peak in each of the lower 49 states, assuredly the youngest to set out on such an odyssey. An avid Nordic skier, that year Galen was the Alaska state champion in his age class, and had set his heart on an exchange year in a Scandinavian school so he could ski with Norwegians. Following in his son's footsteps, 60-year-young Dave was on the verge of completing his quest to be the first to climb the 50 high points of America – in winter.

After quaffing red wine and rhubarb pie, the steaming log sauna on the lakeshore beckoned. We were soon broiled to the colour of barbecued salmon.

An irreverent beaver took great delight in watching the gaggle of skinny pink bodies plunge into icy Lake Chauvina. Rolling in mirth, he tweaked his whiskers, slapped his tail on the water and disappeared.

Postscript: As my daughter and I ran in the forest above our home in Christchurch vivid flashbacks of Alaska came to me: skiing under Moonflower Buttress, pulling over Denali Pass for the first time, sniffing the scent of earthy tundra from out on the Muldrow ice, visiting Russian Orthodox churches on Kenai Peninsula. As usual, I lagged behind my long-legged daughter loping along through the trees. Ah yes! I thought, to dance again with Denali…

Our traverse of Denali went from left to right in this view from Dave Johnston's cabin. Mount Hunter is the small triangular peak at the left.

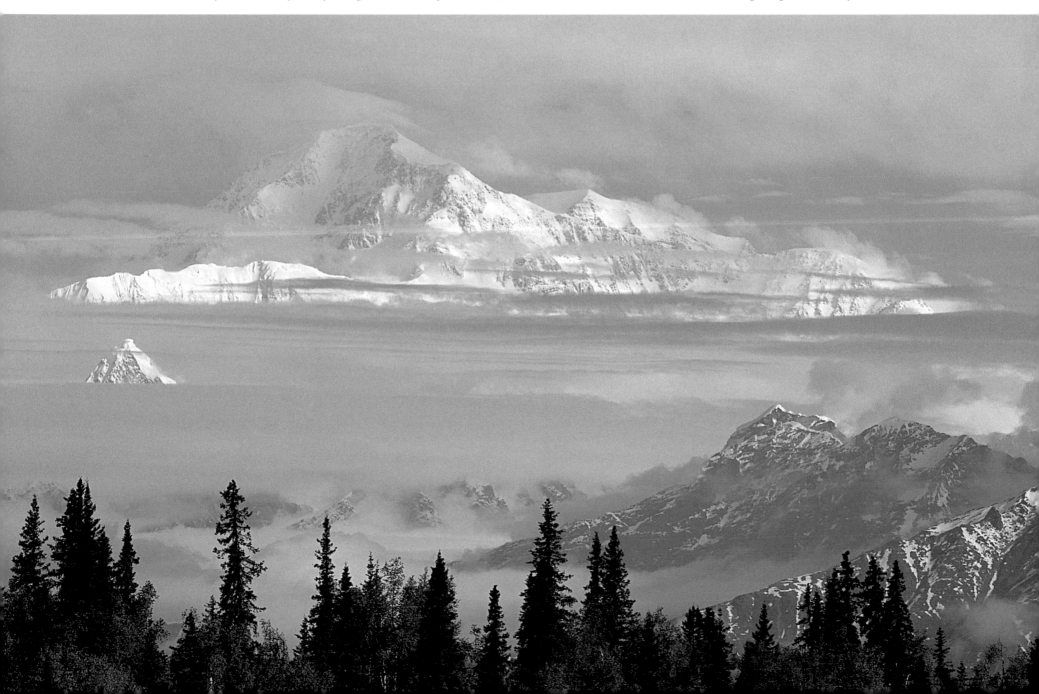

Denali Pass

Denali
(Mt McKinley)

Windy Corner

Wonder Lake

McGonagall
Pass

Muldrow
Glacier

Mount Hunter

Sultana
(Mt Foraker)

Kahiltna
Glacier

Little
Switzerland

Eric

ALASKA

Talkeetna

Denali, Alaska

Beckey, Fred. *Mount McKinley – Icy Crown of North America*, The Mountaineers, Seattle, 1993,

Beckey, Fred. *Mountains of North America*, Sierra Club Books, San Francisco, 1982.

Browne, Belmore. *The Conquest of Mount McKinley*, Knickerbocker Press, GP Putnam's, New York, 1913.

Cook, Frederick. *To the Top of the Continent*, Hodder & Stoughton, London, 1908.

Cook, Frederick, Belmore Browne & Hudson Stuck, *Denali – Deception, Defeat & Triumph*, The Mountaineers, Seattle, 2001.

Davidson, Art. *The Coldest Climb: The winter ascent of Mt McKinley*, The Bodley Head, London, 1969.

Fitzhugh, William & Aron Crowell, *Crossroads of Continents – cultures of Siberia and Alaska*, Smithsonian Institution, Washington DC, 1988.

Jones, Chris. *Climbing in North America*, University of California Press, Berkeley, 1976.

Lopez, Barry. *Arctic Dreams – Imagination and Desire in a Northern Landscape*, Charles Scribner's Sons, New York, 1986.

Rowell, Galen. *High and Wild – A mountaineer's world*, Sierra Club Books, San Francisco, 1979 (Revised edition, Spotted Dog Press, Bishop, California, 2002).

Rowell, Galen & John McPhee. *Alaska – Images of the Country*, Promontory Press, New York, 1905. (Text by John McPhee from *Coming into the Country*, 1976).

Scott, Chic. *Pushing the Limits – The story of Canadian mountaineering*, Rocky Mountain Books, Calgary, 2001.

Sheldon, Charles. *The Wilderness of Denali*, Charles Scribner's Sons, New York, 1930.

Stuck, Hudson. *The Ascent of Denali*, Charles Scribner's Sons, New York, 1914.

Washburn, Bradford & David Roberts. *Mount McKinley – The Conquest of Denali*, Abrams, New York, 1991.

Washburn, Bradford. *Mountain Photography*, The Mountaineers, Seattle, 1999.

Washburn, Bradford and Peter Cherici. *The Dishonourable Dr Cook – Debunking the Notorious Mount McKinley Hoax*, The Mountaineers, Seattle, 2001.

Waterman, Jonathan. *High Alaska – A Historical guide to Denali, Foraker and Hunter*, The American Alpine Club, New York, 1988.

Waterman, Jonathan. *In the Shadow of Denali – Life and death on Alaska's Mt McKinley*, Dell/Bantam, New York, 1994.

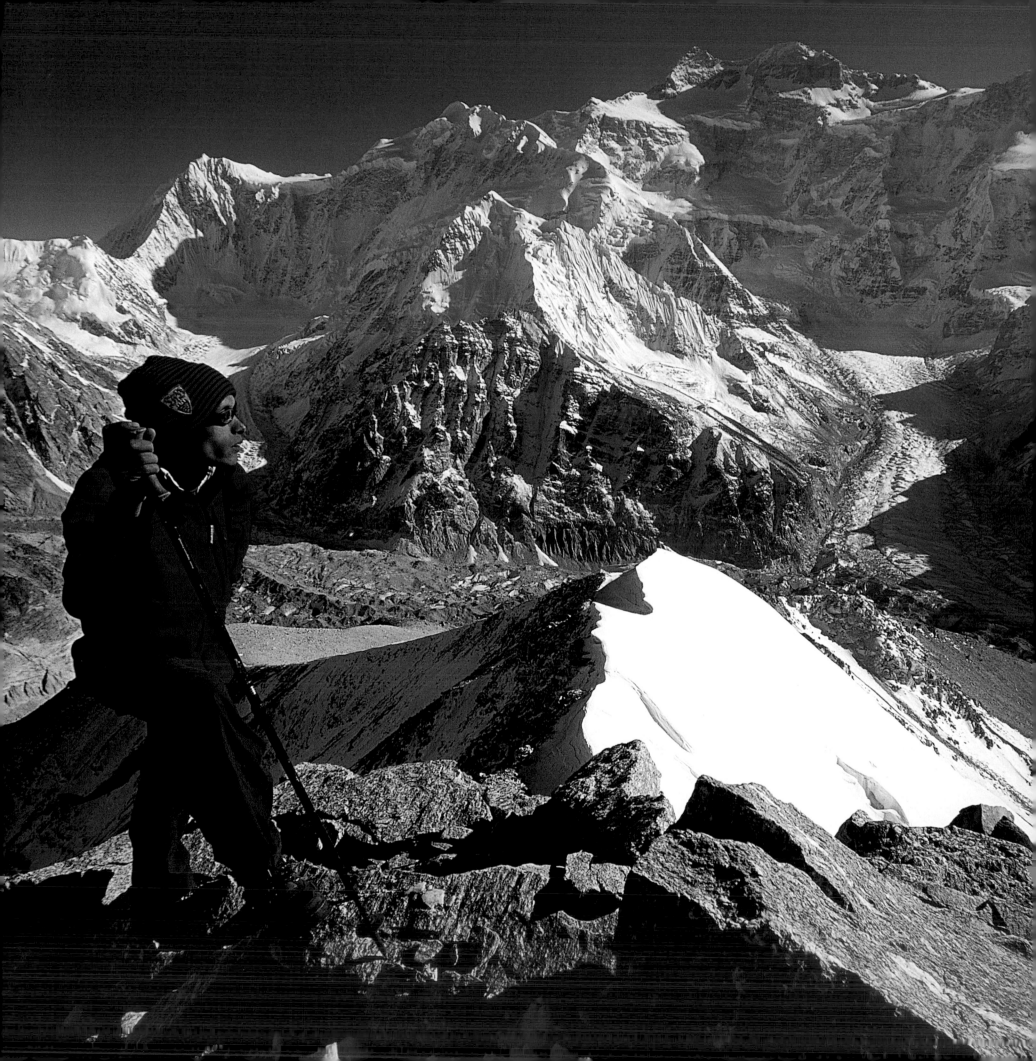

Beyond the Wall of Shadows

An adventure on the Nepalese side of Kangchenjunga

No part of the snowy Himalaya eastward of the north-east extremity of the British possessions had been visited since Turner's embassy to Tibet in 1789; and hence it was highly important to explore scientifically a part of the chain… but it was not then known that Kinchinjunga, the loftiest known mountain on the globe, was situated on my route, and formed the principal feature in the physical geography of Sikkim… In the early morning the transparency of the atmosphere renders this view one of astonishing grandeur. Kinchinjunga bore nearly due north, a dazzling mass of snowy peak, intersected by blue glaciers, which gleamed in the slanting rays of the rising sun, like aquamarines set in frosted silver.

Sir Joseph Dalton Hooker, *Himalayan Journals*

Walungchunggola. The outlandish name spoke to me of medieval Nepal, of age-old caravan routes across the Himalaya and of a time when, for a Westerner, reaching such an isolated place meant hard-won exploration. Walungchunggola first leapt out at me when I chanced upon a wood engraving in Joseph Hooker's classic *Himalayan Journals*. And now, here I was, actually approaching this ancient village with Hooker's old book stowed carefully in my pack. For the past week, first in Kathmandu as we organised equipment, and then as we followed winding overgrown trails up into highland Nepal, all my energy had been focused on getting to Walunchunggola.

LEFT: *Babindra on the summit of Pangpema, Kangchenjunga beyond.* TOP: *Sombahadur plays a flute.*

I came over a rise and there, in front of me, Walungchunggola nestled into the side of a conifer-clad mountain, the houses spread out on a terrace above the Tamur River. Blue wood smoke drifted skyward through dew-covered roof shakes that glistened in soft morning light. My eyes were gradually drawn above the village to an avenue of prayer flags, spirals of coloured cloth that wound across the hillside beside a stone pathway and led up to Diki Choeling gompa. Beyond, rocky crags filled the head of the valley, barring the way into Tibet. What lay before me almost exactly fitted Hooker's illustration and journal entry. Remarkably, time seems to have stood still in the 154 years since his visit.

> …the valley at once opens, and I was almost startled with the sudden change from a gloomy gorge to a broad flat and a populous village of large painted wooden houses, ornamented with hundreds of long poles and vertical flags, looking like the fleet of some foreign port; while a swarm of good-natured, intolerably dirty Tibetans were kotowing to me as I advanced.
>
> The houses crept up the base of the mountain, on the flank of which was a very large, long convent, two-storied, and painted scarlet; with a low black roof, and backed by a grove of dark junipers; while the hill-sides around were thickly studded with bushes of deep green rhododendron, scarlet berberry and withered yellow rose.

Trekking in Nepal always offers special rewards. Since 1980, when I first landed in Kathmandu on an expedition to Annapurna III, I have been enchanted by this landlocked Hindu kingdom that is roughly the same size as New Zealand's South Island. Whenever possible, Betty and I return to Nepal to spend time among the open, friendly people. No matter how poor, Nepalis always have so much to give and to teach while my own culture often seems to be blinkered and self-serving. On this latest month-long adventure, I wanted to see how the Nepali traders lived and worked in the far north-eastern corner of the country. I was also particularly keen to visit a few of the places first described by Hooker.

Joseph Dalton Hooker has been on my list of all-time-great travellers since I read of his part on James Clark Ross's voyages around Antarctica from 1839 to 1843. Twenty-two-year-old Hooker was the assistant surgeon on HMS *Erebus*, but his heart lay with the natural phenomena that he observed during the four-year expedition. Back home in England Hooker produced a meticulous six-volume work on the flora of Antarctica, New Zealand and Tasmania. Having found his calling, he turned away from medicine to devote the rest of his life to botany, later following in his father's footsteps as director of Kew Gardens. As a friend of Charles Darwin, Hooker played a significant role in the seminal *On the Origin of Species*.

When Hooker arrived in India in 1848, he had no intention of undertaking a concentrated piece of botanical research with a view to formal publication. It is a tribute to Hooker's passion as a naturalist, however, that his two years of wanderings in the eastern Himalaya did eventually lead to the definitive seven-volume *Flora of British India*, after he laboriously classified some 7000 species (150,000 specimens), including 22 new rhododendrons. He was a naturalist with a fine eye for detail, and his pioneer work in eastern Nepal and Sikkim stands out as perhaps the finest botanical exploration of the 19th century. Hooker was also a tough outdoorsman, as noted by Frank Smythe, the British mountaineer who attempted Kangchenjunga in 1930:

Carpets woven in Walungchunggola will be traded in Tibet.

Festival masks, Walungchunggola.

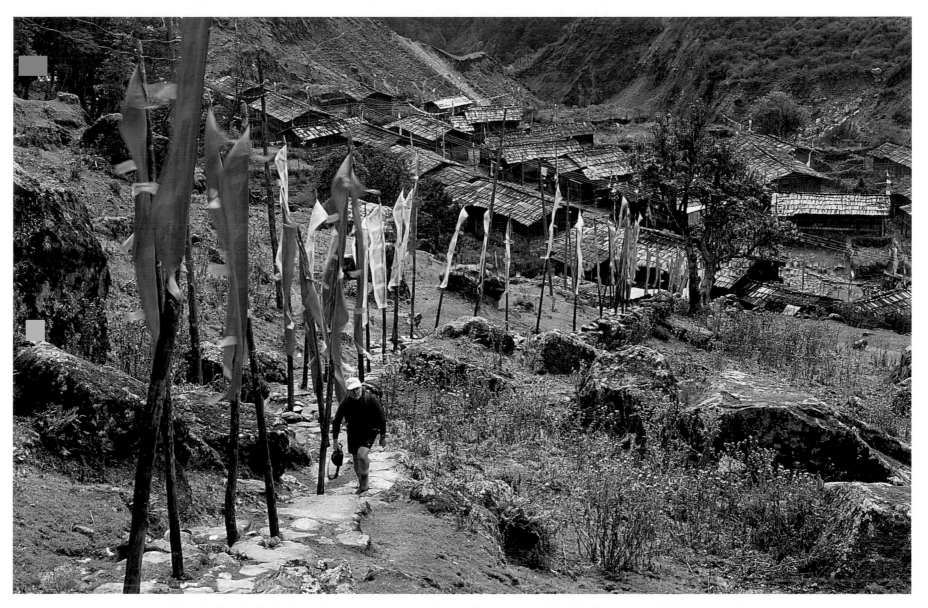

John Nankervis climbs the path under an avenue of prayer flags beneath Diki Choeling gompa, Walungchunggola.

…he explored the Lachen and Lachung Valleys and made attempts on Kangchenjau, 22,700 feet and Pauhunri, 23,180 feet. Unsuccessful though these attempts were, they deserve more than passing notice. In 1849 mountaineering had scarcely begun in the Alps, and it was not until 16 years later that the Matterhorn was climbed, yet here was an explorer attempting peaks 8000 feet higher than the Zermatt giant.

In 1990, I spent a few days in Darjeeling, India, close to Hooker's base for his travels. On my first morning in town, I somersaulted down a flight of steps, smashing a camera and badly bruising my hip. Keen to pamper myself, I limped along Chowrastra Mall and checked into the Windamere hotel, a venerable relic of the Raj. With a sweep of his hand, a turbaned bearer in a red tunic fussed around me, running a bath in my room, slipping a hot water bottle into the bed and lighting the fire. Out on the verandah after a good soak, and sipping a white rum served on a silver platter, I flicked through the visitors' book containing notable signatures and photographs from yesteryear: Lowell Thomas, Ed Hillary and the New York debutante Hope Cooke, who fell in love at Windamere in 1959 with Palden Namgyal, Crown Prince of Sikkim.

Enchanted by a fairytale romance that led to Cooke's enthronement as the Gyalmo (queen) of Sikkim, I looked up from the album and there, rising through a tapestry of mist and forested ridges, was Kangchenjunga. In Hooker's day, this was thought to be the highest mountain in the world, though, at 8595 metres, it is now known to rank third after Everest and K2. Straddling the Nepal-Sikkim

border, with five prominent summits, the peak's original Tibetan name, pronounced Kang-chen-dzö-nga, means 'the five treasures of the great snows'. After Hooker's second journey, he and his companion, Dr Archibald Campbell, were jailed by the Sikkimese, an awkward diplomatic incident that helped to pave the way for the British annexation of Sikkim. Colonisation of the tiny kingdom elevated Kangchenjunga over Nanda Devi as the highest peak in the British Empire. Raising my glass to the mountain, I promised that, one day, like Hooker, I would rub shoulders with this Himalayan giant.

Betty Monteath admires giant bamboo, Tamur River.

Twelve years on, in the 2002 post-monsoon season, our journey to Kangchenjunga began with a delightful walk through lowland Nepal. On the pleasantly warm valley floor, we strolled along a network of narrow paths, periodically encountering clusters of thatched Limbu houses beautifully framed by marigolds, ginger and bougainvillaea. Surrounding the hamlets were cardamom plantations and the makeshift racks needed to smoke-dry this lucrative crop. Thriving paddy fields of rice and millet gleamed in neatly stacked contours above the Tamur River – bright green on our passage up-valley and the golden honey colour of harvest on our departure three weeks later.

Twenty porters had met our party of six New Zealanders at Suketar's flower-fringed, grass runway after we flew in from Biratnagar in eastern Nepal. Bundling out of the Twin Otter beside Betty and me were Jim Harding and Claudia Schneider, both avid trekkers from our group that had recently traversed northern Bhutan. There, too, was the irrepressible John Nankervis, an experienced mountaineer from Wellington who has climbed and explored in many remote ranges around the world. Nank had played a key role in our expedition to Mongolia in 2000 and had initiated our reconnaissance of Tibet's Kangri Garpo Range the following year.

Last to leave the aircraft was Rob Rowlands, a friend from Wellington who now lives in California with his wife Cherie Bremer-Kamp. When Cherie's previous husband, Chris Chandler, died during a winter attempt on Kangchenjunga in 1985, and Cherie lost many fingers and toes to frostbite, she vowed to give something back to the villagers who had helped her to survive. For the past decade, Cherie and Rob have made countless trips to the Kangchenjunga region after raising funds to build a network of medical clinics and schools (www.kangchenjunga.org). They have also played an advisory role in the establishment of the Kangchenjunga Conservation Area Project, KCAP (www.wwfnepal.org.np). Rob and Cherie hope to employ KCAP as an equal partner in future aid work. Joining our trip enabled Rob to check on their projects in the central Ghunsa district so he could pay wages, inventory medical supplies and service solar panels that operate fridges for vaccines. He was also highly enthusiastic about visiting Walungchunggola and nearby Yangma for the first time.

Unlike me, Rob is a technically able person who delights in modern gadgetry. Much to my amazement, while he trekked, Rob carried a mini-computer with a fold-out keyboard and a roll-up solar panel that converted to an electric blanket at night. With the BBC World Service plugged into one ear, Rob could tap out diary entries while down-loading digital imagery from a camera the size of Hooker's snuff box. During GPS-positioned lunch breaks, Rob was pleased to see that I, too, had remained at the cutting edge of word processing when I whipped out a pocketknife and sharpened a pencil. Conscious of the need for a

After a cold day below Yangma, the porters light a driftwood fire.

The porters cook rice and dahl for their evening meal.

back-up, so that my scribbles would later aid the floppy disk between my ears, I told him I had brought two pencils.

We were grateful that our friend Ravi Chandra of Ama Dablam Adventures in Kathmandu had been able to secure a permit to a region butting onto the Tibet border that has been strictly off-limits for almost half a century. I had not heard of Westerners reaching the Walungchunggola district since New Zealander Norman Hardie passed through on his traverse to the Khumbu-Everest region in 1955. After Hardie completed the first ascent of Kangchenjunga with Joe Brown, George Band and Tony Streather, as part of Charles Evans's British team, he embarked on a trek across the grain of the country with Sherpa companions, living largely off the land. This monsoon journey was the inspiration behind *In Highest Nepal*, one of the first books to make detailed observations of the Sherpa culture. Norman lives not far from my home in Christchurch so it had been something of a pilgrimage to pay him a visit and discuss our proposed route before leaving for Kathmandu.

In Walungchunggola at last, we pitched our Tibetan-style mess tent in a courtyard then set off to explore the town. Just as Hooker had found, women in every house that I entered were hard at work weaving carpets. Featuring Buddhist motifs or Chinese dragons, the finished products were destined to be rolled up and strapped onto the back of yaks for transport into Tibet. The carpets would likely be sold in Shigatse or Lhasa, far easier markets to reach than those in Nepal, an arduous journey to the south through the forested gorge we had just trekked up. So dense is the vegetation on this steep-sided canyon that we had been forced to camp on the overgrown trail itself, there being nowhere to pitch tents among the leech- and tick-infested

bamboo thickets. Unsure of exactly where we were one night, we labelled the camp 'Bamboozled'.

The weavers stopped work that afternoon out of respect for a 29-year-old woman who had just died in agony trying to give birth to her fourth child. At best, medical care here is rudimentary: patients are often at the mercy of a shaman's chants and his herbal remedies. Next morning, a funeral procession led by trumpeters and a monk wound its way through the cobbled street. Draped in flowers, the deceased sat upright on her bier, bound for the cremation site down by the Tamur. Just then, the cling-clong of bells echoed in the narrow alleyways as a yak caravan grunted into town in the opposite direction. The mourners stepped aside to give the sharp horns a wide berth as the great shaggy beasts lumbered along unperturbed, heavily laden with coarse woollen sacks of winter barley supplies from over the border.

Leaving our porters to enjoy a rest day playing cards and flirting with fetching girls who coyly displayed nuggets of silver-tipped turquoise in their braids, I wandered slowly up to the gompa. Baby yaks nibbled grass under the forest of poles while the prayer flags slithered around me in the breeze like a knot of silken snakes.

Founded by Hisa Dorje, a high lama from Bhutan, Diki Choeling is reputed to be the second oldest gompa in Nepal. A wizened crone clucked and shuffled through the passageways, proudly showing me the unusual centerpiece in the main chamber, a strange statue crafted from a giant mushroom. Though the gompa is sadly impoverished and its Buddhist frescoes neglected, I did unearth exquisitely painted festival masks hidden away beneath a grubby cloth. And, tucked in a forgotten alcove, I found bookends salvaged from Tibet that held

a sheaf of delicate, hand-scrolled prayer sheets. The slabs of wood were intricately carved with dusty rows of miniature Buddhas that shone again when I rubbed them with my fingers.

Before the baby goats were let out in the morning to frolic in the crisp autumn sunshine, we said our farewells in Walungchunggola and set out for a two-day trek to Yangma, a village that, with the imminent arrival of winter, would soon be largely abandoned. The Yangma Khola is quite a valley – with lush, sun-drenched vegetation, a chuckling, happy river and skeins of misty waterfalls trailing from canyon walls below the razor-sharp Sarphu peaks. Slowed by humping loads on a muddy trail, some of the porters reached camp on the first night well after dark. They were cold and hungry by the time they dumped the loads and squatted by a driftwood fire, their hands held out for warmth. Battered little pots of rice soon bubbled away on a glow of embers. A full moon rose over Sarphu, turning the rapids below our tents into molten silver.

By morning the porters were singing again, content to haul loads up to the head of the valley. After a full day on the move, steadily gaining altitude to over 4000 metres, a nippy wind pushed me past a large chorten at the entrance to the village. Clammy fog wrapped tentacles around indolent grazing yaks. Invited inside a house, I snuggled up to the fire and drank cup after oily cup of Tibetan tea sprinkled with pinches of tsampa. The butter, salt and tea had been churned together in a long-handled plunger by two giggling girls who kept flashing their eyes at impish porters huddled by the hearth. Tucked in my sleeping bag that night, I dreamed once again of Hooker, trying to imagine what the Yangma folk would have made of this alien who suddenly appeared in their midst with his entourage and loads of unfathomable accoutrements.

After breakfasting on omelettes and pancakes, washed down by an ocean of tea, Rob and Nank left for a deep valley under the little-known peaks of the Janak Himal. Heading out in the opposite direction, Jim and I retraced Hooker's route north of Yangma, where he had followed the Pabuk Khola towards the Tibetan border. After several hours of walking, I left Jim at a milky-blue lake known as Chhoche Pokhari and scrambled up onto a high moraine so I could look down on a ribbon of ice Hooker called Hidden Glacier. It was evident that the well-trodden caravan route beside the glacier had not changed much since the botanist's day. From my viewpoint, also the limit of Hooker's exploration, I photographed an ice-choked lake under an icefall that cascaded from the border peaks of Chhoche Himal.

Thirty-three years after Hooker fossicked about above Yangma, sketching and collecting plants, a highly educated Bengali by the name of Sarat Chandra Das came this way too. Unlike Hooker, Das crossed Hidden Glacier in 1881 and entered Tibet. Das, however, was no ordinary pilgrim. Employed by the Survey

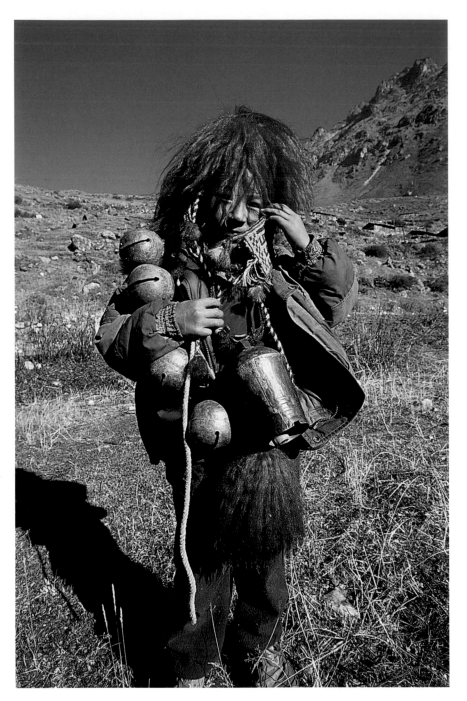

A Yangma yak boy carries bells and tassels down to his herd.

of India, Das became the best known of the so-called pundits, clever spies who worked for the Raj to secretly map southern Tibet. Disguised as a lama on this, his second clandestine journey, Das walked all the way from Darjeeling to Lhasa, recording distances clicked off on an easy-to-count Buddhist rosary of 100 beads instead of the usual 108. Years later, when the Tibetans learned of Das's real identity, Tibetan nobles and religious leaders who had befriended him were tortured and killed. Tibet did not take kindly to threats to its strict policy of isolation. When, in 1901, Rudyard Kipling immortalised the pundits in *Kim*, the character of the secret agent Huree Chunder Mookerjee was probably based on Das.

A stiff, two-day climb followed our departure from Yangma. Winding into the Sarphu Himal, our straggling caravan clambered up to the Marson La and beyond, over swards of alpine herbs that cowered under hanging glaciers. With seracs of crumbling ice draped over the edge of bluffs above the trail, the occasional ice avalanche crashed angrily from the heavens. We chatted with yak men en route from Ghunsa to Yangma, before pushing on to the 4800-metre Nango La, the final snow-covered pass that leads down into the Ghunsa Khola watershed. On the misty high points, I stretched out brightly coloured prayer flags purchased in Kathmandu, adding them to the tattered, faded ones already there. Although I am not a Buddhist, I have grown used to scattering their prayers of peace and goodwill, leaving these little offerings whenever I can. The mountains seem happier places when I release the windhorses on the flags to gallop in the wind.

On Nango La, a chirpy scallywag of a porter named Raj Kumar whistled and wheezed up the last slope, grateful to have the load eased from his back as I beckoned him to rest on a rock. Sharing chapattis and chunks of butterscotch, we peered over the edge into a foggy forest, looking for the way ahead. Though Raj and our other porters were well outfitted, the route up here had been a slog for these tough characters as they threaded their way across unstable moraines and in and out of tricky gullies where an inaccurate foot placement could result in a nasty tumble. Off again, Raj bounced down a steep, slippery trail into a sombre Ghunsa Khola, the prominent sinews on his neck standing out as he strained to support the load, held to his forehead by a tumpline. Grateful though he was for the employment, at times Raj would be away from his family and subsistence farmlet for months at a stretch.

Some in our group also found the going difficult, as they were still struggling to deal with the effects of the altitude. Ever attentive to our needs, Kaila, the cook, brewed up sweet tea or noodle soup in just the right places to keep complaining bodies on the move. Throbbing heads and bouts of coughing were soon relieved as we thundered 1300 metres straight down from the Nango La to the picturesque village of Ghunsa. Unlike the more arid valleys we had come

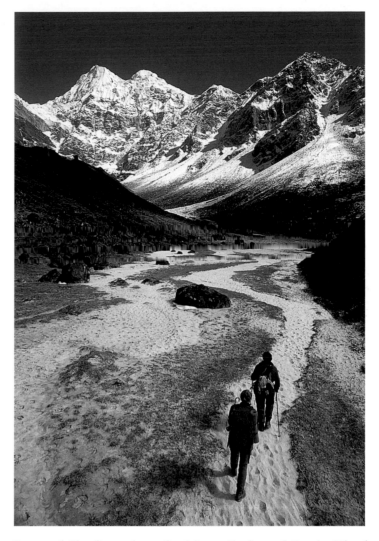

Betty and Claudia on the trail to Marson La, beneath Sarphu Himal.

from, the Ghunsa Khola was suffused with the earthy smell of rich leaf mould. Slender, pale-blue primulas peeped out from the base of gnarled old conifers. The riverbanks were awash with autumn colours; the larches, in particular, glowed like the pouring from a blast furnace.

Ghunsa was a chance to catch our breath, to scrub clothes and to visit the 700-year-old gompa where I constantly thumped my forehead on low roof beams. While Rob discussed operational problems with his Nepali medical staff and tinkered with a malfunctioning solar panel, Jim and I scampered up behind the village into a mixed conifer and rhododendron forest filled with birdsong. I was keen to duplicate the view of Ghunsa that is reproduced in Frank Smythe's 1930 book, *Kangchenjunga Adventure*. At day's end, after a happy spell exploring the riverbank, calm descended on Ghunsa. The night remained crisp and clear and there was a gentleness in the air. I slipped off to bed, energised by the silence and at peace in such a powerful place.

Kids in the Khumbu

Carys gets a lift up a big hill on the trek from Jiri to Kunde.

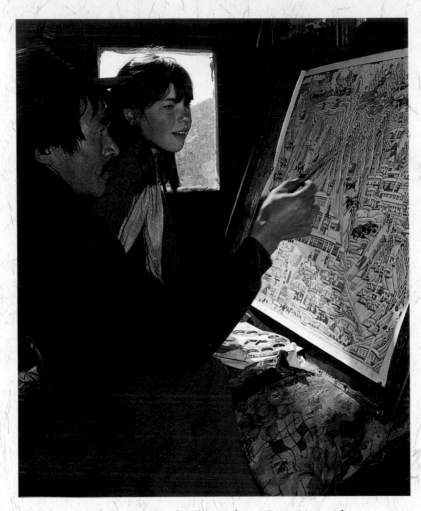

Kunde artist Temba Sherpa shows Carys Monteath his painting of Thyangboche.

Mingma and Ang Dooli Sherpa from Kunde share a joke with Denali (11) and Carys (9).

Danphe pheasants painted on birch bark in thanks for Mingma and Ang Dooli's hospitality.

Trekking in Nepal is always an enriching experience that brings lasting rewards, especially for children. A winter trek from Jiri to Kunde took my family into the Khumbu so we could live with Mingma and Ang Dooli, Sherpas who had long worked with Sir Edmund Hillary and the Himalayan Trust. The Trust's Kunde hospital, now managed by Kami, a Nepali doctor, is a vital focal point for the Sherpa community. Apart from helping a constant stream of trekkers and climbers over the years, the hospital treats refugees who have suffered serious frostbite on their escape from Tibet.

Botty Montoath flies a kite beneath Thamserku and Kangtega.

Carys plays with Sherpa children in Thame.

Betty and Ang Dooli make Sherpa tea in Ang Dooli's kitchen, Kunde.

Betty, Denali and Carys meet Himalayan Trust medical staff, Kunde.

Tibetan refugee children with frostbitten feet after crossing Nangpa La. Photo © Himalayan Trust doctor Lynley Cook.

Betty relaxes beside the Ghunsa Khola, below Ghunsa village.

As we trekked further up towards the Ghunsa Khola headwaters, a feeling of excitement grew in the group, in anticipation of our first glimpse of Kangchenjunga. But the elusive peak would taunt us, remaining hidden for days yet, until we reached the final campsite of Pangpema, situated at the far end of a series of moraine terraces. En route, we were tempted to stray from the path by a great bird-like peak that appeared to take flight above our camp at Kambachen. As clouds parted, Jannu reared up in front of us like the splayed tail of a peacock.

It was the English mountaineer Douglas Freshfield who put Jannu on the map. I have long admired Freshfield's travels which he recorded in his book, *Round Kangchenjunga*, after a monumental journey that circumnavigated the Kangchenjunga-Jannu Himal in 1899. Setting out from Darjeeling, Freshfield's party battled its way up through Sikkim before crossing a high, glaciated pass to approach Kangchenjunga and Jannu from the north. Freshfield returned to Darjeeling via passes on the southern, Yalung side of the range after completing the survey that produced a remarkably accurate map. More than anything,

I wanted to see through my own viewfinder some of the stunning landscapes taken by one of Freshfield's companions, the Italian mountain photographer Vittorio Sella. It had been Sella's large-format images from his expeditions with the Duke of Abruzzi in the St Elias Range, the Ruwenzori and in the Karakoram that had brought these mountain chains to world attention. Lugging a heavy plate camera to vantage points opposite Kangchenjunga and Jannu, Sella painstakingly immortalised Freshfield's exploration in a way that no modern photographer could ever emulate.

Sella produced a hypnotic monochrome print of the 7710-metre Jannu that seemed to be disconnected from Earth as it floated above a backlit cloud. Jim, Nank and I set off, tiptoeing across frosted river boulders in the hope of gaining a better appreciation of this peak that some locals call Khumbakarna. Jannu can best be seen from crags above the Khumbakarna Glacier. Its mighty North Face appeared to me as a brindled wall of shadows and ice-clad buttresses that lurked under a tattered lacework of fast-moving cirrus. After lunch, Jim and Nank left me on a ledge in my pursuit of mountain light. I stood alone

under Khumbakarna, awed by the seriousness of daring to climb such an intimidating wall.

Although their effort was undervalued at the time, the 1975 New Zealand Jannu Expedition did manage to reach the top of the North Face. Peter Farrell and Bryan Pooley were finally forced to retreat from the protracted summit ridge, beaten by October's early winter cold. This audacious route was first climbed in its entirety by a Japanese party the following year, then, in 2000, New Zealander Athol Whimp and Australian Andrew Lindlade attempted the even steeper North Face Direct. Wisely retreating from mid-height, they decided it was prudent to launch themselves onto the original Kiwi/Japanese route, which they climbed in impressively fast, alpine style. As I walked away from Jannu, bound for a warm brew in camp, bharal grazed beside the trail, completely unconcerned by my presence. I turned for a final glance at Sella's masterpiece, but a curtain of mist swirled around me and shut out Jannu, a name that now speaks to my soul.

Pangpema is a windswept, grassy 5100-metre alp directly opposite Kangchenjunga's North Face. Towering above the mess tent, the fluted blade of Wedge Peak dominated the camp, for Kangchenjunga itself was still 6 kilometres away across a glacier. The climbing history linked to Pangpema is absorbing, starting with the Swiss-led attempt on Kangchenjunga's North Face that involved Frank Smythe in 1930. Almost half a century later, in 1979, came Doug Scott's four-man alpine-style ascent of the North Ridge. And my friend, the late Kiwi guide, Gary Ball, and his three companions had made a valiant effort in 1984 to surmount the bands of wicked-looking ice cliffs that dissect the Japanese North Face route. Gary dubbed the trip 'four green bottles' after one of the team, Russell Brice, did accidentally fall, breaking an ankle. A rugged recovery operation followed as Russell was dragged down the glacier back to Pangpema. Finally, after retreating from 8000 metres, Gary recorded in his diary, 'I felt humble in the face of such greatness. The sensation of humility and the beauty of this majesty I was not willing to share with anyone's God. I wrapped my arms about myself and felt the thrill run through me of being a part of it.' Clearly, Freshfield also enjoyed his time at Pangpema: '… and in autumn the brown and gold carpet of frost-bitten turf is silvered with edelweiss and embroidered with patches of sky-blue gentians'.

My first priority after establishing the Pangpema camp was to relocate the exact position that Sella had used to capture his sweeping panorama encompassing Pathibhara Himal (The Sphinx), Nepal Gap (a 6000-metre pass into Sikkim), Kangchenjunga and Wedge Peak. At the end of a strenuous outing, I returned to camp from the rocky ledges above the Jongsong Glacier. Exuberant at taking my own set of photographs, I told my friends that I had been lucky enough to find Sella's original tripod marks.

Betty and Claudia enjoy afternoon tea during a rest day at Lhonak.

Prayerbooks, Ghunsa gompa.

Autumn colours light up the larch trees above Ghunsa.

all the way past Kangchenjunga. (Jongsong, 7400 metres high, was first climbed by Frank Smythe's party on skis during Gunther Dyrenfurth's 1930 expedition. Later, Smythe crossed the Jongsong La and descended Sikkim's Tista River. He returned to Darjeeling, the expedition's start point, thereby completing the second circuit of Kangchenjunga.) Behind Babindra, the corniced crest of Drohmo seemed close enough to touch. Our descent was a helter-skelter affair and we just made it down an enormous gully system to the glacier as darkness caught us well short of camp. Peering into the gloom, we followed bharal tracks in the sand until we could hear the welcoming shouts of Amrit, our sirdar, who had come to greet us with a kettle of tea.

Claudia and I set off at first light the following morning, bound for the bluffs under Tang Kongma, a 'small' 6000-metre hill opposite Wedge Peak. Our plan was to climb to the top, traverse a long ridge to the west, then descend to meet the others who were to re-establish themselves at Lhonak that day. After recently turning back from just below the summit of Argentina's Aconcagua, Claudia was determined to climb Tang Kongma. She urged me on for several hours until we crested a rise and it immediately became obvious that we had made a silly mistake. A massive gully cut us off from the summit ridge. Hoping to short-circuit the problem, we had to make a time-consuming sidle across a dangerous scree slope until forced down to the snout of the Tang Kongma Glacier.

Our reward that day was not a summit but a grand view from the head of the glacier where a 5900-metre pass lies between Tang Kongma and Drohmo. As the temperature plummeted, we scoffed sweets and drained the dregs from our waterbottles and looked across the contorted, rubble-strewn Broken Glacier to the Janak and Tsisima Himals. Assuredly, these fine-looking peaks are worthy objectives for climbers keen to break new ground. Unfortunately, it was too difficult to drop onto the Broken Glacier so we cramponed back along our ascent route, then gingerly picked our way down to the track that leads to Lhonak. Dusk played its usual tricks with us among big boulder fields. Thankfully, Amrit and his strong torch found us just before we would have had to snuggle together in a chilly bivouac.

The way home to Kathmandu was a happy romp back through Ghunsa, then on down to Foley and the tumbling Tamur River. Bound for a rendezvous with an aircraft at Suketar, we strolled along at a leisurely pace in the warmer air of the lower valleys. I dawdled under sacred pipal trees and listened to the banter of porters as they sucked at pipes, their heavy doko baskets balanced on stone slabs. On the last day of the Diwali Hindu festival, a woman came out of her whitewashed house and placed a garland of marigolds around my neck. Betty and I sat in a dingy, smoke-stained tea-house, sipped sweet milky tea and chattered about the next journey – a quest for the orchids of Sikkim.

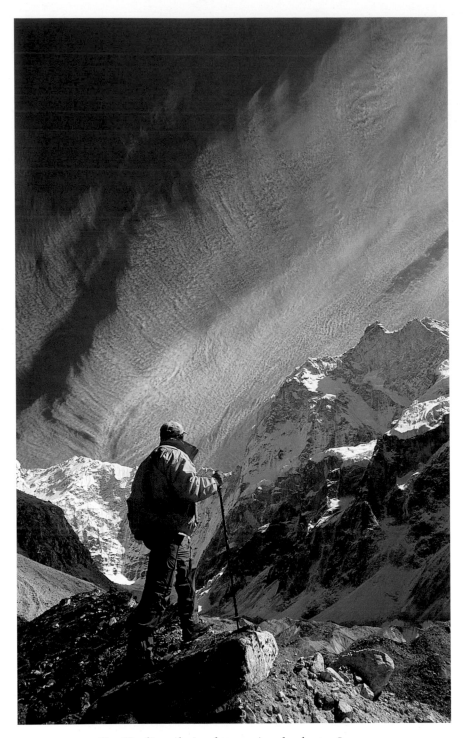

Jim Harding admires fast-moving clouds over Jannu.

Later that day, our assistant sirdar, Babindra, and I pushed on above camp, finally reaching the summit of the 6225-metre Pangpema. A nervous Babindra concentrated hard on the final 200-metre rock climb – he had never been this high before – but his smile on the summit said it all. He was thrilled to take in the commanding view that stretched from Jongsong Peak on the Tibet border

LEFT: *The Yalung Face of Kangchenjunga at sunset from Suketar.* RIGHT: *Norman Hardie with the oxygen set he developed and used during the first ascent in 1955.*

Despite the relaxed, carefree time we had had in the shadow of Kangchenjunga, all was not well in Nepal. Over the past five years, dark shadows had emerged in the shape of a so-called Maoist faction that rose in the west of the country and had now spread its influence to the east. Increasingly disillusioned by the perceived level of corruption within the government, rural Nepalis had become extremely frustrated that aid money was being routinely siphoned off into back pockets, long before it got to the places where it was needed most – in education, medical facilities and water supply systems. The rebels had become sufficiently organised, with their heavy-handed tactics of strikes, reprisals and bombings, to shut down Kathmandu at will. Killing was already out of control, but the situation suddenly took a terrible turn for the worse in June 2001, when King Birendra and much of the royal family were assassinated, apparently by his own son, Crown Prince Dipendra. To Nepalis, royalty are considered deities, so, during a time of significant tension, the whole sordid mess has also weighed heavily on their belief system. The Maoists, though, felt that the newly crowned King Gyanendra would be more inclined to use the army against them than his brother had been. And they were right.

Sadly, in a nation where the men are unusually peaceful and gentle, there have been many tragic deaths, especially of young policemen stationed in remote districts. All along the Tamur River, we had seen red flags flying in the villages and the police posts in Walungchunggola and Ghunsa were gutted by fire.

Though we completed our trek unhindered, a few Western groups had been stopped at gunpoint and asked to make a 'donation'. Thankfully, at the time of writing, a negotiated ceasefire seems to be holding.

On our last evening at Suketar, we sat outside the tents and watched the sun gradually turn the Yalung Face of Kangchenjunga a plum red. There was a stirring in our ranks to return, one day, and probe this side of the mountain, perhaps after a ski crossing of the Kang La on the border beyond Darjeeling, as Frank Smythe had done.

Called to dinner, we wandered back to camp and there, above the tents, we spotted soldiers with searchlights protecting the airfield from attack. Armed sentries patrolled behind a barbed wire fence strung with empty beer bottles that would ring out a warning if disturbed. Before tucking into a fine spread, we were careful not to clink our glasses together as we toasted a journey that had taken us into a very special part of Nepal.

Beaming, Kaila entered the tent to present us with a fruit cake baked in his pressure cooker, its snow-white icing seemingly scraped from the home of the gods. As the top spun off Amrit's whisky bottle, a Sufi poem sprang to mind:

> Oh mountain! High and mighty, reaching into the skies,
> How you seem to be absorbed in self-admiration;
> I am but a small bird, yet I am free to fly
> From flower to flower, whilst you are in chains!

SIKKIM

Kangchenjunga

Darjeeling

INDIA

TIBET

Pangpema

Jannu
(Khumbakarna)

Lhonak

Yangma

Kambachen

Marson La

Ghunsa

Nango La

Walungchunggola

Ghunsa
Khola

N

Tamur
Khola

NEPAL

Suketar

Kangchenjunga, Nepal

Bauer, Paul. *Himalayan Campaign – The German Attack on Kangchenjunga*, Basil Blackwell, Oxford, 1937.

Bauer, Paul. *Kangchenjunga Challenge*, William Kimber, London, 1955.

Boardman, Peter. *Sacred Summits – a climber's year*, Part two: Kangchenjunga, Hodder & Stoughton, London, 1982.

Bremer-Kamp, Cherie. *Living on the Edge – the winter ascent of Kangchenjunga*, Macmillan, Melbourne, 1987.

Das, Sarat Chandra. *Journey to Lhasa and Central Tibet*, John Murray, London, 1902.

Das, Sujoy and Arundhati Roy. *Sikkim – a traveller's guide*, Permanent Black, New Delhi, 2001.

Desmond, Ray. *Sir Joseph Dalton Hooker – Traveller and Plant Collector*, Antique Collectors' Club, Suffolk, 1999.

Dingle, Graeme. *Wall of Shadows – the New Zealand Jannu Adventure*, Hodder & Stoughton, Auckland, 1976.

Dyhrenfurth, Gunter. *To the Third Pole – the history of the high Himalaya*, Werner Laurie, London, 1955.

Evans, Charles. *Kangchenjunga – The Untrodden Peak*, Hodder & Stoughton, London, 1956.

Fanshawe, Andy and Stephen Venables. *Himalaya Alpine-Style*, Hodder & Stoughton, London, 1995.

Franco, Jean and Lionel Terray. *At Grips with Jannu*, Victor Gollancz, London, 1967.

Freshfield, Douglas. *Round Kangchenjunga – a narrative of mountain travel and exploration*, Edward Arnold, London, 1903.

Hardie, Norman. *In Highest Nepal*, George Allen & Unwin, London, 1957.

Hooker, Sir Joseph Dalton. *Himalayan Journals*, 2 vols, John Murray, London, 1854.

Mazuchelli, Elizabeth, 'A Lady Pioneer'. *The Indian Alps and how we crossed them*, Longmans, Green & Co., London, 1876.

Mason, Kenneth. *Abode of Snow – a history of Himalayan exploration and mountaineering*, Rupert Hart-Davis, London, 1955.

Morrow, Baiba and Pat. *Footsteps in the Clouds – Kangchenjunga a century later*, Raincoast Books, Vancouver, 1999.

Sella, Vittorio. *Summit – Vittorio Sella, Mountaineer and photographer, the years 1879–1909*, Aperture, New York, 2000.

Smythe, Frank. *Kangchenjunga Adventure*, Victor Gollancz, London, 1930.

Waddell, Major L. Austine. *Among the Himalayas*, Constable, London, 1898.

Waller, Derek. *The Pundits – British exploration of Tibet and Central Asia*, University Press of Kentucky, 1990.

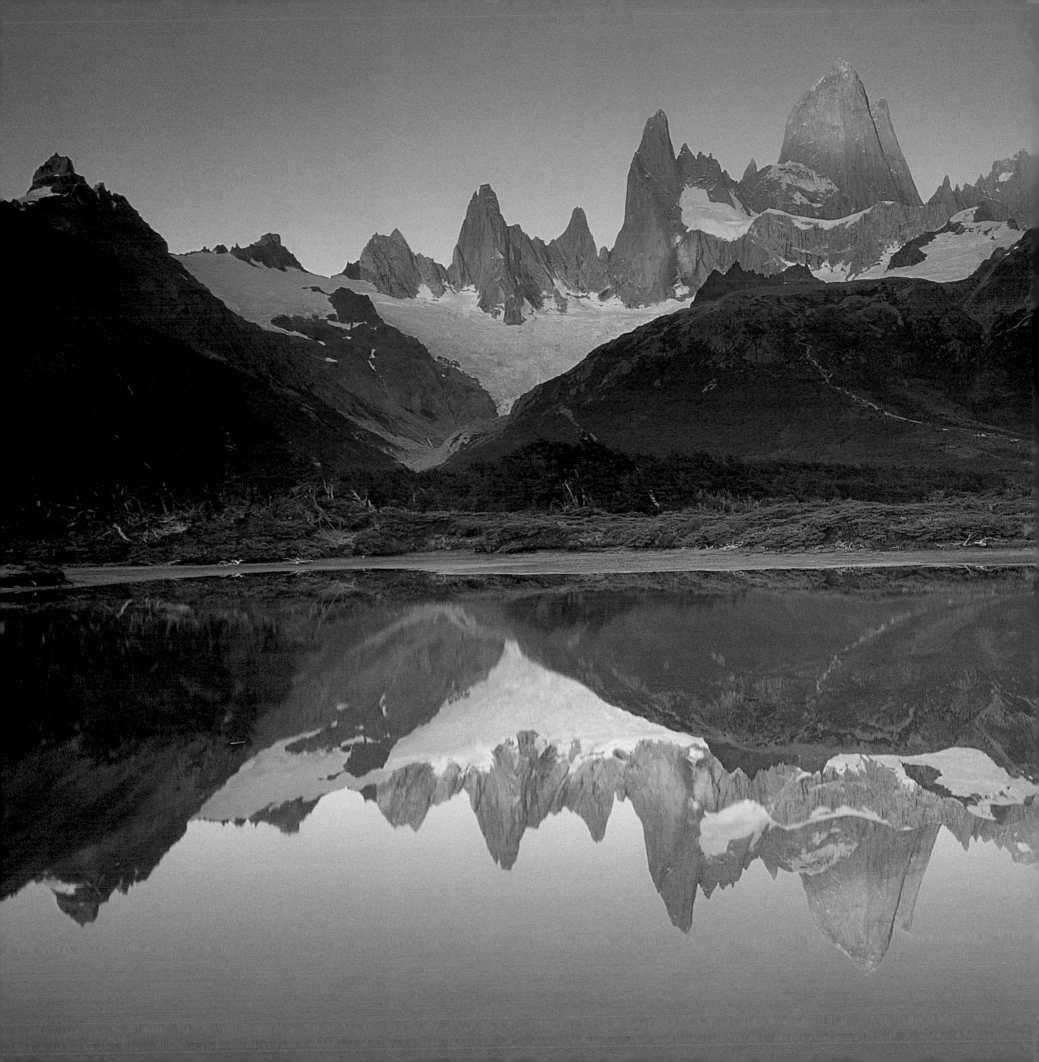

'Patagonia! She is a hard mistress'

Time out in Tierra del Fuego and Patagonia

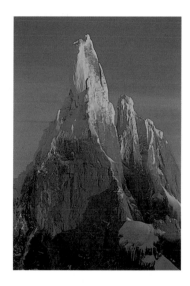

Patagonia! She is a hard mistress. She casts her spell. An enchantress! She folds you in her arms and never lets go… Since its discovery by Magellan in 1520, Patagonia was known as a country of black fogs and whirlwinds at the end of the habited world. The word 'Patagonia', like Mandalay or Timbuctoo, lodged itself in the Western imagination as a metaphor for The Ultimate, the point beyond which one could not go. Indeed, in the opening chapter of Moby Dick, *Melville uses 'Patagonian' as an adjective for the outlandish, the monstrous and fatally attractive.*

Bruce Chatwin, *In Patagonia* and *Patagonia Revisited*

VIGNETTE FROM VOLVER, TIERRA DEL FUEGO

Even inside Volver, a corrugated-iron café overlooking the Beagle Channel, it is hard to escape the wind. It shrieks and wails outside, while cheeky draughts nip through gaps in warped joinery to ruffle plastic flowers and worry the gas-fired fug. I pull closer to the tiny blue flames that flicker through the grille and sip claret. A snug retreat, Volver is my sheet-anchor in a land of tempest.

LEFT: *FitzRoy reflected at dawn, Parque Nacional Los Glaciares, Argentina.* TOP: *Dawn, Cerro Torre.*

213

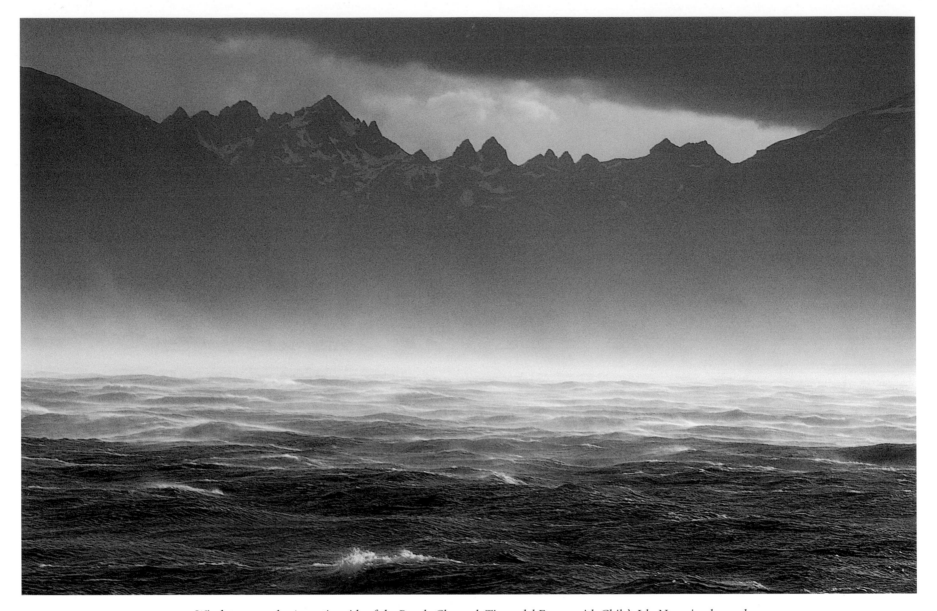

Windstorm on the Argentine side of the Beagle Channel, Tierra del Fuego, with Chile's Isla Navarino beyond.

I sit by the window at my favourite table with its starched cloth and red napkins, embroidered 'Volver' (to return) in white thread. Through dust-smeared glass, I peer across the channel at wind-ripped clouds tethered overhead, straining at the leash. Cut loose, they bear down on lupin-lined Ushuaia as though bent on subduing the cowering, glacier-scarred hills. A slipper of a moon hangs between a bruised purple sky and the inky cut-out crest of Monte Olivia.

This morning, I rode beside the Beagle through open forest rippling with daisies. My horse stopped to tear out tufts of grass while I picked up a cauquén goose feather from a boot-sucking bog. Remounting, I caught sight of a Peale's dolphin breaking the dappled surface of the channel. In its wake, the water was tooled with curlicues of current while rafts of kelp swirled past, tangled in a last furtive tango before open ocean. A headstrong williwaw skittered and twisted across the water. Round the bay, I heard the faint braying of Magellanic penguins. As I stretched forward in the saddle, a shaft of sunlight was snuffed out by scudding grey cloud. By the time I nudged my mount down to the stony shore, a tracery of snow had been laid on the lenga beech trees on Isla Navarino across the way.

Inside Volver, I watch banners of crimson powder snow stream from the peaks, whirled skyward above a tapestry of trees. The last glimmer of autumn sunshine glances across the waterway to ignite an amber glow inside the canopy. In soft focus, dusk lingers lovingly in Tierra del Fuego, land of fire.

As evening draws on, the mozo, a relic from the old school of waiters, brings a plate of centolla (long-legged crab), ensalada mixta, steaming pancitas (bread rolls) and a pisco sour (a traditional drink made from fermented grapeskin). Outside, the wind ploughs through misshapen trees, for once drowning out the carping of sullen mongrels. Sudden gusts rock the dented chimney, lifting flakes of green paint from the tin. Smoke, bent at right angles, ghosts away into the night. The loose Cinzano sign of a rider on a red horse rattles on the porch.

A flint-faced shambles of a man shuffles along the broken footpath, then turns to climb the creaky wooden steps into Volver. With cheeks burnished to the dull sheen of neglected brass, his face is grizzled by grey-flecked stubble, a tobacco-stained moustache and bushy sideburns. His swarm of curls, matted with dust, sticks out beneath a beret. He leans on the wind as if it has been a constant companion, long used to supporting him as he lurches home. Subdued, forgotten, he appears almost afraid to enter.

Until the door slams shut behind him, a shivery blast stops the drone of conversation at the other tables. Dust rises from the floorboards with the sweep of his rancid greatcoat, which is pulled hard around him. A faint sour smell of sweat lingers as he passes to hang his coat on a nail by the fire. I notice that he is wearing a finely plaited rawhide bracelet. A crusty maté gourd protrudes from a pocket in his corduroy bombachas (traditional calf-length riding pants) which are threadbare and have scuffed, crudely sewn, leather knee patches. Legging flaps hang loose over limp leather boots that are spattered with mud but probably have not seen stirrups in years. The mozo tells me later that the wrinkled old man was once a gaucho at Estancia Harberton, a Corriedale sheep and Hereford cattle ranch some 70 kilometres down the channel. With his days in the saddle long gone, Volver offers warmth, wine and a platter of mutton.

Seated with cronies in a corner, the horseman cradles the silver-tipped gourd in his large callused hands, then tops up the slurry of maté herbs with boiling water from a thermos. In a practised ritual, he shares the bitterness and the brotherhood of maté with his caballeros, who, like him, eke out their days as squatters in hand-hewn shacks above town. The mozo knows how to tug at the gauchos' heartstrings. He slips behind the bar, shifts an Underwood typewriter and cranks up a scratchy 78 record by 1930s Argentinian heartthrob Carlos Gardel.

As the record crackles into life, the café goes quiet and all eyes shift to the little monochrome picture above the bar, of Gardel wearing a dapper, double-breasted suit and a trilby. At the mercy of violins, Gardel's sultry voice transports me to a San Telmo footpath, a lifetime away to the north, in Buenos Aires. Entranced by the tango, I sway with the dancers who are seduced by their own snappy movement that alters with the tempo and mood of the music. With faces welded cheek to cheek, the trim bodies strut across the flagstones. Their impassioned legs are entwined in a dangerous liaison and flick from the knee like horses' tails. As the needle clicks round and round at the end of the first side I return to Volver and wipe the beads of moisture from the windowpane.

In a gathering chill outside, I notice a French yacht slip its mooring and put to sea, whipped along by a stiff westerly. Muffled yellow figures scurry about on deck to set a scarf of sail. When the yacht passes Volver, a blue-eyed shag splays ragged wings to test the night air but thinks better of it and hunkers down, wisely settling for the security of a barnacled post. Before long, the yacht will pass the rusted hulk of *El Lobo*, a missionary ship that was wrecked delivering Bibles. Propelled by heaving swells, the stout little craft will soon punch bravely into the Drake Passage, bound for Antarctica. With a frayed tricolor snapping at the stern, she merges with the murk. Knowing that mayhem lies ahead, I raise my glass in respect.

As the record winds down, Gardel's smoky voice fades and is replaced by the raunchy Spanish rhythms of the Gypsy Kings with their strumming guitars and driving drum beat. In these parts, the real gypsy kings are the yachties who maintain a fix on the Southern Ocean and patch together a risky living by renting their home to climbers, divers, sea kayakers and families determined to experience the uniqueness of Antarctica. Though old French seadogs dominate the scene, crusty American, Australian and Dutch salts, among others, also vie for clientele. Decked out before the mast, too, these days, are the frayed-jean set, with their snowboards, paragliders and even fur-trimmed surfboards stowed below. The Drake usually takes its toll on novices who are often humbled by the time they lurch ashore in search of untracked snow above a seal-studded beach. I consider asking the mozo if he has Noel Coward's 'Mad Dogs and Englishmen' but think better of it and point to the empty pisco glass instead.

New Zealand square-rigger Tradewind *in Beagle Channel, bound for Antarctica.*

Street art in Ushuaia tells of the fate of its Indian population and of its convict past.

As a Spanish ship bears down on Tierra del Fuego,
fear shows in the eyes of Indians soon to be decimated by disease.

Yacht crews often have faces like thunder at the end of a hard voyage. They scuttle into the sanctuary of the Beagle, to dry out from a bruising in the Drake and to lie low, drinking their fill in Ushuaia until the thirst for adventure gets the better of them. By the time they are ready to commit themselves again to the 600-nautical-mile passage to the Antarctic, excitement pervades the yacht harbour and the crewmen scuttle about to stow coffee-stained charts, lash down the dinghy and nervously batten the hatches. Though a few yachts are based in the Falklands, far to the north-east, up to 15 embark from Tierra del Fuego each summer on one- to two-month charters, mainly to the Peninsula,

Antarctica's so-called banana-belt. As word has got out about the stunning nature of South Georgia, a growing number of seafarers set their compasses eastward for the long haul to this most mountainous of islands. Many of the yachts have dented steel hulls from repeated encounters with rocks or ice. Retractable keels help to ensure secure anchorages in shallow bays, beyond the grasp of marauding ice. Despite an attitude that knows no bounds or the hindrance of an overbearing bureaucracy, polar yachting remains for the brave and the well prepared.

Square-riggers, too, still round the Horn, though these days, with fare-paying passengers to clamber up the rigging, they are usually bound for the icefields of Antarctica rather than the goldfields of California. Elegant Dutch beauties, like the three-masted barque, *Europa*, and the trim *Oosterschelde* with its cosy, wood-lined wardroom, turn heads as they tack up the Beagle to berth in Ushuaia. I well remember the New Zealand square-rigged schooner, *Tradewind*, under full sail as she glided down the channel. Later, I boarded her in Deception Island's bleak caldera, though my departure, an hour later, turned into a dousing in rather nippy water. A katabatic wind suddenly scudded across Whalers' Bay and, caught unaware, my Zodiac inflatable flipped into the air. Trapped momentarily beneath, I dived under the pontoon, pulled myself up on the stem of the outboard engine and hung onto the upturned hull as the craft was blown out into the bay. Thankfully, I was rescued by Russians. 'Pajalska Kiwi', think nothing of it. I repaid my saviours later, on New Year's Eve in Ushuaia, running to Volver with the crew at a quarter to twelve so I could shout them drinks. Loving Spanish songs were replaced by rowdy Russian ones as midnight Moscow time rolled around. We danced into the wee hours then, much to the crew's disbelief, the mozo dismissed my drinks tab with a flick of his fingers and the cry of 'Feliz Año Nuevo' – Happy New Year.

Over the past decade, the rough-and-tumble township of Ushuaia has established itself as the principal gateway to Antarctica, hosting a proliferation of tourist vessels. By virtue of its latitude, Ushuaia stole the title long-held by Chile's Punta Arenas, a day's sailing to the north. Hardly a morning goes by during the southern summer when an ice-strengthened ship does not slip out of the Drake, to heave a sigh of relief and disgorge a flock of wobbly red-coated passengers into Ushuaia's bustling streets. The vessels range in size from the spartan, 50-passenger Russian ships to 300-berth floating palaces that seem completely out of tune with the environment they purport to relish. From November to March, Antarctica greets some 8000 visitors to its penguin-packed shores, 90 per cent of whom find themselves ushered in and out of Ushuaia at a rapid rate of knots. After a spell dodging icebergs, a few hard-bitten souls remain to roam in the forgotten corners of Tierra del Fuego.

Some years back, after a voyage back across the Drake on *Lindblad Explorer*, we were anchored overnight in Beagle Channel, bound, next morning, for the

Magellan Straits and Punta Arenas. With the passengers tucked up in bed, I sat around a driftwood fire on the beach with other staff members, lying back on cushions of kelp to absorb the smells of the forest. We had already squelched around in a midden of moss to gather calafate berries under lichen-draped lenga . With a glass of rough red in hand and mussels chipped from rocks sizzling on the embers, imagine our horror when the Zodiac slid away from the shore and drifted into mid-channel. Not to be outdone, our sterling historian, Alan Gurney, stripped and dived in, soon boarding the wayward craft. Now picture a rather humourless Norwegian officer-of-the-watch preening his waxed handlebar moustache on the bridge and raising his binoculars just as a naked Mr Gurney drifted past the ship in steady drizzle trying, in vain, to tug the stubborn outboard engine into life.

We landed at first light under the Italia Icefall. Exploding shards of ice and a relentless cascade of water thundered 100 metres or so into the Beagle from the icefield above that blankets Monte Darwin. The Italian connection dates back to Alberto de Agostini's 1929 masterpiece of a book, *Mis Viajes a la Tierra del Fuego*, in which the caption 'Ventisequero Italia', Italian snowdrift, appears under a photograph of the icefall. From 1910 to 1956, Padre Agostini, a Salesian missionary-cum-explorer, documented the geography, glaciology and mountain lore of Tierra del Fuego and Patagonia. Agostini's monochrome images, captured with basic camera equipment, have a distinctive simple charm all their own. Inexorably, I will be lured back, to potter about in the ice-encrusted Cordillera Darwin and to probe the rime-laden defences of the mysterious Monte Sarmiento. Perhaps it was Agostini who coined a phrase that still surfaces periodically in Ushuaia, scribbled on walls under provocative street art: 'Desde el fin del mundo, un mundo sin fin' – from the end of the world, a world without end.

I still feel the pull to return to Volver with its arcane memorabilia from the heyday of sheep. There too, amid the eclectic bric-à-brac from the bygone era of sail, tacked over yellowed 1936 newsprint, is an autographed Greenpeace flag from a heartfelt Antarctic campaign. And how could I forget the café's motheaten mascot, a Magallenic penguin that cocks a glassy stare at gringos huddled over coffee. Beyond the hubbub, out in the Beagle, the wind has blown itself out, the water is mirror-calm. Listen. Pin-drop silence. I step outside Volver, and slowly breathe in this uttermost part of the earth.

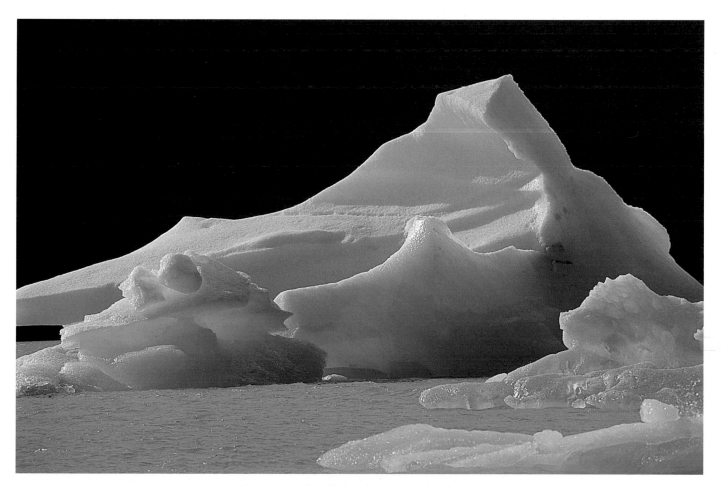

Black storm cloud behind an iceberg, Tierra del Fuego.

In Patagonia

Fiddle-playing mountaineer Vern Tejas, Torres del Paine, Chile.

In the 1920s, Agostini extolled the beauty of the Cuernos del Paine. 'The Paine massif is unrivalled…it rises…like an impregnable fortress, crowned with towers, pinnacles and monstrous horns surging boldly to the sky. In its colours and form it is without doubt one of the most fantastic and spectacular sights that human imagination can conceive.' In 1989, homeward bound from Antarctica's Ellsworth Mountains, I went on a walking trip in Torres del Paine with the Alaskan mountaineer Vern Tejas. At the entrance to the park, Vern promptly struck up Irish fiddle music, filling the mylodon sloth cave with a foot-stomping jig. Over the next week at each of our campsites, he would slip away to fiddle magic into cool night air.

In 1520, the Portuguese navigator Ferdinand Magellan commanded a Spanish flotilla through what is now Estrecho de Magallanes (Magellan Straits) on his way to 'discover' Mare Pacifico (the Pacific Ocean) and the long-sought passage to the Spice Islands of the East Indies. Seeing Alakaluf and Ona Indian fires burning in the forest to the south, Magellan named the land 'Tierra de los Fuegos', the land of fires. When Magellan's men found large guanaco skin moccasin prints in the sand, they thought the Tehuelche Indians must be giants and called them 'patacones' (big-foot). Their land to the north of the strait became known as Patagonia. Though Magellan died in the Philippines, one of his five ships went on to complete the first voyage around the world, a stupendous event that proved the world is a globe. Ironically, today, with the Indians long gone, oil platforms in Magellan Straits near Punta Arenas release fiery banners of gas into the night.

A Chilean horseman or huaso (gaucho in Argentina), Torres del Paine.

Rollerblading under Magellan's statue and an Indian's polished toe, Punta Arenas.

Harberton was carved out of wilderness in the 1870s by English missionary and sheepfarmer Thomas Bridges. His Yahgan-English dictionary, a painstaking piece of work 30 years in the making, was taken by the American Dr Frederick Cook on his way north after the first winter in Antarctica (with Roald Amundsen) on board Adrien de Gerlache's 1897–99 *Belgica* expedition. The unscrupulous American eventually published the book after Bridges's death. Clever wording on the title page indicated to an unsuspecting reader that it was essentially Cook's own anthropological research. In Patagonia there is a saying, 'Trust everyone, but brand your cattle!' Thomas Bridges's son, Lucas, wrote *Uttermost Part of the Earth*, a raw portrait of life on the fringe of the New World. This 1948 classic features stark sepia snapshots of the last pure breed Ona and Yahgan Indians – painted forest warriors wrapped in guanaco skins, soon to be cut down by measles.

Chilean fisherman hand-crafting a new boat, near Puerto Natales.

At 55°S in the Furious Fifties and a skiff north of Cabo de Hornos (Cape Horn), Beagle Channel was named in 1829 during Captain Robert FitzRoy's first voyage in HMS *Beagle* which surveyed the archipelago of Tierra del Fuego. FitzRoy returned to the Magellan Straits, Beagle Channel and Cape Horn between 1833 and 1835, this time with the 22-year-old naturalist Charles Darwin on board. Darwin's journeys to the interior of Patagonia enabled him to observe the natural wonders of the region, including the graceful guanaco, the camel-like cousin of the alpaca and llama, and the feather-duster-like rheas or nandus that kick up their heels and strut off into the scrub. Can the peludo (armadillo), an armoured-tank-like creature, really exist? The lofty crags are a playground for the mighty condor. Below lurks the swift, silent puma. It is no wonder Darwin was impressed with Patagonian wildlife. His work, too, on fossils like the giant sloth, mylodon, played an important role in the development of his ground-breaking theory of evolution.

Founded in 1843, Punta Arenas (Sandy Point) was once a thriving port. In 1915, however, it went into decline following the opening of the Panama Canal. Today Punta Arenas is prospering with a healthy fishing industry centred on shellfish and the centolla crab. The petroleum industry, too, adds significant wealth. It was to the Club de la Union, a grand old lady of Patagonian colonialism in Plaza de Armas, that a desperate Sir Ernest Shackleton came in 1916 to plead for funds to help finance the fourth and ultimately successful bid to rescue his stranded *Endurance* crew from Elephant Island.

A Patagonian photojournalist with his home-made camera.

A Chilean woman and her granddaughter make apple pie, Punta Arenas.

Argentines rarely go anywhere without their maté and a thermos of boiling water.

Patagonia refers not to a political division but to a geographical region encompassing the mainland of both Argentina and Chile south of latitude 40°. Patagonia is dominated by almost a quarter of the 8000-kilometre long Andean chain, the longest mountain range on Earth. This rugged barrier divides Patagonia into two distinct parts: Chile's stormbound Pacific coast dissected by deep forested fjords and, to the east, the soft tawny grasslands of the Argentine pampa. Sandwiched between these remarkable environments, the vast icecap Heilo Continental is shared by both countries and divided roughly into the Heilo Patagonico del Sur and del Norte. The icecap smothers all but the highest mountains though it is fringed by the ice-sheathed monoliths of Argentina's Cerro Torre and Cerro FitzRoy (Chalten).

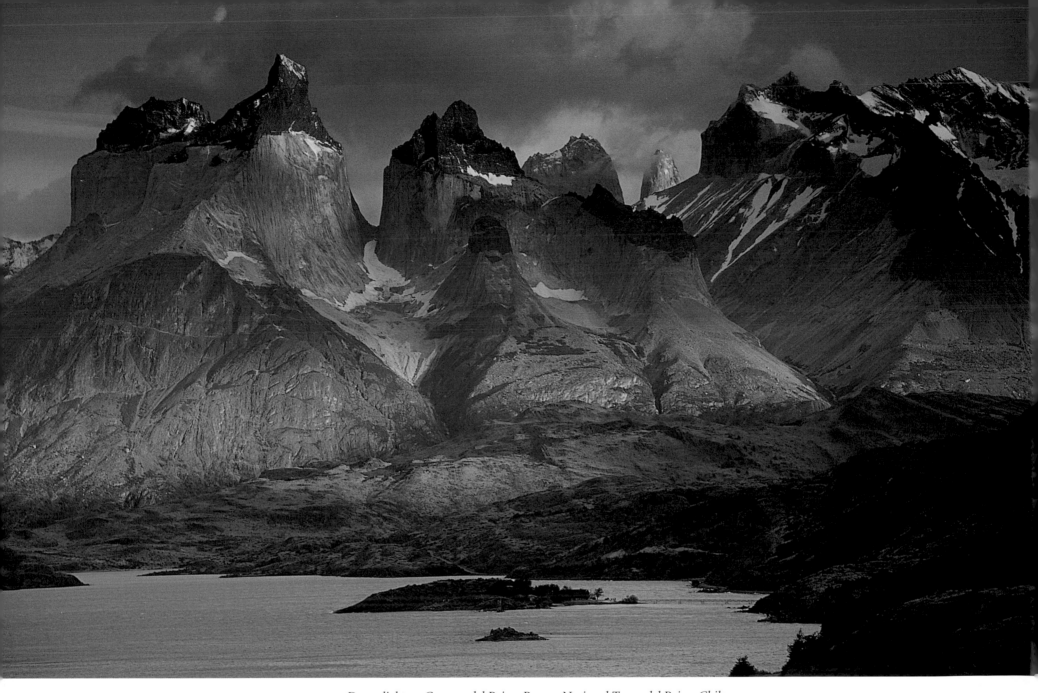

Dawn light on Cuernos del Paine, Parque Nacional Torres del Paine, Chile.

SIESTAS AND STORMS, PATAGONIA

I am absorbed by the colour of granite glowing at sunset on Paine Grande. Below, on the foreshore of silt-laden Lago Grey, I enjoy the contrast of vibrant red notro (the firebush, Chile's national flower) with the iridescent blue of icebergs. Just then, without warning, a piercing scream shatters the hush of a soft evening. At first, I think it is a cry of alarm. But then there is a wild whoop, this time clearly of joy. And then another. Three heavily laden trekkers crash out of the forest, dump monstrous packs, draped with plastic sledges, ice axes and bamboo wands, and hug each other. Others follow. Soon, some 20 people are dancing and shouting in an excited, chaotic babble.

Intrigued, I approach cautiously. When I ask where they began their journey, an exuberant youngster chirps, 'From the sea!' My hunch as to the group's origin and purpose proves correct: they have just crossed el Heilo Patagonico del Sur – the Southern Patagonian Icecap. Over 28 days, in March 2001, the expedition has traversed the icecap (without skis), starting their journey from the shore of Fiordo Peel, which laps the Pacific Ocean. For a full month before climbing onto Chile's slice of the icecap, the team paddled south in kayaks through a myriad of fjords, finally exchanging boats for ice axes for the second leg of the trip. 'For a month in kayaks we have used our arms, then for another month on the ice, our legs. It has been fantastic!'

Most of the Paul Petzoldt National Outdoor Leadership School (NOLS) team are North Americans in their late teens and early 20s. A sponsored place on the expedition has also been allocated to a youngster from the host country, a strong, boisterous lad who could not otherwise afford the expensive undertaking. As I carefully manoeuvre upwind to avoid the smell of damp polypropylene underwear, fetid from hard exercise and close living in tents, the proud Chileano blurts out, 'Chile recently had a sponsored national expedition that crossed the icecap, making use of sophisticated clothing and gear. But now, I too have now crossed with just this little parka. I can't believe it! I am so happy!'

At this point, I decide to retreat, sensing a natural resistance to the first outsider to intrude into the group's hard-won cohesion. I am a stranger encroaching private space, eavesdropping on quirky humour that has evolved to deal with adversity. I can understand their reluctance to lose their team unity as the expedition disperses. The rawness in their eyes speaks of a new understanding that the wilderness must be respected for its own sake. This appreciation often lies undiscovered or is lost among the jostling in the streets.

The Heilo Continental is a powerful place. As the most substantial icecap outside the polar regions, it has tested the bravest and the most adventurous over the years. The first approaches were made from the east by the Spaniard Antonio Viedma in 1782 and, then, in the 1880s, by Francisco Moreno. Between 1914 and 1933, the German, Frederick Reichert, made significant exploratory probes onto the buckled icesheet. Then, in 1930–31, came the ubiquitous Agostini. In 1956, Himalayan climber-turned-yachtsman, H.W. (Bill) Tilman, landed from *Mischief* in Fiordo Calvo. With a fellow Englishman and a young Chileano, Tilman

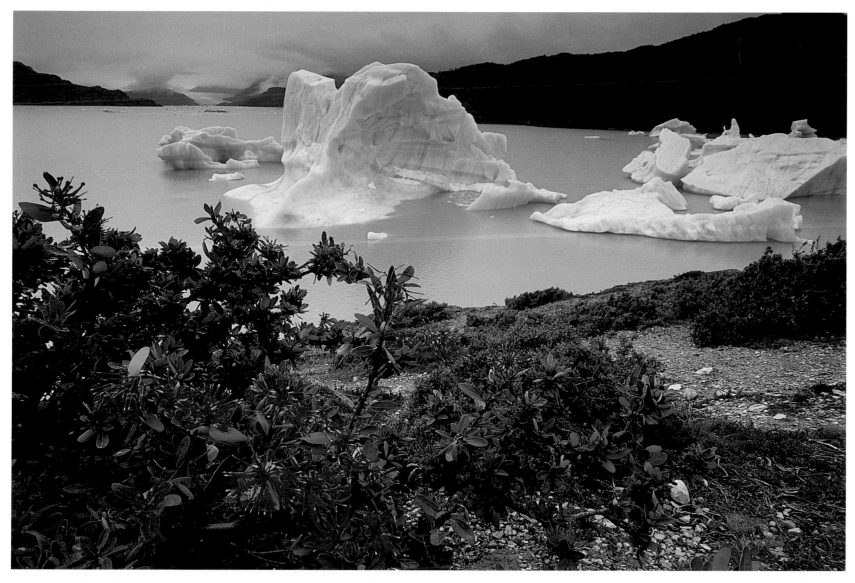

Notro (firebush) flowers and grounded icebergs, Lago Grey, Torres del Paine, Chile.

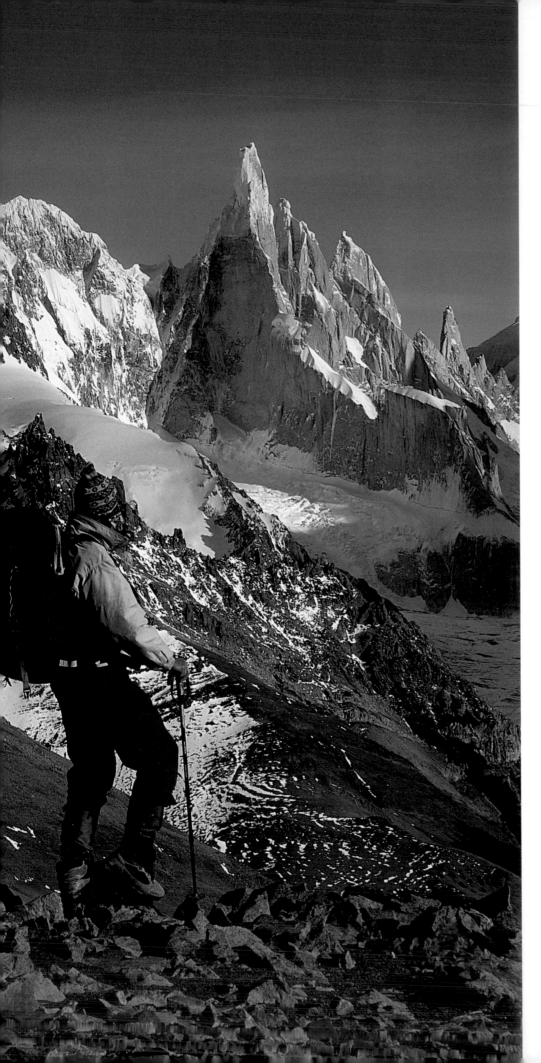

traversed eastward over the icecap to the Perito Moreno Glacier, returning to the west coast the same way, a total of six weeks arduous travel. Destined for a long, torrid affair with the region, Tilman wrote in *Mischief in Patagonia*,

> . . . the Himalaya are high, too high for those who are not 'in the vaward of youth', and though the ageing mountaineer will assuredly find rich solace in its valleys and upon its glaciers he is not likely to resort to them when he knows there are peaks in other parts of the world still within his feeble grasp. So I began thinking again of those two white blanks on the map, of penguins and humming birds, of the pampas and gauchos, in short, of Patagonia, a place where, one was told, the natives' heads steam when they eat marmalade.

Just as Tilman sought a new direction in his life, so too did his old climbing pal, Eric Shipton. A veteran of five Everest expeditions, Shipton was once the doyen of Himalayan climbing circles but, having been sidelined by the British when the route to the summit of Everest was all but blazed, he was cast adrift. Patagonia proved the perfect antidote for a veteran mountaineer who had turned away from the razzmatazz of the big name peaks. In 1960–61, Shipton undertook his second expedition onto the southern icecap. Over 52 days, he sledged 240 kilometres south from Fiordo Baker in Chile to the Upsala Glacier on the southern edge of what is now Argentina's Parque Nacional los Glaciares. Shipton returned to Patagonia in 1963–64, this time crossing the Heilo Patagonico del Norte in a south-easterly direction from San Rafael Glacier to Lago Colonia.

Originally a Spanish dominion, Patagonia was divided in 1881 between Chile and Argentina, a border that was still under dispute 84 years later. In 1965, Shipton was employed by the Chilean government to help calm serious diplomatic wrangling and avert the very real possibility of war. Since the geography of the Patagonian peaks is complicated, Shipton chose not to redefine the border by trying to ascertain the exact line of the Andes that forms the watershed between the Atlantic and the Pacific. Instead, he strengthened his case for a new border after gathering evidence about the nationalities of the pioneers buried in remote graveyards. Cleverly, Shipton calmed the situation by mapping the extent of Chilean penetration eastward and aligning it with the limit of the Gaelic-speaking Welsh community (still thriving) that settled in western Argentina in 1865.

Established in 1959, Chile's Parque Nacional Torres del Paine and, a short condor flight over the border in Argentina, Parque Nacional los Glaciares, are justly famous among trekkers and climbers. There are many fine treks in both parks, including a superb two-day journey in Los Glaciares that leads past FitzRoy to Lago Eléctrico and on up to Paso Marconi on the edge of the icecap.

Cerro Torre from Loma del Pueque Umbado, Los Glaciares, Argentina.

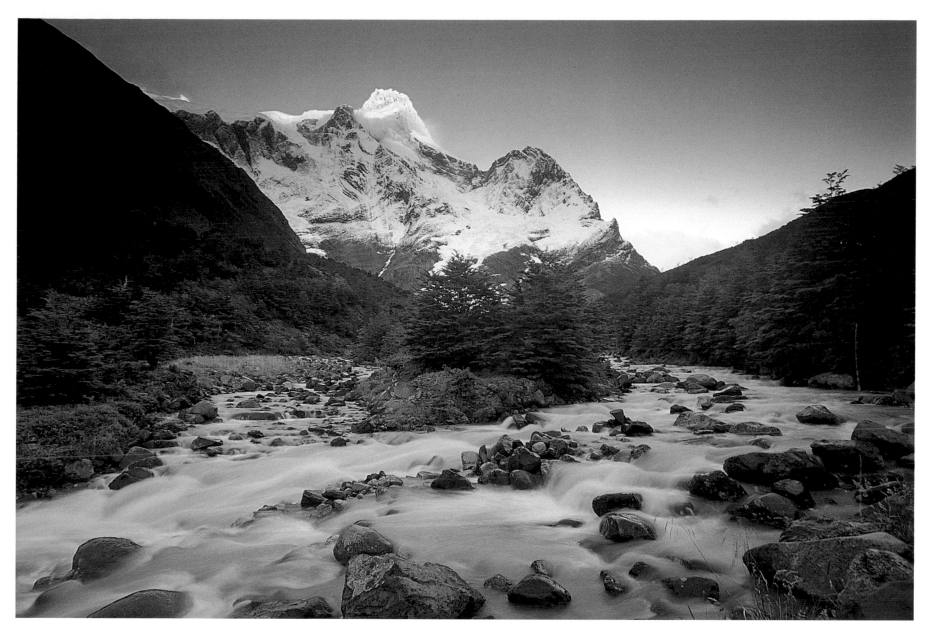

Paine Grande at dawn from Valle Francés, Torres del Paine, Chile.

The popular five-day circuit of the Paine Cordillera encompasses Paine Grande (3050 metres), the highest peak in the park, the Cuernos (Horns) with their awesome walls and distinctive black caps of metamorphic rock and the three plumb-vertical Torres (Towers) of pale, pink granite. As a side trip, the exquisite beech-clad Valle Francés above Lago Nordenskjöld leads to a magnificent cirque of terrifying spires. Names like The Fortress and The Sword have been bestowed on these slender blades by climbers since the late 1950s, in remembrance of desperate battles to reach the prized summits.

Anyone who has ever been to Patagonia always remembers the quality of the light. And that old Patagonian express, the wind! Ripping through a rent in the mountains formed by the Grey Glacier that flows off the icecap, wind can easily reduce a laden trekker to tears. It can toss you aside without warning, just when the struggle for balance among boulders is at its most delicate. Climbers, too, if they are brave enough to emerge from their bothies of branches and tattered plastic, can be soundly lashed by ferocious gusts as they thread their way up the walls. When the wind cuts loose, communication is almost impossible. At best, balance on even the biggest of holds is scary and climbing ropes are virtually unmanageable, flailing skyward, often to become hopelessly snarled on projections. Humbled by wind, climbers retreat – if they can. Those not fast enough to make their ascent in a calm spell could be forgiven for thinking

A month-old guanaco, chulengo, Torres del Paine, Chile.

A Patagonian grey fox, zorro gris chico, Lago Azul, Torres del Paine, Chile.

that the Almighty is a rigorous housekeeper. As local climbers say, 'la escoba de Dios', the broom of God, sweeps this polished rockscape.

On one trip to Los Glaciares I found myself perched on a ledge beneath Chalten (FitzRoy) holding onto the tent poles all night. I thought my little bivouac was secure inside a crude wall of rocks, but the wind did its best to uproot me. The nylon hummed in my ear like barber's shears. There were brief lulls when I thought I could snuggle into my sleeping bag but, in seconds, a roar erupted that grew louder as the next knockout blow rocketed across the snowfield to pummel the tent. Fitful snatches of sleep were the best I could manage. In grey, half-light, as menacing cloud blasted across the upper ramparts of the mountain, I hunkered over a stove to warm my fingers and coax a brew from a pathetic little teabag. By dawn, I was haggard and drawn, ready to retreat.

Tail between my legs, I stumbled down to the lagunas beyond Campamento Poincenot. Cat-napping in the grass, I remembered my university days in Sydney when brooding black images of FitzRoy leapt out of *Mountain* magazine – the antithesis of the sun-drenched sandstone on my doorstep in the Blue Mountains. Every young rock climber dreams of slaying FitzRoy or its feisty neighbour, the rime-coated gargoyle, Cerro Torre. Though my own aspirations as a climber were to be drawn elsewhere, it was a special day in 1987 when Nick Cradock and Russell Braddock, still with Patagonian dust on their boots, crash-landed in my Christchurch garden, fresh from the first New Zealand ascent of Cerro Torre. As we slugged from a wicker-covered flagon of vino tinto, I heard tales of iced-up rock, horrendously exposed climbing and the wind – a bitter, biting wind that sucked away the desire to trudge back up from Campamento Bridwell (now renamed Agostini) past the white-frothed waters of Lago Torre. Then, Nick and Russell enjoyed moments of astonishing beauty that healed the pain of battling the supreme sorceress of the Patagonian Andes.

Other dedicated friends have left their mark here too, among them some of Australasia's best climbers – John Fantini, Nick Kagan, Dave Fearnley, Athol Whimp, Gottlieb Braun-Elwert and Erica Beuzenberg. For others, the dice rolled badly. Some years back, I climbed a route on the North Face of Cerro Solo, trying to keep up with a lean Greg Mortimer, who scampered up the rock like an underfed dingo. After the descent to Chalten, I crunched across frost-heaved feathers of soil and entered the beautiful little chapel outside the village. Solemnly, I read on a brass plaque the names of Kiwi climbers lost in action: after Kevin Carrol's tumble down FitzRoy's Super Couloir in 1973 and, three years later, following Phil Herron's crevasse plunge below Torre Egger.

Bound for Antarctica again, I drove from Calafate, on the soft brown edge of the Andes, back into Chile, before heading on down to Ushuaia. I sat in the Plaza de Armas, Punta Arenas, concerned about the pressure on Patagonia now that Argentina faces unprecedented financial upheaval. Stretched to make ends meet,

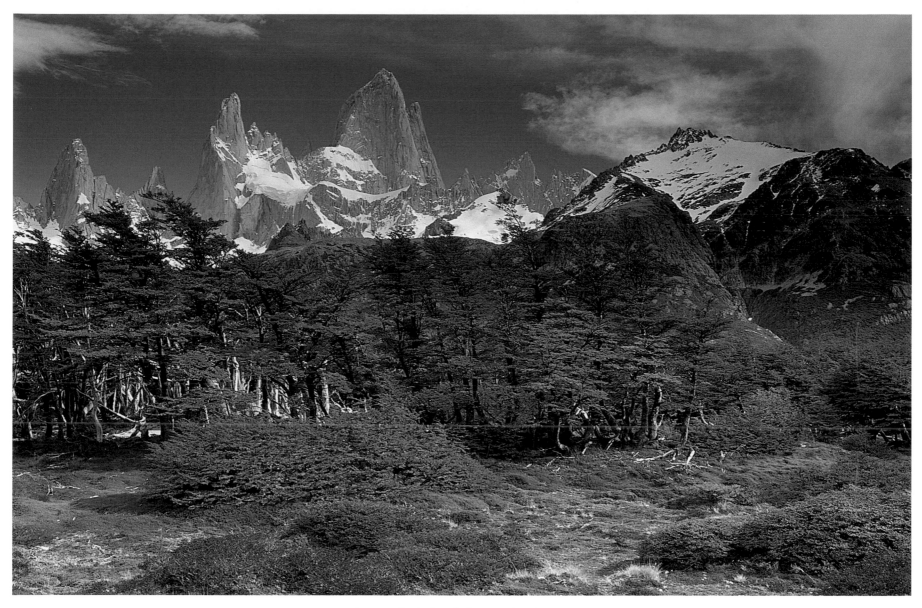

Autumn in the beech forest under FitzRoy.

the farming sector has inevitably had further impact on the environment and now, the national park infrastructure is threatened by such crises as the mooted privatisation of FitzRoy. In recent years, the American climber-philanthropist Doug Tompkins and his wife Kristine have purchased large swathes of coastal Chile, securing it in perpetuity as wilderness. As a follow-up, they have been determined to seal off a unique slice of Patagonia and turn it into Argentina's first coastal national park, by purchasing a run-down sheep farm, Estancia Monte León. The power of one, in this case two, can make a difference.

A Patagonian proverb says 'Quien toma maté y come calafate ha de volver!' – Who drinks maté and eats calafate, will return. And, to rub the shiny bronze toe of the Indian under the statue of Magellan in the Plaza de Armas is said to bring luck and means, quite simply, that you are hooked. You will return to Patagonia – in a heartbeat. I rubbed hard.

As the bus rattled out of Punta Arenas bound for Ushuaia, I thought back to that chance encounter with the NOLS group at Lago Grey. As I had walked away from the youngsters I felt Shipton and Tilman would have been thrilled to witness such a triumph. The tough old climbers would have been heartened that their legacy of low-key travel in wild places has borne fruit. For my part, I am certain that the mountain world is in good hands as long as future generations continue to test themselves on difficult terrain, taking a giant step beyond all previous experience. Content, I fell asleep on the beach that night, listening to the growl of grounded bergs.

Heilo Continental

FitzRoy

ARGENTINA

Cerro Torre

Torres del Paine

Patagonia

CHILE

Punta Arenas

Tierra del Fuego

Cordillera Darwin

Ushuaia

Beagle Channel

Cabo de Hornos

Drake Passage

Patagonia
and
Tierra del Fuego

Andrews, Michael. *The Flight of the Condor – a wildlife exploration of the Andes*, Collins/BBC, London, 1982.

Azema, M.A. *The Conquest of Fitzroy*, Andre Deutsch, London, 1957.

Bridges, E. Lucas. *Uttermost Part of the Earth*, Hodder & Stoughton, London, 1948.

Chatwin, Bruce. *In Patagonia*, Jonathan Cape, London, 1977.

Conway, Sir William Martin. *Aconcagua and Tierra del Fuego*, Cassell, London, 1902.

Crouch, Gregory, *Enduring Patagonia*, Random House, New York, 2001.

De Agostini, Alberto. *Mis Viajes a la Tierra del Fuego*, Professor Giovanni De Agostini, Milan, 1929.

De Agostini, Alberto. *Andes Patagonicos: viajes de exploracion a la Cordillera Patagonica Austral*, Buenos Aires, 1941.

Earle, John. *The Springs of Enchantment – Climbing and Exploration in Patagonia*, Hodder & Stoughton, London, 1981.

FitzGerald, Edward. *The Highest Andes*, Methuen, London, 1899.

Harris, Graham. *A guide to the birds and mammals of coastal Patagonia*, Princeton University Press, New Jersey, 1998.

Hudson, W.H. *Idle Days in Patagonia*, Dent & Sons, London, 1923.

Kearney, Alan. *Mountaineering in Patagonia*, Cloudcap, Seattle, 1993.

Neate, Jill. *Mountaineering in the Andes – a source book for climbers*, Expedition Advisory Centre, Royal Geographical Society, London, 1987.

Neilson, David. *Patagonia – Images of a Wild Land*, Snow Gum Press, Australia, 1999.

Prichard, Hesketh. *Through the Heart of Patagonia*, Heinemann, London, 1902.

Reding, Nick. *The Last Cowboys at the End of the World: the story of the gauchos of Patagonia*, Crown, New York, 2001.

Shipton, Eric. *Land of Tempest – Travels in Patagonia 1958–1962*, Hodder & Stoughton, London, 1963.

Shipton, Eric. *Tierra del Fuego: the Fatal Lodestone*, Charles Knight, London, 1973.

Tilman, H.W. *Mischief in Patagonia*, Cambridge University Press, 1957.

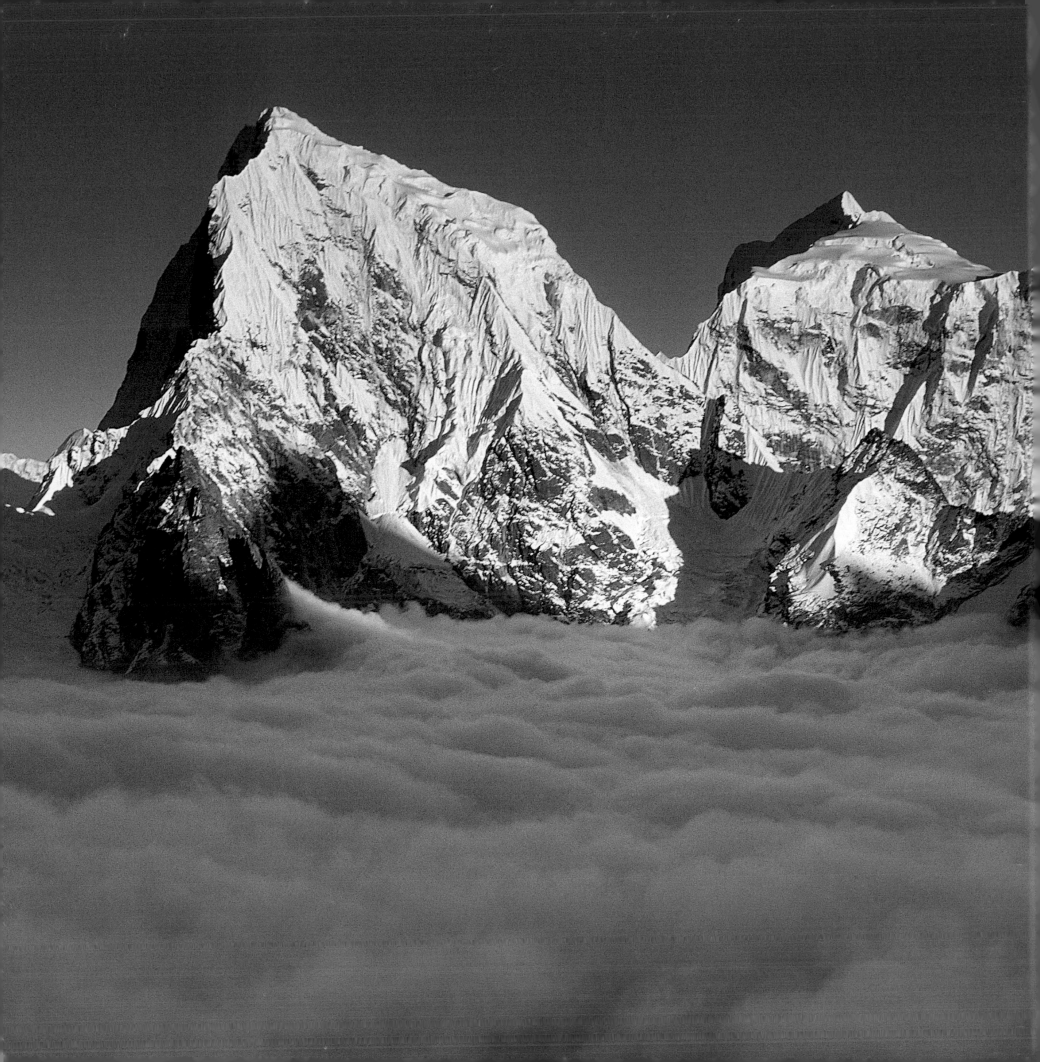

Acknowledgements

Publishing *Under A Sheltering Sky* has been a journey in itself. Although I would rather be crossing a Himalayan pass to see the mountains beyond, the writing and co-ordination of this book has brought its own rich rewards. I could not have achieved a book of this complexity without the help of many fine people who believed in my work.

I especially wish to thank a master of polar art, the explorer Sir Wally Herbert, who graciously allowed me to intrude into his busy schedule of commissioned work when I asked him for a foreword. Thanks, Wally.

Anna Rogers edited my *Hall and Ball – Kiwi Mountaineers*, so, inevitably, the path led to her door as this new book became reality. Anna has a way with authors that makes each one feel special and welcome in her home. And, the coffee and carrot cake help to dull the sharpness of her red pen. Crucially, the tussles that she won have immensely improved this book. Special thanks, Anna.

The warmest of thanks also to Bruce Bascand and Peter Watson of The Caxton Press in Christchurch for their enthusiasm and professional advice as publishing consultants. Hedgehog House has used The Caxton Press for 20 years to print its New Zealand Alpine and Antarctic calendars. I could not imagine receiving friendlier service or a higher standard of printing from any company. And, whether they are drum scanning the images for our calendars or for this book, Nona and Andrew Budd of Tradescans have developed a touch and technical ability that simply must be the best in New Zealand. Thank you both.

The Caxton Press is also lucky to have a graphic artist of the calibre of Sue Elliott, who not only paid incredible attention to the detailed design of every page, but dealt with the 'client from hell' with charm and skill in the face of considerable demands. I have a feeling that this book will spark off some new adventures for you and Wayne. Thank you kindly, Sue.

Long before he returned from a pilgrimage in India, I knew that Hare Krishna artist Yasoda would create the vibrant paintings in this book. Caught up by the energy for the project, Yasoda gradually teased out of me the vision I had to create a single image of each journey. I then gave him the freedom to combine elements of the real geography with the spirituality and essence of the landscape. But, when the 12 vertical mock-ups were all but complete, I changed the shape of the book. In all, it took 84 painstaking days of research and painting to get it right. Hare Krishna, Yasoda.

Friends are the most precious thing on the planet. First and foremost, my wife Betty is special not only for being the finest of companions in the Himalaya and the Antarctic, but also because she has allowed me the freedom to produce a book at a time that meant extra demands on her at Hedgehog House.

Cholatse (left) and Taweche from Gokyo Ri, Khumbu, Nepal.

Advice, writing retreats, meals, finance, the loan of books or route information and, most of all, encouragement, came willingly and lovingly from the following: Stu Allan, Dave Bamford, Leslie Blank, Rob Brown, Robbie Burton, John Cleare / Mountain Camera, Pete Cleary, Lynley Cook, Twit Conway, Tui De Roy, Kurt Diemberger, Linley (the badger) Earnshaw, Nick Groves, Geoff and Shelley Gabites, Bob Headland, Arnold Heine, Jane Hemmen-Marder, Les Hepburn, Betzy Iannuzzi, Candy and the crew at Imagelab, Mike McDowell, Pat and Baiba Morrow, Greg Mortimer, John Nankervis, Duncan Ritchie, Betty and Norman Roberts, Barbara and Galen Rowell, Eric and Ursi Saggers, Audrey Salkeld, Deirdre Sheppard, Judy Tenzing, Stephen Venables, Aat Vervoorn, Wanda Vivequin, Ali Ward and, of course, the Dragon, who planted the spuds while we were away.

I also owe a considerable debt of gratitude to a number of expedition sponsors and logistic outfitters, without whom these journeys would not have been possible. Travelling companions and climbing partners remain forever in my mind, having shared rich experiences in pursuit of a goal. In particular, I wish to mention –

GREENLAND: Mike McDowell, Sjur Mordre, Fred Morris, Tore Stensen and Quark Expeditions.

KARAKORAM: Angela Dale, Kurt Diemberger, Martin Dumaresq, John Ewbank, Ray Fry, Bruce Gardiner, Stuart Hill, Stewart Hughes, Peter Jeal, Greg Mortimer, Pam Powell, Alec Spiller, Lucas Trihey, Peter and Sue Vail, Jin Ying Jie, Sue Werner, the Australian Geographic Society, Sydney Rock Gym and Macpac.

NEW ZEALAND: Stu Allan, Rob Brown, Nick Groves, Hugh van Noorden and the New Zealand Alpine Club.

KHARTA VALLEY, TIBET: Peter Cleary, Ravi Chandra of Ama Dablam Adventures, Kathmandu, the Royal Geographical Society.

KAILAS & GURLA MANDHATA, TIBET: Gerry Essenberg, Fran Ferry, John Kurnick, Key Kwong Woo, Shaun Norman, Martin Reeves, Steve Tully and Mr Mo Mo of the Tibetan Mountaineering Association, Lhasa, Kwang and Sanduk of Asian Trekking, Kathmandu.

BHUTAN – 1995: Nicole Bartels, Ken Campbell, Barbara Gardner and Erika van Lennep and Needup of International Treks and Tours, Paro.

BHUTAN – 1999: Helen Beaglehole, Gin Bush, Jim Harding, Pip Lane, Fiona McPherson, Fiona Miller, Betty Monteath, Dennis Pisk, Claudia Schneider, Thinley of International Treks and Tours, Paro and Judy and Tashi Tenzing of Tenzing's Journeys, Sydney.

MONGOLIA: Mr Atai, Dave Bamford, Geoff and Shelley Gabites, Betty Monteath, John Nankervis, Jennifer and Sandy Sandblom, Sandagash, Sabine Schmidt, Keith Swensen and Graham Taylor and Chinzo of Karakoram Expeditions, Ulan Baatar.

SOUTH GEORGIA: Aurora Expeditions, Roger Booth, Martin Dumaresq, Leigh Hornsby, Mitsiwago Iwago, Kosaki-san, Peter Marsh, Mike McDowell, Gary Miller, Greg Mortimer, Tom Powell, Quark Expeditions, Margaret and Sue Werner, Michelle and Chris Ward.

KANGRI GARPO, TIBET: Wilf Dickerson, Jos Lang, Betty Monteath, John Nankervis, Nick Shearer, John Wild, New Zealand Alpine Club, Bill Ruthven of the Mount Everest Foundation, W. L. Gore & Associates, USA for a Shipton/Tilman grant, Tamotsu Nakamura of the Japanese Alpine Club, Dou Chang Shen of the China Tibet Mountaineering Association, Lhasa, Dick Price and Peter Cammell for medical advice and Verkerks, Christchurch.

DENALI, ALASKA: Gottlieb Braun-Elwert, Gary Kuehn, Eric Saggers, the Australian Geographic Society, Geoff Johnson, Kate Redfern and Andy Sheppard of Brand-X, Cross Clothing and Atomic skis, Christchurch, Dave, Kari and Galen Johnston, Brian Okonek, Joe Reichardt, Roger Robinson, Talkeetna.

KANGCHENJUNGA, NEPAL: Ravi Chandra and both Amrits of Ama Dablam Adventures, Kathmandu, Jim Harding, Betty Monteath, John Nankervis, Rob Rowlands, Claudia Schneider.

PATAGONIA: Peter Cleary, Alan Gurney, Vern Tejas.